KINtop Studies in Early Cinema – volume 6
series editors: Frank Kessler, Sabine Lenk, Martin Loiperdinger

T0329688

A Million Pictures:
Magic Lantern Slides in the
History of Learning

KINtop Studies in Early Cinema

KINtop Studies in Early Cinema expands the efforts to promote historical research and theoretical reflection on the emergence of moving pictures undertaken by the internationally acclaimed *KINtop* yearbook (published in German from 1992–2006). It brings a collection of anthologies and monographs in English by internationally renowned authors as well as young scholars. The scope of the series ranges from studies on the formative years of the emerging medium of animated photographs to research on the institutionalisation of cinema in the years up to the First World War. Books in this series will also explore the many facets of 19th and early 20th century visual culture as well as initiatives to preserve and present this cinematographic heritage. Early cinema has become one of the most dynamic fields of scholarly research in cinema studies worldwide, and this series aims to provide an international platform for new insights and fresh discoveries in this thriving area.

Series editors: Frank Kessler, Sabine Lenk, Martin Loiperdinger

A Million Pictures:
Magic Lantern Slides in the History of Learning

Editors
Sarah Dellmann and Frank Kessler

British Library Cataloguing in Publication Data

A Million Pictures
Magic Lantern Slides in the History of Learning

Series: KINtop Studies in Early Cinema – volume 6

A catalogue entry for this book is available from the British Library

ISBN: 0 86196 735 3 (Paperback)
ISBN: 0 86196 950 0 (ebook-MOBI)
ISBN: 0 86196 955 5 (ebook-EPUB)
ISBN: 0 86196 956 2 (ebook-EPDF)

The contributions in this volume resulted from a conference organised in 2017 by the European research project *A Million Pictures: Magic Lantern Slide Heritage as Artefacts in the Common European History of Learning*, a Joint Programming Initiative on Cultural Heritage – Heritage Plus project funded by NWO, Belspo, AHRC and MINECO and co-funded by the European Commission.
The publication was supported by the Belgian Excellence of Science project *B-magic. The Magic Lantern and its Cultural Impact as a Visual Mass Medium in Belgium* (EOS contract 30802346) and the Dutch NWO project *Projecting Knowledge – The Magic Lantern as a Tool for Mediated Science Communication in the Netherlands, 1880–1940* (VC.GW17.079 / 6214).

Published by
John Libbey Publishing Ltd, 205 Crescent Road, New Barnet, Herts EN4 8SB, United Kingdom e-mail: john.libbey@orange.fr; web site: www.johnlibbey.com

Distributed Worldwide by
Indiana University Press, Herman B Wells Library—350, 1320 E. 10th St., Bloomington, IN 47405, USA. www.iupress.indiana.edu

Printed and bound in the UK by Short Run Press Ltd, Exeter.

Contents

Introductions

Sarah Dellmann

The Many Perspectives on
A Million Pictures

his essay collection documents presentations given at the conference
"A Million Pictures. History, Archiving, and Creative Re-Use of Edu-
cational Magic Lantern Slides" that took place from 29 August – 1
September 2017 in Utrecht, the Netherlands. This conference was the summit
of the collaborative research project *A Million Pictures: Magic Lantern Slide
Heritage as Artefacts in the Common European History of Learning* (2015–2018),
carried out by researchers from the Universities of Antwerp, Exeter, Girona,
Salamanca and Utrecht as well as twenty associated partners from museums,
archives, libraries and independent artists and performers.[1]

The *Million Pictures* project set out with the premise that:

> The magic lantern was a very relevant, if not the most important, visual
> entertainment and means of instruction across nineteenth-century Europe.
> However, despite its pervasiveness across multiple scientific, educational and
> popular contexts, magic lantern slides, its apparatuses and practices still remain
> under-researched. Although many libraries and museums across Europe hold tens
> of thousands of lantern slides in their collections, a lack of standards for
> documentation and preservation limits the impact of existing initiatives, hinders
> the recognition of the object's heritage value and potential exploitation. This
> project addresses the sustainable preservation of this massive, untapped heritage
> resource.[2]

A Million Pictures identified two main problems: firstly, a poor understanding
of the historical objects, and, secondly, a lack of access to relevant source
material. If researchers, artists and interested people cannot access the material
(or are unaware of its existence), demand for and knowledge about the objects
will not increase. And if demand and knowledge stay limited, the documenta-
tion of the objects will not advance, which in turn will not improve conditions
of access. These entangled problems, we believed, could only be overcome
when academic researchers and archival practitioners join forces – which called
for a cultural heritage approach to our project.

Related disciplinary histories

While the cultural heritage approach of *A Million Pictures* was new in lantern research, a number of academic research initiatives included the magic lantern in the respective disciplinary histories.

In Film and Media Studies, especially in the subfield of early cinema studies, the metaphor of the "birth" of cinema and teleological ideas of media history for a long time limited the study of magic lantern and other optical media, as they were described in terms of "pre-cinema history", not as media in their own right or with their own history. This has changed over the last two decades: as early cinema studies embraced approaches from media archaeology, concepts such as "birth" and "invention" became less relevant than research along the lines of "continuities and discontinuities" or "intermedial relations". In addition, the field of New Cinema History, focussing on local cinema cultures and audiences, brought a decidedly social-history approach to the field. These approaches have created new interest in what was actually shown, and to whom, sparking new research questions and a turn to material artefacts and archival documentation, but moving beyond an "object fetishism" of "unique" and "first" apparatuses.

Art History has a remarkable body of scholarship reflecting the history of the discipline and the changing didactics in the teaching of art history, including the media and objects that reproduce art works for study and pleasure (e.g. in the form of prints, plaster statues and lantern slides). Now that art history teaching mostly uses digital means to illustrate the subject matter, some attention has turned to the – often very large – image libraries at art history institutes, with examination of their contents and discussion about what to do with them.[3]

Historians of science, meanwhile, have discussed projected images as part of the study of optics. Work in this field tends to highlight apparatuses, lanterns, and inventors – there has been good work on inventors like Christiaan Huygens (1629–1695), and early instrument makers[4] – but on the whole the 'magic' lantern, perhaps because of that 'unscientific' adjective in its shared name, has not been highly regarded among historians of science and collectors of scientific instruments. Study of the popularisation of science through this medial form is still at an early stage.

A cultural heritage approach to the study of lantern slides

In these and other fields the study of lantern slides has gained academic interest, especially in the last five to ten years. A number of recently edited volumes,[5] monographs[6] and special journal issues[7] offer excellent overviews of the state of the research in their introductions. These publications frame lantern slides and objects of magic lantern culture according to their research questions: as a medium in the public debate on the social question; as part of national histories; as a performative practice; as technologies in an intermedial media

landscape; or as part of disciplinary histories. The following is therefore not intended as a general introduction to the state of research, but flashes out the specificities of the *Million Pictures* project's cultural heritage approach and its overarching concerns.

The admittedly broad bracket of "cultural heritage" allows bringing together different subfields in which lantern knowledge is held – all on equal terms. By establishing the material heritage object as common point of departure, an interdisciplinary discussion was fostered, in which scholars of different disciplines, archivists, curators, museum education practitioners, private collectors, artists and performers could participate from the onset. This was crucial for connecting the existing expertise(s) on these objects.

The cultural heritage approach also enabled a transnational perspective, as we did not restrict our investigation to a national scope. It brought commonalities to the fore, and allowed us to spot similar objects across collections (that were described and managed by different institutional and national logics) and see a common history of learning, without the need to 'nationalise' the research findings. Our observations support the 'gut feeling' speculation of private collectors: that the distribution networks forming the economic backbone to the lantern's dissemination were organised transnationally – a feature which seems to have been particularly prominently established in the educational slide sector. A systematic investigation of such distribution networks will need further research, but the observation of a significant number of similar objects held in collections throughout Europe is a strong point for explaining lantern slides as a mass medium.[8]

The cultural heritage approach invited fundamental research and deductive research methods. The room for open-result experiments with ways of documenting, digitising and creative re-use of this material provided the conditions for the possibility of new research findings, achieved through various methods applied by the interdisciplinary consortium. Among the discoveries were the analogue lantern slides' potential of explaining digital animation technologies in educational settings, as proved by the exhibition "Light! Magic Lantern and the Digital Image. Affinities between the Nineteenth and Twenty-first Century" of the Museum of Cinema in Girona (2017–2018), a deeper understanding of the 'magic' and poetics inherent to projecting fleeting things, as Sarah Vanagt presented in her film A MICROSCOPIC GESTURE (2016),[9] or the productive dialogue during our workshops on the way in which researchers from different disciplines and archivists in different types of museums conceptualise the analogue and the digital object[10] and use both in their research and teaching.[11]

Approaching the objects from a cultural heritage perspective also foregrounded a shared concern. The discussion of what to do with material that becomes obsolete in its original function, for example the question whether or not it should be preserved, is subject of debate among curators of slide collections and discussed in (academic) heritage associations,[12] as (even digital) storage

space is limited and costly. Unlike hand-painted slides or slides with complicated moving mechanisms, which are more likely to evoke fascination from their object character, the bulk of educational glass slides were cheap, mass-produced lantern slides in standard format.[13] The decision to preserve large collections of lantern slides, many of which depict subjects that are also available in better quality in easier accessible media formats, needs other arguments for its justification.

Such an argument, we believe, could be delivered by demonstrating the interest of user groups once material becomes accessible and available for creative re-use. By showing examples of creative re-use of lantern heritage, and by allocating time, space and funds to artistic practice, our project developed new perspectives on and uses of the historical objects and drew connections between the past and the present. These art works and performances also found audiences in communities outside of academic settings, demonstrating the rich potential of the material for connecting people with heritage.

To address our first concern, increasing our understanding of the objects, we worked together to explore what can be learned from the preserved objects about the historical contexts in which they were used. Alongside magic lanterns and lantern slides, archives and private collectors hold lantern-related ephemera such as distribution catalogues, illuminants (light sources), projection manuals, lantern 'readings' offering suggested comments to accompany the slides, newspaper clippings with announcements or reports of lantern performances, the original boxes in which slide sets were sold, engravings documenting lantern events, and more. To address our second main point of concern, ameliorating access to objects of lantern culture, we discussed with collection managers and owners how to best document and digitise the objects online. We explored needs for access and re-use with the various stakeholders of this heritage network, among them Eye Film Institute Netherlands, Museu del Cinema Girona, Museo Nacional de Ciencia y Tecnología de España, Museum for Contemporary Art Antwerp, Royal Albert Memorial Museum Exeter and Utrecht University Museum; film producers at Staccato Films BV and performers at Promenade Productions; private collectors and researchers across the humanities.[14] Here again, working across disciplinary and institutional boundaries enabled us to combine insights from scholarly research, from artistic research and practice, with expertise from archivists, librarians and information scientists, to ensure that different user needs are considered in sustainable and useable ways of documentation, preservation, digitisation and forms of accessibility.

This approach also bore practical results: over 21,000 new additional images of lantern slides and apparatuses, with accompanying metadata records, were added to the Lucerna Magic Lantern Web Resource (hereafter Lucerna), more than doubling the freely available material on that resource.[15]

As the infrastructural backbone, Lucerna provided the virtual environment to share our discoveries and connect our findings to the knowledge already

established in that resource. Lucerna established itself as the sustainable reference database, which is found by a wide array of various users seeking information on lantern culture;[16] in its improved version, Lucerna is more easily useable as repository for future research.

In addition, we set up a digital collection of magic lantern and slide catalogues in cooperation with Media History Digital Library[17] and a resource list on Wikipedia,[18] along with practical guidelines on digitising objects and for contributing information on Lucerna.[19]

An important aspect of the *Million Pictures* project was to share our thoughts and findings with diverse interested publics: through papers at academic conferences, lantern presentations at local history societies and museum events, a series of international workshops and videos documenting art installations. Project events ranged from exhibitions to hands-on workshops in museum pedagogy and university teaching, and from lantern shows with original material, to apps and digital animations, to musical and dramatic performances inspired by the principle of telling stories with light.

Our research team, of course, did not start from scratch. We should explicitly acknowledge the input from members of the The Magic Lantern Society (based in the UK) and the Magic Lantern Society of the US and Canada,[20] feedback on established archival practices shared by our cooperating partners, and curatorial expertise from Screen Archive South East at the University of Brighton, the Museum for Contemporary Art Antwerp (M HKA) and the Museu del Cinema in Girona. We also profited from the invaluable body of knowledge established in various research projects of the (now discontinued) network Screen1900 at the media studies department at Trier University and wish to thank for this collegial exchange.[21]

Researchers on magic lantern culture have developed a number of concepts, resources, infrastructures and tools. Concepts that help to address the complexity of lantern slides, while remaining open enough to investigate their intermedial relations are, for example "screen culture",[22] "screenology",[23] "screen studies",[24] or "the historical art of projection".[25] Approaches of "media ecology" or medial "*dispositifs*" are fruitful to investigate relations, and the concepts of "performance" and "performativity"[26] proved suitable to theorise the ephemeral character of a live performance medium. Methods from (experimental) media archaeology and artistic practice, including re-enactments and creative adaptations, elucidate (historical) media practice and audience experience, allowing conceptual or phenomenological questions on media experience to be merged with embodied experiences. Insights from edition theory and online documentation (and the conceptualisation of meaningful units in the online resources eLaterna and Lucerna) offer a shared vocabulary for describing the objects and their relations.[27]

Beyond Lucerna and the resources developed in the *Million Pictures* project mentioned above, a number of other online resources provide access to digital images of lantern slides,[28] and the Slide Readings Library of the Magic Lantern

Society provides access to historical comments to slide sets.[29] Research articles and digitised primary sources are listed in the Zotero Magic Lantern Research Group,[30] while the Magic Lantern Society and the Magic Lantern Society of the US and Canada provide a network of expertise beyond the running time of individual projects.[31] eLaterna offers tools for documentation and analysis as well as a publication platform for new findings.[32]

Almost all of these resources are freely available online. Archivists, curators and museum practitioners, artistic and scholarly researchers and teachers in museums and higher education are now more likely than ever before to find (digital) resources they need. In retrospect, it is quite amazing to see how the impulses from both project and conference were, it would appear, just what was needed to bring magic lantern research up to its next level. Researchers who start exploring collections today can access resources to further expand our knowledge, and hopefully contribute to the further development of shared tools and resources to avoid 're-inventing the wheel' in insular research communities.

The conference and articles

The contributions in this edited volume are based on presentations given at the conference "A Million Pictures: History, Archiving and Creative Re-Use of Educational Lantern Slides". This conference was attended by over 100 people from 14 countries and mirrored different disciplines and institutional backgrounds: artists and performers from the domains of film, composition, performance art; researchers from BA students to full professors from film and media studies, art history, applied arts, theatre and performance studies, information science, sociology, communication studies, (comparative) litera- ture studies, social history and history of science; heritage professionals, curators, educational museum staff and archivists; and of course private col- lectors and lanternists. All these people contributed to deepen our knowledge and broaden our lantern horizon. During the four days of the conference, 30 short and long papers were given as well as two keynotes, ten posters, and several demonstrations of digital tools for lantern research. Nine performances and film screenings, an exhibition and a round table on working with slides at the intersection of research, archive and performance were also part of the programme.[33]

This edited volume, by nature of its form as an analogue book, does not reflect all the variants of presentations and the organised sharing mix between partici- pants and their various backgrounds. Due to its restriction to written word and printed images, some contributions could not be included in this format without compromising their nature too much.[34] However, the essays assem- bled here do mirror the variety of genres, including longer research articles, shorter project reports and reflections on ongoing work. The relative length of contributions does not imply a degree of relevance.

Some articles assembled here present research into the historical contexts of use of a slide set – from teaching tools in disciplinary histories, to means of persuasion and propaganda from religious and political actors, to the use in early film screenings (Dupré la Tour, Grasskamp, Lee & Wong, Hayes, Kusahara, Männig, Quillay, Wachelder).

Other articles emphasise collection- and object-based methods and other sources to contextualise and theorise the material (Dellmann, Durrant, Huhtamo, Lenk, Pitarch & Quintana, Stanulevich, Vilarigues & Otero). Two articles focus on methodologies: one presents quantitative methodologies for analysing lantern slides (Frutos Esteban & Lopez San Segundo) and another to analyse the *dispositif* (Kessler). Other articles discuss the performative practices of lecturing, lantern shows and audiences – historically and in contemporary practices (Crangle, Kember, Lorenzo, van Dooren, Vanhoutte, Wynants) and share experience obtained in documentation of exhibitions, museum pedagogy and teaching (Pons i Busquet, Puigdevall Noguer, Willis).

The *Million Pictures* project and conference, at least to some extent, succeeded in bringing together hitherto individually working professionals. It extended a network of researchers across traditional disciplinary boundaries that, maybe more importantly, welcomed the knowledges of – from traditional academic perspectives all too often belittled – artistic research, private collectors, museum educators and heritage professionals as equally valuable to the field of lantern studies.

Outlook

It is, however, still accurate to state that the field remains in its emerging phase (especially when considering the relevance of this medium in 19th- and early 20th-century culture). The explorative nature of this project, the conference and this edited volume necessarily leave ground uncovered. The call for papers was about a medium format and a function – lantern slides for educational purposes – inviting conceptual, disciplinary and methodological variety of contributions. Consequently, this volume cannot claim to offer a comparison of the presented research methods, let alone their systematic evaluation or another form of synthesis. Such a reflection on methodologies, and the development of criteria for their evaluation (that also do justice to the interdisciplinary character of lantern slide research), needs to be left to future research. The articles in this collection are intended to show the variety of lantern research and are assembled to foster the dialogue on lantern heritage from various perspectives. It can be expected that case studies and collection-based research methods will remain relevant, if not dominant in the study of lantern slides and lantern culture for the coming years, as more collections, and their makers, users and audiences, still need to be (and are) investigated as case studies before solid conclusions about trends and larger patterns can be drawn.[35]

Looking back as initiator and coordinator of the research project and as organiser of the conference, I wish you a reading full of discoveries, embracing the various perspectives that can be taken on a million pictures.

Notes

1. The research project was financed as part of the Joint Programming Initiative on Cultural Heritage – Heritage Plus project, funded by the Netherlands Organisation for Scientific Research (NWO), Belgium Science Policy Office (Belspo), The Arts and Humanities Research Council (AHRC) and the Spanish Ministry of Economy, Industry and Competitiveness (MINECO). It was co-funded by the European Commission. It ran from 2015 to 2018.

2. Project application to the Call "Heritage Plus – ERA-NET Plus on Cultural Heritage and Global Change Research (618104)" by the European Commission, submitted September 2014.

3. Numerous case studies, especially in the history of art history have elucidated aspects that inform a discipline's media history, as brought together at the workshop "Plaques photographiques. Fabrication et diffusion du savoir", organised by art historians and slide collection curators at French universities, Université de Strasbourg, March 2016 and, more recently, the conference "Media in the Teaching of Art History", organised by the German Documentation Center for Art History – Bildarchiv Foto Marburg at Philipps-University Marburg, October 2018. Proceedings of the Strasbourg event have been published as Denise Borlée, Hervé Doucet (ed.), *La Plaque photographique. Un outil pour la fabrication et la diffusion des savoirs (XIX^e – XX^e siècle)* (Strasbourg: Presses universitaires de Strasbourg, 2019). The question of what to do with material that becomes obsolete in its original teaching function is, of course, not restricted to the field of art history but discussed in all disciplines that apply visual representations and used projected images in teaching such as medical sciences, all subfields of biology, geology, astronomy, archaeology and ethnology, and many more. See the discussion in academic heritage associations (note 12).

4. See e.g. for the Musschenbroek atelier: Willem Albert Wagenaar, Margreet Wagenaar-Fischer and Annet Duller, "Dutch Lantern Workshops", in Willem Albert Wagenaar, Margreet Wagenaar-Fischer and Annet Duller (ed.), *Dutch Perspectives. 350 Years of Visual Entertainment* (London: Magic Lantern Society, 2014), 27–53.

5. Ludwig Vogl-Bienek and Richard Crangle (ed.), *Screen Culture and the Social Question, 1880–1914* (New Barnet: John Libbey, 2014).

6. Ludwig Vogl-Bienek, *Lichtspiele im Schatten der Armut. Historische Projektionskunst und Soziale Frage* (Frankfurt am Main: Stroemfeld, 2016); Caroline Braun, *Von Bettlern, Waisenmädchen und Dienstmädchen. Armutsdarstellungen im frühen Film und ihr Anteil an der Etablierung des Kinos in Deutschland* (Trier: Wissenschaftlicher Verlag Trier, 2019); Karen Eifler, *The Great Gun of the Lantern. Lichtbildereinsatz sozialer Organisationen in Großbritannien, 1875–1914* (Marburg: Schüren, 2017); Elizabeth Hartrick, *The Magic Lantern in Colonial Australia and New Zealand* (Melbourne: Australian Scholarly Publishing, 2017); Erkki Huhtamo, *Screenology* (forthcoming); Lydia Jakobs, *Representations of Poverty in Victorian and Edwardian Popular Media: The Works of George R. Sims and their Adaptations*, PhD diss. (Trier University, 2018).

7. Most recently *Fonseca – Journal of Communication* (issue 1, 2018); *Early Popular Visual Culture* (issues 1 and 3–4, 2019). Some articles in these journals are connected to the *Million Pictures* project or conference.

8. Various case studies on lantern culture in Japan brought to the fore that this media technology was popular for entertainment and education in the Edo and Meiji period. Japanese lanternists combined the imported technology with local genres, image style and presentation formats. For a recent overview in English and Japanese, see Yano Michio (ed.), *The Magic Lantern. A Short History of Light and Shadows* (Tokyo: Tokyo Photographic Art Museum and Seikyusha Co., 2018); Koji Toba, "On the Relationship between Documentary Films and Magic Lanterns in 1950s Japan", in *MDPI Arts*, vol. 8, issue 2, no. 64, online journal https://doi.org/10.3390/arts8020064 (accessed 18 January 2020).

9. Vanagt's film was part of her exhibition "Schijnvis / Showfish / Poisson Brillant" at Museum of Contemporary Art Antwerp (2016). See also the discussion of workshop 3: Sabine Lenk, Kurt Vanhoutte and Nele Wynants, "A Million Pictures: Magic Lantern Slide Heritage as Artefacts in the Common European History of Learning. Notes from Workshop 3: Exploring the needs of

stakeholders for access, documentation and re-use" [Workshop notes, 2017], *Zenodo*, http://doi.org/10.5281/zenodo.1284373 (accessed on 9 September 2019).

10. Sarah Dellmann, "A Million Pictures: Magic Lantern Slide Heritage as Artefacts in the Common European History of Learning. Notes from Workshop 2: Defining guidelines for description and cataloguing" [Workshop notes, 2016], *Zenodo*, http://doi.org/10.5281/zenodo.1284315 (accessed on 9 September 2019).

11. Gillian Moore, "A Million Pictures: Magic Lantern Slide Heritage as Artefacts in the Common European History of Learning. Notes from Workshop 4: Evaluation of the project and setting the agenda for future research and documentation" [Workshop notes, 2018], *Zenodo*, http://doi.org/10.5281/zenodo.1284383 (accessed on 9 September 2019).

12. E.g. the "werkgroup lichtbeelden" ("working group lantern slides") at *Stichting Academisch Erfgoed*, Netherlands https://www.academischerfgoed.nl/projecten/lichtbeelden-project/ (accessed on 9 September 2019) held a workshop in April 2019 at University of Groningen; the conservation of lantern slides was also discussed on the 11th Collections Conference / 8th Meeting of the German University Collections Association in June 2019, at the University of Münster.

13. But even those cheap standard format slides are, as a colleague rightfully stated, "sometimes quite beautiful and fascinating in themselves, too, even if this is overlooked".

14. The full list of partners is available at https://a-million-pictures.wp.hum.uu.nl/project-partners/ap/ (accessed on 9 September 2019).

15. http://lucerna.exeter.ac.uk/ (accessed on 9 September 2019). Access was also ameliorated through additional features, including coding for more security, improved accessibility for visually impaired, implementation of a geographical location system and a multi-language interface. The number of new records related to the project is above 40,000 if cooperation projects initiated during the *Million Pictures* project that are still underway are counted, too.

16. Judging from inquiries received over the last three years.

17. *Magic Lantern and Lantern Slide Catalog Collection*, published in cooperation with Media History Digital Library at Internet Archive, https://mediahistoryproject.org/magiclantern (accessed on 9 September 2019).

18. *Wikipedia List of Lantern Slide Collections* https://en.wikipedia.org/wiki/List_of_lantern_slide_collections (accessed on 9 September 2019).

19. Three guidelines, one each on digitising, cataloguing and preparing image files are available at https://a-million-pictures.wp.hum.uu.nl/category/publications/guidelines/ (accessed on 9 September 2019).

20. For a list of titles, see http://magiclantern.org.uk/sales/ (accessed on 9 September 2019) and the bibliography of the Zotero Magic Lantern Research Group (see note 30).

21. In addition to published dissertations (see note 6), the DVD compilation *Screening the Poor 1888–1914. Lichtspiele und Soziale Frage* (edition filmmuseum, no. 64, 2011) is a rich resource on early screen practices. Work on digital editions of works of the historical art of projection and the platform eLaterna (including the eLaterna companion) are continued at Philipps-Universität Marburg. See https://elaterna.uni-trier.de/ (accessed on 9 September 2019).

22. Charles Musser, *The Emergence of Cinema. The American Screen to 1907* (Berkeley, Los Angeles and London: University of California Press, 1990), 17–20.

23. Erkki Huhtamo, *Screenology* (forthcoming).

24. Frank Gray, "Engaging with the Magic Lantern's History", in Vogl-Bienek and Crangle (ed.), *Screen Culture*, 173–180.

25. Vogl-Bienek, *Lichtspiele im Schatten der Armut*.

26. Especially Vogl-Bienek's adaptation of Erika Fischer-Lichte's conceptualisation of performance, ibid., 98–111.

27. Researchers interested in sharing their findings and who strive for sustainable documentation are usually better off with contributing to existing resources rather than creating their own databases. In any case, digital infrastructures for documentation should always implement the relevant metadata standards of the domain and choose sustainable file formats.

28. Larger online collections include the collection of lantern slides in Australian archives, digitised as part of the project *Heritage in the Limelight* (2016–2019), https://ehive.com/collections/6553/heri-

tage-in-the-limelight (accessed on 9 September 2019). Digital images of lantern slides held in European heritage institutions are also published on the portal Europeana, www.europeana.eu (accessed on 9 September 2019). The *Catálogo Colectivo del Patrimonio Bibliográfico Español* (Collective Catalogue of Spanish Bibliographical Heritage) documents lantern slides that were part of the libraries of Spanish Historical Highschools, http://catalogos.mecd.es/ (accessed on 9 September 2019). Henc de Roo's collector's website "De Luikerwaal" also has records on several thousands of lantern slides, www.luikerwaal.nl (accessed on 9 September 2019).

29. "Readings Library", http://magiclantern.org.uk/readings/ (accessed on 9 September 2019).

30. The Zotero Magic Lantern Group compiles a bibliography of primary and secondary literature on all aspects of magic lantern culture: https://www.zotero.org/groups/33135/magic_lantern_research_group (accessed on 9 September 2019).

31. The Magic Lantern Society of UK and Continental Europe http://magiclantern.org.uk/ (accessed on 9 September 2019) publishes the journal *The Magic Lantern* (before 2014 *The New Magic Lantern Journal*), back issues are available at http://magiclantern.org.uk/publications/ (accessed on 9 September 2019). Monographs and edited volumes are also available via that website. The Magic Lantern Society of the US and Canada, https://www.magiclanternsociety.org/ (accessed on 9 September 2019), issues the journal *Magic Lantern Gazette – A Journal of Research*, with scholarly and collector's research; past issues are digitally available via the Repository of San Diego State University Library, https://library.sdsu.edu/scua/digital/resources/magic-lantern-pubs/gazette (accessed on 9 September 2019).

32. See https://elaterna.uni-trier.de/ (accessed on 9 September 2019).

33. The full programme is available at https://a-million-pictures.wp.hum.uu.nl/conference/programme (accessed on 9 September 2019).

34. A number of artistic works that were created during the *Million Pictures* project are documented on the DVD *A Million Pictures. Magic Lantern Heritage Today. Examples of Creative Re-Use* (2017).

35. But see Eifler, *The Great Gun of the Lantern* for a larger picture.

Frank Kessler

Researching the Lantern

In his contribution to the third volume of *KINtop Studies*, entitled *Screen Culture and the Social Question 1880–1914*, edited by Ludwig Vogl-Bienek and Richard Crangle, Frank Gray stated that studies on the lantern were generally to be found in the margins of academic domains such as Film Studies, Art and Visual Culture or Victorian Studies. The reason for this, according to him, was on the one hand that the lantern was generally seen merely as a predecessor to cinema, and on the other hand a lack of resources. To overcome the first problem, Gray proposed to adopt the more general term of "Screen Studies" and "Screen History".[1] His reference here is Charles Musser's seminal article from 1984 entitled "Toward a History of Screen Practice".[2] But sometimes one needs to be careful what one wishes for: to some extent, but in a very different way, this has happened over the past years, as Film Studies in a number of universities have been transformed into Screen Studies. But the screens studied in such programmes are rather those of television sets or computers than the projection screens of the lantern (while they include film). The lantern may in fact have become even more marginalised by this development. Yet, this position on the fringes might turn out to be not entirely disadvantageous. I will return to this point.

Research resources

The issue of resources, however, is a very important one, indeed. It is fundamental for any field of historical studies to have primary source material available, and secondary sources that have started to assess, analyse and interpret primary sources, thereby constituting a scholarly discourse on which others can build their own work. When Sabine Lenk and I wrote an overview on primary source material available in Germany for historical research on early cinema twenty years ago, the situation was different in several respects.[3] Even though this was a field of research that had only just started to develop seriously in the 1980s, we could refer to the holdings of specialised institutions such as film museums and archives, as well as libraries holding extensive runs of trade journals (in print or as micro-films), books, brochures and other printed material from the period. Films could be viewed in at least some of the archives, but one could also watch them screened at international film festivals such as Le Giornate del cinema muto in Pordenone or Il cinema ritrovato in Bologna which annually presented new restorations and retrospectives. In

addition, there were some bibliographies and filmographies serving as useful reference tools. Also, there were some VHS editions of early films, others followed in the 1990s on DVD. Since then, the situation has continued to improve, in particular because more and more material has become available digitally online, which also means that one can save a lot of time and money that were necessary in those days in order to be able to travel to archives and libraries abroad.

As for the magic lantern, the situation is different, and in many respect hardly comparable. First of all, there are no specialised public institutions dedicated exclusively or primarily to the magic lantern, as there are for cinema. Obviously, every film museum will have somewhere in its collections and exhibition a section dedicated to the magic lantern, but traditionally that is considered to be part of the so-called "pre-cinema" collection, so the lantern is not presented as a medium in its own right. Slides are exhibited as illustrative specimens to document the enormous variety of types of slides, but the performance culture of the lantern is generally not addressed, except for the phantasmagoria. On the other hand, as we have learned in our explorations for *A Million Pictures*, many different institutions hold slides in their collections. Sometimes just a few dozens, sometimes tens of thousands, but often uncatalogued and without an organised access procedure for researchers. There are of course some important reference books such as the *Encyclopaedia of the Magic Lantern*, and in particular the Lucerna database, which brings together information on slides, sets, people, organisations, etc.[4] It is no accident, however, that the latter was initiated and that the former was published by the Magic Lantern Society. As Frank Gray rightly observed:

> The histories of the lantern, as embodied by objects (e.g. slides, projectors, catalogues), the practices of lanternists and the meanings of their performances are eminently available for discovery and analysis. Significant research on the lantern has been and is being undertaken by a few scholars and the Magic Lantern Society has served as a valuable cluster for this work.[5]

Such research has been conducted for a long time mainly by scholars outside academic institutions. Members of both the British and the American Magic Lantern Societies have done an enormous amount of work to gather and make available historical knowledge on the magic lantern. In this field, one can quite safely say that the treasures accumulated by private collectors in many cases may be easier to access than some of the public institutions. Important documents, such as lantern readings for instance, are for the time being very hard to find outside private collections. Some collectors have founded museums to show their treasures, either dedicated specifically to the lantern such as the Toverlantaarnmuseum in Scheveningen, founded by Nico Brederoo and Henk Boelmans Kranenburg, or to a broader perspective such as Laura Minici Zotti's Museo del precinema in Padua, to name just these two.

The increasing availability of primary sources online is therefore an important factor for future developments. Various online resources such as archive.org, hathitrust.org, gallica.fr and others allow to consult and sometimes download

as pdf-files handbooks, technical manuals and treatises. And it is of course worth mentioning here the *A Million Pictures* initiative to digitise and make available magic lantern sales and distribution catalogues – again: thanks to the support of many private collectors – on the website of the Media History Digital Library.[6] Moreover, in several countries extensive runs of newspapers have been digitised and made available online, which constitutes another important source for research in lantern practices, as "illustrated lectures", "projections lumineuses", "voordrachten met lichtbeelden" (finding relevant search terms in different languages is not always easy) were regularly advertised, allowing to see what kind of topics were presented with the aid of a magic lantern. Finally, a resource such as eLaterna, hosted by Trier University, aims at setting standards for the presentation of archive editions and critical editions of lantern slide sets.[7]

Resources have thus become increasingly available to researchers, and a project such as *A Million Pictures* has undoubtedly contributed to bringing together collectors, lantern enthusiasts, performers, archivists, curators and scholars, all sharing a common interest in the lantern in its many guises. Moreover, national academic funding bodies in various countries, among which Australia, Belgium, Germany, the Netherlands and Spain, have awarded research grants for projects connected to the lantern in the past years. The lantern, it seems, has indeed become an object of academic study.

Lantern studies

While it seems rather obvious that there will never be an institutionalised university programme of Lantern Studies comparable to the Film Studies programmes that have flourished across the globe since the 1980s, the lantern itself is increasingly recognised as a medium that, historically, has had an important function in many different fields. As Joe Kember notes in his introduction to the recently published first of two special issues of *Early Popular Visual Culture* dedicated to "The International Lantern", the diverse practices that the projection device made possible, simply preclude its limitation to just one of its various uses:

> … the centuries-long history of the lantern, and its persistent 'failure' to define a single mode of operation or to 'impose itself as an autonomous medium', presents us with a far less coherent – and more exciting – field of research, one that is necessarily open to the contingencies of practice not merely as precursors to or distractions from a medium's 'personality', but as constitutive elements of its long-term existence.[8]

The lantern allowed to tell stories of all kinds to a broad range of audiences, to provide entertainment in various forms, to transmit knowledge, to offer information on a vast range of topics, to engage in campaigns in different areas, from hygiene to temperance, from religion to politics, from colonialism to nationalism and militarism, or conversely from anti-colonialism to internationalism and pacifism. Contrary to cinema, which developed the fictional film as a format that became the backbone of the moving picture industry, the

networks of lantern slide production, distribution and exhibition were much more diverse with respect to the kind of performances that made use of projected images. Depending on the different national contexts, lanterns were to be found in very different places: from classrooms to townhalls, from entertainment venues to churches, from university lecture halls to living rooms in private homes. The lantern was put to a broad variety of uses, which is why Charles Musser refers to it as a "weak medium", taking up a term suggested by André Gaudreault and Philippe Marion to designate a medium becoming "absorbed by its intermedial use".[9] The term "weak" here should not be misunderstood as indicating a deficit or a lack. It rather points to the fact that because of the enormous range of uses the lantern was put to made it an almost ubiquitous device and thus it could practically be taken for granted. Which, in turn, may have led to the very limited and problematic perception of the lantern as one of many 'pre-cinema' devices.

Therefore, studying the lantern generally means more than simply studying the lantern: while exploring the lantern as a medium, one needs to take also into account the contexts where the projected image was employed. While such investigations may still operate on the fringes of disciplines such as the history of science, the history of pedagogy, 19th Century Studies, social and cultural history and others, they have to combine knowledge from these disciplines with a reflection on the specific mediality of the lantern and thus transcend the limits of each individual discipline. In this respect, too, the lantern is an "open medium", to take up Joe Kember's term once more.

A multidisciplinary field

This openness is reflected in this volume as well. The contributors come from very different disciplinary backgrounds, ranging from Film and Media Studies to Art History, Visual Arts, English Studies, Archaeology and Anthropology, Communication Studies, Theatre and Performance Studies, History of Science and Technology as well as Conservation Science. In all of these fields, the lantern can undoubtedly be considered a marginal object of studies, but at the same time the research presented here opens up interesting and productive perspectives, with respect to these disciplines and also beyond them. The knowledge accumulated in these pages will hopefully not only reduce the marginalised position of the lantern in these various fields of study, but also lead to more cooperation between scholars from different disciplines as well as with lanternists, curators and archivists.

The borders between disciplines may in fact have been one of the major obstacles for the lantern to become a much more visible object of study in academia. Even though there have been a number of studies in the past which have also touched upon the use of the lantern as a tool for knowledge transmission, for instance, these have generally not been taken up outside of their original disciplinary context, and at the same time have generally not used existing work on the lantern in other fields of studies. To give but one example:

several studies were written in the field of art history on the use of the lantern in academic teaching, which is virtually unknown to, for example, media historians, while the art historians writing on the projected images seem not to have been aware of media historical work on the subject.[10]

The "A Million Pictures" conference therefore also aimed to offer a possibility for encounters between scholars, archivists, curators, performers and other lantern enthusiasts which hopefully will contribute to breaking down the barriers between the different areas that they work in as well as the frontiers separating academic disciplines. The respective expertise represented by all these fields will be needed to further explore the many collections of lantern slides that exist all over the globe.

Future perspectives

More recently, projects such as "B-magic. The Magic Lantern and its Cultural Impact as a Visual Mass Medium in Belgium" bringing together six research teams from Belgian universities, one from an art school and one from a partner institution in the Netherlands, "Projecting Knowledge – The Magic Lantern as a Tool for Mediated Science Communication in the Netherlands, 1880–1940" at Utrecht University or "Performative Configurations of the Art of Projection for the Popular Transfer of Knowledge. Media Archaeological Case Studies in the History of Useful Media and the Screen" at Marburg University engage in explorations of the use of the lantern in different fields of societal communication and knowledge dissemination.[11] These projects are less concerned with spectacular lantern shows that aim at entertaining an audience, but rather with the everyday uses the medium was put to during the second half of the 19th century and the first half of the 20th century. They thus build upon not only the *A Million Pictures* project, but also on earlier initiatives such as those undertaken by the Screen1900 research group at Trier University.

As the lantern could serve many purposes, it was an ideal medium for a broad range of societal groups, among which learned societies such as the British Association for the Advancement of Science, the Royal Geographic Society, Koninklijk Aardrijkskundig Genootschap and many others,[12] all kinds of social organisations,[13] institutions engaged in adult education, from the French laic Ligue de l'enseignement to the Catholic Church in France and Belgium, the latter using the lantern also to teach religion, as did churches in the US.[14] It became a common teaching tool in schools and universities, but also one for propaganda activities of all kinds.[15]

In these contexts, the projected image was often used to demonstrate something which was first and foremost presented by means of the verbal discourse of a lecturer, as the expression "illustrated lecture" that was commonly used in English also suggests. While this may be perceived as limiting the importance of the lantern as a medium, because it appears as an auxiliary rather than taking centre stage, this hardly is the case. It is in any event the medium which makes

it possible for lecturers to illustrate their discourse in such a way that the entire audience can perceive the visual element at the same time as they hear the speaker's words. The function of the projected images of course depends on the aims that the lecturer pursues, which in turn demands a thorough exploration of the type of communication taking place by the historian. So while the lantern as an object of study may be a marginal phenomenon in the historiography of the various fields in which it intervened, it was at the same time a subservient, but very common means of communication. And as every medium, it afforded certain types and forms of communication, shaped them and therefore had an impact on how things were communicated. Illustrated lectures, both public ones and those aiming at specific audiences within institutions, reached large numbers of people for many decades and thus did play a non-negligible role in late 19th- and early 20th-century culture. The exploration of this field, which is still at its beginnings, can yield many insights relevant to different disciplines and cultural institutions. The present volume can hopefully contribute to this and stimulate further research.

Notes

1. Frank Gray, "Engaging with the Magic Lantern's History", in Ludwig Vogl-Bienek and Richard Crangle (ed.), *Screen Culture and the Social Question 1880–1914* (New Barnet: John Libbey, 2014), 178–179.

2. Charles Musser, "Toward a History of Screen Practice", *Quarterly Review of Film Studies*, vol. 9, no. 1 (1984): 59–69.

3. Frank Kessler and Sabine Lenk, "Quellen zum frühen Kino", in Hans-Michael Bock and Wolfgang Jacobsen (ed.), *Recherche Film. Quellen und Methoden der Filmforschung* (München: Edition text + kritik, 1997), 11–24.

4. David Robinson, Stephen Herbert and Richard Crangle (ed.), *Encyclopaedia of the Magic Lantern* (London: The Magic Lantern Society 2001).

5. Gray, 178.

6. http://vsrv01.mediahistoryproject.org/magiclantern/index.html (accessed on 20 January 2020).

7. https://elaterna.uni-trier.de/#/ (accessed on 20 January 2020).

8. Joe Kember, "The magic lantern: open medium", *Early Popular Visual Culture*, vol. 17, no. 1 (2019): 2.

9. Charles Musser, *Politicking and Emergent Media. US Presidential Elections of the 1890s* (Oakland: University of California Press, 2016), 54. His reference is to André Gaudreault and Philippe Marion, "A Medium Is Always Born Twice", *Early Popular Visual Culture*, vol. 3, no. 1 (2005): 7.

10. See, for instance, Heinrich Dilly, "Lichtbildprojektion – Prothese der Kunstbetrachtung", in Irene Below (ed.), *Kunstwissenschaft und Kunstvermittlung* (Giessen: Anabas, 1975), 153–172; Dilly, "Die Bildwerfer. 121 Jahre kunstwissenschaftliche Diaprojektion", *Rundbrief Fotografie*, no. 5 (1995): 39–44. Conversely, Robert S. Nelson, "The Slide Lecture, or the Work of Art 'History' in the Age of Mechanical Production", *Critical Inquiry*, vol. 26, no. 3 (2000): 414–434, does refer also to film theoretical and film historical studies, but has not been referenced in these fields.

11. http://www.b-magic.eu/; https://projectingknowledge.sites.uu.nl; https://www.uni-marburg.de/de/fb09/medienwissenschaft/forschung/projekte. Another important project is "Heritage in the Limelight" at Australian National University, https://soad.cass.anu.edu.au/research/heritage-limelight (all accessed on 20 January 2020).

12. See the contributions by, respectively, Jennifer Tucker, Emily Hayes and Richard Crangle in the present volume.

13. For Britain see, for instance, Karen Eifler, *The Great Gun of the Lantern. Lichtbildeinsatz sozialer Organisationen in Großbritannien* (Marburg: Schüren, 2017) as well as several contributions to Vogl-Bienek and Crangle (ed.), *Screen Culture and the Social Question.*

14. For France and Belgium see, for instance, Isabelle Saint-Martin, "'Sermons lumineux' et projections dans les églises, 1884–1912", *Revue des Sciences Religieuses*, vol. 78, no. 3 (2004): 381–400; Frank Kessler and Sabine Lenk, "Fighting the enemy with the lantern: How French and Belgian Catholic priests lectured against their common laic enemies before 1914", *Early Popular Visual Culture*, vol. 17, no. 1 (2019): 89–111; for the US see Sarah C. Schaefer, "Illuminating the Divine: The Magic Lantern and Religious Pedagogy in the USA, ca. 1870–1920", *Material Religion*, vol. 13, no. 3 (2017): 275–300.

15. Such activities were by no means limited to Western Europe and North America. See the contributions by Martyn Jolly, Nadezhda Stanulevich and Machiko Kusahara.

Prologue

Ine van Dooren

A Lantern Slide Journey:
127 Years in Just Five Minutes

One can argue that the magic lantern medium is like the kaleidoscopic chromatrope, which was and is such a favourite slide. Its heritage and history show an endless stream of re-invention, adaptation, reproduction, representation, re-use etc. It is indeed a chameleon not easily put in a box. In a research context, the word magic may be off-putting, frowned upon, not high on the agenda of scientific aims and academic bureaucracy. However, it is the recognition of the medium's magic that made the A Million Pictures project such a success. In an innovative way, this project connected people from different disciplines, professions and interests and encouraged them to explore, share and re-think, thus often stepping outside of the box. To know is to engage, investigate, appraise, create and experience the full extent of the magic.

For 27 years now I have been a moving image archivist, which makes my professional life precisely a hundred years less long than my lantern slide subject's odyssey. And, as the slide you will hear from next, I also have been on a journey, especially in regard to my attitude to writing and delivering presentations in a research context. I have found a mode of address that suits me well – combining professional experience and subject research with a performative approach. My conference contribution was well-placed within what was referred to as the "lab section": a short presentation offering crossover pollination between academia and archiving, packaged in a creative delivery.

My presentation was designed around the personification of an object: one particular lantern slide speaking to the conference audience as an 'I' subject. We follow the various ways in which this I-slide is produced and used by multiple historical actors such as manufacturer, distributor, collector, archivist, database designer, researcher etc. I hope that the following text, lacking the pictures and my intonation, gestures, pauses and exclamation marks, is still insightful and entertaining.

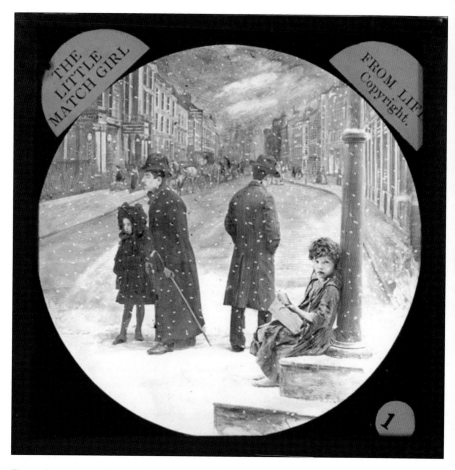

Dear Spectator. Please let me introduce myself. I am, amongst, I have been told, a million others, that eye-catching and magical thing: a lantern slide!

I exist as part of a series, a packaged set of nine: *The Little Match Girl, From Life Copyright*. With my community of friends and family I fit snug in our carton lantern box.

We only come to life through the art of projection. An ingenious performance in which we like to be the star of the show but we cannot shine without a little – yes, I know I should say a lot – of help from more friends: the lens and light system in the apparatus, the great dexterity of the lanternist and the sensitivity of the presenter.

My centre and heart is an image, a representation, a picture of *a little match girl*. I am proud to be part of a long lineage of *match girls*, as portrayed in drawings, books, photographs, films, sculptures, dolls … you name it … we are quite famous, you know.

I was conceived in the town of Holmfirth in Yorkshire in 1890, by slide manufacturers Bamforth & Co. It was exhilarating to be part of a growing successful business. Only two years earlier a factory extension was built. The company specialised in Life Model slide sets. They are moving stories, often with a moral twist. The slide scenes are photographed tableaux, mostly in front of painted backdrops. It was wonderful to work with other life models, all members of the Bamforth family, workforce or locals.[1]

The negative plate was carefully inspected and made into the *me* as I am in front of you now: a UK standard format masked and bound glass slide positive. The girls made a good job at doing the colouring.

I soon ventured out into the wider world. Me and my friends were publicised in catalogues and other listings, available for hire and sale. I went on many outings, showing myself to groups, small and large, in village halls and city slums, making the audience sigh and shed a tear, with an occasional sneer and laugh. I did not just travel around in the homeland counties of Great Britain, but across the water in Europe and sailing even further afield across oceans to Australia.

One new community that embraced me was the Church Army. I fitted quite well in their zealous Christian message. Poverty was a big issue and our story hit the note for good-doers and children alike. The Church Army had their own slide catalogues, hire service and itinerant mobile homes and reached audiences way into the 1930s.

Then, for a while, total darkness. I was back in my box, in a slide cabinet with rare outings. Was this to be the end of my journey?

A very scary moment: there was I and there was the skip. It was the 1960s and the Church Army was getting rid of their glass lantern slide collection.

But hoorah! A most welcome rescue! Hermann Hecht on his way to work spotted me and my family and arranged a van and I moved from public to private. It was the beginning of a wonderful friendship. Ann and Hermann Hecht were keen collectors, knowledgeable writers and educational performers, both in the home and at the art college where Hermann worked. Happy Days indeed!

At the end of 2003, I was ready for another move. This was quite new to me. I was *acquired* by the then still called South East Film & Video Archive. I am gratified to have played a part in their wise decision to change their name to Screen Archive South East in 2006. Because, of course, we lantern slides and lantern heritage are an important part of moving image and screen history. I only will say this once: we are *not* a primitive precursor to film and cinema! I do not like being characterised as pre-cinema either. I am here raising the banner: power to the lantern slide!

An archive. That is quite a different thing. I was packed off to a strongroom, temperature and humidity controlled. But I am glad to say I held on to the familiarity of being snug in the old Church Army wooden slide cabinet.

The archivist did all sorts of curious things such as cleaning my glasses, inspecting my back front and my sides, and then writing it all down, what was called cataloguing. And then there was something new-fangled named *digitisation*. I thought I was *photograph* enough, but no. I was photographed again, for *easy access*, they said.

And so, I have a twin now. Whilst I rest peacefully in the archive box, my double ended up on the *World Wide Web* in the wonderful one and only *Lucerna* web resource. I am part of a database where you can find all sorts of information and, of course, see me too. It turns out that people want to look at me again, still for fun, less for morals, more for learning.

So, the journey continues and here I am again, after 127 years, part of this PowerPoint presentation, yet another lantern heritage adaptation. It is nice to know that I can keep on wandering, and inspire and spread wonder and magic. I salute you. *Goodnight.*

Note

1. "Life Model Studies. A Peep Behind Some Scenes", *The Photogram*, vol. 6 (February 1899): 46–48.

Histories of Lantern Slides:
Artefacts, Performance and
Reception

Sarah Dellmann

Visiting the European Neighbours: Geographical Slide Sets of the *Projektion für Alle* Series

Among the hundreds of thousands of lantern slides available during the lantern's heyday (ca. 1870s–1940s), slide sets with geographical matter made up a considerable part of the available subjects, as evidenced by the extensive lists in commercial distribution catalogues of that time.[1] For my research on slide sets about European countries, and their possible contribution to national stereotyping, I found that the geographical slide sets from the series *Projektion für Alle* (Projection for All, hereafter *P. f. A.*) are prominently present in the archives and private collections I investigated.

Projektion für Alle was launched by Max Skladanowsky. Issued between 1906 and ca. 1928, the series consisted of 96 slide sets of 24 slides each. The images were published in standard lecture format (8.3 x 8.3 mm) as well as in smaller toy formats. From the 49 slide sets that were issued prior to World War I, 43 are dedicated to geographical entities: cities, regions or nations, mostly in Europe. The series, including digital images, is well-documented in the Lucerna Magic Lantern Web Resource.[2]

All *P. f. A.* sets were issued with a slide reading of 12–16 pages, offering comment to the image on each slide. Such readings, as their name indicates, were

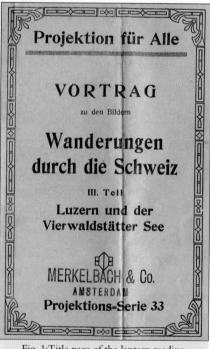

Fig. 1: Title page of the lantern reading *Wanderungen durch die Schweiz, III. Teil. Luzern und der Vierwaldstätter See* (ca. 1906–1914). The fold stems from the reading being delivered in the box of the slide sets. The stamp of Merkelbach & Co., an important Dutch slide manufacturer and reseller, proves international distribution of the slide set. Courtesy: Eye Film Institute Netherlands.

29

intended to be read out while the slides were projected. Readings for the *P. f. A.* series were included in the purchase of the slide sets.

While it is not possible to fully reconstruct historical performances from the preserved evidence of slides and readings, it is nevertheless possible to reconstruct the interplay of word and image as suggested by the producers, i.e. their historically intended meaning. As Ludwig Vogl-Bienek has underlined, lantern slides are often the only physical remainders of complex live performances.[3] In order to understand the (historical) meaning of these objects, it is crucial to recall their historical use. These non-fictional slide sets of the *P. f. A.* series were most likely to have been performed in an educative setting in the form of a lecture. The *dispositif* of educative lantern lectures using the geographical *P. f. A.* slides further comprised photographic images (likely to be performed as a true, maybe even objective, picture with documentary qualities) and a lecturer with the authority and expertise to explain these images.[4]

For this case study I have chosen the *P. f. A.* slide sets on the Netherlands, Italy, Spain and all four sets on Switzerland.[5] This selection is motivated firstly by the fact that these seven slide sets and the corresponding slide readings are completely preserved. Secondly, in order to compare visual and rhetorical strategies, choosing slide sets that cover the same scale (here: a country/nation) and that display the same type of image (all slide sets discussed here are photographic images) is a precondition for a sound comparison. And thirdly, due to the huge changes in international relations and cultural values before and after World War I, I opted to use only slide sets produced in one definable period, in this case before the outbreak of the war.

In the following analysis of word and image, I will focus on rhetorical devices, visual patterns and national stereotyping. I will start with a visual analysis of the lantern slides and then turn to their written comment. All translations from the German sources are my own.

Visual representation: Image repertoire of slide sets

In order to compare the image repertoire and to eventually discern patterns in the (visual) information given about the respective country, I classified the slide images into four broad categories. These are:

- Landscape Panoramas – images that show a landscape. Houses and people may appear in the image, but the most prominent feature is a rural or uninhabited landscape.

- City Panoramas – images that show a large part of or an entire city or village from a distance, with the settlement as the most prominent feature.

- City/Village/Street Views – images that show a specific and recognizable street building or point of interest. People may be visible, but the places are clearly in the focus of the images.

- People Images – images that most prominently portray people or in which people explicitly pose for the camera.

The result of this classification is seen in Table 1:

Table 1 showing type of images per slide set.

	Landscape Panoramas	City Panoramas	City/Village/ Street Views	People Images	Other
Netherlands (24 slides)	0	0	19 (incl. 5 of Marken)	4	1 (beach scene with boats)
Spain (24 slides)	1	9	13	0	1 (bullfight)
Italy (24 slides)	0	4	20 (incl. 9 of Venice)	0	0
Switzerland I-IV★ (96 slides total)	7.25 (29) (incl. 9 with mountaineers)	6.25 (25)	9.25 (37)	0 (0)	0 (0)

★The number of the slides from the four sets on Switzerland is divided by four to facilitate comparison. The total for all four sets is given in brackets.

This formal visual analysis reveals patterns, from which we can draw conclusions about the visually interesting features each country had to offer according to the slide set's producer. The Netherlands are visually not interesting for either landscapes or cityscapes. It is the only analysed *P. f. A.* set that documents local people (the people images exclusively show village inhabitants in traditional costume).[6] Spain seems to be of interest for its cities, not for its landscapes. Cities are either documented with their topographical situation – it is the set with the most city panoramas – or with specific buildings in the cities. Italy, like Spain, does not seem to provide visually relevant landscapes. In contrast to Spain, panoramas or views of cities from a distance are absent. Italy seems only of interest for very specific buildings and streets. Maybe not surprisingly, the slides of Switzerland emphasise the mountains and landscape. Some of the city panoramas actually fall in between the categories "landscape panorama" and "city panorama", resulting in even more landscape views than the table suggests. The only people documented in the photographs are mountaineers, travellers spending leisure time; no Swiss people in traditional costume guarding cows are documented.

Arranged according to the distance or scale of views, those of Switzerland are taken from the furthest distance, followed by Spain and then Italy and the Netherlands in relatively close views. When considering also the image content, i.e. motifs, Switzerland seems to be of interest for its landscape, Spain for the cities and cathedrals, Italy for historical buildings and the canals of Venice, and the Netherlands for street views and people in local costume.

Not expressed in the table, but noteworthy with respect to visual strategies, is the point that the sets do not share a formal visual strategy in their sequencing; there is heterogeneity not only in the type of views but also in the presentation

of their order. No pattern (e.g. first cities, then people; or all sets starting or ending with a slide of a map) can be observed, other than that the numbered order of lantern slides in the set follows a logical travel route.

The variety in visual representation of countries within the *P. f. A.* series indicates that there was no abstract, fixed compositional scheme developed for the sets of the series according to which each country should be documented. Probably the choice of viewpoints, shooting distance and type of motifs was decided with respect to visual appeal (and expected commercial success) by the photographer.

Representation in word: Oral comment as suggested in the readings

While the image repertoire gives insight in what was (suggested to be) visually appealing about each country, the motifs do not offer meaning by themselves. In order to study the knowledge that was performed in the presentation of the lantern slides, I analysed the slide readings for each slide set.[7] All these readings open with a programmatic first paragraph. Recalling the live performance context for which these readings were written, we can imagine the members of the audience sitting in their seats, ready to be taken on a "virtual trip" to another place. The first paragraph of any lecture is a crucial moment for establishing the relation with the audience, as it needs to create trust in the lecturer. In the genre of travelogue shows, the lecturer aims to take the audience from the venue of the performance to the place of their imagination. Here is the opening paragraph from the reading to the slide set QUER DURCH HOLLAND (Criss-cross through Holland):

> Today, we want to perambulate a country off the beaten tracks, which holds magnificent nature views for the painter and relish of art for the traveller. Holland with its art treasures offers many things of interest. The entire country is pervaded by canals [...]. We enter Holland up in the North and first pay a visit to the city of Groningen, which, with its 80,000 inhabitants, presents the Dutch type right away [...]. The architecture of the houses around the square breathes the well-known Dutch style of architecture.[8]

This paragraph addresses the audience right away as demanding views that appeal to artists and travellers interested in art (history). Already in the first sentence, the lecturer and the audience merge to a "we" that travels, a rhetorical figure well-known from travelogue performances (and different from accounts of a trip by a returned traveller who does not invite their public to join them). To be sure that "we" did not take the wrong train, "we" are reminded twice of the fact that everything visible is Dutch: the city of Groningen and the architecture are qualified with the adjective "Dutch".

The rhetorical devices of the reading to the slide set DAS SONNIGE SPANIEN, I. TEIL (Sunny Spain, Part 1) are quite different:

> Spain, the former world power, long shining as a star of the first order, is a magnificent country that emerged as a paradise after the creator announced 'become!', and which men then decorated with the works of their hands. Nature

and the arts are on the highest step of evolution, the splendour of the Orient competes with the authority of Christian-Germanic peoples – a tension which continually captures the imagination of the traveller.[9]

Before the audience is addressed as part of the travel collective two paragraphs later in the collective "we", the reading opens in a more distanced third-person account that lectures the audience about a country that has passed its zenith of power but nevertheless has treasures to offer for the traveller. In the shade of the nostalgic trope, visual pleasures in nature and the arts are announced, sprinkled with the promise of orientalist sensations.

The reading of ITALIEN, I. TEIL starts as follows:

> Italy, ever since called 'land of longing', has so much beauty to offer for the artist, the friend of nature and the rambler that a trip to Italy will be one of the highlights of his life. An impressive past speaks from the architectural monuments, the folk life is interesting and the mild climate creates a shining abundance of colours in the vegetation, so that a huge mass of foreigners ramble this country already in springtime.[10]

Note the difference with Spain: no nostalgic feelings are invoked in the description of historical buildings. On the contrary, the presence of an "interesting folk life" adds to an impression of liveliness. Everything seems to be pleasant and beautiful from the perspective of a traveller longing for beauty who is, at least implicitly, distinguished from the "mass of foreigners".

The opening paragraph of Switzerland is different again:

> Switzerland, situated in the heart of Europe, has forever been the meeting point for friends of nature from all parts of the world. And this is not surprising: the natural beauties that these travellers have only occasionally in their home countries fall with splendour and enormous quantity upon the perception of the viewer who cannot avoid being overwhelmed. The convalescent patient, the hiker and the mountaineer all find for their interest, not at least because the hotel infrastructure is admirably developed to fit all demands.[11]

Switzerland is introduced almost as the cosmopolitan centre of Europe: people of all parts of the world adore its landscape, whether they profit from the air (convalescent patients), are interested in sightseeing (ramblers) or sports (mountaineers). This sounds almost like a description by a Swiss tourist office that highlights, from the very beginning of the lantern lecture, the good infrastructure for various kind of travellers.

These are only the opening paragraphs. A discursive analysis of the entire readings reveals that the tone set in the first paragraph is followed throughout the text. Due to constraints in space, some examples must suffice. In the case of the Netherlands, the act of travelling between the cities, i.e. between one slide and the next, is mentioned, but no vistas from the window of a train are described. As I have shown elsewhere, the reading emphasises the Dutchness of sites and sights to the extent that almost all local instances become tokens of Dutchness.[12]

In the reading for Spain, just as in the case of the Netherlands, the reader/audience is taken on a trip, the travel between the slides is described in great detail

and phrased in a first-person plural ("we" travel), but the information supplied about Spain is very different. Art and architecture are emphasised: many palaces, churches and cathedrals are described in detail, using adjectives related to size (both quantitative and qualitative): "pompous", "grand", "of enormous proportions" and "glorious" recur in the descriptions. At several places, the lecture mentions that Spain will not be able to live up to its past glory again, as it has been shattered by wars and has lost many people (and overseas colonies, although this is not mentioned): "Salamanca is a city of the past, living on its former glory that it will never be able to refresh" (comment to slide 14). A similar comment is made about Burgos, which supposedly was "living in the memory of the great times past that are unlikely to ever reinstall the pomp and glory from back then" (comment to slide 18).

In comparison to the Netherlands, very little information is given about supposedly "national characteristics" of the Spanish, and very few descriptions are generalised on the level of being "typically Spanish". Not even the bullfight is described in terms of the national.[13] The outward appearance of people is discussed only with respect to the people of Saragossa, where the lecture applies orientalist descriptors for people of African origin (comment to slide 23). All in all, the description of Spain is rather distanced. Remarkable structures and buildings are described, but the traveller remains a distant observer. In order to appreciate views in Spain, "Spanishness" seems not necessary.

The lecture on Italy, too, describes the travel between two cities/slides by train or steamboat and the vista of the landscape that "we" travel through seen from the window. Contrary to Spain, everything is about the effects of the views on the traveller. Aesthetic descriptions convey admiration and pleasant contemplation in views, manifested in recurring terms such as "masterpiece", "masterfully", "decorative", "beautiful", "impressive", "picturesque" and "overwhelming"[14] – all of which can only be judged subjectively. Here is the description of the Cathedral in Milan:

> As overwhelming as the outside is the effect of its inside on the viewer, and when, at Mass, the organ blusters through the rooms and the incense kettle pours its scents on the people, then the visitor is mightily touched.[15]

Nothing "typically Italian" is described. Italy's history is described as glorious, but without the sad nostalgia of the reading for the slide set on Spain. In ITALIEN, I. TEIL, the façades of buildings are appreciated, the viewer is invited to delve into the vistas and be carried away, whereas the viewer evoked in the reading of DAS SONNIGE SPANIEN, I. TEIL remains an outside onlooker who is not moved or stirred emotionally.

The four readings on Switzerland contain extensive information about the act and organisation of travelling: explanation in great detail informs about which train, tram, ship or cable car needs to be taken in which direction, including information on fares. In some cases, the exact walking route that the tourist takes is given when hiking in the mountains (part 2, slides 17–19 and 21).

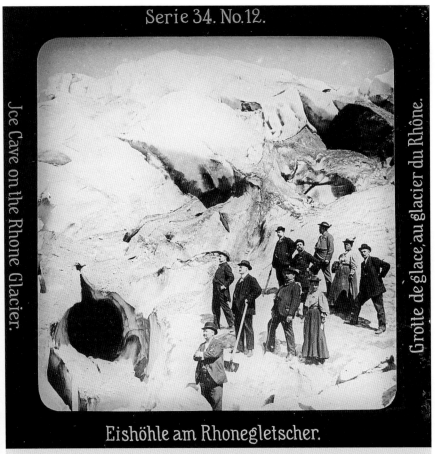

Serie 34. No.12.

Ice Cave on the Rhone Glacier.

Grotte de glace, au glacier du Rhône.

Eishöhle am Rhonegletscher.

Fig. 2: "Ice Cave on the Rhone Glacier". Image 12 of 24 from set WANDERUNGEN DURCH DIE SCHWEIZ, IV. TEIL. VON ZÜRICH NACH LUGANO. The travellers in the picture can serve to strengthen the identification of the audience with the travelogue narrative but also offer the audience the possibility to be entertained by someone else's adventures. Courtesy: Eye Film Institute Netherlands. Image available at Lucerna Magic Lantern Web Resource (accessed on 16 January 2020, http://lucerna.exeter.ac.uk/slide/index.php?language=EN&id=5105423).

Points of interest are described as "very attractive" ("herrlich"). Hardly any references to "typical national characteristics" of the Swiss are made.

Read aloud while the corresponding slide is projected, the reading creates a noteworthy effect when imagined in performance: the audience of the lantern lecture can easily identify with the mountain climbers in the pictures: the collective "we" that travels by train or climbs a mountain can see itself on the screen. In this mode of address, the lecturer is free to alternate between the "travelogue-we" who travel together and the description of activities of other travellers. This word and image strategy is not employed in the other slide sets, where no travellers are depicted in the photographic slides. In the case of the slide "Ice Cave on the Rhone Glacier" (Fig. 2), following the lecture, the

"international travelling party" already had breakfast at 5:30 in order to get their feet into the ice, including the ladies with their very modern shoes. The entrance fee for the ice cave is 50 centimes (comment to slide 12 of part IV). The audience members are free to imagine themselves as listening to the adventures of others or as (virtually) taking part in the trip – note here the explicit address of female mountaineers to female members of the audience.

Conclusion

The analysis of these sets brought to the fore a variation in strategies for presenting and performing knowledge on European countries in the form of lantern lectures. My initial expectation, stemming from my earlier analysis of the set QUER DURCH HOLLAND, was not confirmed: the slide sets of the *Projektion für Alle* series did not generally emphasise the typicality of the nation in question, nor were national stereotypes and clichés prominently featured in these sets. On the contrary, the slide set on the Netherlands seems to be an exception in this respect.

While visual appropriation and consumption of otherness have been described as features of Western modernity and European mass media culture at the turn of the century,[16] the specific ways in which such a position is achieved are usually not analysed in detail. The knowledge of European neighbours given through these lectures applies a variety of strategies, ranging from emphasis on national characteristics (Netherlands) to detailed description of the comforts for travellers (Switzerland), from nostalgic admiration of a glorious history (Spain) to the search of picturesque views unfolding in front of the viewer to satisfy their aesthetic desire (Italy). In spite of the observed variation, all modes of address – moral superiority expressed through nostalgic lament, producing visual evidence of national difference, or the presentation of a country as only there to please the viewer – have one thing in common: in one way or another, these lantern lectures invite and affirm their audiences to be entitled to ramble and consume the world.[17]

Notes

1. Magic Lantern and Slide Catalog Collection at Media History Digital Library (accessed on 23 August 2018, http://mediahistoryproject.org/magiclantern).

2. http://lucerna.exeter.ac.uk/series/index.php?language=EN&id=19 (accessed on 16 January 2020). For details about the production context of the *P. f. A.* series, see Janelle Blankenship, "'Projection for All'. Cataloguing Max Skladanowsky's Scattered and Fragmented Archives of Slides and Ephemera", paper presented at the conference "A Million Pictures. History, Archiving and Creative Re-Use of Educational Magic Lantern Slides", Utrecht, 31 August 2017, and her work on the *P. f. A.* slides on World War I: Janelle Blankenship, "Magic Lantern *World Theater*: Max Skladanowsky's *Projection for All* Slide Company, the *War Diorama* and German WWI Propaganda", in Àngel Quintana and Jordi Pons (ed.), *The Great War 1914–1918. The First War of Images* (Girona: Fundació Museu del Cinema-Collecció Tomàs Mallol & Ajuntament de Girona, 2016), 115–130.

3. Ludwig Vogl-Bienek, *Lichtspiele im Schatten der Armut. Historische Projektionskunst und Soziale Frage* (Frankfurt am Main: Stroemfeld Verlag, 2016), 20–24.

4. For a discussion of the role of the performer in putting together slides and comment, see e.g. Ludwig Vogl-Bienek, "A Lantern Lecture: Slum Life and Living Conditions of the Poor in Fictional and Documentary Lantern Slide Sets", in Ludwig Vogl-Bienek and Richard Crangle (ed.), *Screen Culture and the Social Question, 1880–1914* (New Barnet: John Libbey, 2014), 35–63; Sarah Dellmann,"Getting to Know the Dutch: Magic Lantern Slides as Traces of Intermedial Performance Practices", in Kaveh Askari et al. (ed.), *Performing New Media 1890–1915* (New Barnet: John Libbey, 2015), 236–244.

5. QUER DURCH HOLLAND. Projektions-Serie 7 (ca. 1906); ITALIEN, I. TEIL. VOM LAGO MAGGIORE BIS VENEDIG. Projektions-Serie 8 (ca. 1906); WANDERUNGEN DURCH DIE SCHWEIZ, I. TEIL. VON BASEL ZUM GENFER SEE. Projektions-Serie 31 (ca. 1910), WANDERUNGEN DURCH DIE SCHWEIZ, II. TEIL. INTERLAKEN UND DAS HOCHGEBIRGE. Projektions-Serie 32 (ca. 1910); WANDERUNGEN DURCH DIE SCHWEIZ, III. TEIL. LUZERN UND DER VIERWALDSTÄTTER SEE. Projektions-Serie 33 (ca. 1910); WANDERUNGEN DURCH DIE SCHWEIZ, IV. TEIL. VON ZÜRICH NACH LUGANO. Projektions-Serie 34 (ca. 1910); DAS SONNIGE SPANIEN, I. TEIL. VON MADRID BIS SARAGOSSA. Projektions-Serie 41 (ca. 1910).

6. This is in line with the general pattern of representations of the Netherlands across various popular visual media from the mid-19th century to at least World War I, which I identify and discuss in my book *Images of Dutchness. Popular Visual Culture, Early Cinema and the Emergence of a National Cliché, 1800–1914* (Amsterdam: Amsterdam University Press, 2018).

7. The following readings were studied: Projektion für Alle, *Vortrag zu den Bildern Quer durch Holland.* Projektions-Serie 7, [ca. 1906]; Projektion für Alle, *Vortrag zu den Bildern Italien, I. Teil. Vom Lago Maggiore bis Venedig.* Projektions-Serie 8, [ca. 1906]; Projektion für Alle, *Vortrag zu den Bildern Wanderungen durch die Schweiz, I. Teil. Von Basel zum Genfer See.* Projektions-Serie 31, [ca. 1910]; Projektion für Alle, *Vortrag zu den Bildern Wanderungen durch die Schweiz, II. Teil. Interlaken und das Hochgebirge.* Projektions-Serie 32, [ca. 1910]; Projektion für Alle, *Vortrag zu den Bildern Wanderungen durch die Schweiz, III. Teil. Luzern und der Vierwaldstätter See.* Projektions-Serie 33, [ca. 1910]; Projektion für Alle, *Vortrag zu den Bildern. Wanderungen durch die Schweiz, IV. Teil. Von Zürich nach Lugano.* Projektions-Serie 34, [ca. 1910]; Projektion für Alle, *Vortrag zu den Bildern. Das sonnige Spanien, I. Teil. Von Madrid bis Saragossa.* Projektions-Serie 41, [ca. 1910].

8. *Vortrag zu den Bildern Quer durch Holland*, comment to slide 1.

9. *Vortrag zu den Bildern Das sonnige Spanien, I. Teil. Von Madrid bis Saragossa*, comment to slide 1.

10. *Vortrag zu den Bildern Italien, I. Teil. Vom Lago Maggiore bis Venedig*, comment to slide 1.

11. *Vortrag zu den Bildern Wanderungen durch die Schweiz, I. Teil. Von Basel zum Genfer See*, comment to slide 1.

12. Sarah Dellmann, "Lecturing without an Expert: Word and Image in Educational 'Ready-Made' Lecture Sets", *Magic Lantern Gazette. A Journal of Research*, vol. 28, no. 2 (2016): 3–14.

13. Except that the horsemen wear "old Spanish attire" (original: "altspanische Pracht"), comment to slide 8.

14. Original: "Meisterwerk", "schmücken", "reich", "schön", "imposant", "prächtig", "gewaltig", "malerisch", "herrlich".

15. *Vortrag zu den Bildern Italien, I. Teil. Vom Lago Maggiore bis Venedig*, comment to slide 3.

16. Most prominently, maybe, for the field of visual studies and visual history, Leo Charney and Vanessa R. Schwartz (ed.), *Cinema and the Invention of Modern Life* (Berkeley: University of California Press, 1995) and Vanessa R. Schwartz and Jeannene M. Przyblyski (ed.), *The Nineteenth-Century Visual Culture Reader* (New York: Routledge, 2005).

17. The author thanks Soeluh van den Berg of Eye Film Institute Netherlands and Paul Lambers of Utrecht University Museum as well as the group of Dutch lantern collectors for their contribution to the Utrecht research of the *A Million Pictures* project. Bernard Munnik of Museum Stedhûs Sleat/Sloten contributed additional digital images of *P. f. A.* slide sets. Thanks also to Kerstin Schwedes of Georg Eckert Institute for International Textbook Research Braunschweig for her response paper to this presentation and Richard Crangle for helpful comments on the article.

Martyn Jolly

The Magic Lantern at the Edge of Empire. The Experience of Dissolving Views and Phantasmagoria in Colonial Australia

Australians were 'early adopters' of magic lantern technology. From 1830 audiences in the colonial capitals, as well as out in the remote regions, became well acquainted with all aspects of the technology. Magic lanterns were incorporated into the programs of the big metropolitan theatres, and itinerant lanternists used local mechanics institutes, schoolrooms and hotels for their dissolving view entertainments. Although the hand painted slides they were seeing were the same as those exhibited in Europe, the colonial experience of those slides was profoundly different to that of European audiences. The magic lantern became a fundamental part of a colonial society which was often wracked with homesickness for the 'Old World' while simultaneously trying to make sense of their new social and physical environment. Through sampling the many newspaper reports of magic lantern shows from the 1830s to the 1890s we are able to chart the way disparate, sometimes estranged, individuals were formed into coherent colonial audiences, audiences amenable to further media developments in the 20th century, after the federation of the colonies into the nation of Australia.[1]

Darkness

You had to sit in the dark for a magic lantern show. This was a strange requirement when audiences were used to seeing performances in theatre auditoriums lit as brightly as the stage itself. Probably the first time an Australian theatre was plunged into darkness was in 1835, for an eerie effect produced by a phantasmagoric rear projection of the ghost ship *The Flying Dutchman*, an effect first produced eight years earlier at London's Adelphi Theatre. Sydney audiences going to the Theatre Royal were warned to prepare themselves for the moment at the end of act two: "The House is suddenly observed to be in total darkness: the storm rages, and the Phantom Ship appears (à la Phantasmagoria)".[2]

In theatre shows like *The Flying Dutchman* the sudden darkness of the auditorium and the sudden illumination of the magic lantern were intended to produce an emotional impact on the audience. But gradually audiences began to acclimatise themselves to the darkness that the lantern brought with it

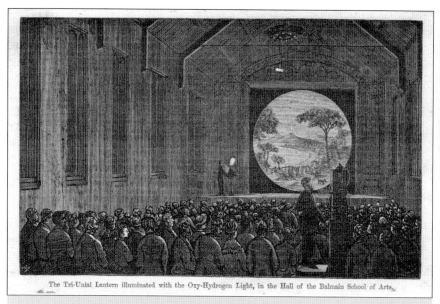

The Tri-Unial Lantern illuminated with the Oxy-Hydrogen Light, in the Hall of the Balmain School of Arts.

Fig. 1: "The Tri-Unial Lantern illuminated with the Oxy-Hydrogen Light, in the Hall of the Balmain School of Arts". *Catalogue of Optical Lanterns and Transparent Views, with the newest forms of Bi-unial and Tri-unial Dissolving View Apparatus*, by William MacDonnell, Sydney, 1882.

wherever it went. In 1846 the schoolhouse at West Maitland, a town about 175 kilometres north of Sydney, needed funds for improvements. One April evening a fundraising tea party was organised. After tea the Reverend J.J. Smith gave a magic lantern lecture on astronomy. But, before he did, the oil lamps in the schoolhouse had to be put out. This novelty, the local newspaper authoritatively reported, was "to admit of the images which [the magic lantern] threw upon the wall being seen more vividly than they could in a lighted room". Colonial audiences were used to seeing 'transparencies', large paintings on canvas lit from behind with oil lamps, but the projected image of the magic lantern demanded new spatial arrangements.[3] In the cramped and dark schoolhouse Smith had nowhere else to throw his images than on the wall, and this created problems for his audience:

> [...] the lantern itself was in the way of a large number of the audience, as it stood between them and the wall upon which the images were cast. If they had been thrown upon a screen of muslin, the spectators being on one side of it, and the operator and his lantern on the other, all would have seen perfectly the objects depicted in the form of transparencies.[4]

Light

If darkness was a novelty, its counterpoint was light. Newspapers were constantly complaining that the darkness demanded by the lantern was failing to bring forth a commensurate amount of visual illumination. Many colonial

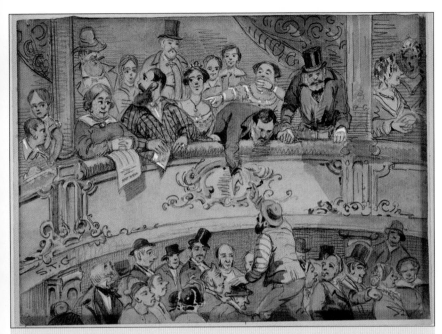

Fig. 2: S.T. Gill, "Dress Circle boxes Queens Theatre, Lucky Diggers in Melbourne, 1853", watercolour, 1880, State Library of Victoria.

lanternists found it difficult to regulate the flame, maintain focus and change slides at the same time.

When, in 1848, Mr Kesterton charged the Adelaide public half a crown to see a "Grand Illustrated Lecture on heavens and the earth, followed by a beautiful exhibition of 20 pictures and six exquisite Chromatropes", he attempted to use gas rather than oil to project his images. But not only did he project his slides upside down, but his dissolving views were "enveloped in mist". Australian magic lantern audiences always measured their experience against an imagined British one so, after robustly castigating him, the *South Australian Register* concluded:

> We have made these remarks because we feel it to be our duty to shew Mr Kesterton that an attempt to foist a lame rehearsal on the public as an exhibition worthy of their patronage will not be tolerated here any more than in the mother-country; and that if he pretends to cater for the public amusement, he must take the trouble to perfect himself in the management of the apparatus.[5]

Sometimes the power of pure light was demonstrated. In 1848, J.W. Newland concluded his dissolving view exhibitions by burning a naked block of lime, displaying the wonder of raw light itself.[6] In 1848 in Hobart, the lanternist Mr Knight concluded his shows with a "chromatic fire cloud" produced by "[…] driving a quantity of muriatic acid against a board suspended parallel with the ceiling; the acid is then ignited, and a cloud of fire of various colours appears

to descend".[7] These spectacles revealed the scientific forces that drove the illusions of the lantern.

Audience behaviour

The play of darkness against light was not only a precondition for the 'magic' of the magic lantern to work, it also brought into play another important aspect of the colonial experience of the magic lantern – the audience's behaviour.

After the 1830s, the magic lantern began to be regularly seen in Australian theatres. For instance, shortly after a lighting effect 'à la phantasmagoria' was incorporated into their staging of *The Flying Dutchman*, Sydney's Theatre Royal featured the magic lantern apparatus itself as a stand-alone entertainment. As part of a program which also included the play *Robinson Crusoe*, the farce *NO!* and a gymnast performing "a variety of evolutions on the slack rope", the theatre presented a: "PHANTASMAGORIA or MAGIC LANTHORN, Being a Novelty never yet produced in the Colony and in which will be introduced Eighty Characters, by Mr. Allan".[8] Later, in 1844, the popular comic actor George Coppin, one of the leaders of Australian theatre, brought a phantasmagoria lantern and dissolving views into his Sydney program.[9]

Australian theatre audiences were drunk, rowdy and combative. There were brawls in the stalls, members of the audience threw missiles of various sorts or leapt on stage in the middle of performances, and the performers themselves often got into arguments with audience members. However, the theatre architecture itself, as well as ticket prices, worked to more or less keep different social strata separated. Generally, prices started at three shillings sixpence for the dress circle, down to sixpence for the gallery and the pit; and the dress circle and pit had separate entrances from the street.[10]

But the magic lantern tended to cut across the established, but unstable, architectural and inherited social divisions of the theatre. The pit was a particularly dangerous place, were patrons stood, or crowded onto benches. When, in 1848, J.W. Newland decided to place his magic lanterns in the pit of the Royal Victoria Theatre, Sydney's successor to the old Theatre Royal, for his first shows of dissolving views of European scenes, comic slides and chromatropes, he was courting trouble. The first show on Monday, 1 May, proceeded uneventfully. But, after his Tuesday performance, Newland announced that someone had "maliciously injured" the magic lanterns so in future performances the apparatus would be set up on the stage.[11] Putting the apparatus up on stage may well have also added to the attraction by exhibiting the act of projection itself.

Newland was not the only lanternist to fall foul of volatile theatre audiences. When they visited Adelaide's Port Theatre in 1864, Seymour and Gordon advertised boxes in the dress circle for three shillings, but nobody bought them, preferring to spend just one shilling sixpence for the pit, or sixpence for the gallery. As a result, the audience, "[…] being unable to appreciate the nature of the entertainment, created such confusion that it was with great difficulty

that the exhibition was gone through. The views were good, but the descriptive part was rendered inaudible by the noise".[12]

If Australian audiences were notoriously boisterous, even in the relatively regulated space of the major theatres, how would they behave in the hotel rooms, mechanics institutes and schoolrooms used by itinerant lanternists?

The very first Australian magic lantern audience recorded were the boys of Captain Beveridge's Mercantile and Naval Academy, Sydney, who, at Christmas time in 1830, were treated to a phantasmagoria show which made them "laugh till they could laugh no more".[13] Perhaps it was relief at just finishing their exams which made them so cheerful, but the uncontrolled behaviour of audiences became a source of anxiety for subsequent lantern shows. As in the UK, the US and Europe, the lantern travelled throughout the colonies and was incorporated into, or competed with, a range of other 'scientific' entertainments: phrenological lectures, wax works, spectral illusions (pirating Pepper's Ghost), camera obscuras, panoramas, dioramas and illuminated transparencies.[14]

For instance, in 1865, South Australians could see "an entertainment consisting of the exhibition of a number of dioramic and dissolving views, lately arrived from London", along with the performance of some "lightning calculations" by a Mr H. Miller who was able to calculate at a glance the number of matches thrown on a table.[15] Phrenologists such as W. Stark and Nicholas Caire combined magic lantern exhibitions of local views with their phrenological readings of the bumps on the heads of their audience. Nicholas Caire would also, as part of the show, administer electric shocks from a galvanic battery to members of the audience who desired it.[16]

Volatile audience behaviour may have been encouraged by the literal volatility of the apparatus itself. For instance, in 1882, a gasbag exploded in the Baptist Church at Parramatta, blowing out all the windows and setting fire to the organ.[17] And, in 1909, an exploding lantern set the Casterton Christ Church Hall on fire.[18]

Anxieties were not only over the behaviours of the audience, but the direct effect the magic lantern might have on impressionable minds. The lantern was recognised as particularly appealing to juveniles. In early 1847 a newspaper, commenting on a magic lantern show attended by 390 people, noticed that: "[…] judging from the uproarious laughter and applause of the younger audience, [the dissolving views and phantasmagoria] were exactly adapted to the taste of the juveniles. The house was crowded, and many fashionables attended."[19] However, the lantern's distant origins and phantasmagoric associations with the occult clung to it as it migrated into mainstream entertainment. For instance, later that year, another newspaper worried over the same show:

> The exhibition was sort of mélange, consisting of optical illusions, phantasmagoria, fun, and harlequinade. The dissolving views were numerous and diversified, but contained too few representations of local objects. Some of the

personal figures bordered upon indelicacy; so much so, as, in our opinion, to deter parents from treating their children to an otherwise harmless amusement; and it struck us that the dance of death savoured too much of profanity, and dangerous disregard [...] a prudential change in their exhibition, with an improvement in the mechanical arrangement, would make it worthy of general patronage.[20]

Other newspapers had more mundane advice to give. In 1852, Alfred Cane put on a dissolving view exhibition at Sydney's Royal Hotel. After visiting the show, one journalist helpfully offered "two or three suggestions". Firstly, that "the issue of tickets should be more proportionate to the accommodation", because many who bought tickets, "far from being able to get seats found it impossible to procure even a standing place from whence a good and clear sight could be obtained of each view". Secondly, that some steps be taken to repress the "unruly propensities" of the "fast-boys" who "persist in standing up so as to hinder the view of those sitting behind, and indulge in other freaks equally amusing to themselves but unpleasant to others". Thirdly, that the lanterns be brighter and sharper, because the views were "scarcely distinct as to their finer lines when seen from any distance". And lastly, "that the music should be so arranged that each air may bear some analogy to the view actually before the audience".[21] This reviewer wasn't all that impressed with the quality of the slides either. While admitting that, as a whole, the views were "truly beautiful", he complained that:

> [...] the artist has indulged somewhat too freely in tints of green and deep blue, and that [...] there is far little light and brilliancy in the skies. In most of the scenes the light appeared rather to flow from the earth than from the Heavens.[22]

Adelaide had a solution to Cane's problem with "fast-boys". In 1854, nearly a thousand people attended the Mechanics Institute for "Mr Knight's beautiful and picturesque views":

> Considerable annoyance has previously been caused by the pranks of some mischievous schoolboys; last night two constables with dark lanterns were placed at the doors, and the boys were removed to the lower end of the room, where they were perfectly visible the whole evening; they were also under proper guardianship.[23]

Fear

If juveniles had trouble containing themselves, adults also felt the new and peculiar power of the apparatus. Sometimes the lantern made adults almost feel afraid, but it was a fear suspended within the terms laid down by the apparatus, like the fear we experience in an amusement park ride today. In 1848, when J.W. Newland projected live weevils through an oxy-hydrogen microscope, their "extraordinary size and quick and ferocious movements almost gave rise to a feeling of fear in the mind".[24] In 1859, the landlord Smith O'Brien gave an annual entertainment for his tenants. However: "Some of the magic lantern 'apparitions' almost terrified many of the rustic spectators, as most of them had never before witnessed a like performance".[25]

Tears

Not only fears, but also tears, could be provoked by the lantern. In 1853, at St Mary's Seminary, "[t]he enthusiastic bursts of applause with which the views of the venerable ruins of our Fatherland were received proved how deeply rooted she is in the affections of her children".[26] When the English baritone G.H. Snazelle presented Tennyson's poem *Enoch Arden* at the Adelaide Town Hall in 1891, he brought tears to the eyes of many in the audience.[27] And, during the 1880s, the entertainment *The Old Home: Or England Past and Present*, and similar entertainments which mixed views of England with portraits of the Queen, were given in Adelaide, and were concluded with the tearful singing of *God Save the Queen*.[28]

Reverie

These examples indicate the consternation, both positive and negative, caused by the apparatus of the lantern. However, that consternation eventually transformed itself into either imaginative reverie or optical wonder. Two developments effected this transformation: firstly, audiences disciplined themselves with self-control; secondly, the images on the screen were disciplined with music and commentary.

The issues lanternists encountered with controlling audience behaviour, while at the same time controlling their complex apparatus, certainly weren't unique to Australia, they were encountered in Europe, the US and the UK as well. But at the edge of the British Empire a heightened awareness of time and geography ran through the Australian experience, not only of the time it took for new inventions to reach them in the form of the new entertainments that they could patronise, but also the various personal and biographical distances those experiential novelties measured. This was not only a distance from metropolis to province, but from one end of the world to another, and from a nostalgically remembered past to a frontier present.

Some magic lantern shows directly conjured this sense of distance as audience experience. Although, for one captious writer, the over-sale of tickets, the antics of "fast-boys", the dim projections, the random music, and the poorly painted slides had marred Alfred Cane's exhibition, for another writer Cane's "dissolving views recently imported from England" were hugely enjoyable because he could relate to them personally, since he too had come to Australia on a long sea voyage. Despite his present geographical distance from home he could still weave the lantern images into his own feelings of British loyalty. But as a colonist he also took exception to being fobbed off with views that reinforced his sense of distance from the motherland, rather than shrinking that distance. His experience therefore became a kind of emotional push and pull:

> "A ship in a calm" was a particularly truthful representation of that most tedious, most trying, most wretched predicament. Gazing at the view, one might almost

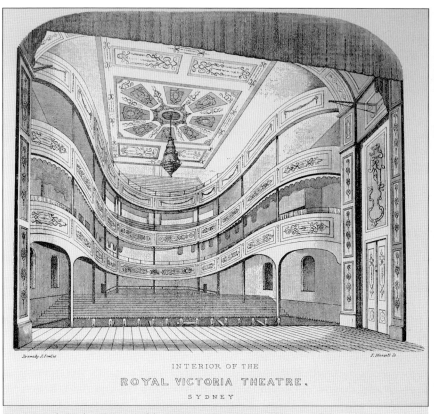

INTERIOR OF THE
ROYAL VICTORIA THEATRE.
SYDNEY

Fig. 3: Joseph Fowles, "Interior of the Royal Victoria Theatre, Sydney", *Sydney in 1848 Illustrated with copperplate engravings of the principal streets, public building, churches, chapels etc., from drawing by Joseph Fowles*, J. Fowles, Sydney, 1848.

fancy one saw the lazy sharks crawling about in the blue water, [...] Then suddenly the scene changed, the ship is caught in a storm, and with double-reefed foresail only set, struggles vainly against the furious surge, which too fatally drives her onto the inexorable rock. These two representations of the chances of the ocean were followed by "the ship on fire", and "the raft", and elicited several rounds of applause, especially from the juvenile portion of the audience, who, with true British feeling, seemed to delight in the danger, although 'twas but in show. [...] A very interesting picture of Balmoral Castle, her Majesty's residence in the Scottish highland, was followed by "Windsor Castle". Both these views were good; the former having a peculiar interest from the associations connected with the mountain glens where the most popular and most worthy of England's sovereigns loves to breathe the free air for a season, and take rest from the cares of state. [...] a variety of other very good views passed before our eye in rapid succession; among which we must not forget to mention a scene representing "Summer", which was dissolved into "Winter", (same subject) and that again into a snowstorm, which, whatever might be its merit, appeared to the Australian spectator somewhat outré. A variety of chromatropes ensued, the exhibition concluding with very so-so portraits of Her Majesty and Prince Albert, evidently painted shortly after the year one. Considering the immense number of excellent recent representations of the

Royal Pair which exist, we really think something better than a cold delineation of "Victoria and Albert in their honeymoon days", in "their hey-day of youth", might have been presented to Her Majesty's loyal lieges of Australia.[29]

In 1855 the journalist James Smith developed this sense of transport in an exhibition he grandly titled the Cosmopoligraphicon, which was very unusual for sustaining a six-week season in Melbourne. Smith's hand-painted slides of European travel scenes were rear-projected, so the apparatus itself wasn't part of the spectacle, and the sequence of slides was geographically ordered, smoothly narrated and expertly propelled by music from a harmonium (which he called a Megaphonicon). The audience settled down for a sustained period of attention during which they cultivated their homesickness.

Seven years earlier, at Sydney's Royal Victoria Theatre, J.W. Newland had shown various views of European cathedrals and other sites, as had Alfred Cane at Sydney's Royal Hotel four years later. But in Melbourne, Smith organised his dissolving views into a grand tour:

> What need of travel, when the results of travel are brought to your own door? Why endure the dust, heat, fatigue, vexations and extortions, the short sleep and the long bills of foreign inns, the garrulous twaddle of the ciceroni, and "all the thousand ills which travellers are heir to", when you can sit in a cosy seat, in a comfortable room, see all the best "bits" of continental scenery produced before your eyes.[30]

His first view was the church of St. Hilders, Paris, shown empty. Then the dissolving apparatus and the megaphonicon began to work their magic:

> [...] a general air of repose diffused throughout the whole edifice; a shadow and a dimness passes over it, the pealing organ is heard reverberating through the long-drawn aisles, which are now seen to be alive with people – the priests in their episcopal robes, and the congregation paying their reverence to the host.[31]

His performances re-connected his audience to Europe through such fanta-sised content, but they also conjured, at least to newspaper reviewers, effulgent personal reveries of cultivated homesickness.

> Some of [the views] called up pleasurable recollections of the past, and revived associations that memory has made very dear [...] How humanizing – how soul-purifying, and how it wakes from torpor our better nature, and makes us divest ourselves of the selfish cynicism with which we are prone to enwrap ourselves. Who, we ask, could see that old village church, with its winter dress, and not think of the bright calm December Sunday morning that he has walked up the pathway to the portal with some dear form that now lies cold beneath its walls? The hymn that seems to peal from the open latticed windows is the one in which he has so often joined, and, anon, as night steals over the coldly quiet scene, and the light streams from the diamond panes, he thinks himself in the old pew in the corner and forgets that sixteen thousand miles of ocean are rolling between him and that beloved spot he never may see again?[32]

Distance

But not only did Smith's audience reconnect with home through the content of his projections, they were also able to self-consciously compare the experi-

ence they were having, in Melbourne in 1855, with the experience that may be being had by others, at the same time, back in Britain; or the experience they remembered having before they had left Britain to emigrate to Australia. Smith himself had previous experience as a writer, editor and public lecturer in Britain before he emigrated, and the Melbourne Cosmopoligraphicon may have featured slides painted by the English miniature painter Walter Francis Tiffin, because, as opposed to Alfred Cane's slides with their dark skies, the high quality of Smith's slides was immediately noted:

> The excellence of their workmanship is most exquisite, both as to composition, effect and colouring; and they are, it may safely be asserted, of a character infinitely superior to anything that has been exhibited on this side of the equator.[33]

6 THE WAR CRY. October 14, 1895.

LIMELIGHT SUCCESSES IN THE FAR NORTH.

Captain Perry Takes the Cake and Shuts Up a Crowd of Theatricals.

Fig. 4: "Limelight successes in the far north. Captain Perry Takes the Cake and Shuts Up a Crowd of Theatricals", *The War Cry*, Melbourne (14 December 1895): 6.

Colonial reviewers assessed their experience of the magic lantern in a global context. The Cosmopoligraphicon was, to use a phrase which was to become overused in 20th century Australian culture, "world class":

> Such of us as have lately dwelt in the modern Babylon have most pleasant reminiscences in connection with these sources of recreation, and we feel a glow of unfeigned pleasure in the opportunity that is now presented of renewing these yet vivid impressions of enjoyment, and in comprehending new joys of a like nature.[34]

> [For] those of us who retain a vivid recollection of the wonders of the London Polytechnic, this exhibition will not in any way suffer by comparison. [...] to those who have not had an opportunity of observing the immense improvement which

has been effected in this branch of art during the last few years, these pictures will appear truly astonishing.[35]

The Cosmopoligraphicon, as a place of entertainment, is a most valuable addition to our places of amusement. There is nothing in the attractions it offers that the most refined taste can object to, but on the contrary, much that will help to compensate our fellow-colonists for the elegant places of public entertainment to which they relinquished their opportunities of access when they quitted Europe.[36]

Smug and pompous reassurances such as these undergirded the internal emotional transport of the exhibition with an imagined network of global citizens, securely gridded together across both imperial geography and imperial history.

By the 1860s the lantern was regularly taking audiences on intercontinental journeys. Lantern shows bridged the geographical distance between Australia and the mother country in imaginatively collapsing space, but they also united the colony and the mother country in their joint technological progress through historical time. After experiencing "the pair of magnificent apparatus [which] astonished and charmed a town hall full of people" on a night in 1868, a Melbourne writer mused on how far the magic lantern had come, both through the temporal space of technical progress and the geographical space of the empire, since the "galantee showmen" of his British youth:

> [...] the exhibition, although thought so highly of then, was in truth but a very simple and unpretending affair, consisting only of a white sheet pinned against the wall, on which were revealed in dim and misty outline a few rude subjects, generally of the coarsely comic order, but now, after the advances represented by the Polytechnic, the lantern was able to illustrate the most striking features presented to the voyager on the long route overland from Southampton to Calcutta. Most of these views are admirably painted, and have besides the merit of being exact portraitures of the places they represent. We may specially instance the views of Cintra, Malta, Boulac, the dead camel in the desert, Joseph's well, Cairo, Mocha, and Pondicherry.[37]

The lantern pacified and shaped Australian audiences, as it did audiences everywhere. It trained them to politely sit together, shoulder to shoulder in the dark. But for Australians, their collective reward was to be taken on virtual voyages back to the worlds they had left behind. After the show they could reflect on their experience, and compare it to the experience they imagined others were having across the globe. Within colonial modernity the special magic lantern show produced an acute and uncanny sense of a 'here' and a 'there', a 'now' and a 'then', re-mapped around the world. Australian audiences were pioneers in more ways than one, they may have been at the outer edge of empire, but they were at the forefront of globalised, technologized experience.

Notes

1. For a discussion of the magic lantern in Australia in the early 20th century, see Martyn Jolly, "Soldiers of the Cross: Time, Narrative and Affect", *Early Popular Visual Culture*, vol. 11, no. 4 (2013): 293–311. For an overview of the magic lantern in Australia, see Elizabeth Hartrick, *The Magic Lantern in Colonial Australia and New Zealand (Melbourne:* Australian Scholarly Publications, 2017).

2. *Sydney Gazette and New South Wales Advertiser* (12 September 1835): 3.

3. For an overview of transparency painting in Australia, see Anita Callaway, *Visual Ephemera: Theatrical Arts in Nineteenth Century Australia* (Sydney: UNSW Press, 2000).

4. *Maitland Mercury and Hunter River General Advertiser* (15 April 1846): 2.

5. *South Australian Register* (19 January 1848): 3.

6. *Maitland Mercury and Hunter River General Advertiser* (6 August1848): 2.

7. *The Courier* (Hobart) (8 September 1854): 2.

8. *Sydney Herald Monday* (2 November 1835): 1.

9. *Sydney Morning Herald* (14 September 1844): 4, and (12 October 1844): 1.

10. See Eric Irvin, *Dictionary of the Australian Theatre 1788–1914* (Sydney: Hale & Iremonger, 1985), 33–34; see also Philip Parsons and Victoria Chance (ed.), *Companion to the Theatre in Australia* (Sydney: Currency Press, Cambridge University Press, 1995), 65–66.

11. *Sydney Morning Herald* (4 May 1848): 1.

12. *The South Australian Register* (26 October 1864): 2.

13. *Sydney Gazette and New South Wales Advertiser Saturday* (25 December 1830): 2.

14. The research into this rich field of colonial modernity has only just begun, see Mimi Colligan, *Canvas Documentaries: Panoramic Entertainments in Nineteenth Century Australia and New Zealand*, (Melbourne: Melbourne University Press, 2002). See also Anita Calloway, *Visual Ephemera: Theatrical Art in Nineteenth Century Australia* as well as Hartrick, *The Magic Lantern*.

15. *South Australian Register* (16 November 1865): 2, and (26 December 1865): 3.

16. *South Australian Register* (31 August 1861): 3, and (14 September 1866): 3.

17. *Morning Bulletin* (Rockhampton) (21 April 1882): 2.

18. *The Argus* (4 November 1909): 8.

19. *The South Australian* (23 April 1847): 3.

20. *The South Australian Register* (13 November 1847): 3.

21. *Freeman's Journal* (5 February 1852): 10.

22. Ibid.

23. *The Courier* (Adelaide) (8 September 1854): 2.

24. *Maitland Mercury and Hunter River General Advertiser* (9 August 1848): 2.

25. *Freeman's Journal* (23 November 1859): 4.

26. *Freeman's Journal* (24 September 1853): 10.

27. *South Australian Register* (18 November 1891): 2.

28. *South Australian Weekly Chronicle* (10 September 1881): 1; *South Australian Register* (28 July 1885): 7; *The South Australian* (25 May 1887): 6.

29. *The Sydney Morning Herald* (30 January 1852): 2.

30. *The Age* (9 May 1855): 6.

31. Ibid.

32. Ibid.

33. *The Age* (3 May 1855): 6; see also Hartrick, *The Magic Lantern*, 56.

34. *The Age* (3 May 1855): 6.

35. *The Argus* (30 April 1855): 6.

36. *The Age* (9 May 1855): 6.

37. *The Telegraph, St Kilda, Prahran and South Yarra Guardian* (18 July 1868): 2.

Joe Kember

The "Battle for Attention" in British Lantern Shows, 1880–1920

Our capacity to "pay attention", as Jonathan Crary has compellingly shown, has been a subject of critical contention across diverse disciplines for the better part of two centuries.[1] Whether debated by educational psychologists, social theorists or media historians, the notion that we face competing centres of attention in our day to day interactions, especially with media, has become a commonplace, the discourse employed to describe this phenomenon routinely metaphorized by ideas of conflict or adversity. In a recent example, writer and journalist Madeleine Bunting has discussed on radio and online the personal and social problems engendered by what she terms "weapons of mass distraction" – that is, by digital technologies mobilised to grab attention, which, she believes, "are dismantling traditional boundaries of private and public, home and office, work and leisure".[2] In such accounts, our capacity to pay attention to specific phenomena is regarded as diminished, constantly undermined, fragmented or even assailed by the "onslaught" of intrusive data streams.[3]

Of course, from the point of view of media industries, especially those linked commercially to varied forms of marketing and publicity, the tenor of such metaphors is rather different. Whereas the consumers of media are frequently figured as the victims of an assault upon the senses, for modern advertisers the battle for attention is a conflict to be engaged with and won, rather than endured. Thus, in 2017, the Direct Marketing Association, a British network of companies and other organisations specialising in 'data-driven industry', and with members as diverse as Sky Broadcasting, the Royal Society for the Protection of Birds and the Labour Party, delivered a workshop on the "Battle for Attention" dedicated to improving "customer engagement".[4] Meanwhile, in the US, management consultancy firm Beyond Reason also addresses the current "battle for attention" in publicity circles, deploying modern cognitive science in order to show customers that "understanding the mental process that directs attention is crucial to improve marketing performance".[5] Researching the "Battle for Attention in your living room" in 2017, Google teamed up with an eye-tracking software specialist in order to map the "attention deficit" in place when homes were occupied by multiple screens, finding that in order to maximise the effectiveness of advertising in this context, it had become necessary to "pay attention to attention".[6] Tim Wu has

described such "industries of attention capture" as global "attention merchants", arguing that the monopolisation of human attention has long been envisaged by advertising agencies, but had first emerged from the propaganda offices that flourished during the First World War, especially in Britain.[7]

This chapter will look back a little further than this, to the turn of the 19th century, a period in which Wu suggests that the embryonic attention merchants were little more than "primitive, one-man operations".[8] Focusing on educational institutions, I will show that, even at this stage, a wide range of agencies were also obliged by the competitive market for attentiveness they found themselves in to pay attention to attention, and that the lantern apparatus – including not only projectors, slides and screens, but also exhibition spaces, lanternists and lecturers – were regularly regarded as important weapons in this large-scale battle. In tracing the presence of attention merchants back into this market, however, my intention is not to claim that the operations of such individuals and organisations were identical to those identified by Wu in the 20th and 21st centuries, nor even to call for some form of 'archaeological' methodology in uncovering the attentive regimes at work in historical media (a task in any case arguably undertaken by Crary in relation to an array of earlier media). Rather, I will only suggest that the problem of attention at the end of the 19th century, as at the beginning of the 21st, was two-sided: in both cases individuals have been represented as beset with competing stimuli demanding scrutiny; in both cases popular media outlets have responded by designing media experiences in order to maximise attention to their own products, thus intensifying the apparent onslaught. Following an investigation of the scale and competitiveness of the British lantern industry in the late 19th and early 20th centuries, the final section of this chapter will therefore return to questions relating to the psychology of attention as these were explicitly addressed by educationalists between the 1890s and the 1920s, finding some similarities in their diagnoses of the problem of attention with the attitudes of modern commentators such as Bunting and Wu.

Scale and complexity of the British lantern industry at the turn of 20th century

While the necessity for analysis of this phenomenon in the contemporary mediascape seems self-evident, in the case of the magic lantern, by some distance the most pervasive large-scale visual medium in Britain from the 1880s until at least the early 1910s, the question has not yet been posed. In part, I believe that this is because the scale and influence of the lantern trade is only now becoming understood. Though some attempts have been made to estimate the number of lantern shows taking place in certain locations in Britain and the United States, the scale of magic lantern use has remained difficult to determine.[9] However, in the course a survey of large-scale and projected media in the South West of Britain from 1820 to 1914, which I have conducted with John Plunkett and other partners at Exeter, it has been possible to determine

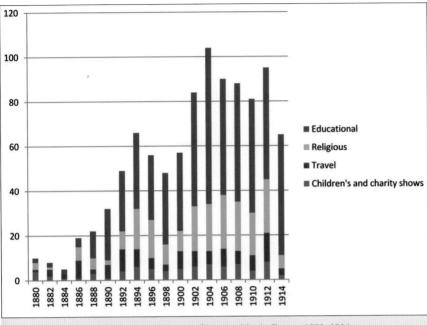

Fig. 1: Newspaper Reports of Lantern Use in Exeter, 1880–1914.

the number of advertised shows taking place each year in a representative range of locations, and to track trends and transitions in this period.[10] This survey has depended primarily on research into both print and digitised local newspapers of the period, a process that we believe has given us the most complete picture, to date, of patterns of urban and rural exhibition in locations as diverse as major, metropolitan Bristol and the tiny coastal resort of Sidmouth, as well as other ports, market towns, and villages in the region.

Drawing from this research, it is possible to build a comparative picture of lantern use across very varied locations. However, for the purposes of this chapter, it will suffice to consider briefly the case of Exeter, a small city of under 40,000 in 1901, but which typifies the powerful upward trend in numbers of lantern shows around the turn of the century.

As can readily be seen from this data, the expansion of shows across the board in Exeter is dramatic during the 1880s, but with numbers peaking during the aughts, and the lantern therefore maintaining and increasing its popularity long after the introduction of the cinematograph to the city in 1896 and the commencement of regular town hall film shows in 1900. Looking at the trends in more detail we can discern a modest rise in the number of travelogue-style lantern shows advertised, but the most dramatic increases were in the numbers of religious and educational performances making use of the lantern, and these were seldom able to employ moving pictures to good effect: they were not often so easy to lecture or preach to. Meanwhile, the incidence of shows intended primarily as entertainment, most often those projected for children

over the Christmas and New Year period and which tended to make use of many comic slide sets and effects slides, remained largely unchanged. Moreover, it is worth noting that the dramatic increase in religious and educational lantern shows represented here is an underestimation: while we have surveyed a representative sample of the newspapers available in Exeter in this period, using both print and digital resources to ensure full coverage, it is certain that many shows were not advertised nor reported, depending instead on word of mouth or forms of street advertisement. It is also likely that, as the numbers of lantern shows increased, so the interest in reporting them all would have waned in the local press. This was especially the case in relation to religious shows, with many church and welfare groups by the 1890s relying upon communication within congregations to pass long information about lantern shows, or simply introducing the lantern in the course of their customary services to spice things up a little.

The data presented here points to a medium that passed during the 1880s from being an occasional treat for citizens to a pervasive presence within their everyday lives, and from a relatively small-scale industry of slide production and lantern performance to a phenomenon bearing some of the characteristics of a mass medium: the lantern began to address an inclusive set of audiences, it made use of extensive mechanical processes of copying and reproduction led by a small number of dominant and centralised companies, and it therefore allowed for the delivery of content to take place in multiple spaces and across long periods of time.[11] However, unlike later forms of mass visual media, it also remained substantially dependent on the live interaction between performers and audiences and frequently also on large quantities of home-made content; partly for these reasons the markets the lantern addressed also remained remarkably complex, structured by venue, audience, subject matter, and style of performance. From the domestic lantern show to the grandest of celebrity lectures, the multiple, layered lantern cultures of the late Victorian and Edwardian periods reached all classes of audience in as many settings, from the workhouse to the athenaeum. As one experienced lanternist claimed in 1899, "pictures of extreme accuracy, not to speak of great beauty, can be efficiently shown to half a dozen people in a drawing-room or to 4,000 in a great public hall".[12] The lantern was exploited by commercial and non-commercial, local and national, small and large-scale organisations, as well as by many individuals working on their own behalf.

Transformations in the market for educational lantern shows, 1880–1920

This type of diversity is familiar to lantern historians, yet more attention might usefully be paid to the way that this complex structure had shifted from the 1880s. The picture was not simply one of industrial growth and decline, though this was certainly how some commentators in the trade press (and generations of scholars) came to see it. Rather, what occurred was a transition in which

itinerant lantern professionals were squeezed out by new generations of amateurs and jobbing lanternists on the one hand, and by a group of increasingly professional national bodies – benevolent, educational, and commercial – on the other.

The case of educational lantern lectures provides especially clear examples of both of these developments, though similar cases can be made for religious or social welfare lantern lecturing traditions, too.[13] Evidence for such transitions can be found in the local press: as the older lecture societies closed or transformed into venues for popular entertainments, the lecture series they had advertised each September and January were gradually displaced by the series offered by a new generation of increasingly professionalised educational bodies, some of which now offered new types of qualification intended for ambitious working or middle-class students. Equally, surviving lecture societies and also some of the public lecturing bodies associated with new generations of public libraries and museums increasingly employed local men and women to fill their programmes: individuals who performed cheaply or for free and who often produced, rented or bought their own lectures and slide sets. Supporting evidence for these changes is also frequently found within surviving lantern slide collections within public educational institutions, which have sometimes retained large numbers of glass-plate slides either commissioned or produced by educational institutions during this period, or donated by amateur lanternists.

In the latter category, the slide collections at Exeter's Royal Albert Memorial Museum have been especially informative in relation to the new generation of local and domestic slide manufacturers and exhibitors, who were enabled by new techniques in amateur photographic reproduction, and by the development of inexpensive slide rental services, to provide a remarkable breadth of citizen-science style lantern lectures within Exeter.[14] As Richard Crangle has shown in biographical research available on Lucerna, such men and women often provided decades of service to their communities, though their material could also be intriguingly idiosyncratic.[15]

Similarly, the Joseph James Phelps collection at Chethams' Library in Manchester offers a fascinating glimpse into the work of a single citizen-lanternist at work in a large city across several decades in the early 20th century.[16] As well as the photographic lantern slides Phelps produced of local and foreign scenes, the collection also contains multiple drafts of his lectures and indications of the locations in which these were delivered. His material was frequently of distinct regional interest, with many slides surviving, for example, of the local canals that had formed such a significant part of Manchester's industrial history (Fig. 2).

Phelps' lectures were painstaking and detailed, likely to last for well over two hours, and sometimes illustrated by hundreds rather than dozens of home-made and commercial slides. However, the presence of so many lecturers like Phelps, who filled the programmes of surviving lecturing societies, had been

Fig. 2: Phelps Collection, Chetham Library: [IMAGES OF THE BRIDGEWATER CANAL]
(lecture: maker unknown, at least 125 slides, n.d.).

regularly bemoaned by the self-styled lantern professionals represented by the photographic trade press and especially the *Optical Magic Lantern Journal*, which tended to denigrate the 'amateur' market during the 1890s and 1900s, but it is fair to say that a large percentage of lantern activity by the turn of the century was conducted by this type of community-based organisation. It's also fair to say that it often wasn't very amateurish: individuals like Phelps present a remarkable, polymathic intelligence that was welcomed within communities, and which still now preserves much of its charm. We might also note, here, the great advances made by photographic societies, which developed rapidly from the late 1880s, and which brought skills of slide manufacture – and some excellent photography, such as in the examples above – to many of these lantern shows.

A great deal of work remains to be completed on the great number of individuals such as Phelps, whose cumulative cultural production helped transform the market for educational lantern lectures during this period. However, the trend that remains even more under-studied, in my view, is the transition from the older generation of professional itinerant lanternists to a new generation of professional lecturers associated with more centralised and highly capitalised institutions. The era of the eminent Professors Procter, Ball, Hepworth, Malden and others gradually came to a close over this period, and the mass of less prominent itinerant professional lecturers found it more and more difficult to attract bookings. To some extent, the more renowned men were simply replaced within major lecturing agencies by new types of performer – such as Nansen, Amundsen or Churchill – who had gained their celebrity in other endeavours, and who came to the lantern on the promise of very large sums of money.[17] But the bulk of educational lectures were not given by such men, but by a new type of professional lecturer: individuals who did not usually travel and did not need to look for bookings from lecture societies.

Instead they were directly employed by incipient colleges and universities across Britain – which regularly required them to give lecture series to the general public as well as to an increasingly defined body of students. The development of this profession was a key step between the era of the 19th-century rational amusement and the career of the modern university lecturer. That connection is directly embodied by surviving university collections of lantern slides, such as that at the Museum of Manchester, which incorporates large numbers of zoological slides made or repurposed for academic courses at Manchester University in the first half of the 20th century.[18]

Among the educational institutions that became more prominent at this time, the new generations of public libraries and museums constructed across Britain in the latter half of the 19th century gradually took on more responsibility for delivering lecture series to the general public. These were frequently quite similar to the earlier Mechanics' Institute series, with one-off lectures delivered by an uneven mix of local men and women, ever decreasing numbers of itinerant professional lecturers and growing numbers of local individuals working in nearby colleges. For regional colleges it was essential to insert educational programmes into existing spaces for public lectures, with free lecturing sometimes offered as a form of shop window for more sustained programmes of education. Sometimes these increasingly centralised organisations also brought heavily sponsored or fully-funded lecture series to the public, and they still frequently depended upon the lantern to provide the bulk of their illustrations, a development that partly explains the greatly increased number of advertised lantern events taking place by the 1900s.

However, perhaps most significant in this transition towards new forms of professionalised lantern lecturing was the University Extensions Movement, which included Cambridge, Oxford, Bristol and London Universities, and which was responsible for delivering lecture series in urban centres across Britain. During the 1889–1890 season, the Oxford University Extension alone delivered 148 twelve-lecture series in British cities across 109 local centres, with a total average weekly attendance of 17,904.[19] According to a survey of local papers in the south west of Britain, approximately half of extension lectures were illustrated by the lantern, a substantial number, since several series took place a year in most centres, with full series usually comprising twelve lectures. They were significant on a national level, partly because they contributed to the growing institutionalisation of Further and Higher Education across numerous urban centres, sometimes feeding into the development of the new Colleges, though an initial plan to develop provincial Oxford Colleges ultimately never succeeded. However, they also contributed to a changed mode of engagement from that expected in the older lecture societies. Whereas these frequently employed a subscription model, with annual payments buying the right to attend very varied lectures across the long winter season, the extension model depended upon subscription to a full course on a given topic, with the expectation that if the student passed the exams associated

with such courses across several years, they might acquire a qualification that could further their prospects. Drawing on the same pool of middle and working class audiences, including large numbers of women, who had populated Mechanics' Institutes for decades, attendance of such courses depended upon prolonged and deep engagement with the subject matter from students. In such a context, the capacity for attentiveness was at a premium.[20]

The lantern as weapon in the "Battle for Attention"

One point I would like to emphasise from this brief outline of the scale and complexity of educational lantern use from the 1880s is that this was actually a very exciting stage of the lantern show's development. This was not a stagnant industry, re-circulating earlier models of presentation to bored or over-familiar audiences; rather, the industry successfully adopted new strategies that revolutionised educational picture-going for audiences from all walks of life.[21] In relation to both the massive expansion of what has been pejoratively labelled as 'amateur' slide production and lecturing, as well as the development of centralised and professional institutions of further and higher education in centres across Britain, an essential aspect of the redevelopment of the lantern trade in these years was a renovation of the modes of attention required from audiences.

In the case of educational lantern slides, this renovation emerged alongside the developing discipline of educational psychology, which witnessed its 'golden age' between approximately 1890 and 1920 at exactly the same time as the magic lantern. This was no coincidence, I would argue: as William James urged in his 1899 *Talks to Teachers on Psychology*, "the less the kind of attention requiring effort is appealed to; the more smoothly and pleasantly the class-room work goes on", and the lantern had been routinely appealed to for some time as a means of transmitting information fluently and without conscious effort on the part of viewers.[22] A generation of educational psychologists, often citing James' work, paid a great deal of attention to attention, especially prioritising what he had called "voluntary attention" as the most productive mode in which to receive information:

> Voluntary attention is [...] an essentially instantaneous affair. You can claim it, for your purposes in the schoolroom, by commanding it in loud, imperious tones; and you can easily get it in this way. But, unless the subject to which you thus recall their attention has inherent power to interest the pupils, you will have got it for only a brief moment; and their minds will soon be wandering again. To keep them where you have called them, you must make the subject too interesting for them to wander again.[23]

Whereas educational psychologists of this period most often considered *mental* imagery as a key part of the apparatus for making the subject interesting,[24] the lantern in conjunction with a public speaker was popularly considered a powerful means of holding the attention of audiences, and this made it an essential component of effective communication outside of educative circles, too. For James Albert Winans, in a 1916 popular work "for public speakers

from pulpit, bar, stump, and lecture platform" that drew heavily on the psychological literature, "attention" remained explicitly a master-term.[25] Like so many of our contemporary attention merchants, he urged engagement with what he also called the "Battle of Attention" and for much the same reasons: for any public audience, he argued, "[a]t any moment there are innumerable ideas and sensations struggling to get into the focus of your attention", and it was therefore necessary to understand the psychology that might enable your message to reach its recipient effectively.[26]

Though very few lanternists, to my knowledge, claimed any great familiarity with educational psychology during this period, I would like to conclude by suggesting that this type of thinking concerning a battle for attention was characteristic of the lantern trade more generally at this time. In large part, this was because of the sheer scale of the industry: as the figures for even a relatively small urban centre such as Exeter have suggested, the lantern was deployed with increasing frequency from the 1880s, with educators, religious and welfare groups especially attempting to gain an advantage in their respective missions to attract, instruct and enlighten, and also to generate income. Following a modern commercial logic of penetrating into diverse, niche markets, the lantern made its presence felt at almost every available public venue, from athenaeums to orphanages, as a mundane, neighbourhood phenomenon, part of the routine practice of everyday life – albeit a part that tended to occupy leisure rather than working hours. Unsurprisingly, then, tracing lantern use in such cities tends to bring us to the heart of a highly complex and often conflicting urban public sphere, populated by varied interest groups seeking to solicit the attention of citizens. This situation was echoed in local newspapers by the competition for column space between these civic groups, often in order to advertise forthcoming attractions. The lantern, and especially the powerful oxy-hydrogen or electric apparatus frequently advertised, could be a useful weapon in the battle for attention among students, congregations and the general public.

We can productively consider this communicative motive, in which varied organisations and individuals sought to solicit and maintain the attention of niche communities defined variously by location, age, gender, education, and class, to be the key *social* imperative underlying the expansion and industrialisation of the lantern trade from the 1880s. For educators, as we have seen, the centralisation of the lecture market and the development of the lectures series, especially, called for the development of new modes for maintaining the attentiveness of students across expanded periods of time, many of which, like the use of the slide show, were institutionally sanctioned and ultimately formalised in the form of the academic lecture. Perhaps most obviously, however, as Karen Eifler has noted in relation to the Church Army, the Salvation Army, and other bodies, militaristic metaphors predominated among religious and welfare groups in relation to their ability to solicit and maintain the attention of target, and especially working-class, audiences.[27] For religious

and temperance causes, especially, a master military metaphor was regularly cited from John Bunyan's 1682 book, *The Holy War*, in which he had allegorised the process of religious conversion in terms of a battle over the town of 'Mansoul' (man's soul). Bunyan had described the predominant influence of entrance to Mansoul via 'Ear-Gate' and 'Eye-Gate', an irresistible description, too, for the work of persuasion that it was hoped a lecture or sermon in combination with a lantern might accomplish in churches or mission halls. "The Eye-Gate is a shorter cut to what we are pleased to call our minds, than the Ear-Gate" wrote one commentator in 1900, and therefore "for interest there is nothing so good as the modern equivalent of the magic-lantern".[28] A 1909 report on Lenten entertainments for convalescent soldiers typifies this discursive trend:

> Our columns frequently testify to the abundant use being made, all over the country, of the optical lantern in bringing home to men's minds the olden truths of God's Word in a new manner. The dark evenings of Spring, during which Lent falls in our hemisphere, provide ample opportunities for the man who desires to get for spiritual truth an entry into man's mind by using "eye-gate" as well as "ear-gate". [...] The present Lenten course has been going on every Thursday night, the splendid "arc" electric lantern throwing pictures some 16 to 18 feet square on a huge opaque screen, which is lowered from behind a sanctuary arch.[29]

Clearly, the subject matter of such lectures differed greatly from educational lectures, but the strategy was similar: the combination of projected image and spoken word was considered an optimal means of attaining high-level atten-tiveness, even when, as in the case of audiences at a military hospital, the audience might have had good reason for being preoccupied, resistant, or distracted.[30]

Far from an abstraction or latent quality within the late 19th and early 20th century lantern cultures, I wish to emphasise that the imperative to solicit attention was objectively recognised and frequently discussed within educa-tional, religious and other groups making extensive use of the lantern. For this reason it is also writ large into surviving archival collections of slides and their associated records, though reconstructing this imperative usually requires careful and detailed reading of such unloved material as acquisition records in museums, or of the ephemera and notes associated with lantern slide boxes or written onto labels on the slides themselves. Upon opening a box of slides we may encounter a bewildering array of commercial and home-made images covering all sorts of topics. But other clues often bespeak efforts to re-order and repurpose the slides, often multiple times over decades, and sometimes when we're lucky, the appearance of surviving lecture scripts over scrawled on printed pages, conveys a bigger fragment of this massive collective effort to communicate. This business of securing and then sustaining the attention of audiences was embodied most obviously by the lanternists themselves and the organisations they represented, which makes it imperative that we remain committed to the type of empirical research that allows us to trace them and to understand their practices in terms of distribution and exhibition. The type

of grounded, location-specific research that has sustained the work of New Cinema Historians as well as some historians of 19th-century popular science exhibition is really, I would argue, the only way we can work towards an inclusive understanding of phenomena as widespread and diverse as magic lantern shows in this period. In doing so, I would suggest, we will not only develop a more thorough historicisation of the industrialisation of human attention capture described by Tim Wu, but will also make possible an understanding of the multitude of very human motivations that occasioned it, to educate, instruct, inspire or edify – as well as to sell.

Notes

1. Jonathan Crary, *Suspensions of Perception: Attention, Spectacle, and Modern Culture* (Cambridge, MA: MIT Press, 1999).

2. Madeleine Bunting, "Disarming the Weapons of Mass Distraction", *New York Review of Books* (accessed on 5 August 2019, http://www.nybooks.com/daily/2018/03/15/disarming-the-weapons-of-mass-distraction/). Her radio essay "Are you paying attention?" is available on BBC iPlayer (accessed on 5 August 2019, https://www.bbc.co.uk/programmes/b09sqvc2).

3. Madeleine Bunting, "Escaping the Onslaught" (accessed on 5 August 2019, https://www.bbc.co.uk/programmes/b09sqz86).

4. "The Battle for Attention" (accessed on 5 August 2019, https://dma.org.uk/event/the-battle-for-attention-bristol).

5. "The Battle for Attention" (accessed on 5 August 2019, http://www.beyondreason.eu/the-battle-for-attention-more).

6. "The Battle for Attention in your Living Room" (accessed on 5 August 2019, https://www.thinkwithgoogle.com/intl/en-154/insights-inspiration/research-data/the-battle-for-attention-in-your-living-room/).

7. Tim Wu, *The Attention Merchants: The Epic Struggle to get Inside our Heads* (London: Atlantic Books, 2016): 8. For an account of the digital "attention economy", see Tiziana Terranova, "Attention, Economy and the Brain", *Culture Machine* 13 (2012): 1–19.

8. Wu, *The Attention Merchants*, 6.

9. See Terry Borton and Debbie Borton, "How Many American Lantern Shows in a Year", in Richard Crangle et al. (ed.), *Realms of Light: Uses and Perceptions of the Magic Lantern from the 17th to the 21st Century* (London: The Magic Lantern Society, 2005), 105–115; see also Stephen Herbert, "A Slice of Lantern Life: Lantern Presentations in and around Hastings in Early 1881", in ibid.: 185–192.

0. For a full account of this research, see our forthcoming book *Picture-going: Moving and Projected Image Entertainments 1820–1914*.

1. For a useful range of definitions, see John Durham Peters, "Mass Media", in W.J.T. Mitchell and Mark B.N. Hansen *(ed.), Critical Terms in Media Studies* (Chicago: University of Chicago Press, 2010): 266–279.

2. Rev. H. Bedford, "Hints on Lantern Lectures, pt 2", *The Optical Magic Lantern Journal and Photographic Enlarger*, vol. 10, no. 126 (November 1899): 132.

3. Karen Eifler, "Between Attraction and Instruction: Lantern Shows in British Poor Relief", *Early Popular Visual Culture*, vol. 8, no. 4 (2010): 363–384.

4. The collection can be seen on the Lucerna Magic Lantern Web Resource (http://lucerna.exeter.ac.uk/).

5. See, for example, Crangle's records concerning Exeter-based photographer and lanternist William Weaver Baker, among a number of others, whose slides are collected at the Royal Albert Memorial Museum (http://lucerna.exeter.ac.uk/person/index.php?language=EN&id=6004024).

6. To see a large selection of Phelps' slides digitized as part of the *A Million Pictures* project, see Lucerna (http://lucerna.exeter.ac.uk/person/index.php?language=EN&id=6004356).

17. The *A Million Pictures* UK team has found evidence for the platform endeavours of such men at the Royal Geographical Society, as detailed by Emily Hayes on the Lucerna database (http://lucerna.exeter.ac.uk/collection/index.php?language=EN&id=2500071).

18. See http://lucerna.exeter.ac.uk/collection/index.php?language=EN&id=2500064.

19. Professor F. Max Müller, "A Lecture in Defence of Lectures", *New Review*, no. 3 (August 1890): 126.

20. Importantly, it was estimated that about two thirds of extension students were women. Lawrence Goldman, *Dons and Workers: Oxford and Adult Education Since 1850* (Oxford: Oxford University Press, 1995), 76.

21. In her book on lantern use in colonial Australia and New Zealand, Elizabeth Hartrick perpetuates the "habituation" argument in relation to the lantern, suggesting of audiences that even by the 1870s and 1880s, "their attention to it dulled". My suggestion is that, while the novelty of the apparatus had certainly worn thin in Britain at this point, new strategies were also deployed, especially from the 1880s, to maintain the attentiveness of audiences, and that this explains its remarkable success. Elizabeth Hartrick, *The Magic Lantern in Colonial Australia and New Zealand* (Melbourne: Australian Scholarly Publishing, 2017), 8.

22. William James, *Talks to Teachers on Psychology: and to Students on some of Life's Ideals* (New York: Henry Holt and Company, 1916), 100.

23. Ibid.

24. See, for example, Edward Bradford Titchener, *A Primer of Psychology* [1898] (London: MacMillan and Co., 1904), 201–202.

25. James Albert Winans, *Public Speaking, Principles and Practice* (New York: The Century Co., 1916) 1. For a consideration of Winans' thinking in relation to the profession of film lecturing, see Joe Kember, "Professional Lecturing in Early British Film Shows", in Julie Brown and Annette Davison (ed.), *The Sound of the Silents in Britain* (Oxford: Oxford University Press, 2013), 19–21.

26. Winans, *Public Speaking*, 64.

27. Eifler, "Between Attraction and Instruction".

28. Watchman, "Jottlins and Tittlings", *Wrexham Advertiser* (20 October 1900): 3. For the reference see John Bunyan, *The Holy War: made by Shaddai upon Diabolus. For the Regaining of the Metropolis of the World. Or, the Losing and Taking Again of the Town on Mansoul*, edited by Roger Sharrock and James F. Forrest (Oxford: Oxford University Press, 1980), 198.

29. "Netley", *Hampshire Chronicle and General Advertiser for the South and West of England* (3 April 1909) 8.

30. For an account of the way in which temperance shows employed not only spoken narratives and lantern images, but also music and songs in a manner precisely calculated to maximise the attention and emotional commitment of audiences, see Joe Kember and Richard Crangle, "Folk Like Us: Emotional Movement from the Screen and the Platform in British Life Model Lantern Slide Sets, 1880–1910", *Fonseca, Journal of Communication* 16 (2018): 115 133.

Nadezhda Stanulevich

Magic Lantern Slides by Sergey Prokudin-Gorskii

Sergey Prokudin-Gorskii (1863–1944) photographed the Russian Empire between 1905 and 1915. On his travels through the empire, covering regions from the Grand Principality of Finland to Turkestan, he took pictures of people, religious architecture, historical sites, industry and agriculture, structures of civil engineering, public buildings, railway transportation routes, scenes at riverbanks and views of villages and cities.[1] As a photographic technician, teacher and inventor, Sergey Prokudin-Gorskii played an important role in introducing advanced aspects of photographic technology to early 20th-century Russia.[2] This chapter examines how Prokudin-Gorskii's photographs were fashioned into lantern slides and shown in his illustrated lectures. Lantern slides, and especially early processes of mechanical colour registration, I will argue, played a crucial role in the production, stabilisation, and preservation of the travel subject.

Just as in the rest of the world, common subjects in the Russian Empire changed little between 1860 and 1900: geographical subjects (including virtual travel), entertainment (including dissolving views, comic subjects, and literature), religion, temperance, statues and artworks, and education (including history and science); specifically popular in the Russian Empire were biblical stories, patriotic ceremonies, royalty, historical subjects, artworks and travel destinations.[3]

While hand-coloured lantern slides existed throughout this period, Prokudin-Gorskii was not happy with the results of applying colour manually to black-and-white photographs; he aimed to develop a process to register "natural colour" instead. As art historian Howard Leighton observes for the period from the 1840s to the 1920s: "While some lantern slides were hand-tinted, the desire for pictures in natural colours was the dream of many early photographers, and a constant challenge to their inventiveness".[4]

According to James Maxwell's theory of colour vision (published as a series of papers between 1855 and 1872), two different methods can be used to create colour in print and projection. In the additive method, the reproduction of colour is obtained by combining three beams of light coloured red, green and blue on the single image plane of a screen. The subtractive method is based on

the production of colour by filtering out the three colours, red, green and blue, from white light.

In 1874, orthochromatic photo plates were perfected by Hermann Wilhelm Vogel (1834–1898) in Berlin. The emulsion of orthochromatic photo plates was sensitive to all colours except for red. By 1906, panchromatic emulsions sensitive to all colours in the spectrum were available, which further improved picture quality when Adolf Miethe (1862–1927) and his assistant Arthur Traube (1878–1948) introduced a new class of cyanine sensitizers.[5] In 1891, Frederick Eugene Ives (1856–1937) introduced the "Photochromoscope" camera.[6] Three separate negatives of the same subject were taken in rapid succession through a red, a green and a blue filter. The resulting three black and white positive slides were transformed into negatives by contact printing. Ives introduced in 1895 the Projection Kromoskop for use with a magic lantern; this Kromoskop dissolved the three separated coloured slides into one image on the screen, creating an effect of a single, full-colour photographic image.[7]

Sergey Prokudin-Gorskii studied the additive method of colour photography at Adolf Miethe's laboratory in Berlin-Charlottenburg from 1901 to 1903. Prokudin-Gorskii created his photographs by using a camera which exposed one oblong glass negative plate three times in rapid succession through three different colour filters blue, green and red. He developed a special emulsion that hypersensitized the Ilford "red label" plates.[8]

Prokudin-Gorskii's first experiments with photography date back to summer 1892. In order to achieve good photographic clichés from drawings or paintings, Sergey Prokudin-Gorskii experimented with different processes. His first non-colour exhibits were photographs from oil paintings, which he presented at the Fifth Photography Exhibition of the Russian Imperial Technical Society in 1898. In December 1902, Prokudin-Gorskii gave the first presentation of the additive method at the general meeting of the Photographic Section of the Russian Imperial Technical Society, which met with great interest from members and received grateful applause.[9] He opened a photographic lab called Prokudin-Gorskii's Art Photomechanical Studio at the beginning of the 20th century in Saint Petersburg. The Prokudin-Gorskii's Studio was a typical printing enterprise and produced colour slides, too.

In 1906, Sergey Prokudin-Gorskii took over the editorship of *Fotograf-Liubitel'* (Amateur Photographer), a Russian monthly photographic magazine. The advertisements[10] (see Fig. 1) in *Fotograf-Liubitel'* claim that all slides were made from original colour photographs, thus not coloured by hand. Prokudin-Gorskii's Studio offered Russian and foreign views, prices being five roubles for an original slide and three roubles for a duplicate. At the same time, a set of twenty full-colour photographic postcards made by Prokudin-Gorskii cost two roubles[11] (for comparison: the monthly income of a teacher of languages and sciences during his first five years of work was 75 roubles at the time).

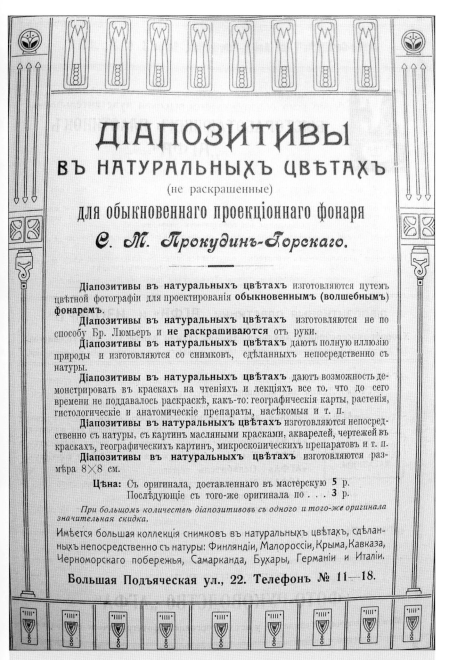

Fig. 1: Advertisements in *Fotograf-Liubitel'*, no. 9–10 (September–October 1909).

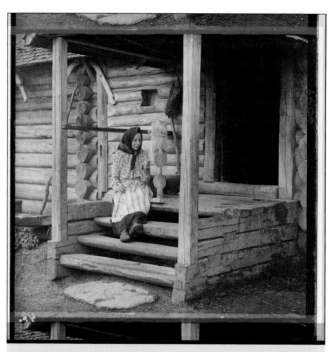

Fig. 2: Woman spinning yarn at the Izvedovo village. Sergey Prokudin-Gorskii. 1910. Digital colour composite from digital file from glass negative. Library of Congress. LC-P87- 6049 [P&P] LOT 10339.

Additional subjects were produced upon request, such as botanical and ento-mological images, maps or anatomical and histological preparations.

In the 19th century, public and private lantern shows were often put on by the photographers themselves. Sergey Prokudin-Gorskii was one of the photo-graphers who lectured about the regions he travelled, using the colour slides he had produced. His son Dmitry Prokudin-Gorskii often operated the lan-tern. A typical lantern performance began with a series of views from Turkestan (now Uzbekistan), especially from the city of Samarqand. After such an introduction, the show continued with a series of tableau scenes from Russian life (see Fig. 2) or panoramic views of nature. The main part of the show included the Ural Mountains and views from the Volga river.[12] Sergey Prokudin-Gorskii also included slides on biblical and religious themes, which he probably bought from commercial dealers, as well as those used to illustrate the parts on history and the Russian imperial family.

On the pages of *Zapiski Russkogo Tehnicheskogo Obshestva* (Bulletin of Russian Technical Society), a description of such a lantern show by Prokudin-Gorskii can be found. The projection screen was painted in white colour without blue pigments and then mounted on a black frame. A black drop-down curtain was lifted and closed for the projection of each image. For the most important show

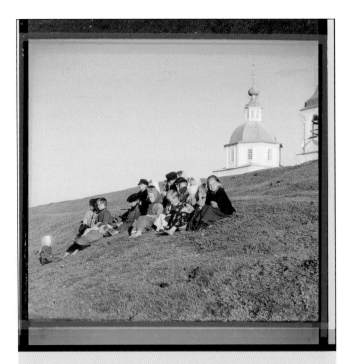

Fig. 3: Group of children. Sergey Prokudin-Gorskii. 1909. Digital colour composite from digital file from glass negative. Library of Congress. LC-P87- 5275 [P&P] LOT 10332-A.

given in 1909 for Emperor Nicolas II and the Court, the article continues, Prokudin-Gorskii had chosen

> [...] his slides very carefully, with pictures of flowers, which would have a special appeal for the Empress Alexandra; autumn landscapes having a universal beauty [...]; scenes of devoutly religious peasants, [...] and pictures of children [see Fig. 3] – the wellspring of Russia's future greatness.[13]

He had chosen a special series of pictures that served the purpose to haven an effect on his viewers. Later, in his diary, Nicolas II wrote about this day: "May 3 [1909]. Sunday. [...] In the evening Professor Prokudin-Gorsky gave an interesting report on photography in colour and showed many beautiful pictures."[14] Actually, Nicolas II was so enthusiastic that he supported Prokudin-Gorskii's project to capture all beautiful views of Russia in natural colours. So, finally, Prokudin-Gorskii had the financial means to realise his plan.

By the early 20th century, educational slides could be bought or borrowed from a variety of agencies. Prokudin-Gorskii believed in the educational potential of slides and, in 1910, he proposed the educational project *Otechestvovedenie* (Motherland study) to Vladimir Kokovtsov, Minister of Finance of the Russian Empire. This initiative was centred around the use of photographic slides in

colour photographs and colour prints. He also suggested using three-colour autotypes accompanied by text as a visual means for instruction.

In 1911, a Special Committee started to discuss the question whether the material produced as part of the educational project *Otechestvovedenie* should become State property. The Special Committee consisted of representatives of different ministries such as the Ministry of National Enlightenment, the Ministry of the Imperial Court, the Ministry of Internal Affairs, the Ministry of War, the Maritime Ministry, the Ministry of Commerce and Industry as well as representatives of religious groups and charities. In November 1911, the Special Committee concluded that the total of all schools in Russia needed 20,000 copies of the colour edition of *Otechestvovedenie*.[15] They agreed with Prokudin-Gorskii on the account that the photographic slides in colour made the teaching of Geography, Ethnography and History more accessible to the students and the general public. He had to wait however for six years for results from the negotiations and different agreements designed to promote his project and slides collection.

Sergey Prokudin-Gorskii developed more methods to produce coloured slides and obtained patents in Great Britain, USA and Russia before the First World War, and in France after 1918. From one of the patents we can derive information about the production process of colour slides. Since the second half of the 19th century, making coloured photographic slides changed from the hand-colouring of black and white slides to using additive colour photography methods and then making a glass slide like a "sandwich" or using autochromes, etc. Since 1913, colour-separated negatives exposed through red, green and blue filters were used for printing two autotype clichés to produce the Prokudin-Gorskii plates. These printing forms were made for magenta and yellow inks. Through a gelatine solution, magenta and yellow images were transferred from paper support onto one glass plate. The third part of the final slide was a cyan slide printed from a half-tone negative that had been exposed through a red filter. The last step was mounting both glass slides – the magenta and yellow one and the cyan one – together so that its result is one lantern slide. Sergey Prokudin-Gorskii wrote that in projection the slides looked like a pigment colour image.[16]

Prokudin-Gorskii began to develop colour cinematography in 1910. In August 1918, he left Petrograd for the production of colour films in Norway. He moved to England in 1919 and then to France in 1921. His documentary project was demonstrated in lectures on "Russia in Images" in different Parisian organisations in the 1930s. All pictures were black and white, though, because an additive magic lantern had to be left behind in Russia. Sergey Prokudin-Gorskii and his sons were planning to organise commercial shows, which they saw as an important educational project for Russian emigrants who started to forget about their motherland.

During his stay in London between 1919 and 1921,[17] Sergey Prokudin-Gorskii published articles and patents reviews in *The British Journal of Photography*. Here

is an important quotation from his article "Importance of Colour Photography for Schools and the Community in General":

> At the present time, when every child visits the cinema, all interest in ordinary monochrome pictures disappears, and even if the latter could be made attractive to a certain degree it aids memory very little. [...] Having shown in Russia for over ten years pictures from nature and life by means of optical colour projection in schools, and to a public of every description, I had sufficient opportunity to be convinced that with suitable explanation everything shown is assimilated with remarkable rapidity and ease and remains in the memory, if not forever, at least for very considerable time. [...] Having made myself several thousand colour photographs of Russian scenes for my projections, I was much preoccupied with the problem of ascertaining the method which could be employed for the preparation of colour diapositives from monochromatic negatives for propagation in schools, because although I could show my projections, the optical appliances were expensive and complicated, and therefore quite out of reach of the schools. [...] For the successful show at elementary schools, the following conditions are necessary: complete transparency of a picture, small cost, possibility of mass production and durability of coloured ingredients composing the picture.[18]

Having been occupied with the problem of producing colour slides, Prokudin-Gorskii came to the conclusion that the principle of three separate regions of the spectrum – i.e. the principle of three separate negatives – is the most advantageous one, because it allows a large amplitude in the ratio of exposures, and these negatives can be utilised for another very useful purpose – i.e. for optical colour projection and for reproducing colour prints typographically.[19]

Sergey Prokudin-Gorskii's notebooks speak of the history of colour photography and especially the additive method. These documents provide evidence that Prokudin-Gorskii started to use film since the second part of the 1920s. Colour films, as opposed to glass plates, began to appear by 1927, and during the next decade, at least eight different colour films were available. In the 1940s, colour negative films such as Kodachrome, from which either slides or prints could be made, were introduced. Glass slides were, of course, displaced by film-based transparencies (whether held between glass plates or not) during the 1930s and 1940s.

Conclusion

A romantic aura continues to cling to the old lantern slides, but they are, above all, a rich source of information on contemporary tastes, values and more. The Library of Congress purchased Prokudin-Gorskii's collection from the photographer's sons in 1948. This collection includes 1,902 black and white glass negatives and more than 3,100 sepia-tone prints without any slides. Fifteen black and white slides of Leo Tolstoi's Estate in Iasnaia Poliana are preserved at the Institute of Russian Literature Collection, and 24 colour slides made in the 1930s are part of the private collection of Prokudin-Gorskii's grandson, Michel Soussaline.

Sergey Prokudin-Gorskii wrote: "I am quite confident, as many thousands of colour diapositives have been made by this process and had a great success in

school".[20] Projected onto walls in darkened rooms and accompanied by Prokudin-Gorskii's words, the photographic lantern slides helped the audience to learn about different aspects of the Russian Empire. The online collection of the Library of Congress shows us that the photographs of Prokudin-Gorskii offer a vivid portrait of a lost world – the Russian Empire on the eve of the First World War.

Notes

1. Sergey Prokudin-Gorskii (1863–1944) undertook most of his famous colour documentary project from 1909 to 1915. The Library of Congress purchased the collection from the photographer's sons in 1948. See Library of Congress, "About this Collection" (https://www.loc.gov/collections/prokudin-gorskii/about-this-collection/, accessed on 1 March 2018).

2. Arthur Goldsmith, "Prokudin-Gorskii and the Photographic Tradition", in Robert H. Allshouse, *Photographs for the Tsar: The Pioneering Color Photography of Sergei Mikhailovich Prokudin-Gorskii Commissioned by Tsar Nicholas II* (London: Dial Press, 1980), 211–215.

3. N. Borisov, *Volshebnii fonar' v narodnoy shkole* [Magic lantern at the public school] (Herson, 1896).

4. Howard B. Leighton, "The Lantern Slide and Art History", *History of Photography*, no. 2 (April–June 1984): 107–118.

5. Sylvie Pénichon, *Twentieth Century Colour Photographs. The complete guide to processes, identification & preservation* (London: Thames & Hudson, 2013), 17.

6. Helmut Gernsheim, *A Concise History of Photography* (New York: Dover Publications, 1986), 27.

7. The Russian State Historical Archive, Fund 24, List 23, Item 410, 20.

8. Allshouse, *Photographs for the Tsar*, XIV.

9. *Zapiski Russkogo Tehnicheskogo Obshestva*, no. 5 (1903): 214.

10. *Fotograf-Liubitel'*, no. 9–10 (September–October 1909).

11. *Fotograf-Liubitel'*, no. 1 (January 1907).

12. The Russian State Historical Archive, Fund 1276, List 6, Item 597, 27–28.

13. Allshouse, *Photographs for the Tsar*, XV.

14. Original text in Russian; see State Archive of the Russian Federation, Fund 601, List 1, Item 254, 6. Translation in Svetlana P. Garanina, "Russian Sights in Natural Colours. The Whole Prokudin-Gorskii. 1905–1916. Catalogue of early 20th-century photographs", *Sergey Mikhailovich Prokudin-Gorskii* (Moscow: Schusev State Museum of Architecture, 2003), 7–26, here 19.

15. The Russian State Historical Archive, Fund 25, List 5, Item 381, 2–3.

16. The Russian State Historical Archive, Fund 24, List 23, Item 410, 20.

17. Svetlana P. Garanina, "From Prokudin-Gorskii's notes", *Kinovedcheskie zapiski*, no. 29 (1996): 127–131.

18. S. de Procoudine Gorsky, "Importance of Colour Photography for Schools and the Community in General", *The British Journal of Photography. Monthly Supplement on Colour Photography*, no. 161 (1920): 13–14 and 19–20, here 14.

19. Ibid., 15.

20. Ibid., 19.

Márcia Vilarigues and Vanessa Otero

Hand-Painted Magic Lantern Slides and the 19th-Century Colourmen Winsor & Newton

ultural Heritage enriches the life of citizens, contributes to the individual and shared understanding of national identity, and has a significant economic impact by attracting tourists.[1] As part of our tangible cultural heritage, historical objects play an essential role in the construction of our social memory, thus their preservation also preserves our collective past.

The magic lantern was a relevant apparatus for the projection of images. The simultaneous projection of images and use of sounds made the magic lantern an audio-visual form which was attractive for 19th-century practices of entertainment and education. Magic lanterns were used in street shows as well as in *salons* and theatres, in academies of science and art, and also by the Catholic Church to teach its doctrine.[2]

Research on magic lanterns and historical glass slides has been predominantly centred on their role as a precursor to film and cinema. This research has resulted in valuable information on social, cultural and economic relationships in the specific context of entertaining and performing arts, and has contributed to an understanding of the history and technical evolution of the apparatus and production processes.[3] Recently, awareness has arisen that the magic lantern should be perceived as a medium and a cultural phenomenon representing a distinct screen practice.[4] The socio-political contexts in which magic lanterns were used has been a topic in media historical investigations.[5] Initiatives to develop appropriate systems for cataloguing and access have produced first results (e.g. the European *A Million Pictures* project 2015–2018).[6] Despite this interest, no systematic information is available to date on the materials and techniques used in the production of magic lantern glass slides.

Until the appearance of photography (and even after) the images projected with magic lanterns were hand-painted on glass plates. This required the mastery of miniature painting on a glass substrate; since the projections magnified details and imperfections, hand-painted glass slides are considered to be miniature masterpieces in their own right.[7]

Three different techniques were used for the manufacture of the image on glass slides for projection by magic lanterns – the first were hand-painted; this gave way to printing techniques in the first half of the 19th century, and in the second

half, to photographic techniques, although the last two often included hand-colouring.[8] The images, painted in watercolour or oil, represented scenes ranging from fables and children's stories to mythological, phantasmagoria, allegorical and comic themes to current events, art works and scientific images.[9] Colour transparency was an important issue, and watercolours were generally preferred to oil, but sometimes both were used in combination.[10]

The project Lanterna Magica – Technology and Preservation of painted glass slides for projection with Magic Lanterns[11] will link the analysis of documented methods and materials used to produce painted glass slides, the reproduction of historical recipes in the laboratory and the development of preservation methodologies for existing collections.

A selected set of hand-painted glass slides from Cinemateca Portuguesa – Museu do Cinema, Museu da Imagem em Movimento and the Portuguese Research Infrastructure of Scientific Collections (PRISC), dating from the 18th to the 20th century and produced by a range of international manufacturers, constitute the corpus for the study into the materials properties. Results of Lanterna Magica will be made available at Lucerna: The Magic Lantern Web Resource.

The innovative combined approach of Lanterna Magica, to investigate the material and immaterial role of magic lantern glass slides will directly impact on their preservation, interpretation and appreciation.

The newly developed watercolours

In 1832, Henry Charles Newton founded together with William Winsor one of the most important 19th-century colourmen enterprise for artists: Winsor & Newton (W&N).[12] They made an important contribution to the art world with their improvement of watercolours: in 1835, W&N introduced moist watercolours based on the addition of glycerine.[13]

A comprehensive study of W&N's 19th-century catalogues by Leslie Carlyle established what products W&N offered throughout the 19th century: oils, mediums,[14] driers, varnishes as well as paints in powder and in oil.[15] W&N became one of the leading colourmen for artists in Britain and, by the end of the 19th century, of the world. They were committed to producing high quality products, and recent investigation supports this claim.[16]

In their catalogue of ca. 1835, W&N provided a list of their newly developed moist watercolours. In total they were selling colours "prepared in spirits, in impalpable powder, for oil or watercolour painting; also, in Bladders, finely ground in oil".[17] Throughout the 19th century, W&N's catalogues bear evidence of a continually expanding range of materials. Their ca. 1870 catalogue consists of 205 pages and includes watercolours (in diverse containers such as cakes, pans and tubes), oil colours in tubes, pigments, oils, varnishes, inks, canvas and millboards, as well as a range of brushes and painter's boxes. Their catalogues detail is also taken to inform customers of their successes, for example in their 1849 catalogue they state:

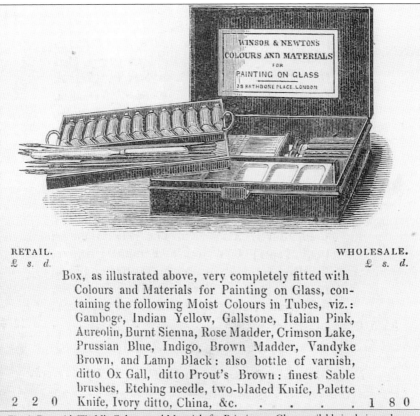

RETAIL.
£ s. d.

WHOLESALE.
£ s. d.

Box, as illustrated above, very completely fitted with Colours and Materials for Painting on Glass, containing the following Moist Colours in Tubes, viz.: Gamboge, Indian Yellow, Gallstone, Italian Pink, Aureolin, Burnt Sienna, Rose Madder, Crimson Lake, Prussian Blue, Indigo, Brown Madder, Vandyke Brown, and Lamp Black: also bottle of varnish, ditto Ox Gall, ditto Prout's Brown: finest Sable brushes, Etching needle, two-bladed Knife, Palette

2 2 0 Knife, Ivory ditto, China, &c. . . . 1 8 0

Fig. 1: Box with W&N's Colours and Materials for Painting on Glass, available in their catalogue from 1863, 28. Digital image ©Winsor & Newton (ColArt Fine Art & Graphics Ltd.). Reproduced with permission.

Fifteen years of experience has now tested the qualities of THE MOIST COLOURS, and the very large and rapidly increasing demand, as well as the very flattering Testimonials received by Messrs. Winsor & Newton from Continental and English Artists, are evidence of the high estimation in which they are held.[18]

The Winsor & Newton 19th-century Archive Database

The W&N 19th-century archive[19] is a unique primary documentary source covering handwritten formulation instructions and workshop notes for pigments, paints, grounds and varnishes, together with shop floor accounts (time and pricing for manufacturing their products). Access to these records provide insight into W&N's deep concern about the quality, durability and reliability of their products. To date, no other comprehensive historical archive of detailed instructions for the manufacture of artists' materials is available to researchers.[20] The W&N 19th-century archive has been available since 2006. It associates a computer-based indexing system with high resolution digitized images from each page of a manuscript.[21] The Researcher's Edition (RE) of the database contains 15,003 database records with 3,579 restricted records[22]

due to their commercial sensitivity at the time of its construction. Presently, the Researcher's Edition is available at five locations.[23]

W&N watercolours for magic lantern slides

Specific colours and materials by W&N for painting on glass are mentioned for the first time in their catalogue from 1863 (see Fig. 1).

Interestingly, this catalogue lists the fourth edition of *The Art of Transparent Painting on Glass* by Edward Groom, a manual on the "method of painting, and an account of the implements and materials employed in producing subjects for dissolving views, magic lanterns ... for obtaining effects of motion and colour".[24] According to Groom, the colours used for painting on glass were those "prepared for watercolour painting, and procurable in tubes" as they were "transparent, that is, through which light is transmitted".[25] The list of colours described by Groom is detailed in Table 1, together with the number of times they appear in the W&N 19th-century Archive Database. These records refer to various aspects of the preparation of the paints – from pigment manufacture to watercolour preparation (as well as diverse containers of such pans and tubes). However, the previously mentioned restrictions imposed on the Research Edition Database heavily concern records about the preparation of the watercolour paints. In the framework of the project *Lanterna Magica* it will be possible to have full access to the W&N archive including the restricted records, but also to samples from historical tubes used for painting on glass.

Table 1. List of colours used for painting on glass and their number of database records.

Colour	Number of database records (available/restricted)*
Gamboge	171/66
Italian Pink	68/9
Gallstone	4/3
Indian Yellow	102/37
Madder Lake	49/47
Crimson Lake	231/27
Prussian Blue	114/39
Indigo	89/48
Burnt Sienna	106/44
Madder Brown	139/138
Vandyke Brown	119/18
Lamp Black	83/53

*Numbers from the Research Edition Database.

Future work: the manufacture of historical glass slides

Thorough investigations of recipe books in the W&N 19th-century Archive Database[26] has produced new information regarding manufacturing processes and paint formulations, allowing reconstructions with historical appropriate materials and techniques. The accuracy of the reconstructions as reference materials has been validated by comparison showing good correlation with analysis of microsamples from historical manuscripts, paintings and artists'

materials. This work demonstrates the high impact of applying a trans-disciplinary methodology to study historical materials, triggering and supporting a growing interest in this field of research from (technical) Art History, Archaeology and Conservation as well as from contemporary artists.

As part of our work for *Lanterna Magica*, we will add to these studies by reconstructing recipes for moist watercolours, of particular importance to the studies of hand-painted glass slides. With these historically accurate reference materials, further studies will be undertaken to address the evaluation of methods for conservation and preservation. These reconstructions will also allow an assessment of the current condition of the actual glass slides and how they may have appeared originally (e.g. the extent of change that has occurred on the originals). Finally, they will be used as a material for workshops and exhibition on the production of historical glass slides and by artists for new artistic production.

With *Lanterna Magica*, we aim to deepen our understanding of the context in which historical glass slides were produced. We will trace the production of glass lantern slides from the initial preparation of the materials employed, especially of glass and paints, to the finished product. The data obtained from the analyses of the historical glass and paints will allow us to create a spatial-temporal map identifying the network of manufacturers and the technical evolution over time of this socially important medium.

Notes

1. See Cornelia Dümcke and Mikhail Gnedovsky, "Introduction", in Cornelia Dümcke and Mikhail Gnedovsky (ed.), *The Social and Economic Value of Cultural Heritage: literature review*, EENC Paper (2013), 4–8 (accessed on 27 July 2018, http://www.interarts.net/descargas/interarts2557.pdf).

2. See Isabelle Saint-Martin, "Du vitrail à la lanterne magique: le catéchisme en images", in Ségolène Le Men (ed.), *Lanternes magiques, tableaux transparents. Les dossiers du musée d'Orsay (1986–1997)*, no. 57 (Paris: Réunion des musées nationaux, 1995), 105–120; see also Donata Pesenti Campagnoni, "História da Lanterna Malográfica vulgarmente dita Lanterna Mágica", in Paolo Bertetto and Donata Pesenti Campagnoni (ed.), *A Magia da Imagem: A Arqueologia do Cinema através das Colecções do Museu Nacional do Cinema de Turim* (Lisboa: Fundação das Descobertas et al. 1996), 58–89.

3. See Laurent Mannoni and Donata Pesenti Campagnoni, *Lanterne magique et film peint: 400 ans de cinéma* (Paris: Éditions de la Martinière, 2009).

4. See Frank Gray, "*Engaging with the Magic Lantern's History*", in Ludwig Vogl-Bienek and Richard Crangle (ed.), *Screen Culture and the Social Question 1880–1914* (New Barnet: John Libbey Publishing, 2014), 173–180.

5. See Ludwig Vogl-Bienek, *Lichtspiele im Schatten der Armut. Historische Projektionskunst und soziale Frage* (Frankfurt am Main and Basel: Stroemfeld Verlag, 2016).

6. See the contribution by Francisco Javier Frutos Esteban and Carmen López San Segundo in the present volume.

7. See Francisco Javier Frutos, "From Luminous Pictures to Transparent Photographs: The Evolution of Techniques for Making Magic Lantern Slides", *The Magic Lantern Gazette*, vol. 25, no. 3 (2013): 3–11.

8. Ibid., 5–8.

9. See Pesenti Campagnoni, "*História*".

10. Frutos, "From Luminous Pictures", 3, 6.

11. For details on the project please consult: https://sites.fct.unl.pt/lanterna_magica/pages/lanterna-magica (last accessed on 5 August 2019).

12. See timeline of the company (accessed on 5 August 2019, http://www.winsornewton.com/row/discover/about-us/timeline).

13. See Rosamond D. Harley, "Background & Development of the Artist Colourmen", in Rosamond D. Harley, *A Brief History of Winsor & Newton* (Harrow: Winsor & Newton, Ltd., 1975), 3–5.

14. The term "medium" here "refers to the liquid in which the pigment is suspended to make paint" (accessed on 5 August 2019, https://www.tate.org.uk/art/art-terms/m/medium).

15. Leslie Carlyle, *The Artist's Assistant: Oil Painting Instruction Manuals and Handbooks in Britain, 1800–1900, with Reference to Selected Eighteenth-century Sources* (London: Archetype Publications, 2001).

16. See Vanessa Otero et al., "Nineteenth century chrome yellow and chrome deep from Winsor & Newton[TM]", *Studies in Conservation*, vol. 62, no. 3 (2017): 123–149; Vanessa Otero et al., "A little key to oxalate formation in oil paints: protective patina or chemical reactor?", *Photochemical & Photobiological Sciences*, no. 17 (2018): 266–270; Tatiana Vitorino et al., "Nineteenth-century cochineal lake pigments from Winsor & Newton: insight into their methodology through reconstructions", in Janet Bridgland (ed.), *ICOM-CC 18th Triennial Conference Preprints "Linking Past and Future": Copenhagen, 4–8 September 2017* (Paris: ICOM-CC, 2017), art. no. 0107.

17. Winsor & Newton Catalogue (London, ca. 1835), 28.

18. Winsor & Newton Catalogue (London 1849), 3.

19. For more information on the archive, please consult: http://webapps.fitzmuseum.cam.ac.uk/wn (last accessed on 5 August 2018).

20. See Sally A. Woodcock, "The Roberson Archive: Content and Significance", in Arie Wallert, Erma Hermens and Marja Peek (ed.), *Historical Painting Techniques, Materials, and Studio Practice*, Preprints of a Symposium Held at the University of Leiden, the Netherlands, 26–29 June 1995 (Marina Del Rey, CA: Getty Conservation Institute, 1995), 30–37 (http://www.getty.edu/conservation/publications_resources/pdf_publications/pdf/historical_paintings.pdf); Mark Clarke, "Nineteenth-century English artists' coloumen's archives as a source of technical information", in Stefanos Kroustallis et al. (ed.), *Art Technology: Sources and Methods* (London: Archetype Publications, 2008), 75–84; Leslie Carlyle et al., "A question of scale and terminology, extrapolating from past practices in commercial manufacture to current laboratory experience: the Winsor & Newton 19th century artists' materials archive database", in Janet Bridgland (ed.), *Preprints of the 16th Triennial Meeting, ICOM Committee for Conservation, Lisbon 19–23 September 2011* (Lisbon: Critério-Produção Grafica, Lda., 2011), art. no. 0102.

21. See Mark Clarke and Leslie Carlyle, "Page-image recipe databases, a new approach for accessing art technological manuscripts and rare printed sources: the Winsor & Newton archive prototype", in Isabelle Sourbès-Verger (ed.), *Preprints of the 14th Triennial Meeting, ICOM Committee for Conservation, The Hague, 12–16 September 2016, vol. I* (London: James & James, Earthscan, 2005), 24–29; Mark Clarke and Leslie Carlyle, "Page-image Recipe Databases: A New Approach to Making Art Technological Manuscripts and Rare Printed Sources Accessible", in Mark Clarke, Joyce H. Townsend, Ad Stijnman (ed.), *Art of the Past. Sources and Reconstructions* (London: Archetype Publications, 2005), 49–52.

22. It is expected that the full unrestricted edition of the database will come on-line within the near future. Contact the Hamilton Kerr Institute, Cambridge University, UK, for more information (http://www.hki.fitzmuseum.cam.ac.uk/archives/winsor-and-newton).

23. See Carlyle et al., "A question of scale and terminology". The locations are: in the Netherlands, the Rijksbureau voor Kunsthistorische Documentatie (RKD); in the UK, The Hamilton Kerr Institute, University of Cambridge; The Conservation and Technology Department, Courtauld Institute of Art, University of London; Department of Conservation, Tate Britain; and in Portugal, the Department of Conservation and Restoration, Faculty of Sciences and Technology, Nova University of Lisbon.

24. Edward Groom, *The Art of Transparent Painting on Glass* (London: Winsor & Newton, 1855), 17.

25. Ibid.

26. See Carlyle et al., "A question of scale and terminology"; Otero et al., "Nineteenth century chrome yellow", Otero et.al., "A little key to oxalate formation"; Vitorino et al., "Nineteenth-century cochineal lake pigments".

Claire Dupré la Tour

The Lantern Slide, a Fabulous Tool for Early Film Titling

Introduction

As early film history has shown, the emergence of kinematography at the turn of the 20th century has important roots in the dispositives and the world of the magic lantern. As to film projection, for example, the projectors were in fact lanterns to which a technical supplement was added: a device allowing the passage of a filmstrip in front of the lantern's light. So, film projection was in a situation in-between an established medium, i.e. the magic lantern used for projecting slides, and a new technology, i.e. the magic lantern used for the projection of moving pictures. As Rick Altman has pointed out, it took several years for film to be completely autonomous from the medium of the lantern (in the United States until around 1912–1913).[1]

Several aspects of film projection corresponded in fact to magic lantern practices. In what follows, I will be concerned with the presentation of films whose titles are projected by means of magic lantern slides and/or pronounced by a lecturer, a practice that was very important in early film exhibition. Indeed, during the first few years, films generally did not have a title printed on the filmstrip. In my contribution, I will first point out some evidence of the projection of film titles on a slide before the start of the film. And we will see how this pattern was followed by the inscription of the title on a piece of film at the beginning of the reel. This technique was a major innovation that slowly contributed to detach kinematography from magic lantern projection practices, including the presence of a lecturer.

Projecting film titles on lantern slides

The projection of film titles on magic lantern slides constituted an important dispositive in early film exhibition. Projecting texts was common in lantern programmes: educational billboards, the lyrics of songs or hymns, poems and verses from the Bible, announcements, inscriptions in drawings, or the titles of slide sets. Early moving picture exhibitors presented a variety of films, lasting generally a minute or less, often within a lantern programme. To do so, they had to use two lanterns: one to project slides and one equipped to project films. The film titles could be projected from the slides lantern, meanwhile the reel

on the other lantern was removed and replaced by the next film to be projected. The spectators would then see a succession of titles and moving pictures. This allowed for an uninterrupted projection, and thus made sure that the spectators' attention was continuously directed toward the screen. A lecturer, or the projectionist, was present to announce and comment on the film, but the projection of titles was indeed considered a mark of quality. However, handling two types of material in rapid alternation was a real challenge for the projectionist.

To project alternatively short moving image sequences and slides, one had to be quick and careful. We have an early testimony of this acrobatic exercise in the memoirs of Billy Bitzer (cameraman and projectionist at the American Mutoscope Company),[2] where he describes his first public projection in New York, on 12 October 1896. He had to operate the Biograph projector, which was still experimental, dangerous and difficult to work with, and a lantern for the titles. The program included eight or ten films on a single reel, separated by a piece of leader. He started by projecting a slide with the company's trademark, then another slide with the title of the first motion picture view, followed by the view itself. At the end of the first film, he stopped the projector on the leader in order to project the title slide of the following one using the lantern, and so on:

> Running the projector was like running a trolley car, in that it made a terrible racket. The projector was also hand-turned, like the camera. I used every resource I had, including my nose, to control the film so that it would not buckle on me. I was scared stiff and almost desperate when I realized that I would have so many different things to do – flashing titles onto the screen with a separate lantern-slide projector; watching the heat from the lamp so there would be no danger of fire; looking at the screen to keep the action smooth; and so on. I would have to use both hands, one foot, my fore-head, and my nose, and I was afraid that two eyes would not be enough.[3]

Combined slides-and-moving-pictures-projectors

Soon combined projectors were invented, which facilitated switching between slides and films. Nicholas Hiley wrote a detailed study on the various designs and technology of several such early projectors, developed first in Great Britain. He also describes the context of those inventions within the world of the magic lantern show, whose showmen needed to include a new attraction into their programmes: moving pictures.[4]

The pioneering apparatus is the *Bi-unial Cinematograph,* designed, and commercialised by John Wrench in 1897 (Fig. 1).[5]

It was possible with this machine to project a slide from the top level and a film from the bottom level. To project the slide, a shutter device was used to block the light of the film projector, the projectionist had then some time to put on another reel. Once the reel was ready to be projected, he blocked the light of the lantern above, immediately de-blocked the light of the film projector and began to crank the handle, setting the filmstrip in motion. The projectionist

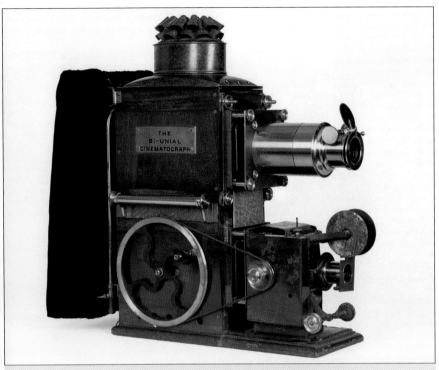

Fig. 1: Bi-unial Cinematograph, John Wrench, London, 1897.
Courtesy: Cinémathèque française Collection.

did not have to go from one machine to another anymore, which made his work a lot easier. Interestingly, the Wrench 1897 catalogue suggests the use of this combined lantern for the projection of films' title slides and describes how this works:

> The great advantage in having a Bi-unial Cinematograph is that ordinary lantern slides can be projected on the screen with the top lantern during the short intervals required for changing the films, also the names of the subjects of the films can be projected before the film is run through.[6]

At that time, several other combined lanterns were tested in the UK, a number of them using a single light source.[7] The American William B. Moore of the Stereopticon and Film Exchange in Chicago offered a model of this kind, *Stereoptigraph*, in November 1897. As Charles Musser explains:

> '[...] Stereoptigraph, a Combination Moving Picture Machine and Stereopticon. Something radically new.' While British dealers had offered this combination at an earlier date, Moore's machine was an American innovation that was promptly and widely imitated by almost every domestic manufacturer. As Lubin's advertisements for his 'Cineograph and Stereopticon Combined' explained, exhibitors wanted to be capable of interspersing slides and film in the course of a single program.[8] (see Fig. 2)

79

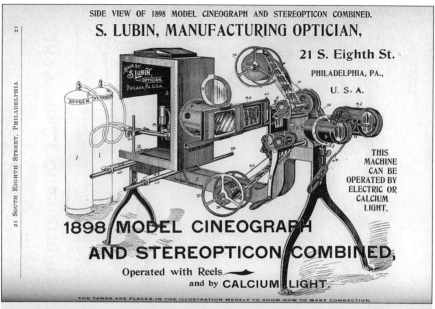

Fig. 2: Cineograph and Stereopticon Combined, 1898. Advertisement: Siegmund Lubin, Catalogue (Philadelphia 1899).

Ready-made title slides and self-made slides

Ready-made title slides could be purchased by the exhibitors from distribution or production companies. Announcements were recommended to be projected from slides as can be read in the 1903 Urban catalogue offering such slides and emphasising how they add value to the film exhibition (Fig. 3).

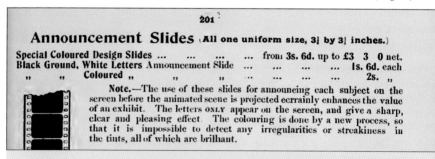

Fig. 3: The Charles Urban Trading Co. Ltd, *Film Subjects* (London, November 1903), 201.

Archives and private collectors have some examples of manufactured announcements on slides in their collections, as this one preserved by the Cinémathèque française (Fig. 4).

Images of manufactured title slides from Nicholas Hiley's collection can be seen in a text where he discusses their use and comments on Urban's "Note" quoted above.[9]

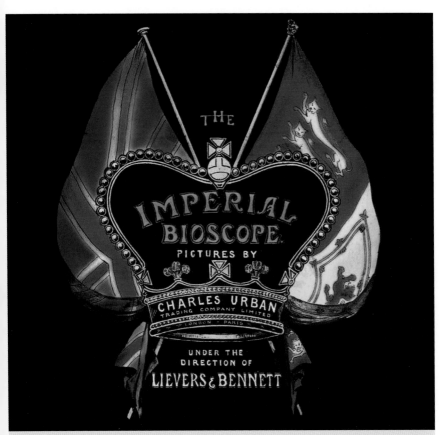

Fig. 4: Announcement slide. Courtesy: Cinémathèque française, Will Day Collection (not dated).

Fig. 5: Handmade title slide, ca. 1900, possibly for *Bataille de neige* (Pathé, 1897). Courtesy: Cinémathèque française Collection.

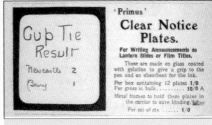

Fig. 6: Butcher and sons Catalogue (London, 1911), 98.

Exhibitors could also make their own title slides for films as the following example shows (Fig. 5).

This practice seems to have lasted for quite some time, as can be seen, for example, in a 1911 catalogue offering material to hand-write "lantern slides or film titles" (Fig. 6).

Titled films: early evidence of a major innovation in sales catalogues

Another way to facilitate title projection was to print the title on a piece of film and splice it to the beginning of the moving picture footage. Preserved copies of pre-1900 films with an original title on film are very scarce, though. Generally, those films were sold untitled. When titles were printed on the filmstrip, exhibitors could still decide to cut it off as they might prefer the lecturer and/or a title slide to announce the film. Or they could replace it by another one, according to their tastes and business interests. Exhibitors were free to do what they wanted as long as they owned the reels. With the switch from sale to rental from 1904 onward, their freedom was gradually reduced, as they had to return the reels in good shape to the exchange.[10]

Company practices concerning titles on films were not always advertised in their catalogues. The earliest catalogues known until now, which advertise titles on films, are British: an 1899 James Williamson catalogue and a 1901 Robert William Paul catalogue, slightly later, in France, a 1901 Parnaland catalogue.[11] Parnaland did not offer title slides. I will discuss here the British catalogues as they offer both titles on film *and* titles on slides. This shows the intermedial situation of moving pictures: rooted in the established lantern practices and trying at the same time to find its own way.

On its first page, the 1899 film catalogue of James Williamson stated:

> **Titles.** All films are neatly titled, and may be used for projecting where a water trough is used.[12]

Thus in 1899, apparently not all projectors were equipped with a water trough. This innovation, patented on 10 May 1897 by the Lumière brothers, functioned both as a condenser (lens) and a cooler. The patent indicated that this transparent glass container placed between the light source and the film was to protect the film from the light's heat and that it "allows the film to be halted without interrupting the lighting".[13]

The trough therefore allowed to stop the film in order to project a title. This indicates that the Williamson titles were not written on several frames, but probably only on a single one, on a piece of leader. It further suggests that the projection started with the film being stationary on the opening title, leaving time for the spectator to read it. Then the projectionist started to run the moving picture projection by cranking the handle. This system, where the projectionist decided how long a title should be projected, is quite similar to the projection of title slides. It seems that the possibility of titles to be projected as film had not yet been explored, and that the lantern model was predominant.

The catalogue specified that the films were "neatly titled", which suggests that not all films of the period were, or at least not neatly (a term which also indicates easy readability), and that these titles were designed for projection. However, the catalogue did not say that they had to be projected, but rather indicated this as a possibility ("may").

ARTISTIC TITLE SLIDES.

Nothing detracts from the effectiveness of an Animated Photograph Exhibition, more than plain, crude or badly lettered title announcements. I have therefore, made a speciality of supplying exhibitors with good title slides and have designed a special series of announcements. for my new films, an example of which is shown above. These are supplied with clear letters on a black back-ground, and tinted in suitable colours. They are found to be much appreciated by the public as a relief to the moving pictures.

Plain title slides can also be supplied for any of my films, at a nominal charge, in white letters on black ground.

Special title slides, with any wording, are made to order at the shortest notice.

"Artistic Series" of slides, tinted each		2/–
Plain title slides, from stock subjects ,,		1/–
,, ,, with special wording ,,		2/6
Portrait slides, from any non-copyright photograph ... ,,		2/6
(Additional Copies, each 1/–).		

TITLING FILMS.

When it is required to give the title of the film on the screen without the use of lantern slides, I supply short lengths of film containing photographs of any of my title slides, at the rate of 1/– per foot with a minimum charge of 5/–.

Fig. 7: *Catalogue of Paul's Animatographs and Films*
(London: R. W. Paul, 1901).

The catalogue also offered title-slides:

Title-slides. A new series of attractive slides has been prepared showing titles in ornamental designs. Price 1s. each plain. 9d. each coloured.
Any other titles specially written at the same price.[14]

These decorated titles differed from the simply "neat" titles on film advertised above. The attractiveness of the title slide is underlined. We see that slide titles could also be written to order. The slide offer implies that the title on film could be cut out, or just used as a leader.

In 1901, Robert Paul advertised in his catalogue "artistic title slides" and presented an example (Fig.7).[15]

Reading this offer, we learn that low quality slide "announcements" were produced at this time. Paul underlined his "speciality": i.e. good-quality title slides, and the creation of specially designed announcements for his new films,

all of them being also supplied on film, on demand. He emphasised the importance of contrast for legibility and declared that he could also make titles on order.

So titles on film could also be "artistic". The good-quality title on film was here explicitly linked to the title slide via a photographic process. Paul also mentioned the length of the title on film: the film projector did not need to be stopped to project the title; instead, the title was printed on consecutive frames. This was a decisive step: titles on film adopted the moving picture film format.[16]

In fact, the shift from titles on slides to the titling on filmstrips was eclectic, slow and hesitant. The development of filmed titling itself was quite erratic until at least until 1905–1906. Certain companies decided to systematically sell titled films. Pathé is a good example of this policy: although some preserved prints show that Pathé had used this technique in 1901 already, available catalogues indicate that it was in 1903 that the company started to advertise the fact that all its films were sold with good-quality filmed titles in several languages spliced to the prints. This innovation apparently was an important factor for the company's film distribution efforts on the international market, which resulted in Pathé becoming the major film producer worldwide up until the First World War.[17]

Meanwhile, the American Biograph, for example, rented its films with the service of a projectionist using only title slides until 1906. And, at least until 1912–1913, title slides continued to be projected here and there by means of combined slides and film projectors. Titles on film were to become an important part in the industrialisation of film production and projection, and opened the path to the intertitle, an indispensable tool for the development of the fiction film. The intertitle brought the lecturer's explanations on the screen, and the motion picture film detached itself from lantern practices.[18]

Conclusion

The use of titles slides for early film titling proves that the lantern was an inherent part of film projections, and that was the case for quite some time. We have seen here that the patterns of this lantern practice were the source for the titles on filmstrips and later intertitles, a decisive innovation for the development of cinema. Moreover, projecting a title by means of a slide was a way to edit on the screen a still image with moving pictures; hence this was one of the oldest, if not the first, forms of film editing. Researching title slide practices and the beginnings of filmed titles opens up a fascinating case of intermediality between the magic lantern and kinematography, and new perspectives on early film editing. Those fabulous processes deserve to be further investigated, documented and analysed.[19]

Notes

1. Rick Altman, "Technologie et textualité de l'intermédialité", *Sociétés et Représentations*, no. 9 (special issue *La croisée des médias*, edited by André Gaudreault and François Jost, 2000): 11–20.

2. The American Mutoscope Company was formed in December 1895, it became the American Mutoscope and Biograph Company from 1899, and the Biograph Company from 1909.

3. Gottfried Wilhelm Bitzer, *Billy Bitzer: His Story* (New York: Farrar, Straus, Giroux, 1973), 14.

4. Nick Hiley, "Lantern Showmen and Early Film", *The Magic Lantern*, no. 15 (June 2018): 5–7.

5. Laurent Mannoni and Donata Pesenti Campagnoni, *Lanterne magique et film peint. 400 ans de cinéma* (Paris: Cinémathèque française and Éditions de la Martinière, 2009), 254.

6. Page of the Wrench 1897 Catalogue, quoted in Hiley, "Lantern Showmen", 6.

7. For details and illustrations see ibid., 5–7.

8. Charles Musser, *The Emergence of Cinema. The American Screen to 1907* (Berkeley, Los Angeles and London: University of California Press, 1990), 258. The quotation is from the *Clipper* (13 November 1897): 617.

9. Nick Hiley, "Announcement Slides", *The Magic Lantern*, no. 13 (December 2017): 7–8.

10. See Claire Dupré la Tour, "Early Titling on Films, and Pathé's Innovative and Multilingual Strategies in 1903", in Jean-François Cornu and Carol O'Sullivan (ed.), *The Translation of Films, 1900–1950*, Proceedings of the British Academy, vol. 218 (Oxford: Oxford University Press, 2019), 60–61.

11. A. F. Parnaland, *Photographie animée. Liste des sujets*, A. F. Parnaland, 30, Rue Le Brun, Paris XIII (1901), 12: "Création de la Maison. Annonce cinématographique pour chacune des vues du présent catalogue… 3 fr. Même annonce faite spécialement sur commande par 30 lettres ou fraction… 5 fr." ("A Parnaland Creation. Cinematographic announcement for each of the views in the present catalogue… 3 francs. Same announcement made to order, per 30 letters or part thereof… 5 francs). In April 1907, the Parnaland company became the Société Française des Films et Cinématographes 'Éclair'.

12. *Williamson's Kinetograph Films. Revised to Sept., 1899. One-Minute Comedy Series. Sports and Pastimes Series. Country Series. Dances. Miscellaneous* (Brighton), 1.

13. Auguste and Louis Lumière patent, BF no. 266,870, 10 May 1897, "Brevet d'invention de 15 ans pour: 'perfectionnements aux appareils de projection pour cinématographes' […] permet de laisser stationner la pellicule sans interrompre l'éclairage".

14. *Williamson's Kinetograph Films. Revised to September, 1899*, 1.

15. Robert William Paul, *Catalogue of Paul's Animatographs and Films* (London: R. W. Paul, 1901), no page number. Page reproduced and commented on by Ian Christie, "Comparing Catalogues", in Frank Kessler and Nanna Verhoeff (ed.), *Networks of Entertainment: Early Film Distribution 1895–1915* (New Barnet: John Libbey, 2007), 212–213.

16. We might wonder why Paul's very detailed *1903 Supplement* no longer advertised this kind of titling. Was this 1901 offer not successful with clients? See *The Latest and Best in Animated Photography. Animatograph Films, Cameras, Projectors & Accessories Manufactured by R*[obt.] *W. Paul.* See also *1903 Supplement* (London: Animatograph Depot, 1903).

17. See Claire Dupré la Tour, "Des titres d'excellente qualité: enjeux et développements chez Pathé, 1903–1908", in Jacques Malthête and Stéphanie Salmon (ed.), *Recherches et innovations dans l'industrie du cinéma. Les cahiers des ingénieurs Pathé (1906–1927)* (Paris: Fondation Jérôme Seydoux-Pathé, 2017), 117–137; see also Dupré la Tour, "Early Titling on Films".

18. For an in-depth investigation into the history of film titling and the intertitle, see Claire Dupré la Tour, *Intertitre et film narratif de fiction. Genèses, développements et logiques d'un procédé filmographique, 1895–1916. L'exemple de la production aux États-Unis et le cas d'Intolerance (D. W. Griffith, 1916)*, PhD thesis, Utrecht University (2016) (https://dspace.library.uu.nl/handle/1874/331185).

19. I wish to address my special thanks to the editors of the proceedings of the *A Million Pictures* conference, Sarah Dellmann and Frank Kessler. Many thanks also to Ian Christie, Nicholas Hiley, Sabine Lenk and Laurent Mannoni for discussions, information and illustrations, and to Eric Bouchier for his technical skills in image treatment.

Lantern Slides in
Educational Contexts

Anna Grasskamp, Wing Ki Lee and Suk Mei Irene Wong

Euro-American Artefacts as Asian Heritage: Lantern Slides of the China Inland Mission at Hong Kong Baptist University Library

Missionaries who had travelled to China and images of China play an important role in the early history of the magic lantern. This is first and foremost in relation to technological advancement: as some scholars suggest, the first European projections of images painted on glass during the 1650s might have been enabled by knowledge that European missionaries derived from optical devices they saw in China.[1] Secondly, the projected images used for some of the very first projection shows in Europe illustrated the tales and findings of the missionary Martino Martini (1614–1661) who had returned from China. China was difficult to visualise for most early modern Europeans, since only explorers and ambassadors, missionaries and merchants and some very privileged members of the aristocracy had the opportunity to travel to far-away places. From the mid-19th to the early 20th century, photographic lantern slides with images of China remained an important transmitter of visual information to Euro-American audiences produced by the privileged few who could travel abroad. While lantern slides with views of China have recently begun to surface in the art market,[2] they remain neglected by art historians because of their popular nature and low status in traditional hierarchies of art. Yet, as this essay will demonstrate, they remain an invaluably rich source of ethnographic and historic information that deserves to be studied according to aesthetic criteria in the context of the histories of photography and visual anthropology.

The following essay aims to contribute to the study of lantern slides worldwide by focusing on one collection that includes 166 photographic lantern slides (some of which are hand coloured), 53 glass negatives, and 6 film negatives produced in the course of European and American missionary endeavours in China between 1900 and the 1930s. This collection has been housed at the Hong Kong Baptist University (HKBU) Library since 1998, when it was donated to the library as a gift from the Billy Graham Center Archives of Wheaton College, USA.[3] Subsequently, this collection has been catalogued, digitised and made available for teaching and research at the HKBU Library. The following section provides a brief historical overview of the processes of making, ownership and archiving of the lantern slides and the glass and film

negatives. We discuss their context and content with a special focus on aesthetic criteria and ethnographic implications. In our interpretation, the images represent an early example of visual anthropology conducted by Euro-American missionaries and are hence products of the Euro-American gaze that serve to construct, reproduce and solidify visions of "China". We argue that the aesthetics of the images also draw on artworks produced by Chinese painters and photographers, which allows us to categorise them as transcultural artefacts. As such, these images materialise and document early 20th-century Chinese history, thus participating in the construction of Asian heritage. These functions of the images were highlighted in a small educational exhibition held in 2017, which we will introduce in the last part of this chapter.

Origin and history of the slides

The photographs on the 225 lantern slides and negatives housed at the HKBU Library were taken by members of the China Inland Mission, known today as Overseas Missionary Fellowship International. By the mid-19th century, many national Protestant denominations in Europe had established Christian missionary societies for overseas evangelism.[4] James Hudson Taylor (1832–1905) founded the China Inland Mission (CIM) in England in 1865 to establish "a mission composed of men and women from different denominations who would give themselves to evangelism, church planting and the training of church leaders".[5] He left England for China in the company of his family and 16 workers in May 1866. By late 1866, 24 workers were active in four stations across inland China.[6] The first mission base was established in Hangzhou, in the province of Zhejiang.[7] As a result of China signing the Yantai Treaty, the Chinese Qing dynasty government opened all of China to foreigners in 1876, enabling the expansion of missionary work from the coastal areas (and cities such as Hangzhou) to the interior provinces and Mongolia, where no Christian mission was active at the time.[8] In 1888, James Hudson Taylor visited the United States and Canada to recruit the first cohort of CIM missionaries, which was eventually comprised of 14 members. A year later, the North America Home Council for the China Inland Mission was formed. The mission reached its zenith in 1934 with 1,368 missionaries serving at 364 stations.[9] By 1939, almost 200,000 people had been baptised in China.[10]

Missionaries began to compile visual records of their activities through photography once factory-made negatives and portable cameras were made available from the 1880s onwards.[11] They took photographs and used lantern slides in evangelistic activities, reports and publications to document their work and present Chinese culture to Western audiences. Margaret Kuo has researched the use and reception of a body of material produced by the American Passionist priest Theophane Maguire (1898–1975) in the province of Hunan from the years 1924 to 1929. She stresses the importance of lantern slides in the fundraising activities of the missionaries, who utilised them to create "affective communities" among Western viewers built on empathy and "a type

of cross-cultural sympathy".[12] Maguire's photographs feature victims of famine – among them chronically undernourished children – who look directly into the camera and, by extension, into the eyes of the viewers of a lantern slide screening.

Among the CIM slides, however, we do not find images of people who exhibit drastic marks of poverty and malnutrition. The very few examples in which children were staged to look directly into the camera include a scene in which an injured and bandaged boy appears before a backdrop of ruins, as well as a picture showing an unkempt boy dressed in rags.[13] Additionally, the collection contains three images of shipwrecks and houses destroyed by natural disasters.[14] Yet, when compared to the photographs taken by Maguire, the majority of images in the CIM collection appear ill-suited towards the creation of "affective communities". This cannot be simply explained by the circumstance that Maguire photographed in Hunan province while most of the CIM images were taken in the provinces of Guizhou, Sichuan, Jiangsu, Jiangxi and Yunnan. Rather, this contrast in affective quality was due to the fact that the CIM refused "to appeal for funds" and relied on "unsolicited contributions" instead.[15] As such, the intentions behind making the rich variety of CIM images went beyond an interest in raising funds through appealing to affect.

Motifs and aesthetics

Three main types of images can be identified in the HKBU Library China Inland Missionary archive: first, images that document the activities of the Euro-American missionaries, second, representations of Christianized spaces and missionized people in China, and third, photographs that do not provide obvious visual references to Christianity. Images of the first category that document missionary activities (e.g. a missionary preaching to Chinese children),[16] include snapshots of the missionaries and their children. At first view, these images (e.g. three portraits of missionary children playing and bathing) appear to be more suited for a private photo album than for projecting in front of a large public audience.[17] The fact that the images are presented on slides (and not on paper) indicates that they might have been used in slide shows screened by and for the missionaries in China. Yet, they could have also been shared with a larger audience to showcase that missionary children led a life according to Western standards of hygiene and pedagogy in the Chinese environment (thereby making it more attractive to young couples to join the mission). The second type of images include photographs that show Christian spaces – such as a church tent[18] – as well as missionized Chinese people expressing their Christian faith (e.g. by holding the Bible, posing in front of Bible verses or posing in the entranceways to churches).[19] Images of the third type do not provide obvious visual references that indicate the presence of missionaries in China. This group of pictures contains motifs that are comparable to those in other photographers' works, such as the photographs taken by Henry William Jackson (1843–1942). Jackson did not have a missionary

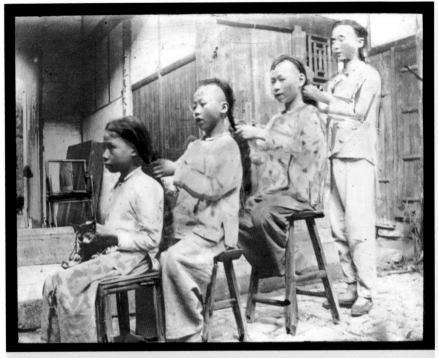

Fig. 1: Anonymous, *Making Braids*, between 1902 and 1905, China, lantern slide, glass, hand coloured, 9 x 11 cm.

background, but he travelled to Africa, Russia and Asia between 1894 and 1896 on behalf of the World's Transportation Commission.[20] The lantern slides made from the photographs that he took in China, Macao and Hong Kong show motifs that can also be observed in the CIM collection. Compare, for example, Jackson's image titled: "Outdoor hairdressing parlor"[21] with the CIM lantern slide dated to 1902–1905 entitled: "Making braids" (Fig. 1).[22] Both images have different backgrounds: Jackson's scene appears before a waterway and a ship, while the figures in the CIM slide sit in a courtyard. Yet, their main motif is the same: the open-air dressing of the long hair that made Chinese men appear so conspicuously different from that of their Western counterparts. "Making braids" is a hand coloured glass lantern slide photograph featuring four children, presumably males, who make braids for one another. The four children are arranged in an ascending order: from left to right, short to tall, seated to standing, and from youngest to eldest. Through the lens of an unidentified photographer, the visual appeal of this arrangement is reinforced through the diagonal composition of the shot. The facial expressions of the four children reveal the complicity and uncertainty of the act of photographing: the third child from the left gazes into the camera, reflecting an awareness of the photographer's presence, whilst the three other children are shown concentrating on the braiding. These visual clues give indication of how the

candidness of an everyday activity in Qing China has been staged for the camera.

Before the colour photographic slide – the autochrome – was patented in France in 1903 and factory-made colour transparencies were produced by Kodak and Agfa in the 1930s and the 1940s, coloured photographic imagery was achieved by applying pigment and paint onto black-and-white photographs. In late 19th and early 20th-century China, artisans working in photography studios were skilled in both photography and painting. Indicated by the loose brushwork and the limited range of three to four colours, the hand colouring applied to a large portion of the black-and-white CIM lantern slides did not aim to render a detailed, realistic portrayal of its subjects. In the slide "Making braids", blue is used to colour the clothes, shades of brown are applied to wooden stools, a lighter brown colours bamboo-made architectural elements, and yellow highlights the children's hair. Blue and brown are close approximates to the original colours of the photographed objects, whereas yellow is used for didactic purpose to highlight the photographed activities. A kitten that the youngest child is holding in his lap is not hand coloured, presumably to avoid distraction from the main subject. Wu Hung's research has shown that photographs of the "braid" (otherwise known as the "queue" or "pigtail") and its cutting was a popular motif during the transition from Qing China to the early Republic of China.[23] Pictorial content such as photographic imagery was a popular form of visual mass communication in the early 20th century and the "braid-making-and-cutting" motif appeared frequently in trade cards, caricatures, postcards and illustrated newspapers. The "Making braids" image in the CIM collection can be compared to other photographic representations of "braid-making-and-cutting": take for example the pictures taken ca. 1912 by the American photojournalist Francis E. Stafford (1884–1938) or, for an early example of this motif, "Barber" (ca. 1870s–1880s) taken by Lai Afong (1859?–1900), a photographer based in Hong Kong who founded one of the earliest photographic studios in China. The motif, as Roberta Wue argues, is in line with 19th-century Western ethnographic practices of racial classification. Ethnographic photography sought to make Chinese society understandable to the outsider by documenting and classifying the Chinese in terms of racial type, social status, geographical origin as well as occupation.[24]

Wearing a braid was a prevalent and culture-specific habit in the eyes of the missionaries. In Chinese and Western mainstream media, the motif of the cutting of the braid was framed as a radical visual statement that declared the destruction of a "nationalistic" and "cultured custom" which was to be replaced by markers of "Western modernity".[25] By contrast, the "Making braids" lantern slide does not show the act of cutting, but instead it showcases braiding, and as such it does not appeal to the aesthetics of sensational journalism. Sarah E. Fraser argues that the encounter with wartime China through the medium of Japanese, American and European photography is one that is characterised by

hierarchically-defined spectatorship, framed by violence and the submission of the photographed.[26] The CIM lantern slide collection provides an alternative perspective that showcases how photographic representations of early 20th-century China can reflect an ethnographic approach that is unaffected by sensationalism.

Visions of "China": The slides as an example of early visual anthropology

In addition to the representation of hairdressing scenes, Jackson's work and the CIM collection also share photographic representations of sedan chairs and different types of boats. In Jackson's project, the latter became a key component of his documentation on behalf of the World's Transportation Commission. However, in the CIM context, the pictures of transportation did not serve to document infrastructure. Instead, these images documented the trips made by the missionaries and presented scenes and motifs – such as hair dressing and "A Chinese junk"[27] – which were absorbed into a wider body of Chinese imagery that had been created and popularised by ethnographers, journalists, and photographers. Other images in the CIM collection that show "Chinese" motifs that frequently appear in Western media include representations of Canton opera actors,[28] acrobats[29] and opium smokers.[30] In the "Canton opera" image, the two "actors" shown in the photograph are costumed children posing for the camera. With no display of operatic gestures or indication of the characteristic Cantonese opera make-up, the photograph was evidently taken outside of the context of a performance. While this image appears staged, the five photographs that feature Chinese acrobats are clearly photographs taken from life. The high number of images that include Chinese acrobats and the implied prominence of these images among photographs that belong to the third type of images unrelated to Christian motifs, illustrate a special interest in this subject.

The earliest representations of Chinese acrobats in European sources can be dated back to an engraving in the illustrated travelogues of Johan Nieuhof (1618–1672).[31] His treatise forms an important source of motifs, many of which were reproduced, modified, and widely appropriated in European representations of "China" and "Chinese-style" imagery.[32] After the publication of Nieuhof's series of engravings, Chinese acrobats appeared in a variety of artworks available in Europe – among them 17th-century tiles made in Delft[33], 18th-century porcelain made in China for export to Europe,[34] engravings from the 1750s[35] as well as numerous 20th-century photographs.[36] With the "Chinese acrobat"-motif reappearing in visual records of "China" throughout the centuries, this motif is a good example of "similar representational practices and figures being repeated, with variations" creating notions of cultural "difference" and "otherness"[37] that get cemented through the ages to form stereotypes.

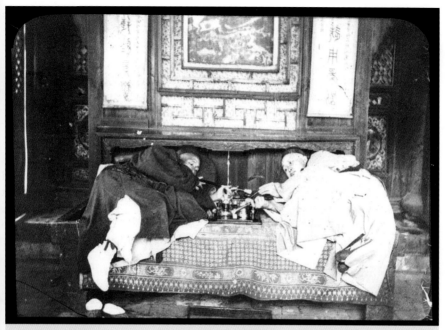

Fig. 2: Anonymous, *Two Men on an Opium Bed*, between 1902 and 1905, China, lantern slide, glass, black and white, 9 x 9 cm.

A similarly stereotypical motif, of which an example can be found in the CIM collection, is "Two men on an opium bed" (title supplied by cataloguer) (Fig. 2).[38] This black-and-white lantern slide depicts two men consuming opium in a domestic environment. The rounded corners of the black matt that mounts the photographic image suggest the architectural framing of a "house" through the use of graphics. Opium smoking is a common motif captured by Western photographers in the late 19th and early 20th centuries. Notable examples include "Opium Smoker" (ca. 1867–1872) and "Opium smoking at home – a middle class Chinese man, 1870s" taken by John Thomson (1837–1921) as well as "Opium Smokers" (ca. 1870) taken by William Saunders (1832–1892). The foreign photographs give the impression that opium smoking was a habitual activity that was essential to Chinese every-day life. This was a misrepresentation of the drug addiction, which was widespread but not om-nipresent, and only very few could afford to regularly consume the drug in the lavish environments pictured in the photographs. The skewed power dynamic between the "foreign" viewer and photographer in relation to the Chinese subject is reinforced through the representation of Chinese "otherness" and the visual consumption of a commodified Chinese body – in this case, the drugged body of the Chinese opium smoker.[39]

Frequently represented in photography, opium smokers were also a common motif in so-called "export paintings", many of which were made in China for sale to foreign merchants who brought them to Europe and the United States.[40]

Produced in Guangzhou, these paintings on plinth paper have received ample scholarly attention in recent years.[41] As we can see through the example of the CIM lantern slides, the visual composition of some early 20th-century photographs is informed by the aesthetics of these paintings. This influence is primarily evident in terms of subject matter: not only does the opium smoker motif appear in export paintings and CIM lantern slides alike, but depictions of a variety of ships and representatives of specific Chinese professions are also found in both bodies of work. An umbrella repairer,[42] a basket maker[43] and a hawker are featured in the CIM collection.[44] In "export paintings" hawkers (and representatives of other professions) are framed by a white background.[45] A blank background also appears in early Chinese photography, for example in the portrait of a street vendor staged in front of a blank studio background by the Chinese photographer Yueke Lou (active late 1800s). Although this image's "style and content unmistakably signify the Western gaze",[46] comparable photographs made in the local studios of Hong Kong and Shanghai were presumably also inspired by the motifs and aesthetics of the "export paintings", which had been produced in the same locations slightly prior to the arrival of the photographs. In this regard, the "export paintings" created by people such as the Beijing-based Zhou Peichun (active 1880–1910), who would map "reality so well that he could compete with the camera", can be seen as predecessors of photographs. Many of the motifs that Zhou (and the other painters) chose, such as "shop signs, women's hairstyles, gods and spirits, punishment and torture, work and recreation, festivals, weddings, funerals and other scenes of daily life",[47] can also be found in the CIM collection. At the same time, notable differences also exist between the imagery of the "export paintings" and the CIM lantern slides. The photograph of the hawker in the CIM collection appears to be taken on the spot as the man is staged in front of an architecturally designed wall and not before the empty space of an album page or the blank background of a studio. The CIM photographs also include glimpses of labourers at work – for example, men carrying buckets of salt or gin cotton.[48] Rather than presenting picturesque visions of "busy" people in the streets or serial representations of porcelain and tea production as per the "export paintings", the CIM collection presents images of hard physical labour, such as the process of salt extraction in the province of Sichuan, which is shown across fifteen slides. The fifteen slides form a serial documentation of the mechanical and manual work involved in the processing of salt. The photographs' seriality is reminiscent of the ways in which "export paintings" document the extraction of kaolin and the manufacturing of porcelain as well as the harvesting and processing of tea leaves in sets of twelve or more gouaches.

The CIM lantern slides bear witness to an aesthetic consciousness that falls in line with earlier visual documentations of China. This is revealed not only through the aesthetic rendering of specific motifs and the use of seriality, but also through the application of additional outer framing to some of the images. Like some of the fragile "export paintings" that were pasted on paper supports and framed with colourful lace textiles, some of the CIM lantern slides were

also provided with special masks within the material frame of the glass plates. A few of the rectangular slides were painted black to provide a circular frame around the pivotal motifs. Other slides feature flattened corners on two or all four sides. Their deliberate enhancement through painted picture frames indicates that the slides, which were primarily intended to provide visual evidence of China, were also objects of aesthetic value.

In addition to image framing, the colouring of some lantern slides provides another indicator of visual enhancement and aesthetic appreciation. The photographs taken by Felice Beato (1832–1909) form an important and widely-circulated corpus of hand-coloured photographs made in Asia.[49] Beato's photographs of Japan are carefully hand coloured, while most of his photo-graphs of China remain colourless. This puts them in line with the work of Japanese photographers such as Kusakabe Kimbei (1841–1934), whose photo-graphs are just as carefully coloured as Beato's. The application of colour was a strategy to enhance the visual appeal of the Japanese images and established an aesthetic relationship between photographs and colourful Japanese prints which had been important collector's items for centuries. Colour was an important tool in the marketing of "souvenir photographs"[50] to foreign clients. By contrast, commercial marketability does not account for the colouring of the CIM lantern slides. Distinct differences can be observed in the colour schemes used for hand colouring Japanese photographs and Chinese slides. In both cases, however, the visual function of the colouring is the same: to highlight key components of the images. In addition to aesthetic enhancement, the colouring of the CIM lantern slides also serves instructive purposes. A classic "souvenir sight" of China, the image of a temple in a landscape,[51] was painted in four colours for aesthetic enhancement, while the same colour scheme appears in the image series on salt extraction highlighting pipes and other crucial elements to facilitate a better visual understanding of the complex process. The enjoyment of visually attractive imagery and the experience of learning, entertainment and instruction were not separated from each other in the production, presentation and projection of lantern slides; consequently, the images were both appealing and easily readable in terms of the information that they convey.

With their carefully hand-coloured surfaces and their referencing of "export paintings", the CIM lantern slides qualify as transcultural artefacts. They furthermore constitute an early example of visual anthropology. The origins of visual anthropology have been traced back to the project of colonial photo-graphy between 1860 and 1920, when "the 'parallel historical trajectories' of anthropology and photography" overlapped and "the colonial project entailed an initial application of anthropological methods to an interdisciplinary project with non-academic ends, and the sensorium was implicated in the early anthropological theory that informed colonialism".[52] While the CIM mission-aries were neither colonizers nor anthropologists, their practices were strik-ingly similar to that of "early fieldworkers [who] used multiple media to collect

ethnographic materials and combined spoken words with photographs, film and sound in their public lectures".[53] Understood as part of the project of early visual anthropology, the CIM lantern slides can be interpreted as products of the Euro-American gaze which constructs, reproduces and solidifies visions of "China".

Transcultural artefacts as Asian heritage: Accessibility and re-use

In recent years, definitions of what constitutes "Chinese heritage" have undergone a number of changes. A small proportion of the artworks that were exported or looted from China during the tumultuous 19th and 20th centuries have been bought back by Chinese collectors. Porcelain items, in particular, were auctioned back into Chinese hands[54] to such a great extent that the *Financial Times* described the phenomenon as "porcelain patriotism" in 2010. A particularly prominent case of repatriation involved bronze sculpture fragments looted from a former Chinese imperial palace. After years of heated public discussion, the fragments were officially returned to China by the French Prime Minister in 2013.[55] In various ways, Asian objects have physically "travelled back" to Asia over the past two decades and reshaped what we define as "Chinese heritage" today.

The lantern slides in Hong Kong discussed in this paper are part of this larger body of Asian objects that have travelled back. Created by Euro-American makers and having never been in Asian hands prior to the donation of this collection to the HKBU Library, the slides are an uncontroversial example of Asian objects that travel back as they are devoid of market interests and not embroiled in heated political debates on questions of ownership, national identity and material heritage. Through a global network of Christianity, the slides have travelled from the Billy Graham Center Archives' Records of the United States Home Council of Overseas Missionary Fellowship (China Inland Mission) to the Archives on the History of Christianity in China at HKBU Library. Transcultural by nature, the slides have meanwhile acquired "global lives"[56] via the "China Through the Eyes of China Inland Mission Missionaries" database,[57] which has been accessible online since 2003 and allows for digital versions of the images to be downloaded.

At HKBU, the lantern slides have been used for teaching in a variety of ways, and some of them were showcased in a recent small-scale educational exhibition: *Fragile Impressions: Photographs taken in China on behalf of the China Inland Mission* held from 20 November to 14 December in 2017 at the Au Shue Hung Memorial Library, HKBU. *Fragile Impressions* presented printed reproductions of a total of 26 lantern slides, glass and film negatives as well as a few slides. The exhibition title was chosen for its dual meaning in regard to the lantern slides: *Fragile Impressions* alluded to fragility and flimsiness in terms of physical condition as well as the very fragile and ephemeral nature of the photographed. As explained in the gallery statement: "[...] many of the photographs are either printed on or enclosed by brittle glass plates, some of which are heavily

damaged. In addition, the images' motifs are 'fragile' and unstable. Many of the photographs appear to be records of everyday life and historic snapshots, but, as we see when we look more closely, were in fact staged for the camera."[58] The selected lantern slides and glass and film negatives on display were presented with two different object labels, written by students from two undergraduate courses: "The Anthropology of Art" and "Critical Studies in Lens Based Media" offered by the Academy of Visual Arts at HKBU.[59] Lectures, first-hand experience with the slides and writing workshops were provided to the students, which prepared them for an engagement with this special collection and its presentation to the public. The aim was to engage students with emic and etic viewpoints through analysis and writing. Through the emic approach, the students explored the perspective of the people depicted in the images; they created "imagined lives" based on an interpretation of the photographed body language and clothing, key objects, surroundings and attributes. Through the etic approach, the photographic perspective was examined from the standpoint of the CIM photographers who documented life in China. Each image presented in the exhibition had two object labels that illustrated these different approaches to the material as seen through the eyes of an ethnographer or as analysed with a focus on lens-based media and technology. The educational exhibition at HKBU Library not only granted public access to the CIM collection and some of its original artefacts, but it also provided an opportunity for undergraduate students to (re)view the lives and events of the CIM missionaries and engage with the early 20th-century visual construction of images of "China" through the medium of photography. The re-use of the images in the 21st-century educational context allowed for an intellectual and material re-appropriation of the CIM artefacts as part of a shared transcultural heritage.

Notes

1. Jennifer Purtle, "Scopic Frames: Devices for Seeing China circa 1640", *Art History*, vol. 33, no. 1 (2010): 54–73, 69; Craig Clunas, *Pictures and Visuality in Early Modern China* (London: Reaktion Books, 1997), 132.

2. See for example: Box 91 "Glass lantern slides with views of China", dated to ca. 1890s–1920s, recently sold by Sotheby's (accessed on 20 February 2018, http://www.sothebys.com/en/auctions/ecatalogue/2013/travel-atlases-maps-natural-history-l13405/lot.195.html).

3. For a guide to Collection 215, see Billy Graham Center Archives, "Records of the United States Home Council of Overseas Missionary Fellowship (China Inland Mission) – Collection 215" (accessed on 12 March 2018, http://www2.wheaton.edu/bgc/archives/GUIDES/215.htm#605). The collection of lantern slides and glass plate negatives housed at HKBU Library are duplicates that originated from the Billy Graham Center Archives Collection 215. The duplicates were not made by the Billy Graham Centre Archives and are assumed to have been duplicated by the China Inland Mission missionaries long ago.

4. International Mission Photography Archive (IMPA): "About" (accessed on 12 March 2018, http://digitallibrary.usc.edu/cdm/about/collection/p15799coll123).

5. Steer Roger, *J. Judson Taylor: A Man In Christ* (Wheaton, IL: Harold Shaw, 1993), 172.

6. OFM: "Timeline" (accessed on 12 March 2018, https://omf.org/us/about/our-story/timeline/).

7. Leslie T. Lyall, *A Passion for the Impossible: The China Inland Mission 1865–1965* (Chicago: Moody Press, 1965), 28.

8. Ibid., 46–49.

9. Billy Graham Center Archives, "Records of the United States Home Council of Overseas Missionary Fellowship (China Inland Mission) – Collection 215" (accessed on 12 March 2018, http://www2.wheaton.edu/bgc/archives/GUIDES/215.htm#605).

10. "Timeline" (accessed on 12 March 2018, https://omf.org/us/about/our-story/timeline/).

11. International Mission Photography Archive (IMPA): "About" (accessed on 12 March 2018, http://digitallibrary.usc.edu/cdm/about/collection/p15799coll123).

12. For the use of lantern slides with images of China in lectures by American Passionist priest Theophane Maguire (1898–1975) see Margaret Kuo, "China through the Magic Lantern: Passionist Father Theophane Maguire and American Catholic Missionary Images of China in the Early Twentieth Century", U.S. Catholic Historian, vol. 34, no. 2 (2016): 27–42.

13. Anonymous, "Survivors of a disaster", n.d., China, lantern slide, glass, black and white, 9 x 9 cm; anonymous, "A family in front of a house", between 1902 and 1905, China, lantern slide, glass, black and white, 9 x 9 cm.

14. Anonymous, "Aftermath of a disaster", n.d., China, negative, plastic, black and white, 9 x 11 cm; anonymous, "Street after flood", n.d., China, lantern slide, glass, black and white, 9 x 9 cm; anonymous, "City gate in Lan-Chi city", between 1902 and 1905, China, lantern slide, glass, black and white, 9 x 9 cm.

15. Archives Hub, "China Inland Mission Archive" (accessed on 13 March 2018, https://archiveshub.jisc.ac.uk/search/archives/4250ee66-183d-3bc3-85a5-b705bb273c9a).

16. Anonymous, "Preaching to the children", between 1902 and 1905, China, lantern slide, glass, black and white, 9 x 11 cm.

17. Anonymous, "A baby girl", n.d., negative, glass, black and white, 9 x 11 cm; anonymous, "A boy and a calf", n.d., negative, glass, black and white, 9 x 11 cm; anonymous, "Young swimmers", n.d., lantern slide, glass, black and white, 9 x 11 cm.

18. Anonymous, "A Chinese church", n.d., lantern slide, glass, hand coloured, 9 x 11 cm.

19. Anonymous, "A Christian family", n.d., China, negative, glass, black and white, 9 x 11 cm; anonymous, "Chinese Christians", n.d., China, negative, glass, black and white, 9 x 11 cm; anonymous, "Wan An Gospel Hall of the early day", between 1902 and 1905, China, negative, glass, black and white, 9 x 11 cm.

20. For an overview of Jackson's travels, refer to the database provided by the Library of Congress, Washington D.C. (accessed 28 February 2018, http://www.loc.gov/pictures/collection/wtc/itinerary.html).

21. William Henry Jackson, "Outdoor hairdressing parlor", 1895, lantern slide, glass, hand coloured, 8.25 x 10.16 cm.

22. Anonymous, "Making braids", between 1902 and 1905, China, lantern slide, glass, hand coloured, 9 x 11 cm.

23. Wu Hung, Zooming In: Histories of Photography in China (London: Reaktion Books, 2016), 84–123.

24. Roberta Wue, "Picturing Hong Kong: Photography through Practice and Function", in Roberta Wue, Joanna Waley-Cohen and Edwin K, Lai (ed.), Picturing Hong Kong: Photography 1855–1910 (New York: Asia Society Galleries & George Braziller, 1997), 42.

25. Wu Hung, Zooming in, 101.

26. Sarah E. Fraser, "The Face of China: Photography's Role in Shaping Image, 1860–1920", Getty Research Journal, no. 2 (2010): 39.

27. Anonymous, "A Chinese junk", n.d., China, lantern slide, glass, black and white, 9 x 11 cm.

28. Anonymous, "Two Chinese opera actors", n.d., China, lantern slide, glass, black and white, 9 x 9 cm.

29. Anonymous, "Chinese circus", between 1902 and 1905, China, lantern slide, glass, black and white, 9 x 9 cm; Anonymous, "Acrobats in a street", between 1902 and 1905, China, lantern slide, glass, black and white, 9 x 9 cm; three slides depicting scenes from a Chinese circus, all three titles anonymous, "Chinese circus", between 1902 and 1905, China, lantern slide, glass, black and white, 9 x 9 cm.

30. Anonymous, "Two men on an opium bed", between 1902 and 1905, China, lantern slide, glass, black and white, 9 x 9 cm.

31. Johan Nieuhof, *Het gezantschap der Neêrlandtsche Oost-Indische Compagnie, aan den grooten Tartarischen Cham, den tegenwoordigen keizer van China* (Amsterdam: Jacob van Meurs, 1665).

32. Sun Jing, "Chapter Seven: Chinoiserie Works inspired by Nieuhof's Images of China", in *The illusion of verisimilitude: Johan Nieuhof's images of China*, PhD diss. (Leiden University, 2013), 269–281.

33. Anonymous, "Plaque with chinoiserie decoration", Delft, ca. 1680, Rijksmuseum Amsterdam, BK-1971-117.

34. See for example a group of objects in the Rijksmuseum collection, among them: Anonymous, "Saucer with three Chinese acrobats and landscapes in panels", China, ca. 1775–ca. 1799, Rijksmuseum Amsterdam BK-AM-32-B-1.

35. For example: Martin Engelbrecht, *Sinesische Gauckler und Comedianten, Sinesische Trachten und Gebräuche nach jetziger beliebten Art zum ausschneiden dienlich*, Augsburg, 1740–1756, Museum für Kunst und Gewerbe, Hamburg, O1973.6.33.

36. For example from "The Hedda Morrison Photographs of China, 1933–1946", see the database *Historical Photographs of China* (accessed on 2 February 2016, https://www.hpcbristol.net/search?query=acrobats), among them: Hedda Morrison, "Acrobat performing a balancing act in front of a crowd at Tianqiao Market", Beijing, 1933–1946, Hv26–189.

37. Stuart Hall, "The Spectacle of the 'Other'", in Stuart Hall, Jessica Evans and Sean Nixon (ed.), *Representation: Cultural Representations and Signifying Practices*, 2nd edition (London: Sage Publishing, 2013), 222.

38. Anonymous, "Two men on an opium bed", between 1902 and 1905, China, lantern slide, glass, 9 x 9 cm.

39. Roberta Wue, "Picturing Hong Kong", 42–43.

40. Examples include: Anonymous, "Two poor Chinese opium smokers", gouache painting on rice-paper, 19th century, Wellcome Library no. 25053i; Tingqua (Guan Lianchang), *Album of 50 Gouache Paintings on Thick Paper*, Canton, ca. 1860 (accessed on 21 February 2018, https://www.ursusbooks.com/pages/books/139997/tingqua-tinqua/album-of-costumes-ceremonies-chinese-junks-portraits).

41. Rosalien van der Poel, *Made for Trade – Made in China. Chinese export paintings in Dutch collections: art and commodity*, PhD diss. (Leiden University, 2016); Paul A. Van Dyke and Maria Kar-wing Mok, *Images of the Canton Factories 1760–1822: Reading History in Art* (Hong Kong: Hong Kong University Press, 2015); Lee Sai Chon Jack, *China Trade Paintings: 1750s to 1880s*, PhD diss. (University of Hong Kong, 2005); Craig Clunas, *Chinese Export Art and Design* (London: Victoria and Albert Museum, 1987).

42. Anonymous, "Umbrella repairer", between 1902 and 1905, China, lantern slide, glass, hand coloured, 9 x 9 cm.

43. Anonymous, "Bamboo hamper making", between 1902 and 1905, Sichuan Sheng, China, lantern slide, glass, hand coloured, 9 x 9 cm.

44. Anonymous, "A hawker in the street", between 1902 and 1905, China, lantern slide, glass, hand coloured, 9 x 9 cm.

45. Examples can be found in Anonymous, Album of watercolours on plith depicting street traders, Kheshing studio, Honamside Canton China, mid-19th century, Caroline Simpson Library & Research Collection, Sydney Living Museums L2007/174–173; an album of 100 sheets, ca.1790, kept by Victoria and Albert Museum. See Koon Yeewan, "Narrating the City: Pu Qua and the Depiction of Street Life in *Canton* Trade Art", in Petra Chu (ed.), *Qing Encounters: Artistic Exchange between China and the West* (Los Angeles: Getty Publication, 2015).

46. The image is briefly discussed in Wu Hung, "Introduction", in Jeffrey Codey and Frances Terpak (ed.) *Brush and Shutter: Early Photography in China* (Los Angeles: Getty Publications, 2011), 8.

47. Ming Wilson, "As True as Photographs: Chinese Paintings for the Western Market", *Orientations*, vol. 31, no. 9 (2000): 91.

48. Anonymous, "Ginning cotton in Suifu", between 1902 and 1905, China, lantern slide, glass, black and white, 9 x 9 cm.

49. Anne Lacoste and Fred Ritchin, *Felice Beato: A Photographer on the Eastern Road* (Los Angeles: Getty Publications, 2010).

50. Mio Wakita, *Staging Desires: Japanese Femininity in Kusakabe Kimbei's Nineteenth-Century Souvenir Photography* (Berlin: Reimer, 2013).

51. Anonymous, "River, temple, rice fields", between 1902 and 1905, China, lantern slide, glass, hand coloured, 9 x 9 cm.

52. Sarah Pink, *The Future of Visual Anthropology: Engaging the Senses* (New York: Routledge, 2006), 5, referring to Elizabeth Edwards (ed.), *Anthropology & Photography 1860–1920* (New Haven and London: Yale University Press, 1992); see in particular Christopher Pinney, "The Parallel Histories of Anthropology and Photography", ibid., 74–95.

53. Pink, 5.

54. Tim Foster, "Perception, Illusion and Manipulation: Chinese Art at Auction", in Stacey Pierson (ed.), *Collecting Chinese Art: Interpretation and Display*, Colloquies on Art and Archaeology in Asia, no. 20 (London: Percival David Foundation, 2000), 69–81.

55. James Hevia, "Plunder, Markets, and Museums: The Biographies of Chinese Imperial Objects in Europe and North America", in Morgan Pitlka (ed.), *What's the Use of Art? Asian Visual and Material Culture in Context* (Honolulu: University of Hawaii Press, 2007), 29–141; Kristina Kleutghen, "Heads of State: Looting, Nationalism, and Repatriation of the Zodiac Bronzes", in Susan Delson (ed.), *Ai Weiwei: Circle of Animals* (New York: Prestel, 2011), 162–183.

56. Anne Gerritsen and Giorgio Riello, *The Global Lives of Things: The Material Culture of Connections in the Early Modern World* (Abingdon and New York: Routledge, 2015).

57. See *China Through the Eyes of China Inland Mission Missionaries* (accessed on 13 March 2018, http://libproject.hkbu.edu.hk/trsimage/lantern/home.html).

58. Anna Grasskamp and Lee Wing Ki, "Gallery Statement" for the exposition *Fragile Impressions: Photographs taken in China on behalf of the China Inland Mission*, Au Shue Hung Memorial Library, Hong Kong Baptist University, 20 November – 14 December 2017.

59. The two courses were taught respectively by two of the authors of this essay: "The Anthropology of Art" by Anna Grasskamp and "Critical Studies in Lens Based Media" by Lee Wing Ki in Fall 2017/18. Participating undergraduate students selected a lantern slide, glass or film negative and drafted object labels under the guidance of the instructors.

Machiko Kusahara

The Magic Lantern as an Educational Tool in Late 19th-Century Japan Seen from the "Magic Lantern Board Game on Education"

The first arrival of the magic lantern to Japan

The magic lantern was brought to feudal Japan by the Dutch in the second half of the 18th century.[1] Soon it was reproduced using wood as material and became available from opticians in Kansai (the region that includes Kyoto and Osaka).[2] A sideshow using the magic lantern was usually named "Dutch shadow play" (*Oranda kage-e*), "Dutch style Nagasaki shadow theatre", or something similar, mentioning the new technology from the West.[3] When it was shown in Ueno in downtown Edo, a kimono designer saw the sideshow and realised its potential as a new kind of entertainment. As an amateur *"Rakugo"* (humorous storytelling) performer he acquired the stage name Toraku to put his idea into practice.[4]

In 1803, Toraku started a performance, which he named *"Utsushi-e"*, meaning projected (or transferred, copied) pictures ("e"). He made original slides using his professional skills in painting. His friend, knowledgeable in "Dutch-style" chemistry, helped him find appropriate paints. Toraku's magic lantern show was a form of narrative entertainment combining the magic lantern and the traditional format of Japanese theatre such as *Kabuki* and *Bunraku*, accompanied with music.

The key technologies of *Utsushi-e* are the use of rear projection and the use of multiple mobile projectors. He chose rear projection to hide the 'magic' from the audience. The wooden projectors made of extra light-weight wood allowed him to animate the image by holding the lantern in his arms and moving it around. Toraku was probably an amateur magician as well, which explains his skills in making and operating mechanical slides to transform images.[5] The main part of the programme was usually a well-known story from *Kabuki* or another traditional entertainment that involves human conflicts with dramatic scenes. As it was a favoured entertainment for hot summer evenings, ghost stories were often chosen to 'chill' the audience. The use of multiple lanterns was essential in performing the interaction between two or more characters. With the mobile projectors, characters could be constantly in motion. Still images were projected from other lanterns on the stalls. The result was thus a

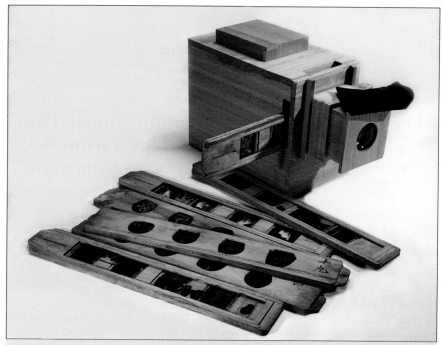

Fig. 1: This lantern (*furo*) is a modern reproduction made by the Minwa-za company for its utsushi-e performances, modified to use it with an electric lamp. Originally an oil dish or later an oil lamp was used. The original slides (*taneita*) for storytelling are from the early 20th century. Each slide has multiple images with corresponding masks and body parts to switch between different poses of a main character. Animating characters and their emotions is an essential element of Utsushi-e.

collage of picture elements on a wide screen, quite different from a Western magic lantern show.

Utsushi-e became extremely popular and was performed nationwide by showmen until around 1900. In the Kansai region it was called *"Nishiki kage-e"*, meaning colourful shadow play (Fig. 1).

The second arrival of the magic lantern

A century after its first arrival the magic lantern came to Japan for the second time as Japan opened its border to foreigners. The Meiji Restoration took place in 1868 and rapid modernisation started. The magic lantern, now called *"Gentō"* (meaning phantom lantern according to the translation from Dutch in the Edo era), was used for public lectures as an important tool of enlightenment, while stage magicians used it as well. The Ministry of Education officially introduced the magic lantern in the 1870s as an educational tool, commissioning the two photographers Nakajima Matsuchi and Tsurubuchi Hatsuzō to produce lanterns and slides to be distributed to normal schools (institutions for educating future teachers) nationwide. The project ended after a few years due to budget problems, but the two studios remained as major

suppliers of high quality lanterns and slides for professional use. As a renowned photographer Nakajima produced high quality photographic slides with precise colouring, together with finely illustrated slides painted by his wife Akio Sono, a first Western-style woman painter with academic training.[6] Another major supplier of magic lanterns and slides was Ikeda Toraku, the shop founded by the successor of the *Utsushi-e* founder.[7] The professional metal lanterns and regular size slides were used for "*Gentō-kai*" (magic lantern show) or "*Dai-gentō-kai*" (big magic lantern show) that combined slides for entertainment (such as mechanical slides and caricatures) with instructional, educational, or topical slides within a programme, concluding generally with a series of chromatrope slides. "Education" was a favoured topic for the *Gentō-kai*.

Especially Tsurubuchi was keen on the lantern's importance in the new, modern Japan, giving public lectures on education himself, writing in journals and publishing magic lantern slide sets on education. From 1886 he published pamphlets titled "*Gentō Zukai*" (magic lantern illustrated), which in this case meant the interpretation of magic lantern images. He included the list of the slides he published with explanation for each, enabling his customers to just read them when giving a lecture. For the first issue in 1886, the subtitle of the pamphlet was "Human Knowledge and Enlightenment". The second one, published in 1887, added a second subtitle "*Kyōiku Hitsuyō*", meaning "necessary for education", in smaller print. The next year, in 1888, "Human Knowledge and Enlightenment" disappeared from the cover and since then "*Kyōiku Hitsuyō*" remained its sole motto.

Around 1900, cinema gained an explosive popularity, practically putting an end to both *Utsushi-e* performances in variety theatres in the cities and *Gentō-kai* in theatres and halls. (Outside the big cities, both were still appreciated.) Medium-sized lanterns and small toy lanterns became available at a modest price, to be used in elementary school classrooms and at home. Eventually, *Gentō* was understood as "Western *Utsushi-e*", with ghosts and demons moving to small-size *Gentō* slides.

The board game as a magic lantern lecture

"*Sugoroku*" (more precisely *E-sugoroku*, meaning a game of life with pictures) is a traditional board game using a dice for multiple players. Two dozen or more images are painted in frames on a sheet of paper that can measure up to 72 cm x 72 cm. Each player proceeds from the starting point to the goal according to the numbers given by the dice. It was popular during the Edo era. Many colourful *E-sugoroku* were published using the woodblock printing technology, with topics such as *Kabuki*, literature, travel, or how to be successful as a *Samurai*.

Since the Meiji Restoration a much wider variety appeared, as *Sugoroku* became people's favourite game for the New Year holidays. Because of that, they were usually published and sold in December. Often they were attached to the New Year issue of children's magazines. Popular topics included: how to succeed in

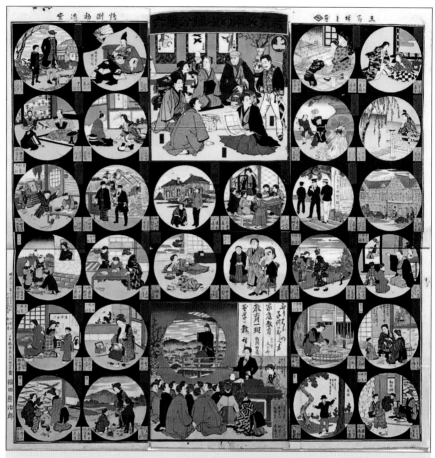

Fig. 2: *Kyōiku Hitsuyō Gentō Furiwake Sugoroku* (1889), by Tsurubuchi Hatsuzō, approx. 72 cm x 72 cm, the author's collection.

life; school life; boy's education; women's education; adventure; imagining the future, etc. Famous painters or illustrators were often hired to give the visual impressions of such topics to the customers. Kobayashi Kiyochika, a painter, woodblock artist and caricaturist, published a gorgeous large format (73 cm x 74 cm) *Sugoroku* of the Sino-Japanese War, using the magic lantern as its model.[8] Against a black background, famous scenes from the War are painted in circles as large as 12 cm in diameter. The combination of strong Japanese paper and woodblock print works well for this kind of paper toy. Another *Sugoroku* in my collection also takes the format of a magic lantern lecture, this one with the theme of health education, which was an important part of the new government's agenda in modernising the country.[9]

Tsurubuchi published a *Sugoroku* titled *"Kyōiku Hitsuyō Gentō Furiwake Sugoroku"* – a board game version of his magic lantern slide sets – in 1889.[10] Six sheets of woodblock prints on standard size Japanese paper are glued to form

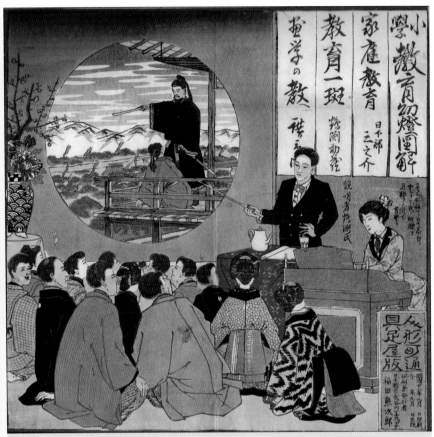

Fig. 3: Tsurubuchi Hatsuzō giving an illustrated lecture on education, from *Kyōiku Hitsuyō Gentō Furiwake Sugoroku* (1889).

a large format (approx. 72 cm x 72 cm) *Sugoroku*, in line with the technique commonly used by then. The illustrations were done by Hiroshige III (Fig. 2).

The game starts with an image of an illustrated lecture by Mr. Tsurubuchi accompanied by a lady playing an organ, the Western musical instrument newly introduced for education (Fig. 3). To a dozen of men and women who sit on *Tatami* the lecturer shows the image of a legendary emperor from ancient times, who is said to care about his people's life and who watched from his terrace if there was smoke rising from their kitchens, to know whether they had food to cook. From there the players proceed to one of the 28 images taken from Tsurubuchi's slides. The first stage is how to take care and educate young boys. Then one proceeds to elementary school, high school, university, or one moves on to acquire professional skills. The final stage presents the images of historical figures known for virtues such as loyalty, diligence, honesty, etc. The goal is a picture of four young men, probably brothers, greeting their parents at the New Year's family reunion. They are a military officer, an engineer, a merchant

Fig. 4: Yōshū Chikanobu, *A Woman Lecturer*, from the series *The Magic Lantern Projecting One's Thoughts* (1889–1891), the author's collection.

and a farmer. Apparently, these categories refer to the fixed classes in the feudal era: *Samurai*, farmer, craftsman and merchant. In the modern era education makes it possible to move to a higher class? Tsurubuchi also published a folding book (*Orihon*, a traditional style between scrolls and books) using the same images as *Sugoroku*, but with a detailed explanation of each image.

Actually, it is striking to realise that women in this game only play the role of those who help raising boys and contribute to men's success. The choice of the "starting point" and the famous historical figures show that the doctrine behind the game is surprisingly conservative. Instead of *Shogun* and feudal lords now it is the Emperor (who takes care of everyone) one should be loyal to, though. What happened to the enlightenment, which the magic lantern was supposed to contribute to? The subtitle of Tsurubuchi's first publication in 1886 that contained lectures for all, promoted "knowledge and enlightenment". What had happened in only three years?

After twenty years since the Restoration, enlightenment and the pursuit of human rights were no longer a convenient tool for the new government. The democracy movement that became active in 1880s was oppressed and ceased to exist by 1889. The Constitution of the Empire of Japan was announced that year and became effective in 1890. While there were women who actively joined the democracy movement and spoke for the equal status of women, voting rights were given only to men paying high taxes.

"The Magic Lantern Projecting One's Thoughts"

Yōshū Chikanobu was one of the most popular woodblock print artists in the Meiji era.[11] He was a *Samurai* who had fought against the Emperor's forces during the Restoration and had been captured. After he was released, he succeeded as a *Nishiki-e* (colourful woodblock prints from Edo to Meiji era, which includes *Ukiyo-e* from Edo era that deals with popular themes) artist

who knew the life in high society. He depicted elegant women in fashionable costumes (both in kimonos and in Western style clothes) at various occasions.[12] One of his series is "The Magic Lantern Projecting One's Thoughts" (*Gentō Shashin Kurabe*, 1889–1891) also known as "Daydreams by the magic lantern", each piece showing a woman and her wish.[13] So far, I have seen 19 images from the series. They depict "dreams" of women, from noblewomen to the middle-class, which are presented as magic lantern images shown behind them. Some dream to go to see *Kabuki* or other theatre plays, while others dream of the seashore or the mountainside on a hot summer day. In a piece titled "School Exam" a young girl studies at home helped by her elder sister, hoping she will graduate with a congratulatory address from the principal.

A print titled "A Woman Lecturer" shows a young woman with an image of a lady giving a public lecture from a podium, surrounded by men cheering at her talk (Fig. 4). They look like normal working class, judging from their clothes. The young woman walks on the street with a Western book under her arm. She looks determined, with her hand firmly gripping the (Western-style) umbrella. What she wears is a mixture of Western and Japanese clothes – a not-so-expensive-looking kimono on top of a shirt. A Western dog looks at her with a warm gaze. When we look at the image closely, it becomes clear that the lecturing lady is she herself, probably in the near future.

It was exactly the time when women started to speak out for democracy, for a better and more equal society and for their own rights. As in case of the temperance movement in Japan, women became involved in social movements.[14] The young lady in Chikanobu's print is probably representing a feeling that normal people shared, when the society, once aimed at enlightenment and more freedom and equality, was changing its direction toward a nationalistic and totalitarian society.

Conclusion

In understanding magic lantern culture, just researching the magic lantern is not sufficient. Both in terms of themes and formats, the magic lantern was part of a network of various media at the time. Japanese magic lantern culture offers an interesting case study in understanding how a technology (that came from the West in this case) met the existing culture and was transformed into another media form. The interplay between the magic lantern, other media, the society and the politics needs to be excavated from multiple viewpoints.

Notes

1. For more information on *Utsushi-e*, see Kobayashi Genjirō, *Utsushi-e* (Tokyo: Chūō University Press, 1987). The richly illustrated 257-page book is the most important source. For the role of the magic lantern in education, see Iwamoto Kenji, *Gento no Seiki – Eiga zennya-no shikaku bunkashi* [Centuries of Magic Lanterns in Japan] (Tokyo: Shinwasha, 2001) and Ōkubo Ryō, *Eizō no Arukeorojī: shikaku riron, kōgaku media, eizō bunka* [Archaeology of screen in early modern Japan] (Tokyo: Seikyūsha Co. Ltd., 2015).

2. It seems lenses for eyeglasses were appropriated for the purpose, as they were available either imported from China or produced in Kyoto. See Matsumoto Natsuki, "The Study of the Newly

Discovered Wooden Magic Lantern of the Edo Period: A comparison with Other Japanese Magic Lanterns", *Engeki Kenkyu*, vol. 35 (Tokyo: The Tsubouchi Memorial Theatre Museum, Waseda University, 2012), 91–113. For the slides, extremely thin glass plates were produced by blowing glass against a flat stone surface.

3. Yamamoto Keiichi, *Edo-no Kage-e Asobi* [Shadow play in the Edo era] (Tokyo: Sōshisha 1988), 138–142; see also Iwamoto, *Gento no Seiki*, 86–89.

4. In this text names of Japanese people, including their artist/stage names, are written in the Japanese order to avoid confusion. Before starting *Utsushi-e* Toraku (1779[?]–1852[?]) had been known as Kameya Kumakichi, Kameya being the name of his shop (ordinary people could not have family names). He acquired the stage name Sanshōtei Toraku as a *Rakugo* performer, but soon performed *Utsushi-e* as Miyakoya Toraku. Posthumously, he was also called Takamatsu Toraku, as his family adopted a family name. As a result, his name appears in various combinations in contemporary and later texts, but usually he was just called Toraku. Toraku II was his son-in-law. Then Toraku's former assistant and the best *Utsushi-e* slide painter (with the artist name Tokyō), Ikeda Yūkichi (or Tomokichi), inherited the title. In the original English version of Timon Screech's book there is a mistaken account on Ikeda's role in the birth of *Utsushi-e*, which he might have found in previous publications such as an article on Heibonsha Publishing's Encyclopaedia, or Furukawa Miki's *Zusetsu Shomin Geinō – Edo-no Misemono* (Tokyo: Yūzankaku Publishing, 1982), 242, which is generally a highly useful reference for the Edo era culture. See also Kobayashi, *Utsushi-e*, 17–22 and 25, and Timon Screech, *The Lens Within the Heart* (Honolulu: University of Hawai'i Press, 2002; first published in the United Kingdom, Richmond, Surrey: Curzon Press), 108.

5. Kobayashi, *Utsushi-e*, 23, 134. Yokoyama Yasuko discusses how 'magic' was integrated into visual entertainment from the 18th to the early 20th century. See Yokoyama Yasuko, *Yokai tejina no jidai* [The era of conjuring demons] (Tokyo: Seikyūsha, 2012).

6. For more detail on Tsurubuchi and Nakajima's activities including the *Sugoroku* made by Tsurubuchi, see Machiko Kusahara "Magic Lantern and its Travels", in Endo Miyuki, Erkki Huhtamo and Machiko Kusahara, *The Magic Lantern: A short history of light and shadow* (Tokyo: Tokyo Photographic Art Museum/Seikyūsha Co. Ltd., 2018), 146–149.

7. Photographic slides of Japanese scenes made by "M. Nakajima" or "T. IKEDA" were bought by foreigners who visited Japan, along with those made by Enami, the major photographic studio in Yokohama. Such slide sets functioned as a parallel to Yokohama Shashin (Yokohama photograph) sets of souvenir photographs, often sold in the form of photographic albums decorated with lacquer.

8. Kobayashi Kiyochika, *Seishin Gentō Sugoroku* [Conquest of China magic lantern *Sugoroku*], 1894, in the author's collection. The image is available from the following link: http://archive.library.metro.tokyo.jp/da/detail?tilcod=0000000004-00000254 (last accessed on 3 February 2019).

9. *Kyōiku Eisei Gentō Sugoroku* [Education and hygiene magic lantern *Sugoroku*], artist unknown, 1902.

10. The image is available from the following link: http://www.tulips.tsukuba.ac.jp/pub/picture/kaken14/lime/10088015240/10088015240.html (last accessed on 3 February 2019). *Furiwake Sugoroku* means a game of life with branching trajectories.

11. Chikanobu's true name was Hashimoto Sakutarō Naoyoshi. He went through several artist names before settling down as Yōshū Chikanobu.

12. *Ukiyo-e* functioned as today's fashion magazines. Chikanobu's *Nishiki-e* depicting women was a continuation of that tradition.

13. For more detail, see Endo et al., *The Magic Lantern*, 47–51 for the prints, 149–150 for the author's text, and 167–168 for the description of images by the author.

14. Inspired by the international temperance movement, the Fujin Kyōfūkai (literally Women's Society for Correcting the Public Morals, officially in English as Japan Christian Women's Organization, or JCWO) launched the campaign against alcoholism. The campaign resulted in legislation of prohibiting underage drinking. JCWO, which by then was named Tokyo Women's Christian Temperance Union, also succeeded in the prohibition of bigamy (traditionally men were allowed to keep concubines) and underage smoking, but had to drop the campaign for Women's suffrage. Magic lantern lectures contributed to the campaigns (see Endo et al., *The Magic Lantern*, 148–149).

Angélique Quillay

The Collection of Magic Lantern Slides from the Pennsylvania Hospital for the Insane

Named after Dr. Thomas Kirkbride, the first director of the Pennsylvania Hospital for the Insane, the Kirkbride collection of magic lantern slides was built between the early 1840s and the late 19th century. I discovered the glass objects at the History Museum of Philadelphia while researching the Pennsylvania Hospital Historic Collections, and although the museum had published a catalogue in 1992, the slides were largely forgotten and only few people knew where they were stored.[1] I had visited the exhibition *Lanterne magique et film peint* at the Cinémathèque française in 2009 and was astounded to find such a treasure in Philadelphia. Philadelphia was the Early Republic's first capital city, and a lively transatlantic trade in optical instruments began in the late 18th century.[2] Like a window open to the outside, the Kirkbride collection was part of a larger therapeutic scheme, in which light and contact with nature were essential. The long period of creation of the collection was marked by a transitional phase in the 1850s coinciding with the acquisition of the first photographic slides. Over 3,000 glass slides were preserved altogether, showing not only a material heterogeneity within the collection but also a diversity of subject matters.

This article aims at underlining the influence of the American photographers William and Frederick Langenheim on the collection's building. I will come back to the turning point that occurred in the early 1860s. First, I would like to contextualise the introduction of illustrated lectures at the Pennsylvania Hospital for the Insane and comment on a few slides dating from before 1858.

The introduction of a magic lantern and the design of a voyage around the world

In her book *Citizen Spectator: Art, Illusion, and Visual Perception in Early National America*, art historian Wendy Bellion focuses upon the exhibition rooms of Philadelphia to explore the culture of spectatorship in the Early Republic. Inspired by 18th-century Enlightenment ideals, Charles Wilson Peale founded the Philadelphia Museum in 1786. The museum held demonstrations of natural philosophy and displayed exhibits bringing nature and art to the fore: the Philadelphia Museum's "Magic Lanthorn" exhibition was thus promoted in *Poulson's American Daily Advertiser* in the early 1820s.[3] At the time, notes

Bellion, the city boasted a concentration of people interested in amateur science, and some societies developed collections of optical devices.

Thomas Kirkbride, who received a medical degree from the University of Pennsylvania in 1832, participated in the activities of Philadephia's scientific community. In the late 1830s, the Pennsylvania Hospital for the Insane was built in the countryside near Philadelphia and Thomas Kirkbride was appointed director of the institution. The director rapidly observed that the long evenings of winter in the hospital were liable to be exceedingly monotonous and declared that monotony was a subject of complaint that had to be addressed.[4] In 1844, he reported the use of a magic lantern in the hospital:

> Throughout the past and present winter, we have frequently used, during the evenings, for the same object [preventing hospital monotony], a very fine magic lanthorn. The great variety of subjects, which may be presented with a full assortment of well executed slides, makes it a very satisfactory mode of combining instruction with amusement.[5]

The physician also made arrangements for a short series of "valuable and interesting lectures by an enthusiastic naturalist".[6] The origin of the lecture series was described by Dr. Edward A. Smith a few years later in one of the rare documents that have survived:[7] "[In] 1844 was planted the germ of a course of lectures, which expanded and matured a beauteous flower, the following season, 1845–46". As the projection system was refined, the hospital's collection of slides became larger. In 1855, forty lectures were organised by the assistant physician, including new lectures on Canada and the fur trade, the Arctic Regions, the aurora borealis and Sir John Franklin's explorations. A geographical design was soon adopted, and a journey was described:

> The voyage to Liverpool gives ample scope for the introduction of much that is interesting in ocean life, the philosophy of the sea, and marine adventure of every kind. From Liverpool, the journey is continued over Great Britain and Ireland, most of the countries of Europe, the Holy Land, various parts of the Eastern World, and thence home again.[8]

Dr Kirkbride and his colleague Dr Lee used a similar format in 1857 and crafted an annual series of lectures and evening entertainments, consisting of 122 evenings over nine months. The director commented upon the content of the series, putting emphasis on the continuity of the lectures: "As will be seen by the titles of the pictures shown, this is a connected course, and, as last year, is considered as a journey, commencing in our own building and extending almost around the entire world".[9] The lecture series was designed as a voyage starting in Philadelphia in the autumn, continuing to a different place each night and returning back to the hospital at the beginning of the summer. Most of the evenings ended on a light note with a comic slide or a ritual "Good night" picture.

The objects of the collection in 1858

The collection of magic lantern slides from the Pennsylvania Hospital for the Insane offers a glimpse into that journey. The catalogue edited by the History

Museum of Philadelphia gives a complete list of the slides preserved in the Pennsylvania Hospital collection with the approximate production dates, the techniques used and sometimes the provenance of the objects. We can assume that the glass slides dating from before 1858, showing an inscription or a label with the titles identical to those in Kirkbride's report, were projected during the season of 1857–1858. The director acquired many slides from McAllister, a Philadelphia-based family business in optical goods, and some of the titles mentioned in the report are listed in *McAllister & Brother's Illustrated Catalogue of Optical, Mathematical, and Philosophical Instruments*, published in 1855.

What is remarkable in 1858 is the material heterogeneity of the hospital's collection. Hand-painted slides and engraved slides made up the majority of the collection. The attribution of many of the preserved objects is unknown, but most of the slides are of British origin. One series of astronomical slides manufactured by Carpenter & Westley dates from the 1840s. The objects bear the British opticians' label, indicating that the slides are from after 1837, when the late Philip Carpenter's firm was renamed. Philip Carpenter had developed a copperplate engraving process in the early 1820s, by means of which outline and considerable line detail were printed on the glass slides. The process facilitated high quality reproduction, yet the result also depended upon the talent of the painter. About thirty engraved slides made by the British firm in the 1850s were preserved: a series of pictures representing the Holy Land and a series of views from England and Europe. One of them, "Crystal Palace", depicts the vista of the Great Exhibition held in London in 1851.

A few hand-painted slides from the 1850s are attributed to the American William Loyd. Loyd made slides after the illustrations of the Philadelphian Dr. Elisha Kent Kane, who wrote a very popular book on his experience in the Arctic upon returning from the U.S. Grinnell expedition in search of Sir John Franklin. The preserved slides in the Kirkbride collection are marked with page numbers referring to different passages in Kane's narrative and were probably projected during the evenings dedicated to Arctic scenes. Another Loyd's slide entitled "Gate to the Pennsylvania Hospital for the Insane" shows the entrance path of the hospital and most likely started or concluded the journey proposed to the patients.

In 1858, however, most of the American-made slides in the collection were the photographic slides made by the Langenheim brothers. William (1807–1874) and Frederick (1809–1879) Langenheim were born in Germany and emigrated to the United States as young men. In the early 1840s, they opened a daguerreotype studio in the landmark Merchants' Exchange Building in Philadelphia and established an international reputation after making the first photographs of Niagara Falls.[10] When the albumen-on-glass negative process was invented by Niépce de Saint-Victor and the first details of the process were being published in 1848, the Langenheims were working on daguerreotype projection. They were inspired to use the new process of albumen-on-glass negative to print albumen-on-glass positives. Frederick

Langenheim was awarded a patent for an *Improvement in Photographic Pictures on Glass &c.*[11] in November 1850, and the photographers called their albumen-on-glass positives *hyalotypes*. The pictures were displayed at the World's Fair held in London the following year, and the official Exhibition catalogue praised the images: "The delicacy of the outlines, together with the accuracy of the detail of all photographic pictures, appears in great beauty when magnified as they are in the present instance of their application to the magic lantern".[12]

One *hyalotype* – identified as the Treasury Building in Washington, D.C. – stands out in the Kirkbride collection. The rectangular wooden frame bears a printed label with the following details: "Original view, Taken from Nature, by the Camera Obscura, By W. & F. Langenheim, No 216 Chesnut [sic] Street, between Eighth and Ninth Sts." According to the McElroy's Philadelphia Directory, the Langenheims' studio was located at 216 Chestnut Street in 1851, yet it is difficult to tell when Kirkbride acquired the slide. This *hyalotype* is one of the two oldest photographic slides in the collection. It is not perfectly preserved, and the dimensions of the frame were obviously unusual because they differ from the standardized dimensions of the later years. The title "Treasury Building" is not listed within the series of lectures of the year 1857–1858, but the second *hyalotype* dated from 1851, identified as James Dundas House in Philadelphia, was probably used.

Among the images projected during that season were also some "photographic copies of engravings, illustrating Sacred History".[13] The photographic production of magic lantern slides lent itself well to the adaptation of copied images, and many photographic slides were coloured. The slide entitled "Infant Samuel", for example, seems to be a photograph of a trade card published in England, now in the collections of the New York Public Library. The original painting by British artist James Sant is dated circa 1853. The preserved glass slide in the hospital's collection is slightly worn and shows some differences from both the original image and its reproduction.

During the year 1857–1858, one evening was dedicated to a lecture on photography. It was a transitional period for the institution, as the photographic glass slides made by the Langenheims gradually replaced the costly imported hand-painted British slides.

The Langenheim influence on the collection

The collaboration between Kirkbride and the Langenheims from the mid-1850s onwards played a key role in the growth of the slides' collection. William and Frederick Langenheim asked for patronage from various Philadelphians in 1855 to support their photographic mission between Philadelphia and Niagara Falls.[14] Among the patrons was Thomas Kirkbride. The chief physician was aware of the perspectives made possible by photography, and he later commented upon the multiple uses of the slides:

> It can readily be understood, what a scope is thus offered for an interesting course of lectures, that may be extended, almost indefinitely, and how much the

illustrations and the lectures mutually increase their separate interest. It is not simply the object pictured to the audience that is brought to their notice in the lecture, but the view may be made the text for a notice of all that is most interesting in the history of the locality, and of the individuals and events that have in any way been identified with it.[15]

In the 1860s, the firm established by the Langenheims a few years earlier – the American Stereoscopic Company – became the main provider of slides for the hospital. In 1861, the photographers published the firm's first catalogue, which offered for sale not only magic lantern slides but also stereoscopic views and microscopic photographs. The objects were classified thematically and were available at opticians in Philadelphia, New York and Boston. The introductory remarks of the catalogue include a quotation from Dr. Kirkbride, referring to the photographically produced details obtained by the Langenheims' process:

> By the process alluded to, copies of the best paintings of the old masters, and of the highest triumphs of sculpture, are as it were reproduced on the wall, of full size, while all the details of the most elaborate architecture, views of natural scenery, and likenesses of individuals, are shown with surprising accuracy.[16]

The albumen process required long exposure time, but the results were remarkable. The American Stereoscopic Company therefore specialised in the photographic reproduction of artworks. New image technologies contributed to the rise of mass production of images in the United States and the source material used by the photographers was very diverse.

American-made images were part of the source material selected by William and Frederick Langenheim. The photographers promoted American creation, and the 1861 catalogue namely includes a slide series entitled SCENES ILLUS-TRATING COOPER'S NOVELS, from the excellent SKETCHES, BY DARLEY. Between 1859 and 1861, Felix Octavious Darley was asked to illustrate James Fenimore Cooper's novels for a new complete edition, and the illustrations were reproduced with a photomechanical process. Darley was a well-known draughtsman, even more so because of the rapidly developing publishing market in the United States, and the Langenheims immediately created a coloured version of his illustrations for the magic lantern. The Pennsylvania Hospital holds half of the 32 titles listed in that series, and there were maybe more in the collection.

In 1862, the director of the hospital reported a thousand slides were on hand for the lectures and evening entertainments. In an article published in the *Philadelphia Photographer* after the end of the Civil War, Coleman Sellers, a grandson of Charles Wilson Peale and a photography amateur, points out that the collection of Langenheims' slides acquired by Kirkbride successfully magnified the entertainments. He wrote the following impressions after having attended an evening projection a few days earlier:

> The audience was a model audience, so quiet and so attentive; there were present about one hundred of the patients. Dr. Lee read to them from some book of travels in Rome, and as he read, the various scenes about which he was reading were thrown on the screen in a circle of light, eighteen feet in diameter. The dissolving

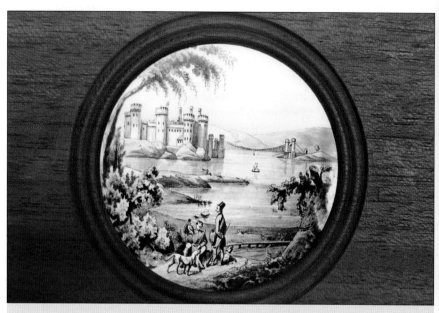

Fig. 1: "Conway Castle, England, Day".
Courtesy of the Pennsylvania Hospital Historic Collections, Philadelphia.

effect was well managed, and occasionally, during pauses of the reading, and while the pictures were being shown, music was introduced to vary the entertainment.[17]

After the Civil War, the American Stereoscopic Company published two additional catalogues, one in 1866 and the other the following year. There were no new stereoscopic views offered for sale nor were there microscopic photographs, as the Langenheims at this point decided to specialise in the production of magic lantern slides,[18] prominently advertised as "*artistically coloured*".

A new series entitled DISSOLVING PICTURES was introduced in the 1866 catalogue. We know from Kirkbride annual reports that hand-painted dissolving views were loaned every year to the institution by one of the managers of the Pennsylvania Hospital. The dissolving views contributed to the magic lantern shows' success, and the opticians McAllister & Brother particularly lauded their magical effects.[19] In the catalogue of the Langenheims' firm, the dissolving pictures series was composed of 46 numbered sets of slides made of two, three, sometimes four images. CONWAY CASTLE is the sole complete set preserved in the Pennsylvania Hospital's collection (Figs. 1 & 2). The letter attributed to each picture mentions the sequence of the images: "Conway Castle, England. Day" (42-A) and "Conway Castle, England. Moonlight effect" (42-B). The sharp contrast between the two images enlarged on the screen would have emphasized the atmosphere created by the time of the day. The brightest image showing Conway Castle during daytime dissolves into a moonlit landscape enhanced by snow and the glittering surface of the sea. The point of view remains the same and the movement goes through autumn and

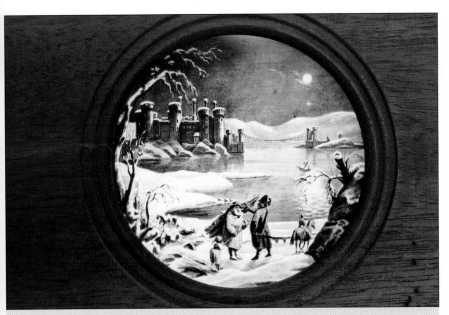

Fig. 2: "Conway Castle, England, Moonlight effect". Courtesy of the Pennsylvania Hospital Historic Collections, Philadelphia.

winter, as if time had become elastic. There is a naïve quality to these images, which is reinforced by the tiny figures in the foreground. The figures in the first scene gradually fade as the figures in the moonlit scene appear on the screen. According to the History Museum of Philadelphia, the Langenheims employed artists to create pencil and ink wash drawings, which were then photographed and coloured. These photographic slides were probably done after drawings but the Langenheims' catalogue does not mention any draughtsman's name for this series.

The Kirkbride collection was removed to the Kislak Center for Special Collections, Rare Books and Manuscripts at the University of Pennsylvania in 2015. At the heart of the collection, a group of over 120 slides produced by William and Frederick Langenheim's American Stereoscopy Company reminds us of the collaboration between Thomas Kirkbride and the two photographers, while providing an insight into the catalogues of magic lantern slides published in the United States in the 1860s. The beginnings of photographic projection constitute a transitional period for the making of magic lantern slides, which coincides with the emergence of a mass visual culture in the United States. Colour was obviously an important feature for the Langenheim brothers, and most of these glass slides were hand-painted after being photographed.

The collaboration between the Langenheims and Thomas Kirkbride enabled the growth of the Kirkbride collection. It also enlarged the content of the lecture series organised by the director of the institution and his assistants: new

subject matters like American landscapes and artwork reproductions became part of the collection and helped avoid repetition in the lecture series. The journey was meant to engage the patients' interest when days were shorter, and no evening projection was held during the summer months, as patients were invited to spend more time outdoors. The introductory lecture in the autumn of 1857 praised the action of light for the miracle annually performed by nature. The collection of magic lantern slides undoubtedly contributed to the performance.

Notes

1. Frances Gage, Carolyn Harper and Robert Eskind (ed.), *The Magic Lantern of Dr. Thomas Story Kirkbride: A Catalog of the Lantern Slides, Stereo Views and Cartes-De-Visite at the Institute of Pennsylvania Hospital* (Philadelphia, PA: Atwater Kent Museum, 1992). In the 19th century, the Institute of Pennsylvannia Hospital was known as the Pennsylvania Hospital for the Insane. Thomas Story Kirkbride (1809–1883) was the first director of the institution and a founding member of what is today known as the American Psychiatric Association.

2. Wendy Bellion, *Citizen Spectator: Art, Illusion, and Visual Perception in Early National America* (Chapel Hill: University of North Carolina Press, 2011), 32.

3. Ibid, 46.

4. Thomas Kirkbride, *Report of the Pennsylvania Hospital for the Insane for the year 1844* (Philadelphia, 1845), 26–27.

5. Ibid, 28.

6. Ibid, 30.

7. Edward Smith, *Our Lecture Room: A Lecture Introductory to the Thirteenth Annual Course of Lectures and Evening Entertainments at the Pennsylvania Hospital for the Insane* (Philadelphia, 1857), 8.

8. Thomas Kirkbride, *Report of the Pennsylvania Hospital for the Insane for the year 1857* (Philadelphia, 1858), 20–21.

9. Thomas Kirkbride, *Report of the Pennsylvania Hospital for the Insane for the year 1858* (Philadelphia, 1859), 21.

10. Georges Layne, "The Langenheims of Philadelphia", *History of Photography*, vol. 11, no. 1 (1987): 43.

11. Frederick Langenheim, "Improvement *in* Photographic Pictures *on* Glass, *&c*", U.S. Patent no. 7784 (19 November 1850).

12. *Great Exhibition of the Works of Industry of All Nations: Official Descriptive and Illustrated Catalogue* (London, 1851), 1437.

13. Thomas Kirkbride, *Report of the Pennsylvania Hospital for the Insane for the year 1858* (Philadelphia, 1859), 29–30.

14. It was on this expedition that the Langenheims created their first series of American stereoscopic views. The preserved transparencies in the hospital's collection were meant for individual viewing.

15. Kirkbride, Report, 21.

16. American Stereoscopic Company, *Catalogue of Langenheim's New and Superior Style Colored Photographic Magic Lantern Pictures — also a Catalogue of Langenheim's Stereoscopic Pictures on Glass and Paper, and Microscopic Photographs of a Superior Quality* (Philadelphia, 1861), 5.

17. Coleman Sellers, quoted in E. Borda, "Photographic Society of Philadelphia", *The Philadelphia Photographer* (Philadelphia, 1 July 1865), 19.

18. American Stereoscopic Company, *Catalogue of Langenheim's Colored Photographic Magic Lantern Pictures* (Philadelphia, 1866).

19. McAllister & Brother, *Illustrated Catalogue of Optical, Mathematical, and Philosophical Instruments, for sale by McAllister & Brother, Opticians* (Philadelphia, 1855), 21.

Teaching Science with Lantern Slides

Richard Crangle

Traces of Instructional Lantern Slide Use in Two English Cities

This chapter examines the vestigial traces of a once widespread practice, the use of the ('magic' or 'optical') lantern slide as a means of education, found in two organisations which, in different ways and for different reasons, set out to enlighten their local communities on the nature of the world around them. The two institutions described here were (and still are) dissimilar in character and scale, and their slide collections also reflect the work of quite diverse groups, yet when the content of the collections, and the contexts of the slides' original usage and acquisition, are investigated some common strands begin to appear.[1]

The slides of the Manchester Geographical Society

The Manchester Museum houses several thousand educational slides from various historical incarnations of the University of Manchester, including notable holdings on archaeology, natural history and anthropology. However, the largest identifiable group of slides, the most varied in subject matter, and probably the most interesting in its background and usage (because it was outside the academic conventions of course-based lectures mainly aimed at undergraduate students) is the surviving slide stock of the Manchester Geographical Society (MGS).

Manchester has been a major industrial and business city since the Industrial Revolution, seeing itself as a rival to London as a centre of commerce, culture and general importance, with ambitions to be taken seriously on a global scale. The MGS was very much a product of this: while not set up in direct opposition to the Royal Geographical Society in London, it aimed to equal the RGS and to present an alternative and more practical approach. Its origins lay in a conception of *commercial* geography, "the need of a knowledge of geography to secure new markets and alternative sources of raw material", not least for the city's cotton industry.[2]

The MGS was founded in 1884 by a group of businessmen and city elders, after an earlier attempt to establish a Society for Commercial Geography in 1879. The Society aspired to permanence and importance – they leased their own premises from 1894, and raised funds to construct a new building in 1905 on the same site, with a 300-seat lecture hall including a 'lantern balcony'

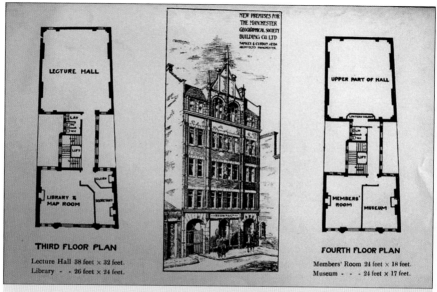

Fig. 1: New premises of the Manchester Geographical Society, 1905, showing the Lecture Hall
extending over the third and fourth floors
(MGS Archive, Manchester University Library Special Collections, MGS/14/14).

(Fig. 1). The MGS remained in that building until it was sold in 1973, partly because it needed expensive renovation, and since then has operated on a more conventional and smaller scale.[3]

The MGS ran two strands of lectures, usually with lantern slide illustration:

1. A main series of between 20 and 40 lectures per year, with free admission for Society members, plus occasional ticketed public events by celebrity lecturers – a lecture by Roald Amundsen in December 1912 made a profit of over £50 (roughly equivalent to £5,800 today), with Amundsen paid a fee of £75 (equivalent £8,100).[4]

2. A 'lecture service', offered at low cost to local institutions (schools, charities and societies) by a section of the Society named The Victorians, who also organised excursions for MGS members. The Victorians were essentially self-financing, with lecturers working unpaid and any income used to maintain the slide stock and lanterns.[5]

The first of these is, effectively, still running – the MGS still offers a regular programme of meetings and talks in Manchester city centre – while the Victorians operated until 1972, though very much reduced in scope in their last few years. The Society has clearly been successful and well organised, in surviving for over 130 years, but a recurrent theme in its published histories is that finances were always tight, and everything always depended on the hard work of a small number of dedicated members who would die at regular intervals and be difficult to replace.[6]

The MGS slide stock (Fig. 2) was used for the Society's lectures and was also available to members for loan. It was built up, in the 1890s and through the 20th century, by donations of slides made by members and by regular purchases

Fig. 2: Six lantern slides from the Manchester Geographical Society collection, including (left to right) two each by MGS members Joseph W. Price (1874–1953), Edwin Royce (1880–1946) and Charles Eastwood (1867–1953) (MGS Collection, Manchester Museum).

from the main Manchester dealers; other slides appear to have been hired from time to time as needed. The Victorians' cash books suggest that they were spending around £10 (equivalent to £1,000) per year on slides in the late 1900s and early 1910s – if that was all purchase it would suggest buying around 400 slides per year, but the figure probably represents a mixture of purchase and hire.[7] There were also donations, bequests and purchases of slide collections, particularly from some well-travelled members as they died in the 1940s and 1950s, which are still evident in the MGS collection through identifiable sub-collections.[8] The fullest extent of the collection is now hard to estimate with confidence, but around 15,000 to 20,000 slides survived until 1973.

In the 1930s there seems to have been some concern about the slide stock, probably because of the space it was taking up. The minutes of the annual meetings of the Victorians show an ongoing discussion which dragged on over several years: in March 1935, "the question of the rearrangement of the Lantern Slides, Maps etc. was adjourned",[9] and in March 1936, "owing to lack of time the question of the re-arrangement of the lantern slides and maps had again to be adjourned but the Secretary was instructed to call a further meeting at the end of April".[10] In April 1936 there was some progress:

> It was agreed that the time was due for a review of the Society's lantern slides in order to eliminate those which had ceased to be worth retaining. It was felt, however, that a slide should only be condemned on account of defects such as fading or cracking and not on account of the obsolete nature of the subject matter, as it was considered that the latter type of slide possesses a potential value which,

under certain circumstances, might be considerable. It was therefore resolved that Mr Marshman should prepare a list of sets and that the Victorians should be circularised asking for volunteers to examine one or more sets and extract slides which, in the opinion of the examiner, should be destroyed. It was considered advisable, however, that the examiners' opinions should be endorsed by a selection committee before the slides were actually destroyed.[11]

It seems that this tidying initiative didn't achieve anything very significant – which, of course, is one reason for the survival of the rich and varied resource we have to work on today. But the main reason it survives is because of a timely, but in essence accidental, intervention in the 1970s by Dr. (now Professor Emeritus) John Prag of the Archaeology Department of Manchester University.

In 1973 the MGS decided to sell its central Manchester building, which meant disposal of a lot of items: the archive includes records of furniture sold to antique dealers, books transferred to the University Library, and so on. But the slide collection was seen as having no value and was destined for the dustbin, until Dr. Prag heard that it was being abandoned, borrowed a van and, with some friends, carried about 180 boxes of slides from the empty building to the University Museum.

Unfortunately – though this was perfectly reasonable at the time, since the intention was to pass the slides on to other institutions based on their areas of interest – after arrival at the University Museum the collection was reorganised by geographical subject, which meant that the original sets and groups of slides were divided up.[12] Digitisation and cataloguing in the Lucerna Web Resource will allow some replication of the original collection structure, but this will take some years.

At the time of writing about 2,600 slides in the Manchester Museum (76% of the 3,400 images processed) have been identified as coming from the MGS collection; these are all in the standard 3¼ inch (83mm) format, approximately 48% of them being commercially-made, with the others made by private individuals. Subjects cover all parts of the world, from the familiar commercial 'a tour of …' sets, particularly focussing on the British Empire, to records made of individual journeys and/or holidays. Standards of photography, and also identification of subjects, vary greatly, and dates of production appear to run from the 1880s to at least the 1930s.

The MGS collection offers a fascinating instance of institutional slide use that would reward more detailed examination, particularly linking the surviving slides to the lists of lectures and individuals involved with the Society. Despite its size and diversity, the collection shows a pattern similar to that seen in much smaller accumulations of slides: institutional use of visual resources often appears to have depended on the initiatives of a small number of individuals, reflecting their own personal interests as much as institutional policy; and surviving materials were often assembled in a less than systematic way depending on a degree of good fortune.

Fig. 3: Six lantern slides from the Royal Albert Memorial Museum collection, covering subjects including temperance propaganda, hand-painted flowers, fungi, birds' nests and miscellaneous artefacts (Royal Albert Memorial Museum and Art Gallery, Exeter).

The slide collection of the Royal Albert Memorial Museum

Exeter is a city very different from Manchester: a historic market town, the main urban centre in a largely rural area, with (by the 19th century) limited trade links beyond its immediate region. Like all cities it exhibits a degree of civic pride and ambition, reflected in the 19th century by the desire (inspired by the success of the 1851 Great Exhibition in London) to establish institutions of learning in the city to make it a more important place and enhance the cultural lives of its citizens. Foremost among these was the Royal Albert Memorial, established in 1868 as a museum, technical college and art college. The museum element still exists under its original name (now abbreviated to RAMM); the college parts evolved independently over decades as the basis of a local further education college and the University of Exeter.

The RAMM's collection of lantern slides (Fig. 3) arises from a number of sources, some of which are typical of the preservation of such material in smaller museums:

a. Slides made in the institution for internal use (in the RAMM these were mainly for lecturing in the College part of the operation, though there are also some interior views of the museum and its exhibits);

b. Slides purchased for specific exhibitions – purchase records in the RAMM archives include slides showing wild flowers bought in 1931, and photos of Exeter-made antique silverware commissioned in 1934;

Fig. 4: Handbills for the Royal Albert Memorial Museum's free lecture programmes, seasons 1904–1905, 1908–1909 and 1914–1915 (Royal Albert Memorial Museum and Art Gallery, Exeter).

c. Slides donated by identifiable individuals, mainly as bequests from people involved with the institution in some way – in the RAMM 2,255 slides (48% of the total) come from just three private collections;

d. Slides with no clear provenance; they 'just happen to be there', probably as an accumulation of smaller donations where the local museum was seen as the best place to dump unwanted material that appeared too historic to throw away.

In the case of the slides made for internal use, this was clearly a deliberate policy by the museum/college in the early 20th century, largely the initiative of two men appointed around the turn of the century: Frederick R. Rowley, Curator of the Royal Albert Memorial Museum, and Arthur W. Clayden, Principal of the Royal Albert Memorial College.[13]

Of those two, I'll concentrate on Rowley because he was more active in using visual media for public activities. Rowley was well-received as curator of the RAMM, presented in local press accounts as a 'new broom' with fresh ideas on organising the museum and its displays, and how to use it to enhance the city's cultural life. The Museum, then as now, was owned by the city council; local press coverage suggests it was well integrated with the governance of the city, with regular participation in its activities by the Mayor and other councillors, several of whom were among regular lantern lecturers at the RAMM in the 1900s and 1910s.[14]

One of Rowley's initiatives was an annual season of free Saturday evening lectures at the museum – the first was held in the winter of 1903–1904, and the series ran annually until at least the 1930s (Fig. 4). The subjects were wide-ranging, and they were always advertised as 'fully illustrated', which generally meant lantern slides – there are a few references to illustration with diagrams or specimens, but most newspaper reviews comment on the use of

slides or give credit to a lanternist. In some cases, slides corresponding to the subject survive in the RAMM collection; sometimes there are records in the RAMM archive of slides being hired for a specific lecture; sometimes they probably belonged to the lecturer him- or herself.

One interesting feature of these lecture series lies in the identity of the lecturers. Throughout the 1900s a fair proportion of them were amateurs, in the sense that their employment was not in educational spheres, and they were talking about their hobby or spare-time activity – people like Ralph Morgan, an insurance clerk by profession but a regular lecturer on natural history subjects and the creator of some exquisitely detailed hand-painted slides still in the RAMM Collection. But also over that decade the Royal Albert Memorial College was becoming more established (it moved into a new building in around 1909) and its staff of lecturers was increasing. By the late 1900s and early 1910s many of the free lectures were delivered by lecturers employed by the College on their professional subjects – in 1908–1909 six of the eight lectures were by college staff, plus Rowley himself and one unknown, though the amateur experts from the wider local community were still in evidence at least until 1914. Many of the same names recur, especially that of Rowley himself, and the same people appear in lecture programmes of literary and historical societies from other towns in the region.

The other activity that Rowley and Clayden catalysed in Exeter was the work of amateur societies and clubs. There had been an Exeter Naturalists' Field Club since 1881, but at Clayden's instigation it was rejuvenated as the Royal Albert Memorial College Field Club and Natural History Society in 1898. A slightly later example, around 1910 and reflecting an interest in recording the 'disappearing' historical fabric of the city, was the Exeter Pictorial Record Society, again focussed around Rowley as its *animateur* and the Museum as its natural home.

Though on a smaller scale than the MGS and without its commercial overtone, I think we see a similar pattern of development in these organisations, with a small number of active individuals, some of them overlapping between several societies depending on their own personal passions. A good case in point is Alfred Rowden, a dairy manager and enthusiastic amateur naturalist with a wide range of interests including butterflies, birds and their nests, fungi, snakes, wasps and other insects, who lectured regularly to the Field Club and elsewhere.[15] He was a personal friend of most of the other naturalists and amateur scholars in the city (Rowden was an executor of Rowley's will in 1939), and acquired or inherited the slide collection of Ralph Morgan before it passed to the RAMM along with Rowden's own collection after his death in 1960.

Similar groups and individuals can be found in many, if not most, British towns and cities at this period, organising excursions and rambles, social events, and learned discussions among themselves and for the community at large. For these societies there was very little distinction between leisure and scientific work: certainly for the natural historians it was in the nature of their interests

that they made field observations of the world around, but that also provided an excuse for enjoying each other's company on boat trips, community walks and afternoon tea.

There are many complex uses of image-based media in instructional contexts, and this small survey of a very limited sample barely touches the surface of a range of practices evolving over decades. There is much work to do, even within the two cities discussed and the small group of organisations brought to light so far, and broadening that study to compare similar activities in other towns and cities, and of course other nations and regions, would help us toward a better understanding of a rich and multi-layered field. However, one underlying trait, at least in the contexts outlined above, is the dependence of this cultural area on the influence, interests, skills and activities of a small number of individuals, often working in a voluntary or amateur way. Even where the activities were organised around local institutions, those in themselves were probably catalysed by a small number of individuals.

There is plenty of primary archival material – perhaps, in some respects, even too much to contemplate – for studying and expanding our knowledge of this area, but the human dimension, emphasising the interest and enjoyment individuals found in making and sharing discoveries, is just as important. The people I have mentioned would be astonished to find that their work, important though it may have been to them, is now the subject of academic investigation. However, it's important to allow the individuals, their sometimes idiosyncratic interests, and the friendships and other connections between them, a place in the scientific discourse now largely appropriated by institutions and corporate interests. The traces that exist, not least the images they created and used, allow us to do that, and hopefully to reflect a little on the people as well as the processes represented.[16]

Notes

1. The British portion of the *A Million Pictures* project focussed on slide collections held in educational institutions in the UK, investigating the resources they now hold and the questions of how, when, and by whom these were used. Two of the main collections researched were those of the Manchester Museum, which holds between 30,000 and 50,000 slides of different origins and types, and the Royal Albert Memorial Museum and Art Gallery, Exeter, which holds an equally varied collection of some 4,700 slides.

2. Typescript summary of the history of the MGS 1884–1954, in MGS Archive (see note 3 below), GB 133 MGS/14.

3. The MGS kept meticulous records of its business, and these survive as an extensive archive including financial accounts, correspondence books, membership records and committee minutes, held in Manchester University Library Special Collections (reference GB 133 MGS). Particularly valuable is a handwritten list of all the Society's lectures from 1884 to 1965, compiled by its Secretary Nigel (T.N.L.) Brown [GB 133 MGS/14/10]. There are several published histories of the Society, in articles in its own *Journal* and a small volume by the same indefatigable Nigel Brown, Brown: T.N.L., *The History of the Manchester Geographical Society 1884–1950* (Manchester: Manchester University Press, 1971).

4. MGS financial accounts, GB 133 MGS/3/4/2, entries for 7 December 1912.

5. Comprehensive records of The Victorians' activities from the 1880s to the 1970s are in the MGS Archive, GB 133 MGS/8.

6. For 50 years from the 1880s the Society was kept running by a dynasty of just three Secretaries, all named Sowerbutts and related to each other.

7. MGS Archive, GB 133 MGS/8/2/1.

8. In particular, John W. Price (1874–1953), Charles Eastwood (1867–1953) and Edwin Royce (1880–1946), Manchester-based businessmen who travelled widely in their careers, marked their slides with names or initials, and other groups of slides can be identified from handwriting or similarities in the style of mounting or binding.

9. Victorians minute book (GB 133 MGS 8/1/1), entry for 26 March 1935.

10. Ibid., entry for 10 March 1936.

11. Ibid., entry for 30 April 1936. There is a further minute on the subject on 19 April 1937, and again on 26 January 1938 when "it was reported that comparatively little progress had been made with the examination of the slides".

12. The commercial set THE EAST COAST FROM THAMES TO TWEED (Wrench & Son, 60 slides, c. 1896), for instance, is now spread among several boxes arranged by the English counties shown.

13. Rowley (1868–1939) was appointed Curator of the RAMM in 1901 and retired in 1934; Clayden (1855–1944) was Principal of the College from 1894 until retirement in 1920.

14. The lectures were typically reviewed in local newspapers a day or two after the event, particularly in the Exeter *Express and Echo* and the *Devon and Exeter Daily Gazette*. If the accounts can be trusted as objective records, they suggest enthusiastic reception and good audiences, and also general approval of the Museum's activities under its new management after 1901.

15. As well as his regular natural history subjects, Rowden also lectured with a set of over 300 slides he created during war service in Mesopotamia in 1918–1919, a remarkable set of images which survives as slides in the RAMM Collection and a family photo album now in a private collection.

16. I am very grateful for the invaluable and generous help of the staff of Manchester Museum, especially Rachel Petts, the Royal Albert Memorial Museum, Exeter, particularly Jenny Durrant, and Manchester University Library Special Collections.

Jennifer Tucker

Making Looking:
Lantern Slides at the British Association for the Advancement of Science, 1850–1920

The study of photography in science is often associated with stories about famous individual discoveries and discoverers, focusing on uses of photography within single scientific disciplines or highlighting "decisive" moments.[1] Yet the story of the making and circulation of lantern slides in science can lead the historian in alternative directions, as the essays in this volume show.[2] First, lantern slides were made explicitly for *showing* to scientific and popular audiences of many backgrounds. Lantern slides were adopted as a common language between knowledge producers whose scientific fields were different. Put differently, critical examination of the cultural reception of scientific imagery in the 19th century is severely limited without historical examination of lantern slides. Our historical study of photographic slide making and circulation in the sciences is, therefore, necessarily interwoven with other stories about the transformation of the cultures and social and material practices of science, and the shifting historical relationships between knowledge producers and their wider audiences.[3]

This essay argues that the British Association for the Advancement of Science (BAAS), in particular, was a major institutional force shaping 19th- and early 20th-century uses and public perceptions of photographic slides in British scientific, educational and popular contexts, across disciplines. Its major premise is that the promotion of photography and photographic slides at meetings helped transform the BAAS into a leading national and even international site for the demonstration and support of practical scientific work across many emerging fields and disciplines.[4] The evidence for this claim comes from the reports of the BAAS annual meetings as well as scientific correspondence from individuals who participated in meetings and their organisation, who were themselves leaders of the major national and local scientific associations.

For years, to a great extent, the BAAS was a leading gathering point in Britain for the testing and propagation of new visual technologies and for exploring new ways of harnessing slides across a wide variety of disciplines for spreading knowledge about current scientific investigations of phenomena in nature and culture.[5] Yet despite its role and influence (e.g. on ancillary organisations, such as museums and educational committees), little has been written about its

contributions to visual culture.[6] By looking at three historical chapters in the organisation's involvement with slides and their use and dissemination – from 1850 to 1870, 1870 to 1916 and 1916 to 1920 – we may trace some of the changing social and material practices that were associated with image-making and display in and beyond Britain during years of major changes in the definition of science and its public meanings.[7] This is part of a larger project in recovering historical meanings of photographic circulation in a variety of evidentiary domains.[8]

The "New Atlantis"

Around 1900 few scientific organizations in the world could boast as long, active and diverse a career supporting interdisciplinary and inter-regional visual methods of scientific inquiry as the British Association for the Advancement of Science. Founded in 1831 by members of Britain's natural philosophy community as a way to energise and organise science across the nation, especially in the northern industrial areas outside Oxbridge and London, the BAAS was called the "New Atlantis" (a reference to an incomplete utopian novel by 17th-century natural philosopher Francis Bacon, in which Bacon portrayed a vision of the future of human discovery and knowledge).[9]

The BAAS's annual meetings around Britain were widely acknowledged as being sites where scientific encounters and exchanges around different knowledge systems in science occurred. As William Robert Grove had forecast at the BAAS meeting in Nottingham in 1866: The "greatest advantage" of annual visits of BAAS to different locales was that "while it imparts fresh local knowledge to the visitors, it leaves behind stimulating memories [...] an effect which, so far from ceasing with the visit of the Association, frequently begins when that visit terminates".[10]

The BAAS regularly attracted to its annual meetings amateur science enthusiasts and popularisers, science teachers, curators of science museums and scientific instrument makers as well as professional scientists. The Association's spokespeople were the leading "men of science" of their day, many of them also photographers (such as John Herschel and David Brewster, for example) who were disgruntled about how the Royal Society was being managed: how, for example, the Royal Society membership was seemingly filled with people whose only qualification was their wealth, which gave them access to networks and, in some cases, scientific instruments. Natural philosophers in the BAAS thought that in a rapidly industrialising nation, there was a social need for practical knowledge – one that could be addressed by both professionals and amateurs.[11] Its records are an especially valuable source, therefore, for better understanding the variety of different specific ways that people in the 19th and early 20th century consumed and produced visual technologies.[12]

Across a wide range of scientific fields and disciplines, therefore, from natural history and meteorology to experimental physics, physiology and archaeology,

the BAAS provided support for pioneering photographic experiments, advocated for new graphic methods in teaching, sponsored public exhibitions of illustrated popular scientific lectures, and generally helped shape the meaning and use of lantern slides in scientific and popular visual culture.[13] The BAAS's concept of "scientific method" as distinctly *visual* (e.g. rooted in observation and representation) was central both to its public identity and to its practical ways of working: shaping how its members engaged with amateur scientific participation, industry-science relations, or dialogues over method with scientists from different disciplines. The BAAS leadership sought to "cultivate" science, as they put it, by linking amateur and professional organisations and holding annual meetings in different towns throughout Britain and Ireland (and, from 1884, in Canada, South Africa and Australia). The BAAS played a vital role as a catalyst both for the popularisation of science, and for the production of public knowledge about contemporary science. Its stated mission was not only to foster public support for science and its financing from private and state sources, but also to enlist participants for the production of public knowledge, opinion and debate about science.

This ambition was not always easy or necessarily straightforward, especially at a time when what constituted professional science in different fields was not clearly defined. The early years of the BAAS, from about 1850 to 1870, saw a dramatic expansion in the membership of the organisation, with large numbers of so-called "amateurs and professionals" flocking to the society's annual meetings in different cities across the UK (and, for the first time, outside it, as well). During this time, the BAAS helped usher in a new conception of popular scientific knowledge: associated with a host of civic virtues, voluntary institutions, and new forms and moral displays of middle-class, cross-sex sociability. The self-proclaimed "men of science" who were involved in these local, national events, moreover, were keenly attuned to theatre and performance, and were deeply interested in finding ways to communicate science to new audiences. They wanted to cultivate a public image of science, yet they also struggled to present a unified image of science at a moment when new disciplines of sciences were emerging, and specialists wanted to use the meetings to talk to other specialists (and not just to amateurs or worse, "enthusiasts", as they were sometimes unflatteringly called).[14]

During a period of growing scientific specialisation, the BAAS leadership sought ways to engage a wider public of amateurs, including men from different social backgrounds and, to a more limited extent, many women. (Both efforts met some, albeit limited, success.) Yet images like those published, for instance, in the *Graphic* magazine, provoked the BAAS where it was itself most vulnerable: its worry of being seen as too amusing or trivial, attracting individuals whom some scientific elites regarded as non-serious (men, as well as women).[15]

The BAAS membership promoted an image of popular science as integral to many different types of activities, from geology and astronomy to photography

and anthropology: which were in turn pictured by the burgeoning illustrated press. An idea of its mission in its first hundred years may be gleaned from these statements by successive Presidents of the organisation. Charles Daubeny, a botanist, in 1856, stated in his address: "... engaging the Public in various useful undertakings, which Science indeed might have suggested, but which the Nation alone was capable of carrying into effect".[16] Prince Albert, a champion of the BAAS, stated at the organisation's meeting in 1859 in Aberdeen: "It is with facts only that the Association deals".[17] One highlight of the BAAS was that, unlike at other society meetings, scientists from one field received light from those in others. (As Prince Albert put it: "And all find a field upon which to meet the public at large")[18]

The annual meetings of the BAAS became important national venues for the testing out and exhibition of new visual methods. Members of the British Association and their audiences included manufactures and dealers in scientific optical instrumentation, scientific professionals and educators who sought new scientific and educational uses of photography, projection microscopes and cinema.

Lantern slides at the BAAS

Through their circulation across the BAAS's scientific research and popular science networks, lantern slides played a large role in defining the cultural meanings of science in the 19th and early 20th centuries. Slides were widely regarded as playing an essential role within scientific and related educational and popularizing activities. Lantern slides both manifested and, to some extent, exacerbated the problem (because slides were associated with popular entertainment and amusement, implicitly posing the question: how much amusement could enter before the presentation moved from the realm of science into the world of 'show'?).[19]

Among their members were some of the earliest British pioneers and demonstrators of photography, and other tools that were being applied in the sciences. Many of its major leaders were active experimenters in new visual technologies and the science of vision: pioneers and developers and campaigners for new uses for visual communication in the sciences. Natural philosophers and popularisers of science were creating demand for new forms of knowledge, many of which were visual. Among those who exhibited photographs there early in the organisation's history was William Henry Fox Talbot.[20] To take another example, the exhibition of models and manufacturers at the 1839 BAAS meeting included a Carpenter and Westley Phantasmagoria with a microscope and a set of slides. Carpenter's lantern was made of tin, with a tall chimney that angled part way up, to protect its argand lamp from draft and to stop light escaping. It had a (sometimes adjustable) lens tube, with double condenser and objective lenses, and a diaphragm to prevent spherical aberration. Its simplicity of use meant that Carpenter could target a non-professional clientele and prompt amateur users (teachers, preachers, gentlemen scientists and so on) to take up the lantern as a useful way of presenting images in

public.[21] The divergent visual activities of the many scientists associated in some way with the BAAS included, for example, makers and users of photography, graphs, lantern slides, self-registering data and, eventually, scientific educational and documentary films.

Samuel Highley, Jr. (1825-1900) is an interesting individual in this regard. Highley's family was in the bookselling business; he published, sold and dealt in scientific and medical instruments and specimens, and he was an agent for the Royal College of Surgeons. He wrote extensively on topics ranging from photography and microscopy to chemistry. He was the assistant editor of the *British Journal of Photography* for forty years and, in 1857, the Secretary of the Photographic Society. Optical projection was of particular interest to him, and he is credited as among the first to design a bi-unial lantern with two projecting lenses mounted vertically above one another as well as a dissolving tap for the exhibition of dissolving views, and he was an accomplished maker of photographic lantern slides. He manufactured optical lanterns as part of his business as a manufacturing optician. At the Liverpool meeting of the BAAS in 1854, Highley gave a survey of the departments of science to which photography had already been applied (including astronomy, meteorology, structure as displayed by polarised light, microscopy, natural history, anatomy, surgery, pathology and types of disease). He demonstrated by a series of photographs, what valuable aid might be rendered where *"truthful* delineations of natural objects were of importance, as on disputed points of *observation*, and how by the application of stereoscopic principles the student might in his closet study the Flora and Fauna of distant lands, or rare cases in medical experience".[22]

The kind of commercial dealers, inventors and collectors, manufacturers and trades people – the subjects of other papers in this volume – were exactly the sort of people that the BAAS recruited for meetings in the early decades of the organisation. The participation of manufacturers and demonstrators like Highley was crucial for giving the BAAS its distinction as a place where industry and science met face to face.[23]

1870 to 1916

The passage of the National Education Act in 1870 and other developments obliged the BAAS to popularise science in significant new ways, such as assisting with the creation of new school science texts and lantern slide shows for science classes. Examples of lecture demonstrations with slide illustrations were especially common by the 1870s and 1880s. Yet during the last third of the 19th century, the BAAS also concentrated attention on a wide variety of scientific enterprises, as well, from the HMS Challenger expedition, a four-year circumnavigation of the oceans, to the scientific defence of Kew Gardens. In 1874, at the BAAS meeting in Belfast, Col. Stuart Wortley lectured on photography in connection with astronomy, using his own slides and some that he had borrowed from the Royal Astronomical Society's collection. Four years later, Sir Wyville Thompson gave a report on the Challenger expedition, illustrated with lantern slides. There were also lectures on the use of pictorial

Fig. 1:Tempest Anderson (1846–1913), "Man standing in a spiracle on a lava plain, Iceland". YORYM: TA3967 (1893). Black and white glass lantern slide. Yorkshire Museum (York Museums Trust).

aids in geographical teaching.[24] In York, in 1881, Francis Galton delivered a paper to the BAAS: "On the Application of Composite Portraiture to Anthropological purposes". Six years later, in Manchester, a committee reported on its efforts to procure "racial photographs from the Egyptian monuments".[25] The interests of BAAS leaders in the making and circulation of slide images were extending at this time beyond educating the public: they also sought to engage ever wider publics in the practice of science by encouraging amateurs to make and contribute photographic images that could become working objects of their science: turning science enthusiasts into "cultivators" of science. Given the spread of photography, field scientists especially tried to recruit observers to record their observations in the field, and this may be traced through lantern slide collections in a variety of archives.

This type of work is especially made visible in the BAAS Geological and Meteorological Photography Committees, which were created in the 1870s and 1880s to build a storehouse of photographs of geological and meteorological phenomena. In the 1880s and 1890s, for example, a Yorkshire volcanologist, Tempest Anderson, demonstrated slides of his research on the spiracles in Icelandic volcanos (when a steam explosion results in the protrusion of a small interbed of wet sediment into the overlying lava flow).[26]

In 1889, a committee within the BAAS was appointed by Section C under the chairmanship of James Geikie, to oversee the "collection, preservation and systematic registration of Photographs of Geological Interest in the United Kingdom".[27] The Committee's idea for the project was grounded in their assumption – built over the past several decades – that the interests of scientists

Fig. 2: Tempest Anderson (1846–1913), "Woman with parasol looking
over edge into crater", Vulcano, Aeolian Islands, North of Sicily,
unknown date, unknown subject. YORYM: TA653. Black and white glass
lantern slide. Yorkshire Museum (York Museums Trust).

and photographers were mutually reinforcing. The "true secret" of the spread
of photography was that "the results of photography were [...] pleasing". The
amateur found a source of "infinite amusement and instruction; combining
healthful exercise with close study and research".[28] Geologists were hopeful of
being able to form a large collection because of the large number of amateur
photographers in "every centre of scientific energy".[29] The British Associa-
tion's involvement in the creation of a national collection of geological and
meteorological photographs in the 1880s and 1890s can provide especially
telling examples of the assumptions underlying their conceptions of "scien-
tific" photograph, and equally interesting, what kind of multiple identities that
photographers had.

1916–1920: "Science for All"

But who should speak for science? A widespread view among historians until
relatively recently was that one consequence of the professionalisation of
science in the early 20th century was a reluctance to engage with the general
public. But a closer look reveals something different. As historian Peter Bowler
has shown, British scientists in the early 20th century "played an active role in
satisfying the increased demand for information about what they were do-
ing".[30]

By the 1910s, significant pessimism about the future function of the BAAS
emerged, despite widespread agreement among its members that it still had a
useful role to play. One significant contribution that the BAAS leaders thought
it should take was in the direction of public science education. From this

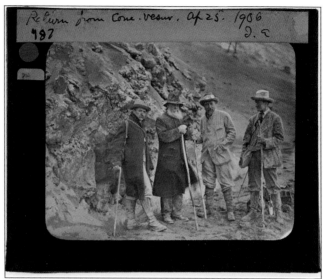

Fig. 3: Tempest Anderson (1846–1913), A group of four men standing before the volcanic slopes of Vesuvius, Italy. Second from right is Tempest Anderson. YORYM: TA987 (1906). Black and white glass

stemmed a series of activities that the organisation undertook in the early 1900s to ascertain how to better interest the public in science. At the meeting of the BAAS Council in June 1916 representatives from the Organising Committee of Section L (Educational Science)[31] observed: "much less attention is given to popular lecturing now than was formerly the case; and it was suggested that efforts should be made to promote increased public interest in science by means of such lectures".[32] The Council, therefore, appointed a Committee representative of all the Sections of the Association to institute inquiries into this subject and prepare a report on it. Many local scientific societies, universities and similar institutions with experience in organising popular scientific lectures were asked to provide details of their successes and failures. The BAAS established a committee on popular science lectures which met and eventually issued a series of reports.[33]

"The great popular interest which used to be taken in natural history arising out of the 'evolution' controversy, and inspired also by the writings of Darwin, Wallace, Huxley, Lubbock, Kingsley, and others, has passed entirely away", lamented M.B. Morris, Town Clerk of Stirling, informing the BAAS Interim Committee "On Popular Scientific Lectures" which reported its findings at the eighty-six meeting of the BAAS, held in Newcastle in early September 1916.[34] He continued: "Such interest now centres in subjects like wireless telegraphy, aviation, and, at present, all matters concerned with the war".[35] Other factors that the Committee heard were limiting the public's interest in science, and that were mentioned in the report included the increasing interest of working men in labour unions, and the rise of new education facilities for teaching science that rendered some of its activities obsolete.

After a long debate, the BAAS decided to use its networks to recommend the use and circulation of visual materials, including photographic slides, in schools, clubs, local natural history societies and so on. Partly as a result of their activities, by the early years of the 20th century, the BAAS had become one of the leading places where visual instruction and educational theories of vision were debated intensively.[36] Many of the organisation's leading members lamented what many of them saw as the decline of public interest in most popular science subjects since the 19th century, and discussed ways of securing more audiences. Lantern slides and films were recruited and seen as especially important to reversing this situation. The *Report* urged: "Science lectures must be illustrated by lantern slides or experiments if they are to appeal to a large public, and their titles should arrest attention."[37] "[...] popular lectures will not succeed unless illustrated by kinematograph, lantern, or experiments, or by all three. The element of entertainment must be present, which implies novelty."[38] Ideally, they should also "deal with recent discoveries of topics which have been mentioned frequently in the daily newspapers".[39] The Interim Committee "On Popular Scientific Lectures" reiterated the need for a "science for all" curriculum in elementary secondary schools. The members were pragmatic, saying that "the application of the film-pictures to microscopy, &c., is about the only way to popularise science lectures, but – why bother? We cannot all be men of science".[40]

The BAAS Committee on popular science lectures proposed an exchange system of lecturers among scientific societies and museum curators. It identified and characterised different types of popular lectures. First were lectures to members of local scientific societies and others interested in scientific subjects. The programs of local scientific societies showed that "a valuable service" was rendered by the many meetings and lectures in which scientific matters and developments were covered, from natural history to physics to war munitions to food science. Second, there were "people's lectures" with lantern slides and experiments, which were "recreative" and "somewhat of the nature of entertainment". (Later the audiences for these were identified as the "mass" of people who were "completely apathetic to scientific development and had no desire for knowledge". This population, they thought, "can be reached only by entertainment or by an appeal to what may be termed their political interests", through "subjects of national and economic importance".)[41] "The best avenue to their attention to scientific discovery and teaching is the picture-house", the Committee urged, suggesting that: "By a selection of suitable films of geographical, industrial, and scientific subjects, it would be possible to enlighten the mass of the people as to the varying aspects of Nature [...], the wonders of natural history, and the services of science to national life and industrial progress."[32]

The BAAS set up a special committee that organised catalogues and promotion of scientific lantern slide shows and, increasingly, bioscope films, and actively promoted these to schools, universities, community groups, natural history

societies and so on, noting: "Increasing use is being made of bioscope films to illustrate popular lectures, and in the future these moving pictures will, in many cases, supersede the lantern-slides which attracted the public in former years".[43] Its members registered a large demand but short supply of shows and films (noting, for example, that Messrs. Pathé Frères had fine films but these were now out of circulation due to the poor condition of the prints.[44] There was much discussion of museums in relation to education and slides. The Education Act passed in 1918, the Libraries Act in 1919).[45] Finally, the report noted that "industry has been heavily involved with making suitable projectors and apparatus" – but needed a stronger "lead" from the "Teaching Professions" before manufacturing educational films (which is where the BAAS stepped in). There was, however, considerable iconoclasm: certain publishers discouraged scientific authors from including too many images, on the grounds that it might create the impression that the text was merely a "supplement to the pictorial content".[46]

The Committee stressed that moving pictures were superseding lantern slides. Though this was not wholly the case, it is worth exploring more the connections among these genres, especially in this moment of transformation in the 1920s and 1930s when both lantern slides and early moving pictures were being used. It seemed doubtful that producers would, on their own, make films about scientific discovery and the "wonders of natural history", saying: "When there is a large demand for such pictures, producers of them will be glad to meet it, but at present they mostly devote attention to sloppy sentiment, stupid antics, and Wild West sensationalism".[47] But they were hopeful that scientists could tap (and ideally, re-direct) interest of movie-going audiences: "Arrangements might be made with local picture-houses to have a fortnightly or monthly scientific evening, which would take the form of a popular lecture with illustrations".[48]

Some reflections

The BAAS's activities in the production and circulation of lantern slides for scientific use in the 19th and early 20th centuries offer preliminary food for thought for historiography and avenues for further research. By appealing to specialists and lay audiences, the BAAS propagated both current research and its special image of science through a wider variety of different forums and formats than any previous individual scientific organization had undertaken. Its research findings were made public through lectures, local scientific societies, local exhibitions, press reports, and via published proceedings of specialised papers in reports that contained articles and transcripts of lectures. Yet the BAAS was also an institution of the "arts and sciences" and saw "scientific method" as integrally linked with visual methods of inquiry.

Examination of the records of the early years of the British Association for the Advancement of Science suggest that it became active in lantern slide production, circulation and popularization as a scientific teaching technique early in its organisational history. It also indicates that the meanings of slides in public

science within, and outside, the organisation changed over time from the 1870s to the early 1920s. Further historical study of the use and promotion of lantern slides in BAAS meetings during the years from the 1860s to the 1920s is needed to understand some of the many ways that the meanings of science shifted across these years, as new ways of seeing nature interacted with changing material encounters and knowledge systems.

Notes

1. On Magnum photographers and the creation of "decisive moment" as strategy for defining the Magnum project in the face of image overload and certain problems with this myth, see Nadya Bair, "The Decisive Network: Producing Henri Cartier-Bresson at Mid-Century", *History of Photography*, no. 40 (May 2016): 146–166. How the language of "decisive moments", that is widely associated with photojournalism, is also reflected in histories of scientific photography is a subject that would be worth exploring further.

2. See, among others, Martyn Jolly and Elisa deCourcy (ed.), *The Magic Lantern at Work: Connecting, Witnessing, Experiencing and Persuading* (New York: Routledge, forthcoming); see also John A. Davidson, "Magic Lantern Optics: Their History and Development 300 B.C. to 2004 A.D.", *The Magic Lantern Gazette*, vol. 23, no. 1 (2011): 3–20.

3. On this theme, see especially Kathleen Davidson, *Photography, Natural History, and the Nineteenth-Century Museum: Exchanging Views of Empire* (New York: Routledge, 2017). On Victorian popular science, instrumentation and spectatorship, see among others Bernard Lightman (ed.), *Victorian Science in Context* (Chicago: University of Chicago Press, 1997); Iwan Morus, *Frankenstein's Children: Electricity, Exhibition, and Experiment in Early Nineteenth-Century London* (Princeton: Princeton University Press, 2014); Chitra Ramalingam, *To See a Spark: Experiment and Visual Experience in Victorian Science* (New Haven: Yale University Press, forthcoming).
 Bernard Lightman, "The Visual Theology of Victorian Popularizers of Science: From Reverent Eye to Chemical Retina", *Isis*, vol. 91, no. 4 (2000): 651–680; Jennifer Tucker, *Nature Exposed: Photography as Eye Witness in Victorian Science* (Baltimore: Johns Hopkins University Press, 2006).

4. On the social, intellectual and organizational transformation of 19th-century science more generally, see David N. Livingstone and Charles W.J. Withers, *Geographies of Nineteenth-Century Science* (Chicago: University of Chicago Press, 2011); David Clifford et al. (ed.), *Repositioning Victorian Sciences: Shifting Centres in Nineteenth-Century Scientific Thinking* (London: Anthem Press, 2006); Thomas W. Heyck, *Transformation of Intellectual Life in Victorian Britain* (London: Lyceum, 1989).

5. On 19th-century scientific visual culture generally, see Lightman, "The Visual Theology"; Tucker, *Nature Exposed*.

6. An important early treatment of the role of visual culture and instrumentation in the BAAS is Susan Faye Cannon, *Science in Culture: The Early Victorian Period* (Cambridge: Harvard University Press, 1978). See also Jennifer Tucker, "Science Institutions in Modern British Visual Culture: The British Association for the Advancement of Science, 1831–1931", *Historia Scientiarum: International Journal of the History of Science Society of Japan*, vol. 23, no. 3 (2014): 191–213.

7. Despite its importance in the field of lantern slide activity, the nature and scope of the British Association for the Advancement of Science's role as a catalyst for visual and, in particular, lantern slide activities, have not been the subject of a major in-depth study. Archival collections of BAAS photographs are scattered across myriad scientific societies, individual collections, libraries and archives. While the published reports of the annual meetings are available online (https://www.bio-diversitylibrary.org/bibliography/2276#/summary), these sources offer only a partial picture of the intellectual encounters and exchanges among BAAS members and their scientific and popular audiences. The archive of BAAS sources at the Bodleian Library, while rich in certain areas, such as the minutes of meetings of leadership and press coverage, has comparatively few sources on the visual methods within the institution relative to the other major scientific organizations. To recover the richness of BAAS correspondence and activities it is necessary to look beyond these central sources, including individual scientific societies and collections of individual scientists' papers, as well as scientific and photographic journals. Photographic slides that are identifiable as BAAS photos may be found in the Geological Society of London (Merriman Collection), 1870–1930s., Royal Albert Memorial Museum Collection (BAAS geological photos, before 1933),

Ulster Museum, Belfast, and Yorkshire Museum (Yorkshire Philosophical Society), among others.

8. Tucker, "Visual and Material Studies", in Rohan McWilliam, Lucy Noakes and Andy Wood (ed.), *New Directions in Social and Cultural History* (London: Bloomsbury Academic Press, 2018), 129–142.

9. On the history of the BAAS, see especially Charles W.J. Withers, *Geography and Science in Britain: A Study of the British Association for the Advancement of Science, 1831–1939* (Manchester: Manchester University Press, 2010); Roy M. MacLeod, J.R. Friday and C. Gregor, *The Corresponding Societies of the British Association for the Advancement of Science, 1883–1920* (London: Mansell, 1975); Ray M. MacLeod and Peter Collins (ed.), *The Parliament of Science: The British Association for the Advancement of Science 1831–1981* (Northwood: Science Reviews, 1981), 211–236; Louise Miskell, *Meeting Places: Scientific Congresses and Urban Identity in Victorian Britain* (London: Ashgate, 2013); Jack B. Morrell and Arnold Thackray, *Gentlemen of Science: Early Correspondence of the British Association for the Advancement of Science* (London: Offices of the Royal Historical Society, 1984); Richard Yeo, *Defining Science: William Whewell, Natural Knowledge, and Public Debate in Early Victorian Britain* (Cambridge: Cambridge University Press, 1993).

10. "Address of William Robert Grove ... President", in *Report of the Thirty-Sixth Meeting of the British Association for the Advancement of Science; held at Nottingham in August 1866* (London: John Murray, 1867), LIII–LXXXII, here LIV.

11. William Robert Grove at the BAAS meeting in Nottingham in 1866 stated that he did not wish to see "the study of languages, of history ... neglected". Yet, he explained: "It is sad to see the number of so-called educated men who, travelling by railway, voyaging by steamboat, consulting the almanac for the time of sunrise or full-moon, have not the most elementary knowledge of a steam-engine, a barometer, or a quadrant; and who will listen with a half-confessed faith to the most idle predictions as to weather or cometic influences, while they are in a state of crass ignorance as to the cause of the trade-winds or the form of a comet's path". Ibid., LIV–LV.

12. By 1920, the BAAS was a model for scientific organisations in other parts of the globe, including similar Associations for the Advancement of Science in more than twenty countries, including the USA. The BAAS had no permanent building, so its impact must be traced by looking at multiple sites, through correspondence, other institutional records and the like.

13. While the legacy of the British Association for the Advancement of Science has been studied extensively, the specifically visual dimension of its work has not been the subject of significant focus.

14. This tension remained at the core of the BAAS until the early 1900s, when it essentially began giving up the idea of being a primary site for the communication of advanced scientific work in special fields, although not its popularising ideal.

15. On the risks that the BAAS faced for appearing too 'entertaining', see Rebekah Higgitt and Charles W.J. Withers, "Science and Sociability: Women as Audience at the British Association for the Advancement of Science, 1831–1901", *Isis,* vol. 99, no. 1 (2008): 1–27; Jennifer Tucker, "'To Obtain More General Attention for the Objects of Science': The Depiction of Popular Science in Victorian Illustrated News", *Historia Scientiarum: International Journal of the History of Science Society of Japan,* vol. 25, no. 3 (2016): 190–215.

16. "Address by Charles Daubeny, M.D., F.R.S., Professor of Botany in the University of Oxford", in *Report of the Twenty-Sixth Meeting of the British Association for the Advancement of Science; held at Cheltenham in August 1856* (London: John Murray, 1857), XLVIII–LXXIII, here XLIX.

17. "Address by His Royal Highness The Prince Consort", in *Report of the Twenty-Ninth Meeting of the British Association for the Advancement of Science; held at Aberdeen in September 1859* (London: John Murray, 1860), LIX–LXIX, here LXIV.

18. Ibid., LXIX.

19. See, for example, the discussion in Samuel Highley, "The Magic Lantern", *The Popular Recreator* (1874), 34–41, 109–112, 236–239, 328–330, 337–340, 361–363, 369–371.

20. A recent show about the work raises further questions that are relevant to this project: How to engage the public in the exercise of imagining what it meant to be at the birth of cutting-edge technologies? What will visitors take away? These are questions that are asked now about history and heritage more generally. A Virtual Reality artwork called "Thresholds" created by the photographic historian and artist Mat Collishaw, recently on display in London and Birmingham, recreates the exhibition of photographs at the BAAS meeting in Birmingham in 1839. The

collaboration resulted in a virtual reality representation of what is arguably one of the first *public* exhibitions of photography, and also one of the first projects using simulated realities to explore photo histories. The exhibition attempted to evoke the sense of magic the public must have felt when they first saw Talbot's photogenic drawings in August 1839 at the meeting of the BAAS in Birmingham. For more about the exhibition, see Mat Collishaw interviewed by historian of photography Pete James: http://newartwestmidlands.co.uk/editorial/qa-with-pete-james (accessed on 15 April 2018). *According to James: "Thresholds* is an evocation of a moment in photographic history which, in turn, seeks to offer a point of departure, a pretext, for consideration of how photography has evolved and impacted upon us – for good and bad – since 1839. It's a recreation in the sense that it's based on sound and detailed research about the space and contents represented, but it's also an imaginary space which enables the modern viewer to consider related ideas from multiple viewpoints: past, present and future."

21. Discussed in Phillip Roberts, "Philip Carpenter and the convergence of science and entertainment in the early-nineteenth century instrument trade", in *Sound and Vision* (Spring 2017), Article DOI: http://journal.sciencemuseum.org.uk/browse/issue-07/philip-carpenter-and-the-convergence-of-science/. Despite Carpenter's own claims to invention, Roberts shows, it was really the manufacturing and retail strategies he implemented that constituted his most important innovations. Instrument makers like Carpenter had to be reputable to fit the taste of the market, but it was equally important that the scientific world that his instruments revealed, through lantern slides or microscopic objects, was wondrous. This was a relationship that previously was negotiated with the kaleidoscope. See "Carpenter's New Phantasmagoria Lantern and Copper-Plate Sliders", *The Liverpool Mercury* (12 April 1822): 327; and Philip Carpenter, *A Catalogue of Optical and Mathematic Instruments Manufactured and Sold by P. Carpenter, Microcosm, No. 24 Regent Street* (London: H. Starie, 1834).

22. Samuel Highley, "Hints on the Management of some difficult subjects in the application of Photography to Science", in *Report of the Twenty-Fourth Meeting of the British Association for the Advancement of Science; held at Liverpool in September 1854* (London: John Murray, 1855), 69–70, here 69; see also Highley, "The Magic Lantern".

23. It is important not to over-estimate the warmth of this relationship, however. Manufacturers, instrument makers and dealers who turned up at the annual BAAS meetings to hawk their wares, sometimes complained that the "men of science" at the event didn't show an active interest in the practice of photography. As one photographer put it, rather ruefully, "our big-wigs [scientists] are always quite ready to use it [photography] to help their investigations on other sciences". Some "men of science", of course, such as astronomers Warren De la Rue, Sir William de Wiveleslie Abney, Colonel Stuart Wortley, the meteorologist James Glaisher and the physicist Sir William Crookes did actively take part in the advancement of photography, as well as the public display and circulation of scientific photographs, but from the perspective of photographers, they were exceptions. For more examples, see, for example, Tucker, *Nature Exposed*, chapter 5.

24. Anon., "On Pictorial Aid to Geographical Teaching, by G.G. Butleb", *Report of the Fiftieth Meeting of the BAAS, held at Swansea in August and September 1880* (London: John Murray, 1880), 660. On the importance of the magic lantern in geographical education see especially Emily Hayes, *Geographical Projections: Lantern-slides and the Making of Geographical Knowledge at the Royal Geographical Society c. 1885–1924*, PhD diss. (University of Exeter, 2016).

25. "Report of the Committee, consisting of Mr. F. Galton … appointed for the purpose of procuring … Racial Photographs from the Ancient Egyptian Pictures and Sculptures", in *Report of the Fifty-Seventh Meeting of the British Association for the Advancement of Science; held at Manchester in August and September 1887* (London: John Murray, 1888), 439–449, here 439.

26. Tempest Anderson was a key figure in the city and the Yorkshire Philosophical Society. He made a living as an ophthalmic surgeon but was also a pioneering volcanologist. Anderson would return to York and lecture at the Yorkshire Philosophical Society using a "magic lantern" to display his glass slides and reveal remote landscapes he had investigated to the scientific community. At his death, he donated half his estate and most of his archive to the Yorkshire Philosophical Society, and it is through this inheritance at the Yorkshire Museum that some of the 5,000 glass slides have come to be digitized for the York Museums Trust's online collection. Documenting his global explorations through photographs, a couple of projects seek to recover his role in the BAAS. See "The Tempest Anderson Collection of Photographs at Yorkshire Museum", *Newsletter of the Geological Curators Group*, vol. 2, no. 2 (April 1978): 68–80; Pat Hadley, Sarah King and Stuart Ogilvy, "Tempest Anderson: Pioneer of Volcano Photography", *The Public Domain Review*

(accessed on 15 April 2018, https://publicdomainreview.org/collections/tempest-anderson-pioneer-of-volcano-photography). For help with information about Anderson I thank especially Sarah King from the Yorkshire Museum and Margaret Leonard from the Yorkshire Literary and Philosophical Society.

27. By 1890, a Committee of Geological Photographs in the British Association was formed, consisting of the chair, Prof. James Geikie, the secretary Osmund W. Jeffs and the following members: Mr. S.A. Adamson, Prof. T.G. Bonney, Prof. W. Boyd Dawkins, Mr. William Gray and Mr. Arthur S. Reid. See "Report of the Committee … to arrange for the collection, preservation, and systematic registration of Photographs of Geological Interest in the United Kingdom", in *Report of the Sixtieth Meeting of the British Association for the Advancement of Science; held at Leeds in September 1890* (London: John Murray, 1891), 429–444, here 429.

"A desire having been widely expressed for facilities by which lantern slides of the geological photographs included in the list issued could be procured, the Secretary was instructed to endeavour to make arrangements to effect this object." But "[o]wing to the fact of the negatives not being in the possession of the Committee, the privilege of supplying lantern slides remains in the hands of the various photographers." "Second Report of the Committee, consisting of Professor James Geikie (Chairman), Dr. Tempest Anderson […] to arrange for the collection, preservation, and systematic registration of Photographs of Geological Interest in the United Kingdom", in *Report of the Sixty-First Meeting of the British Association for the Advancement of Science; held at Cardiff in August 1891* (London: John Murray, 1892), 321–333, here 322.

28. "South London Photographic Society", *Photographic News* (20 April 1860): 400–401, here 400.

29. "Second Report of the Committee", 321.

30. Peter J. Bowler, *Science for All: The Popularization of Science in Early Twentieth-Century Britain* (Chicago and London: University of Chicago Press, 2009), 2.

31. Their presentation to the 1916 BAAS Meeting was later published as "Popular Science Lectures. – Interim Report of the Committee … to consider and report on the Popularisation of Science through Public Lectures", in *Report of the Eighty-Sixth Meeting of the British Association for the Advancement of Science; Newcastle-on-Tyne: 1916 September 5–9* (London: John Murray, 1917), 326–351.

32. Ibid., 326.

33. Ibid.

34. Ibid., 332.

35. Ibid.

36. At the time, in the early 1900s, of course, scientists, teachers and others were beginning to make and use a variety of non-fictional slide sets and films that retrospectively would be known by the term "documentary" or "nature" study.

37. "Popular Science Lectures", 328.

38. Ibid., 332.

39. Ibid., 328.

40. Ibid., 335.

41. Ibid., 345–346.

42. Ibid., 346.

43. Ibid.

44. Ibid.

45. The study focused on twenty institutional museums, nineteen university and school collections, ninety-two municipal museums and two private museums, as well as some overseas museums. For example, the report noted that there was a large effort at building slides in Australian and U.S. museums, for example, the creation of a special Lantern Slide Department at the Natural History Museum in New York.

46. Bowler, *Science for All*, 94.

47. "Popular Science Lectures", 346.

48. Ibid., 332.

Emily Hayes

"Nothing but Storytellers": From One Thousand Royal Geographical Society Lantern Slides to *A Million Pictures*

eographers, Nicholas Entrikin argues, are "nothing but storytellers".[1] With this in mind this article considers how stories of exploration, stories of travel and of science were told verbally and visually at the Royal Geographical Society (RGS) as geographers harnessed the medium of the lantern. It traces how the lantern and lantern slide sets served as vessels which set images in motion in order to tell stories of travel, exploration and of both physical and human science. This occurred at a time when the discipline of geography, which aspired to span the breach between arts and science, was being both professionalised and popularised in the final decades of the 19th century and up to the middle of the 20th century. Coincidentally, as transport technologies and social practices shifted, those with little formal education or training, including enterprising women and working-class men, became makers of geographical knowledge. By harnessing the new photographic technologies as well as lantern slides and the lantern, these people left material traces of their geographical knowledge and experiences.

The nature of the lantern was, historically, a vexed question at the RGS. The medium was adopted incrementally across three RGS lectures performed between 1886 and 1888.[2] Subsequently there was an evolution in the Society's lecture modalities as the once comparatively socially exclusive RGS engaged with a more diverse demographic of visual and verbal knowledge-makers and audiences. Evening lectures for general RGS audiences of male fellows and their male and female guests were accompanied by lantern projections from 1886, but were not frequently held until after 1888; Children's Christmas lectures were initiated in December 1892; finally, the Society's Technical Meetings held in the Map Room, and which would later be called Scientific Meetings, attracted a range of practitioners of the professionalising physical and social sciences from 1894. Today, the RGS collection of several thousand individual lantern slides are testament to the overcoming of opposition to the lantern.[3] The majority of the slides are in the standard lantern slide format of 3 ¼ x 3 ¼ inches.[4]

The *A Million Pictures* project enabled me to continue to pursue my exploration of the hitherto neglected 19th-century heritage of lantern entertainment and

instructional activities in the field of geographical knowledge. The project foregrounds the three-dimensional materiality of individual lantern slides and makes available on the Lucerna database the cataloguing details and images of extant lantern slide sets of important British scientific and cultural institutions, including those of the RGS. Dating from between 1897 and 1945, the selected slides trace the professionalisation of physical and social sciences and their symbiotic relationship with the plural and diverse registers of geographical discourses in the *fin-de-siècle* era. The project thus expands our understanding of the geographies of geographical knowledge-production and the range of scales across which this process took place. This redefines the RGS in terms, not of heroic male exploration of the African rivers, polar regions or the conquest of mountains, as has hitherto been the case, but instead in terms of interacting and mutually-influencing visual technologies, audiences and educational activities that were promoted by a group of reformers within the RGS from the 1870s onwards.

In this investigation of geographical lantern slide narratives, I bring to light a number of hitherto overlooked tellers of geographical tales. I reflect upon who was recognised as an authoritative storyteller and knowledge-maker. I also consider the effects of this visual and verbal narrative method and question the significance of the locations in which geographical stories were told. In light of this, the article also draws from Richard Crangle's theorising of lantern lectures as "hybrid texts".[5] In drawing from an assemblage of RGS archival materials, institutional documents, lecture manuscripts and published lectures as well as published travel narratives, it remains sensitive to the hybridisation engendered by, and seen via, transformations in the lantern practices of the RGS. This article therefore focuses on three areas that narrate the transformations to the demographic of travellers, geographers, lecturers and audiences. Firstly, it addresses the lantern slide production process and the provenance of slides. Secondly, it assesses the number of women who produced the photographs that were remediated into slides or who lectured a number of lantern slide sets. Finally, in seeking to identify the postulated processes of hybridisation it discusses the professional, academic and non-expert producers of lantern slides.

The "mindful hand" of the lantern slide maker

In investigating the production of the slides, I encountered a number of overlooked storytellers. Most notable amongst these was H.W. Simpson (1864–1940), the Society's clerk, lantern operator and lantern slide maker. Simpson's own story has, to date, not been told. However, it is evident that what Lisa Roberts, Simon Schaffer and Peter Dear call his "mindful hand" and eyes shaped the visual practices of the RGS, the lantern slide collections and the projection of slides within lectures.[6] He entered the employment of the RGS in 1878 at the age of fourteen, where he was known as George, the name of his predecessor. He soon rose from the position of boy to become a clerk.

He first began to make lantern slides for the Society in early 1890 in order to increase his salary.[7] Soon after he became sufficiently competent to project the lantern in lectures. His role then expanded to include visiting fellows to assess their photograph collections and select images of use to the Society.[8] In 1905, he was described as: "Inventive and intelligent ... most useful as a photographic artist, apart from his clerical work".[9] His official clerking duties and as a projectionist ended with his retirement in 1923.[10] However, he continued to make lantern slides until 1937, a few years before his death in 1940.[11] His hand and eye therefore extensively shaped the RGS slides, the Society's geographical aesthetics of geography and the effects engendered by visual geographical knowledge as much as any heroic explorer in the field. Thus in addition to being a storyteller in his own right, he qualifies as what Steven Shapin calls an "invisible technician" of geography.[12] The personal, in-house nature of RGS lantern slide production can therefore be understood as an example of the Society's co-ordination, authorization and regulation of lantern-related forms of knowledge and their contingent social practices.

Men, mountains and memories

The RGS was implicated in producing and perpetuating the trope of the heroic male explorer. However, the majority of slides were associated with the travels of men who stood as indexical figureheads of journeys and exploits that only took place thanks to the labours of large retinues of local helpers.[13] If the middle of the 19th century is characterised as the era of river exploration by the likes of Mungo Park, David Livingstone, Richard Burton and John Hanning Speke, towards the end of the century explorers turned their attention upwards to mountains.[14]

The Society capitalised on the popular interest in the Alps that had been so prominent in Albert Smith's "Ascent of Mont Blanc" panorama and lantern show at the Egyptian Hall on Piccadilly, London.[15] Thus, in addition to impressive physical exploits, the ability to demonstrate an artistic sensitivity in both words and pictures came to be valued. Sir Martin Conway's slides of the Alps (1896–1897) comprise one of the most beautiful sets with their numerous decorative vignette frames which enhance the sublimity of the high altitudes *vistas*, and which simultaneously perpetuate visual tropes of an earlier era seen in painting and drawing (Fig. 1).

The digitised slides also attest to the expansion of mountain climbing around the world. Conway lectured on his climbs in the "Bolivian Andes" (1899), and Sir Francis Younghusband shared his "Memories of the Shaksgam" (1926). The photographs by Vittorio Sella, the photographer on the Duke of Abruzzi's expedition to the Ruwenzori mountain range in Uganda and Congo were celebrated in a lecture which included 100 slides delivered in the Queen's Hall before the King.[16] Finally, Eric Shipton's account of the "Nanda Devi and the Ganges Watershed" (1935) informs our understandings of the RGS's support of the attempts to scale Mount Everest. Shipton's expedition helped the Society

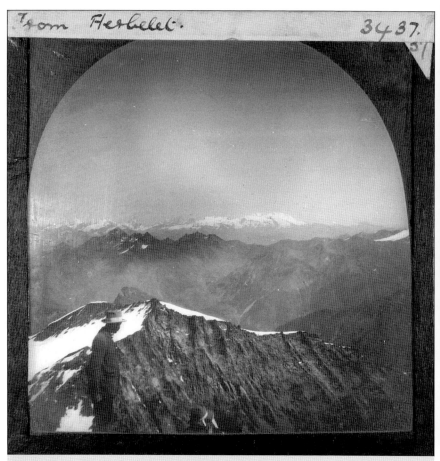

Fig. 1: FROM HERBELET, [34 37], RGS lantern slide set 34, made to illustrate papers by Sir Martin Conway, 1896–1897.

to drum up popular interest in the latter. It also justified the numerous Everest committees in which the RGS invested over several decades before Tenzing Norgay and Edmund Hilary reached the summit in 1953.

Equally emblematic of the turn of the 19th century are lectures and slides associated with polar exploration. The race to the pole and the perception that the latter bore a relation to national identity and supremacy is visible in the slides with which Dr. Fridtjof Nansen lectured about his 1893–1896 expedition around the North Pole in the Albert Hall to an audience of 7,000. There Nansen

> […] held the close attention of the audience for nearly an hour and a half, while he told, without the assistance of manuscript, his story of the *Fram* and of the venture of himself and Lieut. Johansen. The story was illustrated with a series of about fifty slides projected on the screen, partly from photographs and partly from Dr. Nansen's own coloured sketches.[17]

The slides and lectures by Carsten Egeberg Borchgrevink (1900), and Capt. Roald Amundsen's slides taken from the voyage of the "Gjøa" through the North West Passage in 1903–1907 and subsequent South Polar Expedition 1911–1912, also evidence this. Yet in addition these sets demonstrate the RGS's openness to staging lectures by foreign speakers and its desire to contribute to a global community of explorers and, increasingly professionally trained, geographers. The Society, as a consequence, can be understood as having shaped their careers and the expeditionary cultures of a number of countries as well as those of Britain.

In age old fashion it was via stories, told with the medium of the lantern, that the RGS imagined, narrated and propagated its own history and past, and thereby shaped the identity of its fellowship and its future. African river exploration and the perceived triumphs of British explorers were revisited by Sir William Garstin in "Fifty Years of Nile Exploration, and Some of Its Results" (1908). Garstin's vivid language conveyed qualities which were beyond the technical ability of the camera:

> No one who has had the privilege of visiting those spots where the Nile encounters serious obstacles to its course is ever likely to forget their beauty. At the Ripon falls, for instance, the dark-green foliage, the bright-red cliffs, the indigo-coloured water, streaked with foam, and the blue sky overhead, combine to form an enchanting picture. At the Murchison falls, again, the wild accessories, the leap of the stream into the deep abyss, the continual roar of the imprisoned water, and the rainbow that ever plays upon the high-tossed spray, all create memories that linger long in the mind of the observer.[18]

The acute nostalgia for foreign places, such as that evidenced by Garstin's words, resonates across many lectures and in the post-lecture discussions in which audiences participated.

Celebrating the move from Savile Row to the Society's current premises in South Kensington, the African colonial officer Sir Harry Johnston also told stories of geographical storytellers by commemorating the "Centenary of the Birth of David Livingstone" in a lantern lecture (1913). He described Livingstone's "word-pictures" of the slave trade, his freeing of slaves and the assistance of the latter throughout his travels, and how in words and in pictures Livingstone recorded the sensual delight of his encounter with tropical vegetation and landscapes.[19]

In 1926 the former British Army officer, explorer and nature mysticist, Sir Francis Younghusband, shared his "Memories of the Shaksgam" and his travels in the Karakorum region bordering on China, Pakistan and Kashmir with a general evening audience in the Aeolian Hall on Bond Street. Following the event, Younghusband congratulated the RGS Secretary, Arthur Hinks, on his arrangements and expressed his pleasure that the event had passed off so well. "It was great fun giving it & telling old yarns", he confided. Younghusband may have spoken in an extempore fashion since he assured Hinks that he would "write out the more serious part".[20] Such findings, taken with a comment from Edmund George Barrow, one of the post-lecture discussants, that "My remarks

[...] were so disjointed, that the typed report you sent me was unfit for publication in a Journal such as that of the R.G.S.. I have therefore redrafted my remarks in more intelligible terms", suggest that the published lectures in the *Geographical Journal* provide an edited, perhaps not always accurate, account of what was actually said in meetings.[21] As the journal editor, Hinks' hand shaped the image of the society.

Seen and heard: the lantern lectures of women travellers

At the turn of the century the demographic of geographical storytellers diversified. The reform movement that started in the 1870s gained momentum in the 1880s. Despite successfully redirecting the Society's energies towards the geographical science and education, and engineering the adoption of the lantern, the 1893 push to admit women failed. The set of slides purchased from the Scottish-born traveller Isabella Bishop Bird and associated with the latter's lecture "A Journey in Western Sze-chuan" (1897) highlights that early dramatic attempt to diversify the fellowship, which resulted in the admission of Bird and just twenty-two other women.[22]

Nevertheless, between 1893 and the full admission of women in 1913, RGS fellows were intermittently exposed to women's ability to travel, record and narrate their experiences of topographical and cultural displacement just as well as men. The gradual hybridisation of the demographic of storytellers is seen in lectures given by independent female travellers as well as by husband and wife teams. For example, Mr J. Theodore Bent delivered the lecture "A Visit to the Northern Sudan" (1896) about his travels with his wife. The archaeologist and then president of the RGS, Dr. David G. Hogarth, lectured about the middle eastern political officer and archaeologist, Gertrude Bell, "Gertrude Bell's journey to Hayil" (1927), thereby demonstrating the recognition by the RGS of the valuable contributions made by women explorers and travellers to geographical knowledge despite Bell's own "lifelong indifference to what are called the Feminist Movements".[23] The commercial plant collector and botanist Francis Kingdom-Ward spoke about his travels with his wife, Florinda Norman-Thomson, in the evening lecture "Yangtse to Irrawaddy" (1923). It is uncertain who undertook the photography, but the presence of a woman likely facilitated relations with the local women who form the subject of so many of Kingdom-Ward's slides.

Later the diplomat, and RGS Gill Memorial Award winner, Percival Clarmont Skrine lectured in the Society's newly constructed hall in Exhibition Road, South Kensington, on "The Highlands of Persian Baluchistan" (1931) about journeys he had undertaken with his wife. Another diplomat, Harold Ingrams, delivered the lecture "The Hadhramaut in Time of War" (1944) to an evening meeting general audience. At least some of the slides projected in that lecture also featured in the children's Christmas lecture he delivered with his wife Doreen, titled "Young People of the Hadhramaut" (1945). These lectures were hybrid in their co-production by husband and wife teams. In the case of the

Ingrams, the harnessing of the same slides for two distinct audience demographics evidences hybridity, ambiguity and poly-valency of slides which featured in the telling of stories to various audience types.

Although they were organised on a somewhat informal basis, and delivered by RGS staff throughout the 1890s, children's Christmas lectures soon became a fixture. Paradoxically the RGS came to stage the very lantern treats to which some once objected. Additionally, it reveals that certain women were deemed appropriate speakers in specific types of lecture and audience. The slides for Olive MacLeod's 1912 lecture provide a lens through which to further observe the gradual opening of the RGS to women. Soon after returning from her 3,000-mile journey between 1910 and 1911, through what is today Cameroun, Nigeria and Chad, MacLeod wrote to John Scott Keltie, Secretary of the RGS, for advice about her photographs:

> Many of them could I believe be improved by scientific treatment, but I am told the ordinary professional won't take the trouble and that I ought to learn myself. – I am ignorant. – How would it be possible to find someone who would come and stay here. Look through the books to see exactly what ought to be done with each photo, and do some giving instruction the while. You arrange for lessons to be given to intending traveller fellows I believe, but of course I can't come within that category.[24]

She could not take part in the event since the RGS did not at that point admit women. Simpson was therefore dispatched to assist MacLeod in selecting images for her talk, and editing them. He also gave her some instruction in photography. She wrote to Keltie again:

> [...] the title, if our sex is to be brought forward at all, I am very anxious that it should be made plain that I was only one of two women. Would "Women's Experiences in the Central Sudan" do – or would "Through British, French and German Dependencies in Central Sudan" or something to that effect be better?[25]

MacLeod and Simpson's collaboration was positive. Yet her lecture, like most Children's lectures, was not published in the *Geographical Journal*.

Stories of human and physical science

Compared to European countries such as Germany and France, the academic discipline of geography was slow to develop in Britain. Following his lantern slide lecture "The Scope and Methods of Geography" at the RGS in 1887, Halford Mackinder became Reader in geography at the University of Oxford. In 1899 the Oxford School of Geography was founded. Cambridge founded its school of geography in 1903. The RGS was keen to cultivate its scientific credentials, but physical subjects, once deemed abstruse, had to be communicated in such a way that non-expert audiences at evening meetings could enjoy them.

Yet geographical knowledge was not only produced by universities and trained practitioners. The RGS nurtured diverse knowledge makers. MacLeod's published account, *Chieftains and Cities of Central Africa* (1912), is primarily a travelogue. However, it also evidences the dissemination, and thus populari-

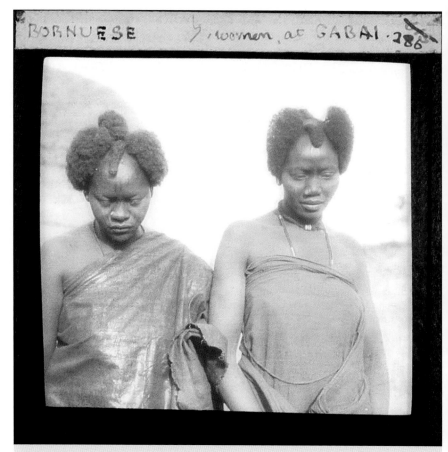

Fig. 2: "Bornuese Women at GABAI", RGS lantern slide set 286, made to illustrate a paper by
Miss Olive MacLeod on "A Lady's Journey in Central Sudan", read 11 January 1912.

sation, of notionally scientific anthropological ideas. In the Tuburi lake region,
where they were travelling amongst the Wadama people, MacLeod's fellow
traveller, Mr. Talbot, performed anthropometric measurements:

> Talbot summoned Mastaba and measured him, so that the Wadama might see no
> suffering was entailed. Presently the Bamm was induced to come, and after he had
> retired with a rich reward of salt his people crowded round. One after another
> they presented themselves; and as the salt sunk lower in the tin, so did our spirits
> flag. Mr Talbot's were high, however, and we fixed our thoughts on the
> enrichment of the world's knowledge. I do hope the Anthropological Society really
> appreciate the measurements they ask for. Mrs Talbot and I often wondered how
> much they do, for, to our untrained feminine minds, it seemed that general
> observations were just as effective as measurements.[26]

MacLeod's witty voice, humour and critical mind shine through, thereby
making up to some extent for the lack of journal manuscript in the RGS
archives.

MacLeod's account thus attests to the establishment of human sciences contingent to geography, and inter-disciplinary symbiosis. The study of the features of indigenous peoples and of their material culture was advocated in the multiple editions of the RGS-published travel guide, *Hints to Travellers General and Scientific*, which contained chapters on anthropology, written by Edward Burnett Tylor and later James Frazer.[27] It popularized anthropological knowledge. Although not professionally trained, MacLeod's attentiveness to anthropology is evident in the anthropological "type" images of hair-styles of Borneuse women (Fig. 2), dancing scenes and a medicine man, in which none of the individuals are named.[28] Following the guidelines advocated in *Hints to Travellers*, MacLeod acquired many objects on her travels. She later displayed them during the Christmas lecture to give form to her words.

The development of academic geography in Britain which overlapped with social science and anthropology, and its role as the discipline that sought to bridge the widening gap between the human and physical sciences, is seen in three sets of slides concerning Papua New Guinea, notably that by the colonial administrator who studied under the Cambridge anthropologist Alfred Cort Haddon, Ernest W.P. Chinnery on "The Opening of New Territory in Papua" (1920). In the post-lecture discussion, the Cambridge natural historian Alexander Frederick Richmond Wollaston was openly critical of imperialism. He pleaded for the creation of autonomous regions for the peoples of Papua New Guinea where "no traders, no missionaries, no exploiters, not even Government police themselves should be allowed to go".[29] Wollaston also read Charles H. Karius' "The first crossing of the Fly River to the Sepik, New Guinea" (1929). That paper, together with the Australian railway guard turned explorer, Michael Leahy's "The Central Highlands of New Guinea" (1935), evidence how such human subjects were enduring popular and fascinating to RGS audiences.

The RGS slides also tell stories about the practice of physical geography. The university expedition slides demonstrate the professionalisation of geography, and shifts in knowledge-making locations and practitioners. The RGS lent £100 and instruments, amongst which was a copy of *Hints to Travellers*, to the Cambridge University scientific survey of Edge Island in which "Gino" Watkins participated.[30] As a reviewer, Frank Debenham of the Cambridge University geography department, described Watkins's lecture as a "trifle immature", but thought his plain style would read well in the *Geographical Journal*. The lecture, he said, "with the slides should be of considerable popular interest".[31] The RGS had agreed to produce the slides with a view to retaining them in the collections thereby enabling Watkins, then still a student, to tour his lecture at other venues.[32]

The geologist James M. Wordie also lectured on his arctic expedition with Cambridge students to "Jan Mayen Island" (1921). In organising the event, Hinks stressed the importance of communicating the science so as to make it comprehensible and entertaining for non-specialists: "You will remember that

it is an evening meeting and that you don't want to be too technical in your geology. I suppose that you will speak to your slides rather than reading the paper solemnly."[33] Such findings reveal how carefully the secretaries cultivated the tone of lectures and the image of the Society even after the establishment of academic geography. Nevertheless, Hinks was not alone in fashioning the lectures; Simpson also helped to co-produce this particular lecture.[34]

The lantern slides associated with Michael Spender's "Further Work on the Great Barrier Reefs" (1929) demonstrate the arduous nature of his research. Hinks urged Spender to "[…] write out what you want to say in the paper with the idea that the more technical section may very well either be omitted from the reading, though printed in the narrative, or as an alternative relegated to an appendix in smaller type. It depends upon the nature of the case."[35] Spender understood that "the paper as read is usually shorter and less elaborate than that appearing in the journal", and although his lantern slides depicted in detail and at considerable length his fieldwork sites and experiments, he struggled to write the actual lecture.[36]

The sets of Henry Stavely Blunt, Sir Walter Caine Hillier and Captain J.A. Forrest are composite.[37] They contain slides from multiple sources including Newton & Co, 3 Fleet Street; Newton & Co, 37, King Street (Covent Garden) and Wigmore Street. The 70 slides of China from photographs by Sir W.C. Hillier and H.S. Blunt's small selection of slides representing the Indian Army (circa 1923–1927) are amongst these. The trade labels of the Autotype Co. and the firm of J. Lizars Opticians in Aberdeen are present in these donated sets.

These sets of slides were not used in RGS lectures. Additionally, when Simpson retired from the clerkship and production of slides, the Society experimented with various commercial slide-making firms, including Newton & Co. Originating as they do from multiple hands – not just those of the traveller or photographer in the notional field – with, often, divergent methods of production, the slides offer an object lesson in the collaborative nature of knowledge making. As examples of photographic slides with additional hand-colouring, or paper collage text, they constitute hybrid objects. These sets demonstrate the ubiquity of the lantern as a medium and its use in lectures beyond institutions such as the RGS. In such events, space itself was hybridised via the lantern. The diverse and distributed geography of lantern lectures, the creative storytelling and knowledge-making possibilities of the lantern slide medium and of lantern lectures, are perpetuated in the process of digital remediation and the Lucerna website.

Conclusion

Returning to Entrikin, this article shows that geographers did indeed tell stories. Yet geographers were not only storytellers, but also image makers and artists, and the visual and verbal images they produced interacted in powerful ways. This survey of just a few aspects of the lantern slide production process shows that it took place within and without of the RGS and points to its

collaborative, spatially and temporally-distributed nature. We thus need to pluralise understandings of the processes involved in the production of lantern slides and sets of slides so as to uncover the multiplicity of spaces involved in producing knowledge with the magic lantern. The precise work of the multiple "invisible technicians" and their "mindful hands" needs to be mapped set by set and slide by slide. Crangle's claim that lantern slide lectures comprise a species of "hybrid text" thus holds. Yet the image-objects of lantern slides need to be contextualised in relation to other sources and in terms of the often plural value systems in which they were produced, co-produced and reproduced.[38]

Notes

1. Nicholas Entrikin, *The Betweenness Of Place: Towards A Geography Of Modernity (Baltimore:* The Johns Hopkins University Press, 1991), 58.

2. Emily Hayes, "Geographical light: the magic lantern, the reform of the Royal Geographical Society and the professionalization of geography c. 1885–1894", *Journal of Historical Geography*, vol. 62, (October 2018): 24–36.

3. As part time post-doctoral Associate Research Fellow on the *A Million Pictures* project working with Dr. Joe Kember and Dr. Richard Crangle (University of Exeter) I was responsible for photographing, processing and cataloguing of 1,000 individual lantern slides from 30 sets in the collections. My role was to remediate the original glass slides into pixels for viewing on the free online Lucerna database (http://www.slides.uni-trier.de). The digitised slides include twenty-eight sets projected in RGS lectures and two sets not associated with RGS lectures, but which were donated to the Society.

4. I also photographed and digitised one set of 26 stereoscopic slides associated with Captain J. A. Forrest.

5. Richard Crangle, *Hybrid Texts: Modes of Representation in the Early Moving Picture and Related Media in Britain*, PhD diss. (University of Exeter, 1996), unpublished.

6. Lisa Roberts, Simon Schaffer and Peter Dear (ed.), *The Mindful Hand: Inquiry and invention from the late Renaissance to early industrialization* (Amsterdam: Royal Netherlands Academy of Arts and Sciences, Edita KNAW, 2007).

7. RGS Map Room Accession book 1882–1890, 460.

8. RGS/CB6/2057, letter from H.W. Simpson to the RGS, 2nd December 1889. This letter cannot be found by the RGS. Transcribed details of it come from Francis Herbert, former RGS Map Curator.

9. Clements R. Markham, "Address to the Royal Geographical Society", *The Geographical Journal*, vol. 26, no. 1 (July 1905): 5.

10. RGS Committee Minutes February 1918 – February 1926, Finance Committee, 20 March 1923, 177.

11. RGS Committee Minutes December 1938 – May 1940, Finance Committee, 18 March 1940, 165. Simpson manufactured eleven of the slide sets digitised in the *A Million Pictures* project.

12. Steven Shapin, "The invisible technician", *American Scientist*, vol. 77, no. 6 (1989): 554–563.

13. Felix Driver and Lowri Jones, *Hidden Histories of Exploration*, London, Royal Holloway and RGS-IBG, 2009.

14. Felix Driver, *Geography Militant: Cultures of Exploration and Empire* (Oxford: Blackwell Publishers, 2001).

15. Erkki Huhtamo, *Illusions in Motion. Media Archaeology of the Moving Panorama and Related Spectacles* (Cambridge, MA: MIT Press, 2013), 222–223.

16. H. R. H. Duke of Abruzzi, "The Snows of the Nile. Being an Account of the Exploration of the Peaks, Passes, and Glaciers of Ruwenzori", *The Geographical Journal*, vol. 29, no. 2 (February 1907): 121.

17. Dr. Fridtjof Nansen, "The Nansen Meeting in the Albert Hall. Presentation of the Special Medal", *The Geographical Journal*, vol. 9, no. 3 (March 1897): 249.

18. William Garstin, "Fifty Years of Nile Exploration, and Some of Its Results", *The Geographical Journal*, vol. 33, no. 2 (February 1909): 136.

19. Sir Harry H. Johnston, "Livingstone as an Explorer", *The Geographical Journal*, vol. 41, no. 5 (May 1913): 426 and 428.

20. RGS/CB9 1921–1930, letter from Francis Younghusband to Arthur Hinks, 15 February 1926, Currant Hall, 1.

21. RGS/CB9 1921–1930, letter from E.G. Barrow to Arthur Hinks, circa 19 February 1926, 1.

22. Avril M.C. Maddrell, *Complex Locations. Women's Geographical Work in the UK 1850–1970* (Chichester: Wiley-Blackwell, 2009), 28–31.

23. RGS/CB9/84, David G. Hogarth correspondence block 1921–1930, vol. 1 of 2, 20 October 1926, Arthur Hinks to David G. Hogarth, 2.

24. RGS/CB7/Keltie [1870–1926 P–Z]/Talbot, P.A./ Uncatalogued sub-file of letter from Olive MacLeod to John S. Keltie, 17 July 1911.

25. RGS/CB7/Keltie/Talbot, P.A./ Uncatalogued sub-file of letter from Olive MacLeod to John S. Keltie, 24 September 1911, 2–4.

26. Olive MacLeod, *Chieftains and Cities of Central Africa* (Edinburgh and London: William Blackwood & Sons, 1912), 90.

27. The Royal Geographical Society (ed.), *Hints to Travellers General and Scientific*, 6th edition (London: The Royal Geographical Society, 1889).

28. Such images were typical of this period, but they remain challenging for audiences, particularly for those related to the indigenous peoples concerned. It is vital to remain alert to their potentially sensitive content. Consequently, Lucerna has the facility to flag up slides bearing offensive content or language. The Lucerna database usefully specifies the attribution of titles with the categories 'found, attributed or unknown'. It is critical to consider how the cataloguing of such sources is complicated and how the process has the potential to perpetuate challenging historical categories and outlooks, which though once prevalent, are deemed unacceptable or criminal today.

29. F.R. Barton, George le Hunte, W.M. Strong, A.C. Haddon and A.F.R. Wollaston, "The Opening of New Territories in Papua: Discussion", *The Geographical Journal*, vol. 55, no. 6 (June, 1920): 457.

30. RGS/H.G Watkins/CB9 1921–1930, letter from Arthur Hinks to H.T. Morshead, 31 May 1927, 1.

31. RGS/H.G. Watkins/CB9 1921–1930, letter from Frank Debenham to Arthur Hinks, 19 January 1928, Department of Geography, Downing Street, Cambridge, 1.

32. RGS/H.G. Watkins/CB9 1921–1930, letter from Gino Watkins to Arthur Hinks, 12 [October 1927], Trinity College, Cambridge, 1.

33. RGS/CB9/159, letter from Arthur Hinks to James M. Wordie, 7 March 1921, 1.

34. RGS/CB9/159, letter from James M. Wordie to Arthur Hinks, 30 October 1921, St John's College, Cambridge, 1.

35. RGS/CB9/159, letter from Arthur Hinks to Michael Spender, 21 October 1929, 1.

36. RGS/CB9/159, letter from Michael Spender to Arthur Hinks, Frognal, Hampstead, 18 October 1929, 1.

37. The Lucerna database treats slides as three-dimensional objects rather than as images alone. By showing the whole slide including the title, commercial makers and number sequence Lucerna captures the numerous aspects of the networks of image flow, manufacture and thus hybridization by individuals, institutions and commercial firms across the *fin-de-siècle* era. The whole slide, rather than the image alone, is thus able to tell stories.

38. The amalgamation of visual and verbal imagery and of lantern slide and published article on Lucerna highlight the longevity of the mutual influence, or inter-mediality, of modes of geographical storytelling. The Lucerna database thus enables the Society's slides to transcend the physical space of the collections in the Society. The online platform prolongs the ongoing process of remediation, thereby enabling the slides to be seen by more people in more places who will assign new meanings to them, and thus use them to tell new stories and histories.

Joseph Wachelder

Science Becoming Popular:
Colour Slides, Colour Discs and Colour Tops

Over the last decades the popularisation of science has become an important frame for studying the abundant use of magic lantern slides, and Victorian Britain often served as the backdrop of inquiry.[1] Although science popularisation provides a promising alternative for technologically focused 'pre-cinema' accounts, the study of magic lantern practices from such a popularisation perspective comes with new challenges. The very notion of 'popularisation' tends towards one-directional dissemination practices, whereas historians of science commonly embrace constructivist, contextual or network approaches to study the co-evolution of science and society. This paper proposes a focus on 'science becoming popular' in order to grasp the manifold changes in science and society, and in their interactions, especially for the time period between 1800 and 1870. The specific wording aims at drawing attention to some simple observations, which are easily overlooked. For one, the magic lantern was not the only instrument used to raise the popularity of science. Microscopes[2] and educational or philosophical toys[3] served a similar goal. In the vocabulary of media scholars: it is relevant to pay attention to the "media landscape" and to "intermedial interactions". Moreover, technologies do not only enable dissemination practices; they can also serve in inquiry practices. Here too, media scholars endorse symmetrical approaches.[4] Finally, dissemination practices, like all forms of communication, operate selectively. Applying the above to colour slides, I will argue that lantern slides only gradually appropriated newly acquired insights regarding simultaneous colour contrasts, which were more easily demonstrated, by both professionals' and 'amateurs', as well as disseminated among the wider public by rotating colour tops.

A multi-faceted transition

Late 18th-century natural philosophy differed radically from late 19th-century scientific inquiry. Andrew Cunningham and Nicholas Jardine articulated the radical changes involved by referring to two "Scientific Revolutions": "[...] a first revolution around the turn of the sixteenth century, in which new mathematically and experimentally oriented branches of natural philosophy were created, and a second revolution around the turn of the eighteenth century, in which was formed the federation of disciplines that we call 'sci-

ence'".[5] Others have qualified the transition's dating and timeframe. James Secord, for instance, highlights the 1840s as the period in which the "status of the practitioner of knowledge was at a point of maximum flux".[6] Numerous studies have in fact attempted to pinpoint and elucidate this 19th-century transition in science, highlighting different relevant factors.

In this regard it is useful to distinguish between three different strands of research. First, scholars have looked at the increase of the number of universities, the democratisation of its student population and the emerging research-orientation of universities.[7] Secondly, some adopted a professionalisation perspective on both civic occupations and science. For Great Britain, for instance, the term "scientist" was coined by William Whewell in 1833. Gradually this label would replace "natural philosopher". Doing scientific research was no longer seen as a gentlemen's privilege; it became a profession. This went hand in hand with a different approach to studying nature. Whewell's coining of the term "scientist", on 24 June 1833 at the meeting of the recently-founded British Association for the Advancement of Science, was a direct response to Samuel Taylor Coleridge, who considered "natural philosopher" no longer an appropriate term.[8] As commented by Laura J. Snyder:

> Men digging in fossil pits, or performing experiments with electrical apparatus, hardly fit the definition. They were not, he meant, "armchair philosophers", pondering the mysteries of the universe, but practical men – with dirty hands, at that. As a "real metaphysician", he forbade them the use of this honorific. [...] If "philosophers" is taken to be "too wide and lofty a term", then, Whewell suggested, "by analogy with *artist*, we may form *scientist*".[9]

This development prepared the ground for a third strand of research, which focuses on changes in the sciences' internal classification, organisation and communication media. In this respect, Johann Heilbron rightly applauded[10] Rudolf Stichweh's transcendent *Zur Entstehung des modernen Systems wissen-schaftlicher Disziplinen. Physik in Deutschland 1740–1890*.[11] In this study, Stichweh argues that the distinctions between the sciences in the 18th century were based on hierarchies, either between different faculties (medicine, law, theology) or between different methodologies, ways of inquiry, such as mathematics, natural history and natural philosophy. In the first part of the 19th century a disciplinary organisation emerged, marked by new communication media (scientific journals), the deliberate choice of (mixed) methods and a more autonomous agenda setting by the scientific community. The interest in science popularisation I consider as the fourth and youngest strand of scholarship dealing with the transition of the sciences in the 19th century.

By introducing the short-cut "science becoming popular", I aim to draw attention to the complementarity of the abovementioned strands of scholarship. The popularisation of science was interwoven with changes pertaining to science and its approaches, content, organisation, institutionalisation, practitioners and audiences. In 19th-century Britain, for example, the ongoing professionalisation in science was counterbalanced by the flourishing of amateur scientists.[12] The establishment of chemical laboratories went hand in hand

with laboratory chests for home use.[13] In Germany, discipline formation in mathematics and the availability of teaching jobs at secondary schools reinforced each other.[14] The call to integrate the popularisation of science into wider narratives is hardly new, however. It was a core message of James Secord's 2004 presidential address on "knowledge in transit". He considered the creation of a subfield within the history of science devoted to the study of popular science a pitfall.[15] Instead, he advocated a focus on communication, in connection to the circulation of knowledge, which in his view should be centre-stage. Eventually, the core question to be answered is: "How and why does knowledge circulate?"[16] At the same time, according to Secord, one should not underestimate the interrelated challenges: "[...] we should think much more consistently about the problem, from the kinds of analytical resources we apply to the specific kinds of narratives we write".[17] Indeed, the study of "science becoming popular" might benefit from invoking new sources and interests, following Cooter and Pumfrey's earlier advice to move "towards a greater plurality of signifiers of scientific activity", in order to grasp the dynamics and interactions between science and its publics.[18]

Despite the increased attention for science as visual culture, many studies of communication still base their argument exclusively on texts, implying an asymmetrical distribution of authority. As to the first, a careful look at magic lantern shows used for the dissemination of knowledge may be productive. Scholarship about the lantern shows in the Royal Polytechnic Institution – particularly those by John Henry Pepper[19] – and other venues has revealed new aspects of Victorian science. For example, Iwan Rhys Morus drew a link between the illusionary shows and Scottish sensationalist philosophy, to demonstrate that bodily sensation and spectacle still played an important role in Victorian science, while concomitantly attenuating the idea of the 19th century as an age of widespread belief in mechanical objectivity. For Morus, David Brewster's *Letters on Natural Magic* (1832) served as a go-between. Brewster created a framework legitimising the interest in illusion, to avoid being misled and to clearly understand nature.[20] However, the asymmetrical distribution of authority continued to persist in spectacular shows. As argued by Morus in the paper's conclusions: "The production of spectacle – the appeal to visual sensation – clearly continued to offer a plausible route to the production of authority for Victorian scientific performers".[21] Without contesting this conclusion, I would like to suggest that different, more symmetrical relationships might be found in another vehicle for "making science popular": educational toys.

An intermedial approach: colour slides, colour discs and colour tops

Magic lantern shows made science popular, for sure. But they were not the only contrivance to do so. Educational, rational and philosophical toys started to become widespread and important in the first part of the 19th century as

well.[22] They too can be linked to Scottish sensationalist philosophy, with Thomas Beddoes, Maria Edgeworth and Peter Mark Roget serving as go-betweens.[23] There are three main arguments why the study of "science becoming popular" can be enriched by taking educational toys into account, parallel to magic lantern shows. First, toys have been in various ways connected to scientific practice. Active scientists often engaged in their design. In some cases, the dividing line between toys and scientific apparatus was thin, especially when different versions were manufactured for youngsters and amateurs. For instance, the back of the booklet *The Model Steam Engine* was used to promote a volume on the magic lantern in the same series on *How to buy, how to use, how to make it*. Specifically, the publisher quoted a review from the *Wolverhampton Chronicle*:

> No optician desiring to increase the sale of the instruments it describes, will allow this attractive volume to be absent from the window, and we are glad to find, that while it contains matter from which the most experienced may gain, a 'wrinkle', 'A Chapter For Children' is not omitted, so that the little ones may have and enjoy their Magic Lantern, as well as the man of science.[24]

Secondly, toys provided a more symmetrical relationship between its author/designer and its users than could be established by a magic lantern show. In such a show the presenter is the authority, while the members of the audience have a rather 'passive' role, despite their physical presence and the bodily sensation. In contrast, toys and games can always be played against the grain. To conceptualise this, Maaike Lauwaert distinguishes in the "geography of play" between core and periphery. The core refers to facilitated play practices, following, among others, the "structure of a toy, its technical specificities, its materiality, the rules and manuals, examples and guidelines, its 'reputation' and connotations".[25] Yet the periphery, Lauwaert argues, is crucial in the geography of play as well: "[P]laying is in essence experimentation and boundary testing, which inevitably results in play activities outside what has been facilitated or prescribed".[26] Play and experiment, in other words, can have a lot in common. Thirdly, magic lantern shows seem to have privileged effects, in particular regarding light and colour, by utilising persistence of vision above demonstrating other recently acquired insights. To what extent this observation is related to the *dispositif* of the lantern show, or an artefact of selective sources previously studied in the context of 'pre-cinema' history, needs further study.[27] The observation of privileging persistence of vision effects, might not apply to polarisation. Yet newly acquired insights regarding simultaneous colour contrast and colour mixing were primarily mediated, acquired and/or disseminated by colour tops. These were only partly, and belatedly, disseminated in magic lantern shows.

Colour slides were an important and recurring element in magic lantern shows. So-called chromatropes, which consisted of two discs rotating in reverse directions, produced spectacular, inward or outward, moving phenomena,[28] to some extent comparable to those produced by Brewster's kaleidoscope (1817),[29] a gadget which caused an extreme and completely unexpected craze.[30]

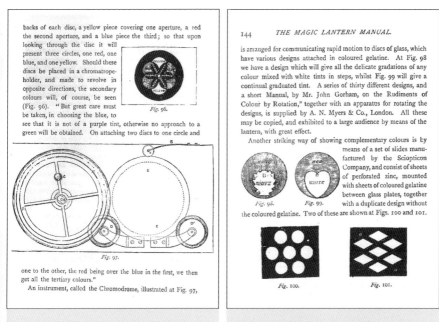

backs of each disc, a yellow piece covering one aperture, a red the second aperture, and a blue piece the third; so that upon looking through the disc it will present three circles, one red, one blue, and one yellow. Should these discs be placed in a chromatrope-holder, and made to revolve in opposite directions, the secondary colours will, of course, be seen (Fig. 96). "But great care must be taken, in choosing the blue, to see that it is not of a purple tint, otherwise no approach to a green will be obtained. On attaching two discs to one circle and

Fig. 96.

Fig. 97.

one to the other, the red being over the blue in the first, we then get all the tertiary colours."
An instrument, called the Chromodrome, illustrated at Fig. 97,

144 *THE MAGIC LANTERN MANUAL.*

is arranged for communicating rapid motion to discs of glass, which have various designs attached in coloured gelatine. At Fig. 98 we have a design which will give all the delicate gradations of any colour mixed with white tints in steps, whilst Fig. 99 will give a continual graduated tint. A series of thirty different designs, and a short Manual, by Mr. John Gorham, on the Rudiments of Colour by Rotation," together with an apparatus for rotating the designs, is supplied by A. N. Myers & Co., London. All these may be copied, and exhibited to a large audience by means of the lantern, with great effect.
Another striking way of showing complementary colours is by means of a set of slides manufactured by the Sciopticon Company, and consist of sheets of perforated zinc, mounted with sheets of coloured gelatine between glass plates, together with a duplicate design without the coloured gelatine. Two of these are shown at Figs. 100 and 101.

Fig. 98. *Fig. 99.*

Fig. 100. *Fig. 101.*

Fig. 1: Chadwick, *The Magic Lantern Manual* (2nd edition), 143.

Fig. 2: Chadwick, *The Magic Lantern Manual* (2nd edition), 144.

Henry Langdon Child (1781–1874), who throughout his life was involved in projections, is mostly considered the genius behind the chromatrope. Its first appearance dates from the 1830s,[31] or 1844 at the latest.[32] Dating is difficult, in part because chromatropes built on slides called "Artificial Fireworks", which utilised one rotating disc masked by another. Chromatropes were manufactured in many different guises, and tinkered to produce even more stunning special effects. It led to a proliferation of names for slides producing different spectacular effects, utilising the phenomenon known as persistence of vision. Chromatropes were often used at the beginning or as apotheosis, heralding the end of a lantern show.[34]

Despite the popularity of chromatropes, not all colour effects produced by colour tops were reproduced in lantern shows. This observation is from the 1880s, when *The Popular Educator* noted in the context of a newly invented "Chromatic wheel": "The effects of the colour top had not been displayed on the screen".[34] Manchester based William Isaac Chadwick provides another example. He devoted two pages to colour experiments in his *The Magic Lantern Manual*.[35]

The two figures above, depicting texts and illustrations from Chadwick's *The Magic Lantern Manual*, elucidate what an intermedial approach, taking optical toys into account, can add. Figures 98 and 99, which are reproduced here, stem directly from John Gorham's paper "The Rotation of Coloured Discs applied to facilitate the Study of the Laws of Harmonious Colouring, and to the

Multiplication of Images of Objects into Kaleidoscopic Combinations", published in the January 1859 issue of the *Quarterly Journal of Microscopical Science*.[36] It is to be situated in the mid-19th-century educational reform movement.[37] The *Quarterly Journal of Microscopical Science*, founded in 1853, is a good example of the rapidly expanding market of popular science periodicals in the middle decades of the 19th century.[38] Gorham indicated that the device, together with the discs for producing the kaleidoscopic effects, could be procured from the publishers, Messrs. Smith, Beck, and Beck, Opticians, 6, Coleman Street, London. Later on, the A.N. Myers firm also produced Kaleidoscopic Colour Tops, a cheap version for children and a fancy edition in a "polished mahogany box, with directions for use".[39] In a rather casual reference to "gradations of any colour mixed with white tints in steps" and other ways of "showing complementary colours" (see Fig. 2), Chadwick lightly touches on the core of Gorham's experiments, which entailed playing with Michel-Eugène Chevreul's laws of simultaneous contrast phenomena (after their gaining popularity in the context of the Great Exhibition).[40] It is telling that John Henry Pepper, in 1860, in his description of the Kaleidoscopic Colour-top invented by "John Graham [sic], of Tunbridge" exclusively focuses on the second part of Gorham's paper, showing kaleidoscopic effects employing persistence of vision.[41] This fits in the historiographical pattern of overlooking the interactions between Chevreul and Joseph Plateau in the 1830s.[42]

In the above I have argued that the study of lantern slides for educational goals, more specifically the "popularisation of science", may benefit from an interactionist and intermedial approach. Popularisation affects the dynamics of science and vice versa. Lantern shows functioned in a landscape of other media, such as educational toys. Certain effects, such as simultaneous colour contrasts, were more easily demonstrated, and became an object of experimentation, with help of rotating colour tops. Notwithstanding the popularity of chromatropes in lantern shows, the above-mentioned colour effects were only belatedly disseminated by lanternists. As regards colour effects, I would like to suggest that Tom Gunning's claim about the cinema of attractions should be moved 40 years backwards in time.[43] It seems that for much of the 19th century, lanternists, with respect to colour effects, were primarily engaged with spectacular effects rather than with educational narratives. This is in line with Edward Groom, who around 1865 promoted the application of the magic lantern for educational aims, at the expense of entertainment.[44]

Acknowledgement: I would like to thank Ton Brouwers for his wonderful copy-editing. All remaining flaws are mine.

Notes

1. See, for example, Bernard Lightman, *Victorian Popularizers of Science. Designing Nature for New Audiences* (Chicago and London: University of Chicago Press, 2007); Aileen Fyfe and Bernard Lightman (ed.), *Science in the Marketplace. Nineteenth-Century Sites and Experiences* (Chicago and London: University of Chicago Press, 2007); Joe Kember, John Plunkett and Jill A. Sullivan (ed.), *Popular Exhibitions, Science and Showmanship, 1840–1910* (Brookfield, Vermont USA: Pickering & Chatto, 2012).

2. See Alison D. Morrison-Low, *Making Instruments in the Industrial Revolution* (Aldershot, Hampshire: Ashgate, 2007), 233–234; Lea Beiermann, "'Microscopical Science': Building an Instrumental Community in London's Periodical Press 1860–1880", MPhil. thesis (Maastricht University, 2017).

3. See Joseph Wachelder, "Toys as Mediators", *Icon: Journal of the International Committee for the History of Technology*, vol. 13 (2007): 135–169.

4. See José van Dijck, "Picturizing science: The science documentary as multimedia spectacle", *International Journal of Cultural Studies*, vol. 9, no. 1 (2006): 5–24.

5. Andrew Cunningham and Nicholas Jardine, "The age of reflexion", in Andrew Cunningham and Nicholas Jardine (ed.), *Romanticism and the Sciences* (Cambridge: Cambridge University Press, 1990), 1–9, here 1.

6. James Secord, *Victorian Sensation. The Extraordinary Publication, Reception, and Secret Authorship of Vestiges of the Natural History of Creation* (Chicago and London: University of Chicago Press, 2000), 405.

7. As an introduction may serve Rainer Christoph Schwinges (ed.), *Humboldt International: Der Export des deutschen Universitätsmodells im 19. und 20. Jahrhundert* (Basel: Schwabe & Co. AG, 2001); see also Ana Simões, Maria Paula Diogo and Kostas Gavroglu (ed.), *Sciences in the Universities of Europe, Nineteenth and Twentieth Centuries. Academic Landscapes* (Dordrecht: Springer, 2015).

8. Whewell refers to this in an anonymous review of "On the Connexion of the Physical Sciences. By Mrs. Somerville", published in *Quarterly Review*, vol. 51, no. 101 (March 1834): 54–68, 59; retrievable via https://babel.hathitrust.org/cgi/pt?id=mdp.39015074711394&view=1up&seq=64 (accessed on 25 August 2019).

9. Wonders & Marvels: Laura J. Snyder, "Inventing the Scientist" (accessed on 26 April 2018, http://www.wondersandmarvels.com/2011/01/inventing-the-scientist.html).

10. Johann Heilbron credits Stichweh, next to Foucault, for offering the main, distinct sociological interpretations of the rise of disciplinary science. See Johann Heilbron, "A Regime of Disciplines: Toward a Historical Sociology of Disciplinary Knowledge", in Charles Camic and Hans Joas (ed.), *The Dialogical Turn. New Roles for Sociology in the Postdisciplinary Age. Essays in Honors of Donald N. Levine* (Lanham, MD: Rowman & Littlefield Publishers, 2004), 23–42, here 27.

11. Rudolf Stichweh, *Zur Entstehung des modernen Systems wissenschaftlicher Disziplinen. Physik in Deutschland 1740–1890* (Frankfurt am Main: Suhrkamp Verlag, 1984).

12. See Ann Secord, "Science in the Pub: Artisan Botanists in Early Nineteenth-Century Lancashire", *History of Science*, vol. 32, no. 3 (1994): 269–315; Adrian Desmond, "Redefining the X Axis: 'Professionals,' 'Amateurs' and the Making of Mid-Victorian Biology – A Progress Report", *Journal of the History of Biology*, vol. 34, no. 1 (2001): 3–50; Ruth Barton, "'Men of Science': Language, Identity and Professionalization in the Mid-Victorian Scientific Community", *History of Science*, vol. xli, no. 1 (2003): 73–119.

13. See Brian Gee, "Amusement Chests and Portable Laboratories: Practical Alternatives to the Regular Laboratory", in Frank A. J. L. James (ed.), *The Development of the Laboratory. Essays on the Place of Experiment in Industrial Civilization* (Houndmills: MacMillan Press, 1989), 37–59; Bee Wilson, *Swindled. The dark History of Food Fraud, from Poisoned Candy to Counterfeit Coffee* (Princeton, N.J.: Princeton University Press, 2008), here 1–45; Melanie Keene, "From Candles to Cabinets: 'Familiar Chemistry' in Early Victorian Britain", *Ambix*, vol. 60, no. 1 (2013): 54–77.

14. See Gert Schubring, "Pure and Applied Mathematics in Divergent Institutional Settings in Germany: The Role and Impact of Felix Klein", in David Rowe and John Mc Cleary (ed.), *The History of Modern Mathematics*, vol. II (Boston: Academic Press, 1989), 171–220.

15. James Secord, "Knowledge in Transit", *Isis*, vol. 95, no. 4 (2004): 654–672, here 670.

16. Ibid., 655.

17. Ibid., 656.

18. Roger Cooter and Stephen Pumfrey, "Separate spheres and public places: reflections on the history of science popularization and science in popular culture", *History of Science*, vol. 32, no. 3 (1994): 237–267, here 255.

19. See Lester Smith, "Entertainment and Amusement, Education and Instruction", in Richard Crangle, Mervyn Heard and Ine Van Dooren (ed.), *Realms of Light. Uses and Perceptions of the Magic*

Lantern from the 17th to the 21st Century (London: The Magic Lantern Society, 2005), 138–145; Bernard Lightman, "The Showmen of Science: Wood, Pepper, and Visual Spectacle", in Bernard Lightman (ed.), *Victorian Popularizers of Science. Designing Nature for New Audiences* (Chicago and London: University of Chicago Press, 2007), 167–218; Jeremy Brooker, "The Polytechnic Ghost", *Early Popular Visual Culture*, vol. 5, no. 2 (2007): 189–206; Brenda Weeden, *History of the Royal Polytechnic Institution 1838–1881. The Education of the Eye* (Chesterton: Granta Editions, 2008).

20. See Iwan Rhys Morus, "Illuminating illusions, or, the Victorian art of seeing things", *Early Popular Visual Culture*, vol. 10, no. 1 (2012): 37–50.

21. Ibid., 49.

22. See Joseph Wachelder, "Toys, Christmas Gifts and Consumption Culture in London's *Morning Chronicle*, 1800–1827", *Icon: Journal of the International Committee for the History of Technology*, vol. 19 (2013): 13–32.

23. See Hugh Torrens and Joseph Wachelder, "Models, Toys and Beddoes' struggle for Educational Reform 1790–1800", in Trevor Levere et al. (ed.), *The Enlightenment of Thomas Beddoes. Science, Medicine and Reform* (London and New York: Routledge, 2017), 206–237.

24. Quoted in "A Steady Stoker", *The Model Steam Engine. How to Buy, How to Use, and How to Construct it* (London: Houlston and Wright, 1868), back cover.

25. Maaike Lauwaert, *The Place of Play. Toys and Digital Cultures* (Amsterdam: Amsterdam University Press, 2009), 12–13.

26. Ibid., 13.

27. See Christoph Hoffmann, "Die Unterwerfung der Sinne: Joseph Plateau, das Phénakistiscope, Jonathan Crary, Friedrich Kittler", in Daniel Gethmann and Christoph B. Schulz (ed.), *Apparaturen bewegter Bilder* (Münster: LIT Verlag, 2006), 81–95.

28. I would like to thank the Museu del Cinema in Girona for allowing me to study their complete collection of chromatropes. Specifically I would like to express my utmost gratitude to Montse Puigdevall Noguer for her support in guiding me through the collection.

29. See *The Magic Lantern. How to Buy and How to Use It. Also How to Raise a Ghost. By "A Mere Phantom"*, (London: Houlston and Sons, 1874), 60.

30. Morrison-Low, *Making Scientific Instruments*, 224–226.

31. See Laurent Mannoni and Donata Pesenti Campagnoni, *Lanterne magique et film peint. 400 ans de cinéma* (Paris: Éditions de la Martinière / La Cinémathèque française, 2009), 226.

32. See entry "chromatrope (or chromotrope)", in David Robinson, Stephen Herbert and Richard Crangle (ed.), *Encyclopaedia of the Magic Lantern* (London: The Magic Lantern Society, 2001), 67.

33. See ibid., 67; see also Ludwig Vogl-Bienek, "Opera on the Lantern Stage", in Crangle et al., *Realms of Light*, 239–245, here 245.

34. "Recreative Science", in *The Popular Educator* (1880s), quoted in "Chromodrome", in Robinson et al., *Encyclopaedia of the Magic Lantern*, 68.

35. William I. Chadwick, *The Magic Lantern Manual. With one hundred and five Practical Illustrations*, 2nd revised edition (New York: Scovill Manufacturing Company, 1886).

36. John Gorham, "The Rotation of Coloured Discs applied to facilitate the Study of the Laws of Harmonious Colouring, and to the Multiplication of Images of Objects into Kaleidoscopic Combinations", *Quarterly Journal of Microscopical Science*, vol. VII (January 1859): 60–78, Reprint London: J. E. Adlard, 1859 (accessed on 5 August 2019, https://books.google.nl/books?id=ZrdbAAAAcAAJ&printsec=frontcover&hl=de&source=gbs_ge_summary_r&cad=0#v=onepage&q&f=false).

37. See Morrison-Low, "Making Scientific Instruments"; Roy M. MacLeod, "Education – Scientific and Technical", in Roy M. MacLeod, *The 'Creed of Science' in Victorian England* (Aldershot: Ashgate, 2000 [1977]), 196–225; David Layton, *Science for the People: The Origins of the School Science Curriculum in England* (London: Allen and Unwin, 1973).

38. See Susan Sheets-Pyenson, "Popular science periodicals in Paris and London: The emergence of a low scientific culture, 1820–1875", *Annals of Science*, vol. 42, no. 6 (1985): 549–572.

39. Pollock's Toy Museum in London holds a copy of A.N. Myers and Co.'s *Descriptive Catalogue* (n.d.): "Kaleidoscopic Top for Children. This Toy illustrates a few of the almost countless

experiments, which may be shown with the instrument known as Gorham's Kaleidoscopic Colour Top".

40. See Wachelder, "Toys as Mediators".

41. John Henry Pepper, *The Boy's Playbook of Science Including the Various Manipulations and Arrangements of Chemical and Philosophical Apparatus required for the successful performance of scientific experiments. An illustration of the elementary branches of chemistry and natural philosophy, illustrated with upwards of 400 Engravings chiefly executed from the Author's sketches, by H.H. Hine* (London: Routledge, Warne, and Routledge, New York: Walker Street, 1860), 318.

42. See Joseph Wachelder, "Nachbilder, Natur und Wahrnehmung: Die frühen optischen Untersuchungen von Joseph Plateau", in Gabriele Dürbeck et al. (ed.), *Wahrnehmung der Natur – Natur der Wahrnehmung. Studien zur Geschichte visueller Kultur um 1800* (Dresden: Verlag der Kunst, 2001), 251–273.

43. Tom Gunning, "The Cinema of Attractions: Early Film, Its Spectator and the Avant-Garde", in Thomas Elsaesser (ed.), *Early Cinema. Space Frame Narrative* (London: British Film Institute, 1990), 56–62; see Nicolas Dulac and André Gaudreault, "Circularity and Repetition at the Heart of the Attraction: Optical Toys and the Emergence of a New Cultural Series", in Wanda Strauven (ed.), *The Cinema of Attractions Reloaded* (Amsterdam: Amsterdam University Press, 2006), 227–244.

44. Edward Groom, *The Art of Transparent Painting on Glass for the Magic Lantern: comprising the method of painting and an account of the implements and materials employed in producing subjects for dissolving views, etc.; also chromatropes, and mechanical slides and contrivances for obtaining effects of motion and varying colours*. With twelve Illustrations (London: Windsor and Green, Rathbone Place, (n.d. [ca. 1865]), reprinted in Stephen Herbert (ed.), *A History of Pre-Cinema*, vol. 2 (London and New York: Routledge, 2000), 245–295, here 248–249.

Concepts of Lantern
Historiography

Francisco Javier Frutos-Esteban and Carmen López-San Segundo

An Approach to the Discursive Genre of Magic Lantern Slides

In the context of the research project *A Million Pictures: Magic Lantern Slide Heritage as Artefacts in the Common European History of Learning*, the University of Salamanca research team performed an empirical study of magic lantern slides employing content analysis in order to classify them according to their discursive genre. Content analysis is a method that allows the content of any material of human communication to be investigated in detail, and it can be an essential tool in the ordered description of communicative and cultural repertoires. The use of content analysis in this study was considered appropriate, as it is a scientific method for organising and classifying a collection of magic lantern slides. Content analysis is based on reading messages as a tool for gathering information, establishing the accumulated recurrence of elements in order to statistically evaluate their internal relationships, to subsequently form indicators that define a standard vocabulary. Achieving this goal involves the following steps: (a) formulation of objectives and (b) of a hypothesis, (c) conceptualisation of relevant or critical variables, (d) rendering these relevant variables operative, (e) devising the codebook and the coding form, (f) selecting a sample group, included the magic lantern slides of the Museu del Cinema – Col.lecciò Tomàs Mallol, and training researchers to encode the samples, (g) encoding the sample and checking the reliability of the coding procedure

Fig. 1: Content Analysis Guidelines.
Compiled by the authors.

169

(Fig. 1). The results have to check if the empirical study has been productive and if the hypothesis initially formulated has been confirmed.

(a) The formulation of objectives

We formulated the following objectives for our content analysis:

(1) To classify magic lantern slides without taking as starting point the content of the images on their own, and without depending on their content, chronological dating or geographical origin.

There are many kinds of slides: from the most common commercial slides made on glass to the exceptional and rare slides with complex moving mechanisms made for entertainment or scientific demonstration, hand-painted slides, or the slides for the cinematographic lantern distributed in the early 20th Century.

(2) To define a typology of magic lantern slides derived from their discursive genre in order to develop and implement a standard vocabulary for describing and cataloguing magic lantern slides.

(b) The formulation of a hypothesis

Our working hypothesis was the following: magic lantern slides show regularities concerning the discursive genre that informs their content.

(c) Conceptualisation of relevant or critical variables

This concerns variables that become central in developing a good understanding of a sample of messages according to the aims and hypotheses of the study. This usually requires a prior qualitative immersion in the object of study. Within the framework of content analysis, the conceptual definition of a variable is a kind of declaration of what one wants to measure in the messages. A variable is a dimension or characteristic of a study object that can have different values. The act of defining a variable implies that values can be established, and this in turn implies nothing but measuring them, although always in relation to a referential theoretical frame. Scrutinising the magic lantern slide is necessary for the reading, but it is not sufficient in itself: because of that, in audio-visual production it is necessary to refer to the concept of the 'discursive genre'. The discursive genre is a constant element and it affects how the message is processed.

However, this is where the first dilemma appears: does analysing the material of the medium make sense, or is it better to analyse the surface on which the images are presented, i.e. the projection screen? This can be solved by maintaining a balance: the screen is where to measure the discursive genre and its indicators in magic lantern slides, although based on examining the medium which is accessible, i.e. the slide itself. The discursive genre could be identified as a variable relevant enough to be the organisational criterion, that is a standard able to offer a typology of magic lantern slides according to the principles of mutual exclusion, uniformity, completeness, relevance, unmistakableness and productivity.

(d) Rendering the relevant variables operative: The system of categories

The discursive genre indicates the existence of a preexisting scheme that favours the perception, understanding and recall of the messages contained in the magic lantern slides. The discursive genre would constitute the constant element of the slides and, therefore, it not only influences how the message is processed, but could also serve as a good criterion to produce a standard vocabulary for magic lantern slides. Given that each magic lantern slide is the unit to be analysed, and the series of slides is the context unit, the next step is to make this operative, that is to transform theoretically relevant variables (discursive genre) into empirical variables or indicators, and then obtain a system of categories that permits their quantification and facilitates their codification. Since there was no previous or verified system of categories that would have allowed quantifying the discursive genre, a new one was created *ex professo*.

(e) Devising the codebook and the coding form

The codebook is a document that includes all relevant variables and categories used in the research. It records a short name, a definition, a numeric or alphanumeric code for each of them, a name, and, if necessary, illustrative examples. A codebook serves as an instruction manual designed to fit each content analysis research study. According to Igartua, a codebook can be defined as a sort of questionnaire that the analysts fill in as if they were pollsters asking questions to themselves and answering them, depending on how each unit of analysis is read, heard or displayed.[1] Our codebook establishes the magic lantern slide as the unit of analysis and aims to systematically collect information about the discursive genre as a theoretical construct, based on two kinds of observations: first, a *direct one*, understand the magic lantern slide as a material element of cultural heritage, and second, another *indirect one*, obtained from an interpretation on what the screen image from the slide in a magic lantern show would look like. For this second element, we also took into account whether there were other relevant performance elements to interpret this screen image. This second, indirect observation must be inferred from additional documentation accompanying the slide, such as readings or printed brochures, the testimony of observers of the time or the hypotheses of researchers in the field.

To achieve the target set in this study, our codebook has operational definitions for each of the relevant variables that we suspect to articulate the discursive genre. The discursive genre as a theoretical construct applicable to magic lantern slides refers to the existence of a prior 'mindset' (both of the viewer and the 'lanternist') which promotes and conditions the production, exhibition and reception of the message contained in the images – in the course of any magic lantern performance/show. The discursive genre refers to both the technical and formal aspects of the 'projection on the screen' of the slides for any magic lantern performance/show, such as to how to organize and imple-

ment all social and communicative human activities linked to the 'reading', 'interpreting' or 'staging' of these performances/shows. The discursive genre applied to the magic lantern connects Russian theorist Mikhail Bakhtin's classical reflections regarding genre. For Bakhtin, the notion of genre not only refers to an aesthetic category, but it defines various workings of language in the social sphere or a type of relatively stable 'statements' made in the various action areas of human activity.[2]

Since the discursive genre in the context of the magic lantern as a social medium works as a system of expectations for both the receivers and the senders, and as a model for producing meaning, the assembly of the relevant variables associated with the production, exhibition and reception conditions of graphically registered contents in magic lantern slides is proposed as its operational definition. These conditions allow the viewers a relative mastery of their care processes and information processing; likewise they provide guidelines to lanternists on their production routines and/or display of magic lantern shows/performances. For greater clarity, this codebook divides the chosen variables to operationalize the discursive genre as a mediator with a formal and social character into three groups:

(1) The 'graphic production conditions'-set is composed of variables associated with the 'format', the 'graphic record' and 'graphic coding'.

(2) The 'scenic public exhibition conditions'-set is composed of the variables 'commercial orientation of the device', 'social context' and 'scenic complexity'.

(3) The 'conditions of reception regarding cultural contents'-set is composed of 112 variables that connect the 'discursive genre' of magic lantern slides to the great cultural traditions for transmitting content: visual, musical, literary and scientific.

(1) Variables of the 'Graphic Production Conditions'

1.1. *Format*

The format – like the other variables that are discussed in the codebook – is operationally defined and considers two kinds of observations mentioned above: the *direct one*, taking into account the structural configuration of the magic lantern slide; and the *indirect one*, predicting the final graphic result from the plate once its image or images are projected on the screen of a magic lantern session. From these observations, an operational definition of seven parameters or indicators is proposed: (1.1.1) structural dependence, (1.1.2) structural mobility, (1.1.3) movement axis, (1.1.4) movement method, (1.1.5) time-space treatment, (1.1.6) material configuration and (1.1.7) morphological configuration.

1.1.1. Structural dependence

Level of dependence on the use of external methods to project a sequence of magic lantern slides onto the screen. External methods can be mechanical (using a sequencer base in the viewing holder) and/or lighting (using a compound system of projection).

0 = Clearly unidentifiable (should be a residual category).

1 = Independent: The magic lantern slide does not depend on external methods to create a sequence of images.

2 = Dependent: The magic lantern slide depends on external methods to sequence the images.

1.1.2.Structural mobility

Level of mobility of the inner structure of the magic lantern slide.

0 = Clearly unidentifiable.

1 = Fixed: No mobility of the inner structure of the magic lantern slide.

2 = Mobile: Mobility of the inner structure of the magic lantern slide.

1.1.3.Movement axis

Movement axis of the slide in relation to the optical system of the magic lantern or movement axis in relation to the magic lantern itself.

0 = Clearly unidentifiable.

1 = Horizontal: The magic lantern slide glides across the horizontal axis.

2 = Vertical: The magic lantern slide glides across the vertical axis.

3 = Longitudinal: The magic lantern slide glides simultaneously across the vertical and the horizontal axis.

4 = Central: The magic lantern slide spins around its own geometric centre.

5 = Noncentral: The magic lantern slide spins around a point that is not its own geometric centre.

6 = Mixed: The magic lantern slide glides across an axis and spins around a point.

1.1.4.Movement method

Mechanism that allows the movement of the inner structure of the magic lantern slide.

0 = Clearly unidentifiable.

1 = Sliding: The magic lantern slide moves using tracks.

2 = Shutter: The magic lantern slide moves using opaque shields.

3 = Blinds: The magic lantern slide moves using cylinders.

4 = Pulley: The magic lantern slide moves using grooved wheels that can move around an axis. Around each channel, there is a string whose two ends control, respectively, power and resistance.

5 = Zip: The magic lantern slide moves because of pieces that engage others. For example, a jagged metal bar that engages a pinion and turns a circular movement into a linear one or the other way around.

6 = Mixed: The magic lantern slide moves through a system that combines two or more of the above-mentioned procedures.

Fig. 2: Lapierre, 1860. Magic Lantern Slide, "Don Quichotte". France, 5 x 20.8 x 0.1 cm. Museu del Cinema – Col.lecció Tomàs Mallol.

1.1.5. Time-space treatment

Treatment of spatial representation, proximity in time or space-time relationship of the sequence of images registered in the magic lantern slides.

0 = Clearly unidentifiable.

1 = Elliptical: The time-space information image sequence is represented so that it suppresses spatiotemporal fragments of the action or story.

2 = Unabridged: The time-space information of the sequence of images is represented in a diachronic way.

1.1.6. Material configuration

Combination of materials that forms the magic lantern slide.

0 = Clearly unidentifiable.

1 = Exempt: The magic lantern slide is made of a piece of glass without frame or with a frame made of paper (Fig. 2).

2 = Mounted: The magic lantern slide is made of one or more pieces of glass with a metallic or wooden frame (Fig. 3).

Fig. 3: 1890. Magic Lantern Slide, "Chromatrope". 10.6 x 25.6 x 1.5 cm. Museu del Cinema – Col.lecció Tomàs Mallol.

1.1.7.Morphological configuration

Level of complexity of the inner structure of the magic lantern slide.

0 = Clearly unidentifiable.

1 = Simple: The magic lantern slide structure shows a morphological configuration composed of one or no mechanism for movement.

2 = Complex: The magic lantern slide structure shows a morphological configuration composed of two or more mechanisms for movement.

1.2. *Graphic record*

Graphic record refers to the type of technique used in image registration on the plate.

0 = Clearly unidentifiable.

1 = The image of the magic lantern slide was produced by pictorial recording techniques.

2 = The image of the magic lantern slide was produced using stamping recording techniques.

3 = The image of the magic lantern slide was produced using other photographic techniques.

4 = The image of the magic lantern slide was produced using other or mixed techniques.

1.3. *Graphic coding*

Graphic coding refers to the graphic coding level or degree of referentiality of the image recorded on the magic lantern slide, that is the relationship between the real benchmark and what is seen on the screen.

0 = Clearly unidentifiable.

1 = Low-Scenic: The perception of visual reference contained in the image of the magic lantern slide is set from a low or representative level of coding: pictures of recreated scenes ('slice of life').

2 = Low-Photography: The perception of visual reference contained in the image of the magic lantern slide is set from a low or representative level of coding: documentary photography.

3 = Low-Pictorial: The perception of visual reference contained in the image of the magic lantern slide is set from a low or representative level of coding: naturalistic figurative image with pictorial origin.

4 = Low-Stamping: The perception of visual reference contained in the image of the magic lantern slide is set from a low or representative level of coding: naturalistic figurative image produced by a stamping technique.

5 = Medium-Non-Naturalistic: The perception of visual reference contained in the image of the magic lantern slide is set from a medium or symbolic level of coding: a figurative image, which is recognised whatever referent is represented in the image, but is perceived as non-naturalistic.

6 = Medium-Sketch: The perception of visual reference contained in the image of the magic lantern slide is set from a medium or symbolic level of coding: a reasoned sketch, such as, for instance, the lines representing geographical boundaries or roads.

7 = Medium-Pictogram: The perception of visual reference contained in the image of the magic lantern slide is set from a medium or symbolic level of coding:

a pictogram representing an idea in which the figure is abstracted to a point, bu is still recognised.

8 = High-Idea: The perception of visual reference contained in the image of the magic lantern slide is set from an abstract or high level of coding: an arbitrary sketch that depends on a previous social agreement to communicate an idea, such as a traffic sign.

9 = High-Ideogram: The perception of visual reference contained in the image of the magic lantern slide is set from an abstract or high level of coding: ideogram for example, the notation used in a musical score.

10 = High-Abstract: The perception of visual reference contained in the image o the magic lantern slide is set from an abstract or high level of coding: abstrac image.

(2) Variables of the 'Scenic Public Exhibition Conditions'

2.1. Commercial orientation of the device

The kind of commercial market to which the magic lantern slide is oriented.

0 = Clearly unidentifiable.

1 = Professional: The magic lantern slide is oriented towards entertaining professional and/or educational markets that shape their products and services to meet institutional demands and/or to cater to public spectacles.

2 = Amateur: The magic lantern slide is oriented to a recreational amateur and/or educational market whose products and services are addressed to meeting the demands of the private or domestic market.

2.2. Social context

Type of social context in which the entertaining and/or educational performance/show that included the magic lantern slide took place.

0 = Clearly unidentifiable.

1 = Public: The magic lantern slide refers to a social context related to public access to the exhibition space, either communal or collective.

2 = Private: The magic lantern slide refers to a social context related to private access to the exhibition space.

2.3. Scenic complexity

Level of scenic complexity of the magic lantern slide during a performance with respect to the use of other auxiliary sets of formal languages in addition to the graphic and/or linguistic ones registered on the slide itself. Two auxiliary formal languages could accompany the magic lantern slides synchronously: sonic-musical, composed of sound effects as well as vocal and/or musical-accompaniment, and spoken language, consisting of spoken comments and/or readings synchronic to the projection, sometimes based on printed texts supplied by slide manufacturers.

0 = Clearly unidentifiable.

1 = Autonomous: There is no documentary evidence that the lantern slide was accompanied and/or required other formal auxiliary languages of a sonic-musical and/or linguistic character.

2 = Dependent: There is documentary evidence that the images of the lantern slide were accompanied and/or further elaborated with other formal auxiliary

languages with linguistic characteristics, such as the reading of printed texts supplied by the manufacturer.

3 = Performance: There is documentary evidence that the images on the slides were accompanied and/or further elaborated with other formal auxiliary languages with linguistic characteristics, such as the reading of printed texts supplied by the manufacturer, as well as vocal and/or sonic-musical performance.

(3) Variables of the 'Conditions of Reception Regarding Cultural Contents'

Various types of cultural traditions can serve as a reference to transmit the registered contents contained in the magic lantern slides. We estimate that at least one of the four important cultural traditions coeval to the magic lantern mediates the reception of the contents of the magic lantern slide: (1) visual, (2) musical, (3) literary and/or (4) scientific. The following table includes 112 variables of non-mutually exclusive categories, which we have coded dichotomously (0 = absent, 1 = present); these variables represent as many forms of disseminated contents grouped according to the cultural tradition.

The *visual tradition* is represented in the table by pictorial genres and printed forms of representative graphic narratives, and by some optical artefacts that, from the 19th century onwards, enjoyed public favour, such as the kaleidoscope, stereoscope, stroboscope, panorama, diorama and photography. Some optical instruments, such as the magic lantern, maintained prosperous equipment industries and met a wide demand of consumer practices.

Images of magic lantern slides also adapted or recreated all kinds of contents and *musical and literary forms* spanning from popular traditions, such as songs, hymns, varieties, stories, fables or mixed performances that could include dances, musical numbers, illusionism, declamation, imitation, humour, pantomime, shadows and silhouettes to circus arts such as acrobatics and juggling, or exhibitions of biological rarities or trained animals. These cultural forms stem from popular traditions and were presented to the public without a predefined storyline. They were staged in multiple versions with often unknown or unrecognized authors, and usually referred back to other forms of graphic traditions.

The categories in Table 1 also respond to the images on magic lantern slides. The categories refer to the ways in which print media illustrated the news, to popular literature published in instalments in the periodical press, and also to the works of musical literature, whether lyric, dramatic or narrative, whose authors were at the time well-known and whose works used to have a version conceived and transmitted by a fixed written text.

Finally, images of magic lantern slides also refer to informative *scientific traditions* cited in the categories of the table, inspired by the areas of knowledge as categorized by UNESCO. The magic lantern was used widely in the service of popular science by the second half of the nineteenth century; the collections of slides with an informative scientific character covered all fields of knowledge and were shown not only in the public context of (mandatory) formal educa-

3.1. VISUAL TRADITION			
3.1.1. Picture			
3.1.1.1. Portrait	3.1.1.1. Naked	3.1.1.1. Still life	3.1.1.1. Landscape
3.1.1.1. Religious	3.1.1.1. Mythological	3.1.1.1. Allegorical	3.1.1.1. Historical
3.1.2. Graphic			
3.1.1.3. Illustration	3.1.1.4. Comic strip	3.1.1.4.Comic	
3.1.3. Optical			
3.1.2.1. Photography	3.1.2.2. Stereoscope	3.1.2.3. Stroboscope	3.1.2.4. Panorama
3.1.2.5. Diorama	3.1.2.6. Kaleidoscope		
3.2. MUSICAL TRADITION			
3.2.1. Classical	3.2.2. Traditional	3.2.3. Religious	3.2.4. Varieties
3.3. LITERARY TRADITION			
3.3.1. Lyric			
3.2.2.1. Song	3.2.2.2. Hymn	3.2.2.3. Elegy	3.2.2.4. Eclogue
3.2.2.5. Satire			
3.3.2. Major dramatic			
3.2.3.1. Tragedy	3.2.3.2. Comedy	3.2.3.3. Tragicomedy	3.2.3.4. Melodrama
3.2.3.5. Farce	3.3.3.6. Didactic work	3.2.3.7. Play	
3.3.3. Minor dramatic			
3.2.4.1. Dance	3.2.4.2. Shadows and silhouettes	3.2.4.3. Illusionism	3.2.4.4. Declamation
3.2.4.5. Imitation	3.2.4.6. Humor	3.2.4.7. Pantomime	3.2.4.8. Acrobatics
3.2.4.9. Jugglery	3.2.4.10. Shows of rarities	3.2.4.11. Shows of trained animals	
3.3.4. Narrative			
3.2.4.1. Epistle	3.2.4.2. Sermon	3.2.4.3. Parable	3.2.4.4. Fable
3.2.4.5. Story	3.2.4.6. Costumbrist	3.2.4.7. Romance	3.2.4.8. Historical
3.2.4.9. Gothic	3.2.4.10. Adventure	3.2.4.11. Society	3.2.4.12. Events
3.2.4.13. Travel	3.2.4.14. Sports	3.2.4.15. Sign	3.2.4.16. Advertising
3.4. SCIENTIFIC TRADITION			
3.4.1. Natural sciences			
3.4.1.1 Astronomy	3.4.1.2. Bacteriology	3.4.1.3. Biochemistry	3.4.1.4. Biology
3.4.1.5. Botany	3.4.1.6. Chemistry	3.4.1.7. Entomology	3.4.1.8. Geology
3.4.1.9. Geophysics	3.4.1.10. Math	3.4.1.11. Meteorology	3.4.1.12. Mineralogy
3.4.1.13. Physical Geography	3.4.1.14. Physical	3.4.1.15. Zoology	
3.4.2. Engineering and Technology			
3.4.2.1. Military	3.4.2.2. Mechanical	3.4.2.3. Forest	3.4.2.4. Geodesy
3.4.2.5. Industrial Chemistry	3.4.2.6. Architecture	3.4.2.7. Science and food technology	3.4.2.8. Civil Engineering
3.4.3. Health Sciences			
3.4.3.1. Anatomy	3.4.3.2. Medicine	3.4.3.3. Pharmacy	3.4.3.4. Public health
3.4.4. Agricultural sciences			
3.4.4.1. Agronomy	3.4.4.2. Zootechnics	3.4.4.3. Fishing	3.4.4.4. Forestry
3.4.4.5. Horticulture	3.4.4.6. Veterinary		
3.4.5. Social Sciences			
3.4.5.1. Anthropology	3.4.5.2. Ethnology	3.4.5.3. Demography	3.4.5.4. Economy
3.4.5.5. Education and Teaching	3.4.5.6. Geography	3.4.5.7. Law	3.4.5.8. Linguistics
3.4.5.9. Political Sciences	3.4.5.10. Psychology	3.4.5.11. Sociology	
3.4.6. Humanities			
3.4.6.1. Fine arts	3.4.6.2. Languages and ancient and modern literature	3.4.6.3. Philosophy	3.4.6.4. Prehistory and History
3.4.6.5. Archeology	3.4.6.6. Numismatics	3.4.6.7. Paleography	3.4.6.8. Religion

Table 1: Types of cultural traditions that served as a contextual information for the registered contents in the magic lantern slides. These categories come from UNESCO areas of human knowledge.[3]

tion, but also in university departments, scientific societies or other didactic public institutions.

In order to ensure the consistency of the code, the codebook was submitted to a content validity test, conducted by a panel of experts.[4] As we judged the degree of agreement among experts was high, we were able to continue with the content analysis.

(f) Selecting a sample group

The sample for the case study was selected through a non-probability strategy. It included the 2,609 magic lantern slides of the Museu del Cinema – Col.lecció Tomàs Mallol, one of the most complete collections with an interesting variety of magic lantern slide models in Spain and even internationally. Then training prior to the encoding process ensured the consistency and validity of the codes used by the analysts and the encoders, who participate throughout the case study.

(g) Encoding the sample and checking the reliability

The encoding of the 2,609 Magic lantern slides of the Museu del Cinema – Col.lecció Tomàs Mallol was carried out, following the instructions of the codebook, by the analyst (Francisco Javier Frutos) and one judge (Carmen López San Segundo). The whole process was aimed at quantifying the information contained in the slides, that is to convert all that we observed in each slide into numerical data.

To check coding reliability, a statistical coefficient can be used (for instance, Cohen's Kappa, a value that measures the degree of reliability of the agreement reached between the assessments of the analyst and the judge when both are rating the same object) to estimate the degree of agreement between the encodings of the analyst and the judge. To calculate this coefficient, usually 15% of the messages of the sample are randomly selected and re-encoded by the judge.

Data processing with specialised software (SPSS) for hierarchical cluster analysis is a statistical method we used for clustering our cases. It serves to identify homogeneous groups of cases based on selected variables that are nominal and ordinal. Hierarchical cluster analysis obtains as a result a standardised vocabulary for magic lantern slides with three main types of meta-genres – autonomous, dependent and performance – and 24 genres:

- According to the variability in the literary-narratives employed, magic lantern slides can be grouped into nine *autonomous* types: sequential art, tale, romance, adventure, everyday, phantasmagoria, topical, title and advertising.
- According to the variability in the scientific field, magic lantern slides can be grouped into twelve *dependent* types: astronomical, microscopic, zoological, botanical, technological, health, agricultural, anthropological, geographical, artistic, historical and religious.

- According to the variability in the musical, lyric and drama traditions, magic lantern slides can be grouped into three *performance* types: burlesque, drama and musical.

In conclusion, it can be affirmed that the empirical study using content analysis has been productive. The hypothesis initially formulated has been confirmed: magic lantern slides show regularities concerning their discursive genre. This empirical study confirmed that the stability of the discursive genre of magic lantern slides is very high and that their content is presented through a stable structure. The discursive genre made it possible for receivers to control the processes of attention, searching and processing, and for the producers and lanternists to organise their routines as well as their production and exhibition skills. In our corpus, the major discursive genre categories for slides, 'autonomous', 'dependent' and 'performance', were defined primarily according to the contexts of slide projection as well as to the wider contexts that governed their effective interpretation, i.e. the cultural traditions. These cultural traditions conditioned to a large extent the understanding of the slide content, especially insofar as some slides required extensive explanation or other forms of simultaneous performance external to the lantern slides proper, while others were semantically relatively self-sufficient.

Notes

1. Juan José Igartua, *Métodos cuantitativos de investigación en comunicación* (Barcelona: Bosch, 2006).
2. Mikhail Mikhailovich Bakhtin, *Estética de la creación verbal* (México: Siglo XXI, 1982).
3. Retrieved from http://vocabularies.unesco.org/browser/thesaurus/en/.
4. Sarah Dellmann (Utrecht University), Ine van Dooren (University of Brighton), Joe Kember (University of Exeter), Frank Kessler (Utrecht University), Sabine Lenk (University of Antwerp).

Frank Kessler

The Educational Magic Lantern *Dispositif*

When we hold a magic lantern slide in our hand, then what we have is just one single piece of a multi-dimensional historical puzzle which, as a whole, we will hardly ever be capable of piecing together. Yet, we may be able to map parts of it, to create pockets of knowledge, as it were, that can help us to get a better grasp of what at least some parts of the puzzle may have looked like. The slide only contains the image to be projected on a screen, and it was the latter that was seen during a performance. The projected image, in turn, was part of a programme or a lecture, and it was shown as one of a series of images appearing successively on the screen, according to a preconceived order. The sequence in which the slides were projected was determined by the reading or by their order within a set as listed in a catalogue – if the performers chose to respect it and did not create one of their own.

In a performance, the projected images were accompanied by an oral discourse, sometimes with additional music, or sound effects. This discourse framed the images in such a way that they became meaningful to the audience, illustrating, supplementing, commenting, underlining or maybe even contradicting the words. Words and images participated together in a rhetorical strategy adopted by the performer to entertain, amuse, amaze, inform, instruct, influence, convince, persuade, enthuse, agitate or arouse the audience. The mode of address that was chosen depended in turn on the specific circumstances of a performance as well as its goals.

Given the complex interplay between these different aspects, which in fact also include the position taken by the spectators, Ludwig Vogl-Bienek has suggested to approach what he calls "the historical art of projection" in terms of *dispositif*. He uses the concept in a historical-pragmatic perspective, close to the one that I have developed discussing early cinema.[1] Vogl-Bienek not only considers the various components of this *dispositif* – the operator (lanternist), the lantern, the slide, the screen, the projected image, the performer, the darkened hall and the audience –, but also distinguishes between different performance practices such as, for instance, the illustrated lecture or the phantasmagoria, which can in fact be seen as constituting different *dispositifs*.

In what follows, I would like to further develop my earlier reflections on the concept and try to operationalise it with regard to the educational magic lantern *dispositif*, considered here as a specific communicative situation. One *caveat*, however: the term *dispositif* should be understood above all as a heuristic tool

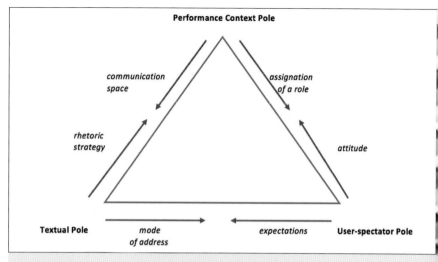

Fig. 1: The Performance *Dispositif*.

helping to outline the complex interplay between the various constituents of an educational or instructive projection situation. It can be seen as a 'model' in the sense attributed to this term by Roger Odin: "[...] a mediator between theory and observation, [...] an optical instrument, a telescope, or rather a microscope, whose purpose it is to help *to see better* and *to ask questions*".[2] So to begin with, I will present the performance *dispositif* and the three poles that constitute it. Then I will describe the educational magic lantern *dispositif* as a specific instance of the performance *dispositif*. Finally, I will look at two cases to illustrate the possibilities of a historic-pragmatic study of the educational magic lantern *dispositif* on the basis of historical source material.

The performance *dispositif*

I conceive of the performance *dispositif*, to begin with, as the triangular relation between the following poles: the *performance context pole*, the *textual pole* and the *spectator pole*. The performance context pole comprises the physical location of the performance, the technology and its affordances, as well as the pragmatic status of the communication process taking place. The textual pole consists not only of the projected images but includes also the lecture as well as music and sound effects.[3] The spectator pole, finally, does not refer to the experience of individual members of the audience, who may have reacted in a variety of ways,[4] but to the positioning of the audience in a specific type of performance.

Within this triangular relation, several interactions occur. The *performance context pole* constitutes, on the one hand, a communication space. I borrow this concept from Roger Odin, who defines it as a theoretically constructed and thus non-physical space characterised by the specific type of communication process that takes place there, such as, for instance, transmitting knowledge, providing information, offering fictional entertainment, political or religious

propaganda etc.[5] In a media historical perspective, this includes taking into account the concrete historical, cultural and social circumstances under which a given communication process takes place. Seen from the perspective of the textual pole, the communication space thus provides a pragmatic frame for the text to be performed. Accordingly, the latter has to adopt a rhetoric strategy in order to function optimally within this frame, and also a specific mode of address towards the audience.

On the other side of the *dispositif*, the performance context pole assigns a role to the spectator, which, in every individual case, can of course be refused, but still continues to function as a general positioning of the audience. From the viewpoint of the spectator pole, in other words, the audience adopts an attitude in accordance with the role that is assigned to it, and it has expectations with respect to the way in which it is going to be addressed by means of the performance text. The performance *dispositif* conceived in this way thus allows to analyse the interplay of the three different poles within a theoretical framework that makes it possible to also take into account factors stemming from both the pragmatic and the historical situation one is studying.

The educational magic lantern *dispositif*

When looking at the historical educational magic lantern *dispositif*, a number of general observations can be made: firstly, within such a *dispositif*, the audience was ascribed the role of those wanting or needing to learn, and they were supposed to develop a corresponding attitude. Apart from the fact, however, that not every spectator may have been willing to act according to this role (spectator pole), the relationship of the performer – who is one element of the performance context pole – with the audience could differ considerably, depending on the type of educational situation: teachers were in a different position vis-à-vis the pupils than the Salvation Army officer was vis-à-vis those who attended a temperance meeting, or a scholar vis-à-vis an auditorium full of people listening to a public science lecture. There is, in other words, a variety of educational situations, which do share some characteristics, such as the transmission of knowledge or ideas, but which differ with respect to others.

Secondly, there were a number of different set-ups for an educational lantern presentation. The lecturer could play the role of the operator of the lantern as well, which may often have been the case in a class room. Conversely, during public performances, the lecturer may have rather stood next to the screen, facing the audience and pointing with a stick at the elements of the projected image that were meant to be highlighted, while the lantern and the operator were positioned in the back of the lecture hall or theatre next to, or even among the spectators, a situation that is depicted in several distribution catalogues.[6] The set-up of the educational slide and film projections organised by the German *Kinoreformbewegung* included a lecturer, who during some parts of the programme stepped down, while the projected images were accompanied by

music and sound effects that were performed behind the screen to facilitate the audience's immersion into the spectacle.[7]

When doing historical analyses, the way in which the three poles of the educational *dispositif* are to be conceived needs to be specified on the basis of source material. Obviously, such sources are scarce, and the available ones will generally offer only partial insights and demand to be extrapolated. In some cases, there may be reports on illustrated lectures in newspapers or in the bulletins of the institutions or associations that organised it, and which comment on or even describe the lecturer's performance, the programme and maybe also refer to the audience's reactions. Sometimes, boxes in archives also contain printed or even hand-written materials that allow to reconstruct the order of slides that were shown, and additionally maybe indications about the text of the lecture that was illustrated with these slides. Surviving commercially distributed lantern readings do provide such texts, yet the actual performance may have deviated considerably from the printed version. Information on the concrete circumstances of a performance with regard to the technology, but also, for instance, the layout of the hall in which the projection took place, will in most cases be absent and at best sketchy.

Conversely, however, when assessing and analysing the information that can be found in the historical source material, the model of the *dispositif* provides a productive theoretical framework that helps to organise and interpret such primary source material. The term "educational magic lantern *dispositif*", in other words, should be understood in the first instance as a *heuristic category* and not as a generic label. It refers to a specific configuration where the transmission of knowledge is foregrounded, but does not exclude other purposes, which can range from entertainment to propaganda, from scientific demonstration to public health strategies.

In what follows, I will discuss two examples based on different types of primary source materials and sketch out way in which different aspects of the educational lantern *dispositif* might be elucidated. The first will be focusing on conclusions that might be drawn from *distribution catalogues*, which are indeed a particularly rich research resource in many different respects. The second will start from *advertisements, reports and announcements in the daily press* and concentrate on the profile of an individual lecturer.

Teaching about territories

Magic and optical lantern sales and distribution catalogues are invaluable sources indeed, and they pertain in fact to all the aspects of a lantern performance *dispositif*. The sections on apparatuses, devices, accessories help reconstruct aspects of the performance context, the affordances of different types of lanterns, lighting systems, lenses, etc., and sometimes one may even find pointers for performers that elucidate elements of performance practice. The lists of available slides and sets provide information about the offer that performers, lecturers, educators could choose from (including lantern readings

accompanying some of the sets), as well as on the internal structure of certain sets, for instance the very frequent trope of a journey as an organisational principle for geographical slides.[8] By the same token, albeit indirectly, such structural principles allow to draw conclusions regarding the modes of audience address that are preconceived or even suggested by them. Catalogues listing slide series might even be considered "virtual collections", as they take stock of the available material, categorise it, order it, provide metadata and at least partial elements for a description.[9]

Taking geographical slide sets as an example, one can observe that in many cases the subdivision within the catalogue reflects the national origins of the seller or distributor. In European catalogues, it is rather common that images from the firm's country of origin are listed first, frequently subdivided into sections dedicated to different regions. These are followed either by other European countries or the home country's colonies. Yet as a caveat one should add that it is very difficult to generalise here, because there are in fact no fixed patterns and the producers of a given catalogue may have had various reasons why they chose to present sets in a specific order. Also, for the time being the number and the range of catalogues available for research is still rather limited, and thus conclusions can only be drawn with the utmost precaution.

An interesting example here is the 1895 distribution catalogue of the French "Société d'enseignement par les projections lumineuses", a secularist teachers' organisation located in Le Havre.[10] They propose eight "excursions" into different French regions, covering the entire territory of the country, a set on Le Havre, one on its surroundings and one on the *département* to which the city belongs, one on Paris, one on the French ports and one on French castles.[11] This is followed by several sets designated as "journeys": one from Paris to the sea, followed by one to Northern Europe consisting of a roundtrip from Hamburg, Lubeck, Copenhagen, Christiania (Oslo), Stockholm, Uppsala, Riga, St. Petersburg, Moscow, Smolensk, Warsaw, Berlin, Potsdam, Hannover, Bremen and back to Hamburg.[12] This is all there is on Europe, except for one slide set entitled "Europe physique", showing lakes, rivers and mountains from different countries, and another one named "Europe politique" with views from major European cities that maybe had some overlap with the slides from the set representing a journey to Northern Europe.[13] Follows a journey through all of the French colonies and several other sets on the French colonies or protectorates of Algeria, Tunisia, Tonkin (Northern part of Viet Nam) and Madagascar.[14] Given that this catalogue contains material destined to a large extent for use in schools and which could be obtained free of charge, as the title of the catalogue specifies, it gives some indications about the world view (in the various meanings of the term) that was conveyed to French pupils around the turn of the century. Slides offering views of European countries outside of France are rather limited in scope and number, so teachers did not have much to choose from. One would have to dive into the school curricula of the time to see whether the catalogue simply reflects what was taught in

VI. — FRANCE. — 1ʳᵉ Excursion : Régions du Nord,
du Nord-Est et de l'Est

Carte de la frontière du Nord-Est.	Famille alsacienne émigrant en
Lille.	France.
Arras : Cathédrale.	Belfort.
» Vieilles maisons.	Lyon : Vue prise de la Croix-Rousse.
Sedan.	» Perspective du quai St-Claire.
Verdun.	» place Bellevue et Fourvières.
Nancy.	Hôtel de Ville.
Metz.	Palais de Justice.
Strasbourg : Vue panoramique.	Statue du maréchal Suchet.
Mulhouse.	Ile Barbe.

Fig. 2: Excerpt of the 1895 catalogue of "Société d'enseignement par les projections lumineuses".

geography lessons of the time, but chances are that this hypothesis would be confirmed.

In this catalogue there is another set strongly marked by a nationalist perspective. In the Franco-German war of 1870–1871, France had lost Alsace and parts of Lorraine to the German empire. Interestingly, however, in their 1895 catalogue the "Société d'enseignement par les projections lumineuses" apparently refused to admit this state of affairs. The first "excursion" exploring France is dedicated to the northern, north-eastern and eastern regions of the country and leads from Lille to Lyon, passing through Metz, Strasbourg and Mulhouse, which at that time were part of Germany. The three slides depicting these cities are followed by one showing an "Alsatian family emigrating to France".[15] This is the only slide in the entire set depicting and identifying a group of people, and it does so by turning this into a very strong and explicit political statement, which doubtlessly was meant to invite teachers to reflect on this unfortunate (and from their point of view most certainly only temporary) situation.

Looking at some other French catalogues, it turns out that slide sets on Alsace and Lorraine are indeed listed in a way that indicates that the region did have a somewhat specific status. In the 1912/13 catalogue issued by the French firm Mazo, Alsace and Lorraine are listed together with all the other French regions, but at the end of the section and preceding the one with slides on Germany. Yet, by using a slightly divergent font size for the subsection on Alsace and Lorraine, this region is distinguished from others such as the Vosges or Corsica. The layout of the catalogue and the typography signal a specificity of the region's status, while in terms of national belonging it is clearly claimed for France.[16] Another presentational strategy can be found in the 1912 catalogue by Deyrolle. The first section under the heading "Geography" is dedicated to Europe, and the first European country is France, subdivided into regions, excluding Alsace and Lorraine. France is followed by Algeria and Tunisia,

which thus are categorised as "European". The next country is Germany, subdivided in regions, but also excluding Alsace and Lorrain. Then Alsace and Lorraine are listed, preceding Austria, so in the catalogue listing they appear as independent countries, also typographically, as the same font size is used as for all the other countries. So, interestingly, Alsace and Lorraine follow Germany in quite the same way as Algeria and Tunisia follow France in this catalogue, which may have been done to suggest that these two regions had been colonised as well.[17] However, one can safely assume that in the case of Algeria and Tunisia the French considered their colonial rule "legitimate", while it is doubtful that they thought in this way concerning Germany's rule over the formerly French territories of Alsace and Lorraine.

The catalogues thus draw, as it were, imaginary maps that reveal the contested status of regions such as Alsace and Lorraine, and therefore they can add an interesting dimension to the slides or slide sets as well as the readings. In the catalogues, the political statements are implicit, but nonetheless present, and they need to be taken into account as one form of what Michael Billig has called "banal nationalism".[18] They also provide information about possible framings of the slides and slide sets within this particular historical situation and thus help to specify some of the parameters that intervene in the educational lantern *dispositif*, in this case regarding the teaching of geography in France in the period between 1871 and 1918.

Illustrated travel lectures: Entertainment, instruction and advertisement

While it is very difficult to find information about when and where teachers or lecturers used the lantern in schools or universities as part of their regular teaching activities, public lectures were often advertised in the press and can thus be retraced thanks to the increasing availability of digitised newspapers in many countries. In the Netherlands, free online accessibility of printed material on a website called Delpher is not only quite advanced, but also includes an easy-to-use and rather efficient search engine.[19]

During an explorative research on Delpher, I happened to come across several reports and advertisements for illustrated lectures by a certain J.P. Lissone, a travel agent who organised trips abroad for groups. All of these date from 1888, and Lissone had apparently joined up with the firm of Merkelbach & Co in Amsterdam, which sold lanterns, slides and accessories, but also offered its services for projections.[20] According to several of the short reports, Johannes Wilhelm Merkelbach operated the lantern himself.[21] For Lissone, whom one of the journalists referred to as the Dutch equivalent of Thomas Cook,[22] these lectures may have served as a means to advertise the group travels that he organised. For his audiences they rather combined information and entertainment. Lissone is indeed announced as a skilled and entertaining speaker. He lectured in various public venues, one of his performances having been organised by a Roman Catholic reading club.[23] Lissone's programmes included

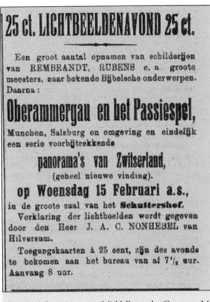

25 ct. LICHTBEELDENAVOND 25 ct.

Een groot aantal opnamen van schilderijen van REMBRANDT, RUBENS e. a. groote meesters, naar bekende Bijbelsche onderwerpen. Daarna :

Oberammergau en het Passiespel,

München, Salzburg en omgeving en eindelijk een serie voorbijtrekkende

panorama's van Zwitserland, (geheel nieuwe vinding).

op Woensdag 15 Februari a.s.,

in de groote zaal van het **Schuttershof.** Verklaring der lichtbeelden wordt gegeven door den Heer J. A. C. NONHEBEL van Hilversum.

Toegangskaarten à 25 cent, zijn des avonds te bekomen aan het bureau van af 7¹/₂ uur. Aanvang 8 uur.

Fig. 3: Advertisement *Middelburgsche Courant*, 14 February 1911.

a "trip to America", "a day in London" and "a journey through the Scottish Highlands".[24] According to one report on his presentation, he apparently described the adventures of a fictive group of travellers, whom he characterised individually and, it seems, not without humour.[25] The fact that Merkelbach is mentioned in some of these reports indicates that his contribution to the event was recognised as a matter of importance and as a performance in its own right. However, the collaboration seems to have been short-lived. Maybe hiring both the speaker and a projectionist turned out to be too expensive for the associations that organised the lectures, or Lissone had to pay the fee for Merkelbach out of his own pocket and deemed this to be too expensive. In any event, for the time being, I have not found other advertisements for, or reports on such performances after 1888.

However, more than twenty years later, the name Lissone appears once more in connection with illustrated lectures. Between 1911 and 1913 one can find several announcements, reports and advertisements referring to illustrated lectures by J.A.C. Nonhebel, a former journalist, who during these years at least is said to work as a tour guide for Lissone's travel agency.[26] The topics of Nonhebel's lectures were Switzerland, the Oberammergau Passion Play (which had been performed in 1910) as well as trips to Egypt, Syria and Palestine. Nonhebel continued his lecturing activities up to the late 1920s, but apparently rather as a freelance performer.

Nonhebel is declared to be a captivating speaker, and his rather long career seems to confirm that this claim was justified.[27] Interestingly, one of his lectures on the Oberammergau Passion Play, which is deeply rooted in the Catholic tradition of southern Germany, was organised by an association of Dutch protestants.[28] He presented this lecture also at the Schuttershof in Middelburg, preceded by reproductions of paintings depicting biblical scenes by Rembrandt, Rubens and others, followed by apparently touristic views of Munich, Salzburg and Switzerland (Fig. 3).[29] His lectures on "Egypt, Syria and the Holy Land" were based on trips for which he had acted as a tour guide for Lissone's agency, and thus equally combined entertainment, instruction and advertisement.[30] A short article in the *Leeuwaarder Courant* of 29 November 1912 gives in fact a brief glimpse into the type of problems a lecturer might

encounter. While that night, the audience listened attentively and thanked Nonhebel with a warm applause, "the evening before the speaker had had a hard time", because of some unruly adolescents.[31]

Nonhebel continued working as a lecturer associated with the *Maatschappij tot nut van't algemeen* Society for the benefit of all. According to a list of speakers offering their services to the local departments of the association published in 1917, Nonhebel's repertoire consisted of lectures on Palestine, Egypt, Italy, the Bernese Highlands in Switzerland, Oberammergau, the western coast of Norway and Paris.[32] His name also appears in their catalogue listing available speakers that was published in 1927. Nonhebel could be hired to lecture on Palestine, Egypt, Italy, Switzerland, Oberammergau and biblical paintings.[33] So overall, the topics of Nonhebel's lectures hardly changed, but apparently they were interesting enough to attract audiences during a period of almost twenty years at least.

Tracing public lecturers through newspapers and, if available, other material can thus yield important information about topics, practices, lecture circuits and locations. The example of Lissone and his later employee Nonhebel provides interesting insights into the combination of motives for their travel lectures and allows at least some hypotheses concerning the modes of address they adopted in their lectures.

Some provisional conclusions

The two historical examples discussed here – the information to be found in distribution catalogues and in press announcements, advertisements and reports – have allowed to sketch at least some possibilities to conduct research on specific cases of educational uses of the projected image. Such sources help to concretise the educational lantern *dispositif* by adding contextual details and to thus turn a general model into an analytical tool. In the case of the "Société d'enseignement par les projections lumineuses" the catalogue provides indications about the way in which the series were framed and about the ideological message that they were to convey. As for Lissone and Nonhebel, the primary sources yield information on the topics of the lectures and also some indications concerning the performance context. At the same time, the model served here to orient the reading of the sources, functioning as a theoretical framework that makes available criteria to organise the historical data.

The field of lantern practice, the "historical art of projection" in its many facets, constitutes an extraordinarily rich domain for scholarly investigation. Research, however, needs theoretical models in order to be able to proceed. The performance *dispositif*, I believe, can be a productive conceptual tool for such an enterprise.

Notes

1. Ludwig Vogl-Bienek, *Lichtspiele im Schatten der Armut. Historische Projektionskunst und Soziale Frage* (Frankfurt am Main, Basel: Stroemfeld Verlag, 2016), 57–80. For an English version, see his

article "The Dispositif of the Historical Art of Projection. Heuristic Concept for Interdisciplinary Research" on the online resource eLaterna. Historical Art of Projection (http://tcdh01.uni-trier.de:9191/en/sections/fundamentals/copy_of_magic-lantern/Dispositif). Vogl-Bienek refers to my article "The Cinema of Attractions as *Dispositif*", in Wanda Strauven (ed.), *The Cinema of Attractions Reloaded* (Amsterdam: Amsterdam University Press, 2006), 59–69. For an overview with regard to the various ways in which the concept of *dispositif* has been used by different authors, see my "Notes on *Dispositif*" (2007) (http://www.frankkessler.nl/wp-content/uploads/2010/05/Dispositif-Notes.pdf).

2. Roger Odin, *Les espaces de communication. Introduction à la sémio-pragmatique* (Grenoble: Presses Universitaires Grenobles, 2011), 17.

3. Depending on the kind of performance, also its tactile or olfactive dimensions might be part of the textual pole, as may have been the case in some phantasmagoria shows.

4. See, for instance, the various attitudes of spectators attending a Gilchrist Science Lecture in contemporary sketches reproduced in Vogl-Bienek, *Lichtspiele*, 42–43.

5. See Odin, *Les espaces de communication*, 31–47.

6. See, for instance, George H. Pierce, *Illustrated Catalogue of Stereopticons, Magic Lanterns and Dissolving View Apparatus and of Every Variety of the Best Lantern Views and Lantern Novelties* (Philadelphia, December 1888), back cover, or Queen & Co., *Photographic Illustrations for Projection* (Philadelphia, 1897), front cover.

7. See Frank Kessler and Sabine Lenk, "Kinoreformbewegung Revisited: Performing the Cinematograph as a Pedagogical Tool", in Kaveh Askari et al. (ed), *Performing New Media 1890–1915* (New Barnet: John Libbey, 2014), 163–173.

8. For the internal organisation of geographical slide sets, see also Sarah Dellmann's contribution to this volume. As part of the *A Million Pictures* project, Dellmann has initiated a section of the Media History Digital Library dedicated to lantern-related material, in particular sales and distribution catalogues (http://mediahistoryproject.org), which were mainly supplied by private collectors. However, it should not be forgotten, that lantern slides preserved by educational institutions often consist for a very large part of self-made slides, in many cases reproductions from books. See also Sabine Lenk's contribution in this volume.

9. See Frank Kessler and Sabine Lenk, "Une 'collection virtuelle': les plaques de projection pour l'enseignement de la société Ed. Liesegang en Allemagne avant 1914", *Transbordeur* 1 (2017): 96–105.

10. Société d'enseignement par les projections lumineuses, *Catalogue de collections de vues prêtées gratuitement aux Écoles et aux Sociétés d'Instruction* (Le Havre, 1895). This catalogue can be found on and downloaded from the French Bibliothèque Nationale's website Gallica.fr.

11. Ibid., 26–32.

12. Ibid., 32–33.

13. Ibid., 24–25.

14. Ibid., 33–35.

15. Ibid., 26.

16. E. Mazo, *Catalogue No. 50* (Paris, 1912–1913), 294–295.

17. Les Fils d'Émile Deyrolle, *Diapositifs sur verre pour projections, photographies et microphotographie* (Paris, 1912), 97–114.

18. Michael Billig, *Banal Nationalism* (London: Thousand Oaks, New Delhi: Sage, 1995).

19. See https://www.delpher.nl.

20. See Merkelbach & Co., *Prijs-Courant No. 1 van Tooverlantaarns, Sciopticons (Dissolving Views). Mode Stoom- en Electrische Machines* (Amsterdam, 1896). This is the earliest catalogue I had access to.

21. *Het Nieuws van de Dag* (5 April 1888); *Algemeen Handelsblad* (8 April 1888); *Rotterdamsch Nieuwsbla* (7 November 1888).

22. *De Maasbode* (9 December 1888).

23. See *Het Nieuws van de Dag* (5 April 1888); *Algemeen Handelsblad* (8 April 1888); *Maasbode* (2 December 1888).

24. *Maasbode* (21 December 1888).

25. *Algemeen Handelsblad* (8 April 1888).

26. *Nieuwe Veendammer Courant* (19 December 1911); *Het Nieuws van de Dag* (23 October 1913).

27. *Het Nieuws van de Dag* (23 October 1913).

28. *Algemeen Handelsblad* (23 October 1913).

29. *Middelburgsche Courant* (14 February 1911).

30. *Middelburgsche Courant* (14 February 1911); *Leeuwaarder Courant* (29 November 1912).

31. *Leeuwaarder Courant* (29 November 1912) (my translation). This report mentions that the lecture lasted "for 8 hours", which however seems to be either a misprint in the original or a digitisation flaw (possibly the number 3 erroneously identified as an 8).

32. "Lijst van sprekers en onderwerpen voor 1917–18", *Nutswerk. Maandblad van de Matschappij tot nut van't algemeen*, vol. 2, no. 1 (July–August 1917): 5. Thanks to Dulce da Rocha Gonçalves for sharing this source.

33. Hoofdbestuur der Maatschappij tot nut van't algemeen, *Sprekerslijst 1927 en volgende jaren* (Amsterdam, 1927), 13. Thanks to Dulce da Rocha Gonçalves for sharing this source.

"The Wall" at Zusters van het Heilig Graf (Turnhout).

Sabine Lenk

Re-Use Practices, the Classical Canon and Out-of-Canon Slides[1]

<p>elgian archives and museums keep huge amounts of lantern slides. Many of them are *unique*, not only because there may be no identical second glass positive, just a glass negative from which it derived. They are also special in their aesthetics as they are *self-made*. Their makers often cannot be identified, only the institution which used them and/or the occasion for which they were made are re-traceable with some luck.</p>

We, researchers from the University of Antwerp, one of the teams of the international research project *A Million Pictures*, became first aware of the existence of such slides during a visit to the Sisters of the Holy Grave in the Flemish town of Turnhout in 2016. The person responsible for the collection, teacher Peter Coupé, showed us "the wall", a construction containing about 176 slides, the 'left-over' of an exhibition in the municipal archive which had been organised in 2013.[2] Our reaction was amazement. What we saw were black-and-white slides, partly (almost crazily) coloured with pen and brush to highlight details and to intensify the depicted scene's expressiveness. The slides showed photographic images, mainly copied from printed source material (books, newspapers, maps, postcards, etc.), as well as reproductions of photographs and drawings; a small number of them were hand-drawn.

Fig. 1: Photographically reproduced printed photograph taken from Walter Hutchinson (ed.), *Customs of the World. A popular account of the manners, rites and ceremonies of men and women in all countries*, vol. 1 (London: Hutchinson & Co, 1931); coloured probably with an ink pen and a brush. In relation to the book publication, the photo in the "Wall" is mirror-inverted.[3]

In the following, I will reflect on the 'bewilderment' I felt, and the reason which caused it: the *practice of re-use* in the past[4] which generated a '*classical canon*' that, I would argue, had conse-

193

quences for the expectancy and acceptance of slides in re-use occasions, thus in another context in a later period and with a different comment. After a short description of the 'unusual nature' of the specimen from Turnhout, I will discuss a recent example that integrated slides from outside the canon and presented them in a show addressing an audience with few or no experience of lantern shows.

The object of amazement

The glass slides, kept by the Zusters van het Heilig Graf in Turnhout, have the standard format 8.3 x 10 cm and a protection plate to shield the image from damage by handling; a neat black paper frame all around protects the hands from cuts and the glass borders from damage. During the 1920s and 1930s, the Sisters had used them for teaching in class.[5] It is not certain whether the nuns could not acquire enough material,[6] or whether they thought that what was in circulation was not what they needed: pictures suitable for the education of *Catholic* girls and boys. In any case: the slides in the "wall" of the Heilig Graf-school are visibly all self-made, and the surviving lecture texts are typo-scripts or hand-written manuscripts, both from a non-commercial source.[7] One can assume that the slides were produced by a professional photographer copying documents which the Sisters (or teachers they were connected to) had provided.

Why did the slides make such an amazing impression on me? Looking at them in the "wall", studying one after the other displayed as in a photographic exhibition, produced a sentiment of estrangement. The situation reminded me of Maxim Gorki's famous description of his first encounter with the cinematograph: "Last night I was in the Kingdom of Shadows. If you only knew how strange it is to be there".[8] Looking at the pictures felt like discovering a strange, distant, motionless world, with bizarre creatures looking vaguely like human beings; it was as if visiting the silent country of the dream where long-gone people return from the sub-conscious to greet the sleeper without awakening her/him. The slides in the "wall" were anything but what I had expected – projection pictures produced by commercial manufacturers, made for exportation to different countries, with a simple structure, quickly graspable for an international audience, with clearly visible hints to support a fictional story or a scientific talk, with the typical aesthetics that has the purpose to celebrate a spectacular landscape or building or to intensify the spectator's feelings (laughter, sorrow, pity, etc.) provoked by a narration. What I expected was to find images from what I would call the *'classical canon of lantern slides'*.[9] This canon can be described as the type of slides that have, to a very large extant, shaped the idea of a lantern show and thus the expectations of the general audience. Naturally there are always 'exceptions to the rule', but they do not change the existence of a generally used assembly of motives, topics, etc. based on traditions in the past. To be clear: a canon is for me a *positive* concept, it has its *raison d'être* and fulfils its tasks in our society, such as making aware of a specific

cultural heritage. However, it can block the understanding of elements which are not part of it.

The lantern tradition, the 'modern' lanternists and the 'classical show'

We owe the *classical canon of lantern slides* to some remarkable young enthusiasts that started to revive the *magic* lantern at the end of the 1960s and during the 1970s. One can roughly say: after the turn of the century (1900), the *show dispositif* had lost its magical radiance and its narrative power for big audiences. Instead of using slide projections in multi-functional ways to entertain and instruct the spectator from the height of the *theatre stage* or the lectern of a *public hall*, the presenters concentrated for several decades on the *didactic* qualities of the instrument and its *propagandistic* power to (politically, socially, religiously) influence the audience. The *optical* lantern was used in private and public schools and within the (closed) walls of academic institutions or by associations, churches and all sorts of organisations addressing just their constituencies in locations specially selected for this purpose. Already in the 19th century, the travelling lanternists had abandoned their (one man-)shows in private houses[10] or on the fairground[11] and had 'split up' into projectionists and lecturers to fill huge auditoriums. In the 20th century, a school or university clerk sometimes helped the (secular) teacher or priest, otherwise the educator had to project and lecture alone in the class room.[12] When in the 1950s smaller projectors appeared more massively on the market, teaching staff turned progressively to the "24 x 36 mm" as image format. The so-called "diapositives" were easier to handle as they didn't break like the 8.2 x 8.2 cm and 8.3 x 10 cm glass slides, were lightweight, needed less storage space and could be taken on a reversal 35 mm film even by amateurs in photography. As our findings in archives suggest, the last instructors, who had still insisted on the much better aesthetic qualities of the glass plates, gave up in the 1960s and turned instead to diapositives.

As the *public* career of the *magic* lantern spectacle for a *mixed mass* audience (as opposed to "illustrated lectures") had seen a slow but steady decline and had almost disappeared at the beginning of the 20th century, the tradition was lost for at least two generations when the above-mentioned young enthusiasts rediscovered the projection device. Among these 'modern' lanternists were such great talents as Laura Minici Zotti (Italy) who created in 1998 the Museo del Precinema in Padova, and the late Mervyn Heard (UK) who formed a company with his wife Chrissie and their colleague Cherry.[13] Minici Zotti was motivated by a slide collection and a lantern found on the attic of her grandparent's house.[14] In 1969, Heard read an article in an English newspaper on a collector which aroused his curiosity.[15] Minici Zotti turned to Janet Templin and Mike Bartley (whom she considers her teachers) while Heard traced down the person mentioned in the newspaper article, who would introduce him to slides: Joe Milburn, one of the founding members of the British Magic Lantern

Society, and also began to organise shows. They did research on the medium, compiled knowledge on how to stage, produce, distribute and present slides, spent time and money on retrieving and buying items, trained themselves to become 'modern' lanternists. Collectors such as the late John and William Barnes[16] helped with information. Finally, they started touring to introduce people to a historical *entertainment* tradition they had never heard of, or which reminded them of stories their grandparents had told them.

Before Laura Minici Zotti, Mervyn Heard and others revived the *magic* lantern in the 1970s and the 1980s, they had done media-archaeology *avant la lettre*. This led them to select the 'classical' scenario: a re-enactment of the *traditional* show of the second half of the 19th century with the entertainer placed in the 'lime light' of the stage and (if financially affordable) a pianist and a technician changing slides, both hidden in the dark. They chose the *fictional* performance: a charming narration based on slides that touched the audience by their Victorian wittiness, their astonishing beauty or their curious strangeness. Especially Mervyn Heard was known for his spectacular shows, evoking often the Victorian tradition of the Gothic Magic Lantern Show with phantasmagoria effects such as ghost-raisings, shocking close-ups of skeleton faces and disturbing facial contortions of 'mad women'. Storytelling was one of his great talents, and he moved his audience with his sense for dramatic moments, his acting skills and his wonderful hand-painted images and mechanical moving slides which could carry people away. However, the fantastic world of the *magic* lantern, presented by people in costumes evoking the Victorian era, working with a shiny historical lantern in mahogany and brass and with original wooden-framed slides that made 'click' when gliding into the light beam, would constantly remind the (adult) spectators not to forget that they were assisting the re-staging of an entertainment from the last century. Thus, when it came to selecting slides, their visual appearance had to support the outfit of the actors, and their message the intentions of the programme. This created a canon which is preponderant until today.[17]

The *out-of-canon slides* and their 'disturbing' effect

What most of us are used to are the slides shown by the 'modern' lanternists for the past forty to fifty years. On the one hand, one can assume that those with a fictional (or easy to fictionalise) content were employed out of practicability; on the other hand, it is possible that those made for teaching in schools and universities may not have been as accessible then as they were hidden in the cellars and under the roofs of institutions,[18] or were already destroyed as they were not aesthetically pleasing and therefore not of much interest as collector's items. Those 'other slides' were not 'nice to look at'. Some people may have found them interesting, but also mysterious, as their content asked for special knowledge and interpretation efforts, others may have perceived them as incomprehensible, boring or even disturbing.

In any case, many slides from the "wall" in the Heilig Graf-school look 'disturbing' for an untrained eye. They can be described as (a) *incoherent* with the traditional *magic* lantern slide canon; (b) *transgressing* boundaries with other media categories such as postcards, (amateur) photography, newspaper illustrations, colour books for children, picture series from collecting albums, etc.; (c) they are a *mixture* of production methods: the slides were photographed, printed, hand-painted or manually copied from a document with ink on the glass plate, in black and white with (hand-)coloured details, etc.; (d) they *ask for* historical *research* (e.g. on production context, presentation conditions); (e) some *break with* traditional *standards* and aesthetic codes of figurative visual art. And as already mentioned, they disturb any expectation, shaped by what I call the 'slide canon'. I was in the first instance disappointed, as my mind, used to the aesthetics of artefacts belonging to the canon, was not open to accepting and appreciating this *disruption* right away.

Had my colleague and I been archivists and curators of museums that keep such slides, had we worked with big collections which came as cultural heritage from schools and academic institutions, church and missionary associations, politicians, archaeologists and art historians, just to name some, we would have been familiar with them, and I would probably have reacted differently.

What is *not part of the classical slide canon*? Based on the slides inspected in the Turnhout "wall", one can say that this concerns mostly slides which are:

– self-made by copying (photographically) illustrations, tables, diagrams from books, newspapers, etc.;

– presenting a certain degree of 'amateurishness';

– revealing their (mass) production process by showing marks such as a printing grit from newspaper, course-grained dots (like on toy slides from the 1920s), layout traces from the copied document, pale contrast, fuzzy areas, clumsy colourisation, etc.;

– functional-practical instead of being produced as ocular pleasure;

– not self-explaining, thus not to be grasped without explanation of the content;

– not part of a fictional narrative;

– rather 'stand alone' artefacts than series objects, thus forming a chain of discrete elements instead of one that progresses following a dramatic structure;

– difficult to deal with as, when part of a presentation, they hardly give the opportunity for an *entertaining* performance;

– missing visual attractiveness to charm the audience;

– becoming only interesting when the historical context the slide was made for or facts it represents is revealed and touches the audience;

– escaping attribution as they blur the boundaries between different media (see above).

These slides are almost never seen in re-use practices. Are they not accessible? I don't think so as most collections contain (some of) them. However, can an artist or a lanternist easily 'sell' an exhibition or a show to an institution when success factors such as visual attractiveness and high narrative potential are missing? Besides, the complicated essence of the out-of-canon slides asks for

Fig. 2: Photographically reproduced postcard showing Nandi, Shiva's sacred bull, on Chamundi Hill, Mysore; edges cut for the slide, details hand-coloured to direct the gaze.[19]

(broad) historical research, and the result is probably rarely apt to support a comic or dramatic tale. Last, but not least, due to their complexity, the non-canonical slides may make it difficult for the lanternist to show her/his acting potential trained in showmanship.

The influence of the *slide canon* and some ideas on its genesis factors

Canon traditions can be hard to overcome. In film history, it took *several decades* and a *new approach* (*New Film History*) before early cinematography was acknowledged and conceded a particular place in film history, that films from before 1914 were no longer considered 'primitive', but were accepted for having an inner logic of their own (although not always immediately understandable) and special aesthetic rules (although not always appreciable by cinema-goers of today).[20] However, it still needs training to appreciate their intrinsic value. Certain parallels can be observed with lantern slides. Their appreciation today is strongly influenced by, and even deeply rooted in the canonisation of aesthetic forms and certain types of subject matter.

As to the canon which (mis)guided me the day of the visit to Turnhout, it is reflected by the extremely useful taxonomy for magic lantern slides, established by María Carmen López San Segundo, Francisco Javier Frutos and Beatriz

Fig. 3: Photographically reproduced and hand-coloured document, original not yet identified, probably showing married Massai women.

González de Garay from Universidad de Salamanca, based on the Tomàs Mallol collection kept by the Museu del Cinema in Girona.[21]

I think that at least two aspects strongly contributed to establish such a slide canon and to keep it alive until today:

a. Commercial preferences:

Auction catalogues give criteria why certain slides are singled out and get high prices, while others are almost overlooked and sold as 'appendage' to lanterns; these characteristics can be found in the slide canon: a considerable age and a 'respectable' size, an illustrious ex-proprietor (e.g. Étienne-Gaspard Robert called Robertson), a well-known producer (e.g. Carpenter & Westley), a talented painter (e.g. Joseph Boggs Beale), a high-class show environment (e.g. The Polytechnic Institution in London), a non-industrial production technique (hand-painted by preference), a spectacular subject (e.g. horror nuns, devils, ghosts), etc. These kinds of slides, when offered in auctions, ended up as favourites in private and public collections and are often exposed.[22]

b. Re-use preferences:

When the 'young enthusiasts' became lanternists and revived the lantern-show tradition they followed schemes: a. in their presentations they used partly collections inherited by predecessors (e.g. Paul Hoffmann's series WAGNER'S RING DER NIBELUNGEN) filling an afternoon or an evening; b. they created a program out of shorter series made by manufacturers, mixed with effect slides for a bi- or tri-unial lantern; or c. they composed themselves a lecture from heterogeneous slides out of different series. The chosen slides had to allow a narration, and they had to have a *Schauwert* – an entertainment value for curiosity seeking onlookers – as well as a certain educational value. The last was welcomed by 'modern' lanternists as they were motivated by the wish to show their audience what a fascinating medium the lantern had been.[23]

So, in the course of time, mostly attractive and amusing slides ended up in the shows, and not the strange, incomprehensible, rather disturbing ones. The pleasing ones were also exhibited in media museums such as Girona, Padova, Paris (Musée du Cinéma), etc., figured in their catalogues and were published in books by collectors and connoisseurs.[24] One can say that in the past forty to fifty years a slide canon emerged about which several observations can be formulated:

(a) the repeated preference for a certain kind of slides and the omission of others in *re-use events* (shows), *re-use locations* (exhibitions) and *re-use occasions* (catalogues, books) was at the basis of this canon;[25]

(b) *(auction) sales* contributed to establish the canon (a statistical analysis of auction catalogues could reveal the factors for including / excluding slides);

(c) for the reintroduction of the lantern tradition into modern society by re-enactment, the shaping of a canon was extremely helpful, maybe even indispensable, to grant success to this enterprise as spectators got used to the images that were fascinating and entertaining which made the audience's expectations homogeneous, their reactions to a lantern show became relatively predictable.

The expectation of audiences attending live lantern shows today (e.g. families with children in the pre-Christmas period) is still determined by the 'charming' slides; they love the auratic and seek the magic. Here, the slide canon will keep its influence on the viewing habits. And why shouldn't it?

Re-using out-of-canon slides in the 21st century: "In Treue Fest!"

On the other hand, some 'contemporary' lanternists have started to follow other paths, motivated by the discovery of pictorial source material which can also be projected with a lantern. Here just one example: Karin Bienek and her colleague Cornelia Niemann have successfully integrated glass photographs taken during the First World War into a *theatre play* about the life of soldiers at the front and their families at home ("In Treue Fest! – Stricken und Sterben im Ersten Weltkrieg"). Both were inspired by the then approaching centenary of the war which marked Europe so intensely and which aroused interest in the destiny of the soldiers at the front and the daily life of their families at home. Beside the historical background which invited to a serious treatment of the topic and excluded magic enchantment, both actresses knew that many of the visitors coming to their programme might have lost ancestors between 1914 and 1918, or that their potential motivation could be to merely seek infotainment instead of entertainment.

Bienek and Niemann selected a serious topic and presented it at a well-chosen moment in a convincing narration. Before writing the script and selecting the slides, they had studied the history of the First World War and read books on how people back home dealt with the emotional stress. They still adapted the slides for their purpose, and they told a story as they would have done in a magic lantern show. Both approaches took the strangeness from the constellation (*private* glass *photographs projected* to a *public* audience) and made the public

follow the images with great interest. Besides, the actresses' re-enactment of a historical situation also motivated the audience to accept the slide presentation as a 'serious play'.

Conclusion

Re-use is all but innocent as it presents artefacts with a new comment to a spectator of today. Curators have discussed the consequences for a historical object when it is taken out of its original context and put into another environment.[26] To take a historical practice (such as a slide projection) and present it in front of a modern audience has a strong effect, especially in the particular form of a re-enactment, independently whether it is done 'histori-cally faithfully' or adapted to fit today's predilections. The re-staging practice of the last five decades left aside a big section of the once used slides and concentrated mainly on the fictional and/or pleasing ones which lead to the slide canon still preponderant in many minds.

As mentioned above, early cinema had the same problem to be accepted in its own right. Still today, films belonging to the non-fiction genre are much less projected than comedies and dramas; however this is slowly changing too.[27] What happened with early cinema may also happen with slides types and series from out-of-canon: the more work is done on them and the more is known about them, the more they become readable, comprehensible, showable out-side the walls of a museum's study centre or an academic library. Research projects such as *A Million Pictures* and *B-magic*, lantern shows such as "In Treue Fest!" and initiatives such as Anke Napp's newsletter presenting regularly special glass images from the collection of Kunstgeschichtliches Seminar Hamburg have and will draw attention to other long forgotten slide series once preponderant in specific contexts such as academias and universities, learned societies and (professional) associations.[28] These slides may not end up in today's slide canon, but this canon will no longer determine the gaze and eventually affect their appreciation.[29]

Notes

1. This article was presented at the conference as part of the panel "Appropriation, Re-use and Re-enactment: Contemporary Perspectives on the Lantern" together with the contributions by Nele Wynants and Kurt Vanhoutte (see elsewhere in this volume). The three articles report on the work and results of the University of Antwerp team in the European project *A Million Pictures*. We examine the *dispositif* of the magic lantern from a contemporary point of view and concentrate on the legacy of the optical lantern and its accessories as well as the question of how to revive a collection. This is important for many museums and cultural heritage institutions as the aim is to bring a collection back to life for contemporary audiences. The contributions focus more specifically on (1) the appropriation of the historical projection device (Wynants), (2) the re-use of the projected object (Lenk) and (3) the re-enactment as performance (Vanhoutte).

2. Many thanks to Bart Sas from the Municipal Archive in Turnhout who informed Nele Wynants and me about the local treasure. He was the first to show slides from the collection in his exhibition "Project-I. Vergeten glasplaten belicht" in the Taxandriamuseum in 2013.

3. See https://ia800600.us.archive.org/11/items/in.gov.ignca.7698/7698.pdf (accessed 6 August 2019; "A Maori Chief of the Old School", p. 127). All illustrations courtesy Zusters van het Heilig Graf, Turnhout.

4. During the Antwerp conference of *A Million Pictures* in October 2016, I gave a talk on "Re-Use in the Past" in which I approached the legacy of the optical lantern and its accessories from a practical-philological and semantic point of view to better understand the term 're-use' in its many facets. This text can be seen as a follow-up.

5. Information received from Peter Coupé and Bart Sas.

6. When we visited the collection, we saw a small number of geographic slides, probably from the German company Ernst Plank, some reproductions of paintings by the French slide producer La Maison de la Bonne Presse, and a small series of astronomic slides of yet unknown origins could be found. The collection was not catalogued, and we did not have time to stay long enough to see more.

7. Among them was a description of a visit to the Heilig Land-Stichting in Nijmegen (today Orientalis), an open-air museum recreating Palestine in the times of Jesus. Other folders contained artistic and architectural, historical, geographical or religious topics as well as material for natural science classes.

8. Maxim Gorki's text about the Nizhni-Novgorod Fair in the journal *Nizhegorodski listok* (4 July 1896) was translated by Leda Swan and reproduced in Jay Leyda, *Kino. A History of the Russian and Soviet Film*, 3rd edition (Boston, Sydney and London: Georges Allen & Unwin, 1983), 407–409, here 407.

9. The formation of a 'canon' happens by collective reception during a longer period. A group of experts, authorised by their profound knowledge, (aesthetic) experience and capacity of judgement, shapes criteria and assembles corresponding works. The norms, which are not rigid, can change and lead to the exclusion of artefacts and the inclusion of new ones. For more information, see Holger Brohm, Birgit Dahlke, "Kanon / Kanonbildung", in Achim Trebeß (ed.), *Metzler Lexikon Ästhetik. Kunst, Medien, Design und Alltag* (Stuttgart and Weimar: J.B. Metzlersche Verlagsbuchhandlung, 2006), 189–191; Tabea Schindler, "Kanon", in Stefan Jordan, Jürgen Müller (ed.), *Lexikon Kunstwissenschaft. Hundert Grundbegriffe* (Stuttgart: Philipp Reclam jun., 2012), 173–175.

10. See Laurent Mannoni, *Le grand art de la lumière et de l'ombre. Archéologie du cinéma* (Paris: Nathan, 1994), 102–103, who situates the end of the Savoyard's home performances around 1850.

11. In the last two decades of the 19th century at least, the projection lantern seems to have played no *significant* role on the fairgrounds in countries such as France, Belgium, Italy, Germany and Austria as an analysis of the French show people journal *L'Industriel forain* (checked from no. 1, 30 September 1883 onwards) and the German *Der Komet* (no. 1, October 1883, checked from January 1894 onwards) with their reports and exhibition lists of international fairs showed: events that involved a lantern are not mentioned. I did not check for Great Britain.

12. Propagandistic lectures by politicians are another field that needs to be explored.

13. One could think of other long-time lanternists that came later such as, e.g., Herman Bollaert with the Laterna Magica Galantee Show (Deinze, Belgium), the late Willem Albert Wagenaar with the Christiaan Huygens Theater (Zeist, The Netherlands) or Terry Borton with The American Magic-Lantern Theater (East Haddam, Connecticut), just to name a few. They helped to disseminate the lantern tradition.

14. See "Laura Minici Zotti about her lantern career and the museum of Precinema in Padua", *Newsletter* of the international research project "A Million Pictures. Magic Lantern Slide Heritage as Artefacts in the Common European History of Learning", no. 12 (December 2017): 10–11 (an abridged version of her interview with Jeremy Brooker in an issue of *The Magic Lantern*, the journal of the Magic Lantern Society UK and Europe). I also received information from her while I did research at the Museo del Precinema in Padua.

15. See Mervyn Heard, "White Wonders. Mervyn Heard and Company", *The New Magic Lantern Journal*, vol. 5, no. 3 (April 1988): 4–5.

16. Both kept a huge collection of pre-cinematographic apparatuses and started their museum in St. Ives (Cornwall) which, however, was closed long time ago.

17. This can especially be noticed in the wonderful journal of the British Magic Lantern Society: in every issue are published highlights of slide collections which are mainly beautiful fictional scenes and a real ocular pleasure.

18. This is still the case in many institutions in Belgium, but also in the Netherlands and Germany as members of the research project *B-magic* experienced; this is due to the lack of (trained) staff, money, primary sources, etc., or 'just' the incredible size of the collection.

19. See the original at http://indian-heritage-and-culture.blogspot.com/2015/10/nandi-sacred-bull-and-vehicle-of-lord.html (accessed 6 August 2019).

20. In a lecture given in 2010, Frank Kessler and I studied the canonisation of early films by film historians and the influence of it on its perception by the film community. See Frank Kessler and Sabine Lenk, "La canonisation des films des premiers temps", in Pietro Bianchi, Giulio Bursi and Simone Venturini (ed.), *Il canone cinematografico / The Film Canon* (Udine: Forum, 2011), 55–64.

21. See their contribution to this book. They were helped by researcher Daniel Pitarch from University of Girona who identified the slides, digitised the collection and presented it on Lucerna.

22. In opposition, archives and museums with collections that are difficult to understand and ask more effort than others generally do not consider them a priority for preservation if they are not threatened by decay or demanded for special exhibitions.

23. One great example for point c. was the last show by Laura Minici Zotti who told the life of Casanova. The narration worked like a 'grading' in film post production: it harmonised the diversity of the images. See the film La Vita Di Giacomo Casanova mostrata con la lanterna magica (David Da Ros, I 2007, DVD by Museo del Precinema).

24. See e.g. Detlev Hoffmann and Almut Junker, *Laterna magica. Lichtbilder aus Menschenwelt und Götterwelt* (Berlin: Frölich und Kaufmann, 1982); Jordi Pons i Busquet, *Image Makers. From Shadow Theatre to Cinema* (Barcelona: Ámbit Serveis Editorials, 2006); Terry Borton and Deborah Borton, *Before the Movies. American Magic-Lantern Entertainment and the Nation's First Great Screen Artist, Joseph Boggs Beale* (New Barnet: John Libbey, 2015), just to name some.

25. This slides selection was confirmed by *musea* devoted e.g. to film and pre-cinema, optical technique, children's toys as well as 'those were the days'-shops which needed their 'exhibition value' for temporary and permanent exhibitions, catalogues, special events, etc.

26. This aspect is discussed since 1796 when Antoine-Chrysostome Quatremère de Quincy protested against Napoleon's army stealing artefacts from other countries and bringing them to France as, according to the French artist, architect and jurist, artworks *in their own context* unfold a much more intense aesthetic effect than elsewhere (see Ingeborg Cleve, *Geschmack, Kunst und Konsum. Kulturpolitik als Wirtschaftspolitik in Frankreich und Württemberg (1805–1845)* (Göttingen: Vanden-hoeck & Ruprecht, 1996), 64.

27. Thanks to, for instance, the preservation and exhibition initiatives regarding the Mitchell & Kenyon nitrate prints during silent film events, film festivals and their distribution on DVD, these films are now widely known.

28. The scans from the collection in this article lost their mysterious, disturbing aspect for me once they were identified and contextualized; now I look at the pictures with the original image in mind, which pushes the defamiliarising manipulation for the lantern presentation to the background.

29. One can only hope that these 'making aware-activities' will prevent future annihilations of cultural heritage such as some 70.000 art historical slides of Kunstgeschichtliches Seminar Hamburg which were thrown away, and thus destroyed, in October 1998 (see Anke Napp, *Zwischen Inflation, Bomben und Raumnöten. Die Geschichte der Diasammlung des Kunstgeschichtlichen Seminars Hamburg* (Weimar: VDG, 2017), 87–88).

30. My thanks go to Sarah Dellmann, Frank Kessler and Anke Napp for their most valuable suggestions and information.

Museum and Archive Practices

Jennifer Durrant

Rediscovering and Re-using the Magic Lantern Slide Collection at the Royal Albert Memorial Museum and Art Gallery, Exeter, UK

Project background

The Royal Albert Memorial Museum and Art Gallery, Exeter (RAMM) is a multi-award-winning regional museum in South West England containing over one million items of Antiquities, Art, Natural History and World Cultures. The collection of magic lanterns and slides was created in the mid-20th century with the intention of their display in a permanent gallery tracing the history of technology. With a proposed focus on technical rather than social history, very little information about the provenance, donors or context was recorded. The ambition for this gallery failed to materialise due to a lack of funding and changes to the museum's mission. From the 1970s to the mid-2000s, the magic lantern collection remained in store without direct curatorial responsibility or public access. Within that period of time two cataloguing and repacking attempts by enthusiastic staff and volunteers focussed limited attention on this collection. But this work inadvertently added layers of physical and intellectual confusion which further prevented use of the slides.

Following a major museum redevelopment, which opened in December 2011 and subsequently won the acclaimed Art Fund Prize "Museum of the Year 2012", RAMM undertook a full collections review. Staff and external specialists assessed the entire museum collection for relevance, significance, purpose and use. This provided a significant opportunity for curators to identify areas of the collection which were under-used but had potential for exhibition and display, research and learning, artistic inspiration, handling or disposal. Coinciding with this opportunity, I developed a temporary exhibition *Life through the Lens* (6 October 2012 – 27 January 2013) which comprised the first significant exhibition of lantern material at RAMM for at least forty years.

The exhibition featured a small number of photographic lantern slides and sought to bring the collection to the public attention, to gather information from visitors about the provenance of the slides or their associated photogra-

Fig. 1: Dr. Richard Crangle digitising RAMM's collection. All images: © Royal Albert Memorial Museum & Art Gallery, Exeter City Council.

phers, and to ask whether museums should continue to own such collections of poorly-provenanced material. The visitors' responses to these questions demonstrated the appeal and value of lantern slides. One such visitor was Richard Crangle, a local magic lantern expert and subsequently a project member of Exeter's *A Million Pictures* team (Fig. 1). Another significant new contact was the grand-daughter of Alfred Rowden, an amateur photographer, whose name was present on slides and original storage boxes within the collection. Rowden was subsequently identified as the photographer and private producer of the most numerous sub-collection of lantern slides in RAMM's collection. This contact led to the discovery of two photograph albums still owned by his family which correlate very closely to his slides in RAMM's collection. The exhibition was the catalyst for the museum's involvement in the *A Million Pictures* project and the many positive outcomes arising from the partnership.

Collections knowledge and history

RAMM was invited by Joe Kember, University of Exeter, to join the *A Million Pictures* UK team as an associate partner, initially as the representative of the UK museum sector with a 'typical' museum collection of lantern slides. The success of this partnership with the University of Exeter has become a model for other areas of collections research between the two institutions and culminated in the hosting of the final *A Million Pictures* workshop at RAMM in January 2018. Collaboration between museums and universities can bring

significant benefits for public engagement with history; academics provide very detailed specialist knowledge of a particular area, which complements the expertise of museum staff with skills in the physical materiality and handling of objects, and modes of visitor interaction.

The first and perhaps most typical benefit of this partnership has been the full cataloguing, digitisation and research of the collection by Richard Crangle, which is now known to number nearly 4,500 slides of private and commercial manufacture, and four slide projectors. By studying clues including the hand-writing of slide titles, slide production techniques and the peculiarities of original storage boxes, Crangle unravelled the confusion created during pre-vious collections work. He identified background information and interesting social history stories which demonstrate the relevance to the museum's col-lection and enable the curators to use the collection in contemporary museum practice. Most notably this research uncovered the prolific work of local photographers William Weaver Baker, Lily Baker and Alfred Rowden. We now know their personal stories which bring these slides to life, including the location of the homes of these makers in the city and the settings for many of their photographic series. Both William Weaver Baker and Alfred Rowden were most active between the 1910s and 1930s, and their work comprises over half of RAMM's slide collection. Examples of their work include unique photographs of historical buildings and artefacts in Exeter, many of which were later destroyed during the Second World War. Their photographic slides also demonstrate links between RAMM and other local organisations including Exeter Cathedral, whose own archives contain examples of their work. Both Baker and Rowden deserve to be recognised in the region as important amateur historians and photographers. While evidence hints at Lily Baker's involve-ment with her husband's endeavours, her role is less clear and demonstrates the familiar story of the invisibility of married women in the creation and production of artistic and cultural works at that time.

Collection research also revealed significant stories of RAMM's own history in time for its 150th anniversary in April 2018. Both Rowden and Baker worked closely with Frederick Rowley, RAMM curator from 1902 to 1932, photo-graphing museum artefacts and providing slides for lectures by the associated College Field Club and Natural History Society. Details of these events were identified using the museum's archive, thereby demonstrating the value of such records and instigating a new cataloguing system to improve accessibility. Other anonymous photographic slides of the building's interior chart changes in museum practice, showing displays of prehistoric lithics, which are still exhibited in the contemporary museum in a very different format,[1] and ethnographic artefacts displayed in gallery spaces still used for this purpose.[2] A most unusual image shows the back-lit display of lantern slides in the early 20th century and demonstrates an early example of a display technique commonly found in contemporary museums (Fig. 2). The photographs of ancient stone

Fig. 2: Historical display of lantern slides in RAMM (accession number 318/1977/243).

crosses in the Dartmoor landscape reveal that lantern slides were regarded as a valuable tool for interpreting local archaeology.

The teaching history of the museum has been revealed with several small groups of slides purchased by the Technical College, a founding element of the Albert Memorial Museum, School of Art and Science and Free Library, which later outgrew the premises and became the University of Exeter. Cash books in the museum's archive record the purchase of several geology- and natural history-themed slides in the 1930s. These were quickly accessioned into the permanent museum collection by Edith Aviolet, the sub-curator of the museum, whose role included teaching with a special emphasis on geology. Why these particular slides were treated in this way is unclear, but perhaps the museum collection inventory system provided a method for easily organising and filing the slides. In any case, these lecture slides provide a glimpse into the changing nature of formal teaching at the museum: while some slides today

remain glorious examples of the natural world with colourful images of fungi[3] or evidence of local geological changes,[4] other slides contain racial stereotypes and attitudes which prove how far society has changed over the last 100 years. The publication of the lantern slides on the museum's own collections database and licensed to the Lucerna Magic Lantern Web Resource enables the whole collection to be publicly available for the first time in its history. Such accessibility is enabling difficult issues to be explored in academic publications.[5] With careful consideration and curatorial expertise, historical material containing racial or other stereotypes can become a tool for addressing issues of tolerance, inclusion and understanding in contemporary society.

Exhibition and display

Whilst digitising and cataloguing a collection are essential steps for museum collections, it is not the end of the process but one step towards their re-use. Digitisation enables curators to easily search the collection to select physical slides for exhibition and display. For when seen as an artistic medium in its own right, the art contained on magic lantern slides can complement more traditional artworks on paper or canvas as an interpretive record of landscape, people and attitudes. This potential was explored by RAMM in a major temporary exhibition *Dartmoor: a Wild and Wondrous Region* (22 December 2017 – 1 April 2018). Exhibited alongside traditional artworks, the physical lantern slides and modern prints from the digital images of the slides enabled visitors to explore the development of Edwardian tourism in this geographical area of Devon, and the transformation in human appreciation of the landscape.

Other temporary exhibitions at RAMM have included a small display highlighting the magic lantern as a witness of the social history of the First World War, while the museum's magnificent bi-unial lantern, complete with its original gas fittings and block of lime (accession number 335/1974), helped tell the story of human interaction with marine environments in the exhibition *Sea Life: Glimpses of the Wonderful* (15 May – 17 September 2017). Yet more display opportunities are planned in the museum's schedule, including Alfred Rowden's story forming a core storyline in a social history exhibition *Devon Voices 1914–1918: Home Front Stories* (15 September 2018 – 6 January 2019). The process of digitisation and subsequent ease of access has therefore created interest among the curatorial team and facilitated opportunities for physical display and access.

Creative re-use: beyond the norm

Museums hold collections to safeguard them for society, yet static preservation is not their only goal: contemporary museums aim to engage and enthuse their audiences. With a working ethos: "Home to a Million Thoughts", RAMM seeks to inspire its visitors to engage with the natural and human worlds in diverse ways. As an eclectic visual medium, the magic lantern provides an array of opportunities to captivate visitors through performance and practical dem-

Fig. 3: RAMM curators Jennifer Durrant and Thomas Cadbury performing the magic lantern at the "Victorian Time Travellers' Ball", 17 February 2018.

onstration. RAMM's curators are actively developing a programme of family and adult activities using slides and a refurbished Victorian lantern from the collection. Children and young people are fascinated by the physical and mechanical workings of the analogue technology, which sharply contrasts their norm of digital experiences activated by the touch of a screen. Many visitors – young and old alike – are baffled by the concept of life before electricity. Exclamations of delight abound when they see an image they have drawn on a modern glass slide projected and enlarged onto the wall before them. The physics of lenses intrigues children before they are old enough to understand their scientific explanations. When involving grandparents who remember

seeing lantern shows in their own childhood, the shared experience of a lantern show today brings back memories and creates links between generations.

The stories in our modern projections are not re-enactments of educational lectures or one-hundred year-old tales of morality. Instead we curators use our creative skills to compose new stories using an eclectic selection of slides. By doing so the audience is taken on a time-travelling journey encountering the weird and the wonderful. In this way, RAMM is enticing new and diverse adult audiences into the museum, which was most powerfully represented by a Steampunk-themed "Time Traveller's Ball" in February 2018. This sell-out event saw two of the museum's curators performing a series of magic lantern shows to 250 adults, many of whom had never been in the museum before (Fig. 3). By working with selected partners, audiences can further test the boundaries of reality and fantasy in the peepshow entitled "Lucky Dicky Crangle & the Cinnabar Moth". Written and performed by the local theatrical company Promenade Promotions, the show uses digitised slides from RAMMs collection and tours to festivals and events across the UK. In using the slide collection to entertain in such novel ways, RAMM is not only providing access to its stored collection by sharing slides beyond the physical boundaries of the museum building, but following the principles for which the slides were originally made.

Beyond the boundaries of the magic lantern

An interesting aside to the project has been the opportunity to explore other areas of visual history within RAMM's Technology collection. The research of Exeter's historical photographers has brought to light a studio portrait camera belonging to Owen Angel, a prolific Victorian portrait photographer whose work is represented in RAMM's Costume and Fine Art collections. Whilst known to museum curators when it was acquired in the 1970s, the knowledge about its significance was lost in the intervening years. Even more tantalising was the discovery of a Megalethoscope, a large Victorian optical viewing device, which had been acquired in the 1970s to demonstrate the history of technology but whose provenance was not recorded at the point of acquisition. With only two other examples currently known in UK museums and fewer than ten identified in international museums, the Megalethoscope is now recognised as a very significant object in RAMM's collection.

Conclusion

After many years of inaccessibility, RAMM's magic lantern collection is be-coming embedded in the museum consciousness as a resource with opportu-nities for engaging existing and new visitors – physically within the museum building, but also digitally via national and international platforms. This collection is now a valuable resource for exploring local and social history, experiencing visual and scientific technology, challenging societal attitudes, and a creative medium for flights of fantasy and delight. The work to catalogue,

digitise and research the collection demonstrates the importance for museums of working with key partners to bring in and share expertise. The diversity of visitor engagement and interaction enabled by RAMM's involvement in the *A Million Pictures* project proves the possibilities that arise through curatorial skills and enthusiasm. Magic lanterns encapsulate the journey of learning, discovery and enjoyment which museums strive for and form a novel medium for visitors to engage with the world around them.

Notes

1. Slide accession number 318/1977/210.
2. Accession numbers 318/1977/213 and 318/1977/214.
3. Accession numbers 107/1931 and 15/1933.
4. Accession number 51/1933.
5. Shalyn Claggett, "The Animal in the Machine: Punishment and Pleasure in Victorian Magic Lantern Shows", *Nineteenth-Century Contexts. An Interdisciplinary Journal*, vol. 40 (2017): 1–18.

Daniel Pitarch and Àngel Quintana

Back from the Shelves: Exploring the Museu del Cinema's Collection and Documents about the Magic Lantern in Catalonia

In the course of the *A Million Pictures* project, the University of Girona and the Museu del Cinema – Col·lecció Tomàs Mallol have collaborated closely to digitise, research and make the magic lantern known to the general public. This short article explains some of the work that was carried out, and it is divided into two sections. The first gives a brief overview of the Museu del Cinema collection and explains the digitisation process and some of its possibilities. The second section looks at several documents about the magic lantern in Catalonia, which were used for a temporary exhibition at the Museu del Cinema.

Digitising a collection

The Museu del Cinema's magic lantern collection is very rich, comprehensive and, like the rest of the Museum's collections, it mainly comes from the personal collection of Tomàs Mallol (1923–2013). At the time, the collection of lantern slides contained about 2,800 slides,[1] of which roughly 55 per cent are slides of standard square format, 30 per cent are panoramic slides in toy format and the remaining 15 per cent are slides with a wooden frame, either fixed or with a mechanism to create moving effects in the projected image. There are several cases of noteworthy slides, for instance a rare set of 18th-century slides or examples of special mechanisms like a wheel of life, a choreutoscope or a cycloidotrope.[2]

Between 2016 and 2017, the entire collection of slides has been digitised, resulting in 7,400 digital objects, which are either photographs or video recordings. Having the possibility of working on site, in the Museum facilities, and given that this was a rare opportunity to re-open the collection's store boxes, it was decided to carry out an in-depth digitisation. This means that several photographs were taken of each slide. The whole slide was photographed with front and backlight lighting, and a picture was taken of each side when this was judged necessary (this was usually done in the case of slides in a wooden frame or when written information was found on both sides). Also, the image on the slide was reframed and photographed solely with backlight, in order to obtain a high-quality photograph of the slide's image in the largest

possible size (instead of cropping it from the photograph taken from the slide as a whole, including the frame), as this file would be the one most likely to be needed for re-use purposes. For all slides with a moving mechanism, photographs were taken in several position of the movement. In addition, a video recording was made of the effect of the projected image when the slide was set in motion.

Many small issues became manifest in the process of digitisation. It may be useful to keep in mind that lantern slides were inserted into the lantern with the image upside down; this means that the slide mechanisms usually move more easily in this position. Consequently, some of our video recordings where done upside down and then changed to their proper position in postproduction. Moreover, regarding hand painted slides with two glass plates, and different visual information painted on each (usually a background and figure moving against it when the slide is pulled out), it is interesting to point out that when taking a photograph it is better to have the piece of glass with the figure facing the camera; if it is done the other way around, the background piece of glass (usually fully painted) can produce the effect of the figure appearing blurred. This issue – the blur – was not visible to the naked eye, but was clearly perceptible in the photographs; we mention this also to insist on the importance, whenever possible, of doing the digitisation whilst controlling the camera through a computer screen where images can be seen better than through the display screen of a digital camera.

It may seem obvious, that being able to engage with the actual historical artefacts (even without projecting them) is fundamental to understanding them. The photographic record of different positions in moving slides does not fully reflect the inherent possibilities of the slides. The closer you get to actually 'perform' the slides, the better your understanding of them. For instance, the complexity of a multiple rackwork slide representing the orbits of the planets around the sun was fully visible to us only during its video recording. All video recordings were made with the intention to use them as loops – that means that the first and the last position are the same – except for this slide of the planets, which we recorded for about seven minutes without getting back to the start position.

Digitisation also allows one to work further with the images as digital objects. Magnifying the images can reveal details about inscriptions or painting techniques (for instance, a night sky painted with fingerprints; see Fig. 1).[3]

It is also possible to produce digital reconstructions of the slides. Moving slides and their mechanisms can be separated into different layers and reassembled into a digital object, either for animation purposes or to be used in an interactive environment.[4] Some chromatrope slides (that consist of at least two separate glass slides revolving against each other, producing abstract patterns in movement) were originally constructed allowing to easily substitute the glasses, these replacement glasses can be digitally assembled and animated to recreate their effect in movement.

Fig. 1: "Harbour and sailing ship at night." Museu del Cinema – Col·lecció Tomàs Mallol (Girona).

The Museu del Cinema collection has also been added to the on-line database Lucerna Magic Lantern Web Resource (including an image of each slide).[5] And it was further used as a test sample for the genre typology developed by Javier Frutos and Carmen López from the University of Salamanca.[6] The cataloguing into Lucerna, based on the detailed catalogue of the Museu del Cinema, resulted in some new information, for instance, and as a quick example, some original images were discovered. This is the case of the Newton set entitled THE KING'S MESSENGERS that reproduces illustrations of a book.[7] This case is particularly interesting because one illustration resulted in two magic lantern slides – a dissolving view. This was done because the original illustration depicted an apparition, an effect that could be enhanced in the medium of the magic lantern. This example underlines the fact that images travelling between media are not simply reproduced, but, in fact, recreated.

Documents of magic lantern culture in Catalonia

The main dissemination activity carried out during the *A Million Pictures* project in Girona has been a temporary exhibition at the Museu del Cinema entitled *Light!*.[8] In the process of curating the exhibition, it was decided that using examples with a local background would be a good way to bring the magic lantern closer to the public, and this is why objects and documents related to the use of the magic lantern in Catalonia were extremely interesting to us.[9]

The museum's collection of magic lanterns and slides contains some interesting objects relating to local views or institutions. Regarding slide sets, there are

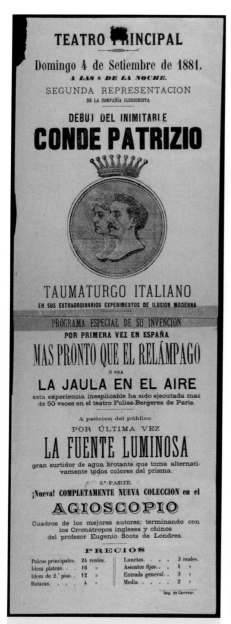

Fig. 2: Programme Teatro Principal (AMGi. Fons Ajuntament de Girona, Teatre Municipal).

two beautiful hand-painted sets which depict views of Catalonia, which not only show that slides were produced locally, but which also offer a glimpse of which places were important at the end of the 19th century in Catalonia (a reference to a railway line makes it possible to date the sets as being produced in or after 1880).[10] With respect to lanterns, there is a very interesting case of a fantascope bought and used in Girona's public high school in the mid-19th century.[11]

Besides slides and lanterns, we looked at newspapers, theatre programmes and personal recollections. Current digital collections of newspapers led us to detect several accounts of lantern shows. An interesting example, because of the prestige of the theatre, is a show given at the Gran Teatre del Liceu – the Barcelona opera house – on 14 January 1855.[12] The names of the showmen mentioned in different newspapers – Bienvenu, Peirard, Nast or Laschott, amongst others – provides insights into itineraries (for instance, Nast and Laschott also performed in Valencia).[13] Also important are the names of opticians established in Barcelona who were showmen as well, like Francesc Dalmau.[14] All these references allowed the museum visitors to understand that magic lantern shows were a common experience in 19th-century Catalonia.

Some theatre programmes which include lantern shows have been preserved in different collections. The Museu del Cinema collection contains a programme of a show at a theatre in Barcelona (Teatro Patronato del Obrero) on 13 December 1898 by Armando Duvregny. The whole show of "tableaux fondants artistiques" – as it is entitled – includes LA PESADILLA DE MISTER DABBERTON [Mr. Dabberton's nightmare]

that could be DAN DABBERTON'S DREAM, a well-known life model set by York & Son, of which one example is preserved in the Museu del Cinema's collection. Furthermore, this programme mentions a *Travel to Paris* "visiting its main sights" (listed in detail) and a section of "Surprising and praiseworthy animated slides (great illusion)". At the Arxiu Històric de Girona a poster listing a show programme was found which includes an *agioscopio* performance – one of the various names for the magic lantern used at that time – in a theatre in Girona on 4 September 1881 by Conde Patrizio (in 1876, his name appears in another show at the Liceu in Barcelona). This part of the show included "the English and Chinese chromatropes of Professor Eugene Soots of London". Another detailed programme was found at the Institut del Teatre in Barcelona, listing all the acts of a dissolving views show by Victor Peirard at the Theatre Romea on 31 December 1879.[15] It is worth pointing out that in the Filmoteca de Catalunya collection of film programmes, there are some which also contain slide projections. In some cases, lantern slides are referred to in general terms, but there are several cases of local news being shown with slides.[16] All these documents allowed us to show in detail what a lantern show may have been like, in terms of themes, structure and venue (and their publics).

The research carried out for the exhibition also unearthed two documents relating to the use of magic lantern slides for advertising at night. One article in the newspaper *La Vanguardia* of 24 September 1888 explained the use of slides at night in Paris.[17] The article explains the combination of publicity slides with other slides in order to keep the public interested in the projection (the reporter writes about showing slides of views of the world, comical slides or even moving fleas or microscopic scenes of a drop of water or vinegar). The other document is the memoirs of Joan Amades – a well-known folklorist in Catalonia –, who remembers that, after the first exhibitions of cinema in Barcelona, several screens were set up in the streets at night, and these showed advertising slides combined with views or moving slides.[18]

The exhibition was intended to explain the international importance of the magic lantern in the 19th century, but all these documents and objects are important because they bring this subject closer to local visitors. In the context of *A Million Pictures*, the exhibition was a perfect occasion to distil the academic research and the exhaustive digitisation and cataloguing; the fact to work for a different public than the academic community made us think differently and see other faces of the historical objects we work with.

Notes

1. Since the end of the *A Million Picture Project* another collection of slides was acquired, so currently the museum holds about 3,500 slides.

2. For an explanation of the choreutoscope, see http://users.telenet.be/thomasweynants/opticaltoys-choreuto.html; for the cycloidotrope, see https://www.luikerwaal.com/newframe_uk.htm?/bi-jzeffecten1_uk.htm.

3. "Harbour and sailing ship at night", Museu del Cinema record no. 2624, online accessible on *Lucerna Magic Lantern Web Resource* (accessed 11 March 2020), www.lucerna.exeter.ac.uk/slide/index.php?id=5120329.

4. See the contribution by Montse Puigdevall in this volume.

5. http://lucerna.exeter.ac.uk, search item Museu del cinema (accessed 11 March 2020).

6. See the contribution by Javier Frutos and Carmen López in the present volume.

7. William Adams, *Sacred allegories* (London: Rivington & Co., 1855), illustrations by Charles West Cope.

8. See the contribution by Jordi Pons in the present volume.

9. Regarding the history of the magic lantern in Catalonia, see Jordi Artigas' studies, for instance: "La Llanterna màgica a Barcelona. Segles XVIII i XIX", *Cinematògraf*, no. 4 (1992): 65–84. For examples in Spain, see Bernardo Riego, *La construcción social de la realidad a través de la fotografía y el grabado informativo en la España del siglo XIX* (Santander: Universidad de Cantabria, 2001) or Francisco Javier Frutos, *Los ecos de una lámpara maravillosa* (Salamanca: Universidad de Salamanca, 2010). For a study of optical media in Valencia, see Carmen Pinedo Herrero, *El viaje de ilusión: un camino hacia el cine* (Valencia: IVAC – La Filmoteca, 2004).

10. See the sets VIEWS FROM CATALONIA (Museu del Cinema record no. 2638) and MONTSERRAT (Museu del Cinema record no. 2623).

11. For a detailed history of this lantern, see Jordi Pons and Daniel Pitarch, "History of a Fantascope: A Device for Education in Nineteenth-Century Girona", *Early Popular Visual Culture*, vol. 15, no. 1 (2017): 83–99.

12. *El áncora*, no. 1838 (14 January 1855): 228. (Available online at Biblioteca Nacional – Hemeroteca Digital; the newspaper lists the entire programme of the show.)

13. Pinedo Herrero, *El viaje de ilusión*, 96–98.

14. A doctoral research on this subject is currently being done by Cèlia Cuenca at University of Barcelona. See her article "La linterna mágica en Barcelona: las fantasmagorías del óptico Francisco Dalmau (1844–1848)", *Fonseca, Journal of Communication*, no. 16 (2018): 101–114.

15. The program, translated into English, is the following: 1) Castle of Saint Livrada (France). 2) Surroundings of Granada (Spain). 3) Chapel of Saint Clair, Bayonne (France). 4) Ruins of Bontell Castle (England). 5) Cloister of Saint Gil (Spain). 6) Railway (train passing) (Switzerland). 7) View close to Tivoli (Italy). 8) La Piacetta [sic], Venice (Italy). 9) Sultan Palace, Constantinople (Turkey). 10) Caricature. 11) Mill on the banks of the Loire (France). 12) Interior of the park of Fontainebleau (France). 13) Batalha's cloister (night and day) (Portugal). 14) Strength defeated by Beauty. 15) Witter chapel. 16) Aurora Borealis at the North Pole. 17) View of Switzerland. Summer and winter with snow effect. 18) Place Concorde. Natural water effect (Paris). 19) The last day of Pompeii (Vesuvius eruption). 20) Colour games of great effect.

16. This collection is available digitally at http://repositori.filmoteca.cat/handle/11091/17820. See the programmes of Cinematógrafo Moderno of 13 June 1908 or Sala Montserrat of 30 December 1906, 14 April 1906 and 20 October 1907. For a study of actuality films and slides in this film programmes collection, see Daniel Pitarch, "L'exhibició de pel·lícules del natural i d'actualitat a Catalunya (1905–1919): estudi dels fons de cartelleres de la Filmoteca de Catalunya", in Àngel Quintana and Jordi Pons (ed.), *Objectivitat i efectes de veritat* (Girona: Museu del Cinema – Ajuntament de Girona, 2004), 181–192.

17. Luis de Llanos, "Carta de Bruselas", *La Vanguardia*, no. 452 (24 September 1888): 1.

18. Joan Amades, *Quan jo anava a estudi* (Barcelona: editorial Barcino, 1982), 112–113.

Jordi Pons i Busquet

Experiences from Setting Up the Exhibition "Light!" The Magic Lantern and the Digital Image. Complicity between the Nineteenth and Twenty-first Centuries

From 28 June 2017 to 8 April 2018, the temporary exhibition *Light! The magic lantern and the digital image. Complicities between the nineteenth and twenty-first centuries* took place at the Museu del Cinema in Girona (Fig. 1). This exhibition was part of the magic lantern awareness activities organised by the Museu del Cinema and the University of Girona as part of the European project *A Million Pictures*. It was curated in a joint collaboration of Daniel Pitarch and Ariadna Lorenzo from the University of Girona, and Jordi Pons and Montse Puigdevall, director and curator respectively of the Museu del Cinema. 14,378 people have visited this exhibition in the months that it has been open to the public.

This exhibition was housed in a space of 120 square metres on the ground floor of the Museu del Cinema, and the entrance was free to all. It featured a total of 320 original objects and devices. Except for two items, all are part of the Museu del Cinema's own collection.

With this exhibition, the curators hoped to achieve three main objectives. The *first* was to make the magic lantern more widely known to the general and wider public who, by and large, knows little of what this type of audiovisual communication was and what it meant before 1900. What were the projections like? Where were they done? What images were projected? In order to answer these questions, the exhibition had been divided into four main sections, which corresponded to the main areas where magic lantern projections were performed in the second half of the 19th century: in the theatre, at school, at home and on the street. There was also an introductory section about what a magic lantern is and a short chronological tour through its history.

Lantern shows and their venues

The first section was dedicated to projections in theatres and exhibition halls. It featured professional apparatuses, magic lanterns, posters and newspaper announcements of these shows and, above all, glass lantern slides.

Fig. 1: Poster of the exhibition "Light!".

The slides were selected to give an impression of the thematic, aesthetic and mechanical diversity of the slides and their images: far-away places, chromatropes, slides to create the effect of 'dissolving views', comical gags, etc. were just some of the examples on display. Also, in this area, there was a special

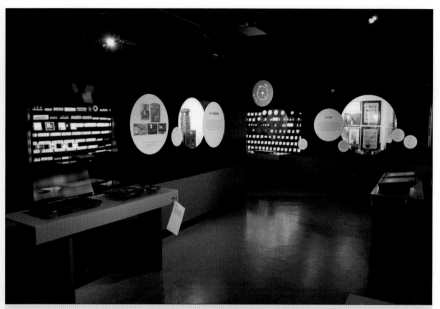

Fig. 2 (a, b) Sections of the exhibition "Light!".

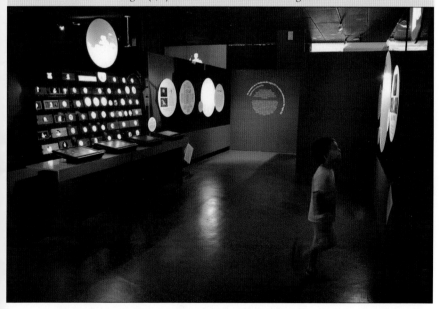

section dedicated to phantasmagoria, with the exhibition of several slides and a fantascope, a magic lantern that offered various types/forms of projection.

The second large area of the exhibition focused on projections in the fields of education and community. The lantern was also an educational resource, used both in classrooms and for public lectures. Teachers, scientists or explorers used the projected image, visible throughout an auditorium, as a medium for

their presentations or for experiments. The exhibition showed magic lantern slides from different academic disciplines such as geography, astronomy, art, anthropology, geology and more. In this section, we also included magic lantern slides known as 'life models', which often told moral stories and were mainly shown by religious or charitable associations as part of their missionary work, to propagate Christian morals and beliefs to the audience. As in the theatrical field, there was also a special section, in this case dedicated to the lantern slides produced for and shown at the Royal Polytechnic Institution in London, one of the iconic sites of magic lantern shows in the 19th century.

The third section of the exhibition dealt with projections in the domestic field. In the home, children were the main audience of the lanterns. Magic lanterns were also produced as toys, allowing children to become projectionists themselves. Slide sets of popular stories, comic strips, etc. were especially designed for the young viewers. The exhibition displayed equipment and slides intended for this audience, which was marketed since the second half of the 19th century.

The last area was devoted to projections on the street and in public space, where in the late 19th century the magic lantern was used to project large-scale advertisements onto facades in the centre of cities.

At the end of the exhibition, the "epilogue section" showed various tools used by lantern projectionists, from slipping-slides to a trade catalogue of lanterns and slides. In this final area, there was also an interactive touch screen that allowed the visitor to experiment with digital replicas of fifty magic lantern slides. Through this screen, one could manipulate and see in practice how the movement of the images was produced in magic lantern shows.[1]

Complicity between the nineteenth and twenty-first centuries

The *second objective* of the exhibition was to show visitors a large number of magic lantern slides from the collections of the Museu del Cinema, which had never before been exhibited in public. Only a small number of the Museum's more than 3,500 magic lantern slides are on display in the permanent exhibition. In this temporary exhibition, more than 75 per cent of the 275 slides had never been displayed to the public.

The *third objective* of the exhibition *Light!* was perhaps the most original and also the most daring one: looking for analogies or similarities between certain practices of the magic lantern shows of the 19th century and visual culture of the 21st century. Although the technologies are very different, some uses and ideas behind the images were much more similar than we would think. For example, the exhibition established a link between the 'dissolving views' effect of the magic lantern shows with the digital time-lapse technique. Furthermore, the digital moving image format known as GIF and the magic lantern slides with mechanisms that create a repetitive movement of the projected image share a similar strategy for animation. Other analogies discussed in the exhibition were those between Google Street View and slides with images of urban landscapes in cities around the world; between the chromatropes of the 19th

century and the video art of the 21st century; between slides that describe astronomical movements and certain types of apps that show the movement of planets in the solar system; between magic lantern slides that recount children's stories or teach the alphabet and some apps that have the same purpose; between lantern slides that illustrate the world's great works of art produced for teaching and the Artstore app, for example. Or finally, between the external and night-time projections of a magic lantern on the facades of buildings for advertising purposes, and the large video screens in Times Square, for example, or video mapping projections.

We believe that this exercise of looking for similarities between the visual cultures of the 19th and 21st centuries demonstrates that there is an unchanging, connecting thread that runs between both centuries: some of the intentions or purposes or created effects in the use of images did not change from one century to another, although the technology used is radically different.

Beyond this theoretical exercise, this area had another objective: to attract the attention of young audiences to the historical content of this exhibition (the magic lantern), through references to what they know well (the digital visual culture).

In addition to the historical artefacts, this exhibition had about fifteen audio-visual displays, either projected or on screens. In particular, there were six projections that showed the projected images of some of the magic lantern slides, and nine screens that compared the uses of the magic lantern in the 19th century and our current visual culture.

Additional activities

As a complement to this exhibition, the Museu del Cinema has organised several activities. Worth mentioning are the conference coordinated by Daniel Pitarch, entitled *Fantasmagoria i educació: cultura audiovisual a la Girona del s. XIX* (Phantasmagoria and education: audiovisual culture in 19th-century Girona), also the magic lantern show aimed at a family audience – *La Llanterna Màgica. Petit Museu Visual de les Meravelles del Circ* (The Magic Lantern. Small Visual Museum of the Wonders of the Circus), curated by Jordi Pujades –, and the guided tours of the exhibition.

The Educational Service of the Museu del Cinema offered workshops for students aged 6 to 14. In this workshop, students could create their own magic lantern show, with a script they have written and with images they designed themselves.

In short, the exhibition *Light!* involved a three-fold educational activity: about the spectacle of the magic lantern, about its links with our current audiovisual culture and the collections of magic lantern slides of the Museu del Cinema.

The positive response and the large number of visitors prove that our approach of connecting people with heritage through their present-day experience was largely successful. On 23 October 2019, the Museu del Cinema has opened a

new and original exhibition about the magic lantern and pre-cinematographic shows. It is entitled "Ooooh! Francesc Dalmau and the art of optical illusions", and it presents the shop of the Catalan optician Francesc Dalmau, who performed magic lantern shows (phantasmagoria, dissolving views …) and other optical shows in Barcelona in the middle of the 19th century. This exhibition is based on the results of Cèlia Cuenca's research for her doctoral thesis.

Note

1. See the chapter by Montse Puigdevall in this volume.

Montse Puigdevall Noguer

Creating a 3D Interactive Tool to Become a Lanternist. The Cooperation between Museu del Cinema and CIFOG (Girona), an Educational Centre for Programming 3D Animation

In the process of creating the temporary exhibition *Light! The magic lantern and the digital image. Complicities between the nineteenth and the twenty-first century* (Museu del Cinema, Girona, 28 June 2017 – 8 April 2018), the curators, Jordi Pons, Daniel Pitarch, Ariadna Lorenzo Sunyer and myself, agreed on the need to incorporate a digital interactive display. This display should allow different types of magic lantern slides to be manipulated virtually and, at the same time, be a tool for telling stories with a combination of different projected images in the same way as the lantern projectionists.

In order to develop such a 'touchscreen lantern', we started with the digital images of lantern slides from the museum's magic lantern slide collection. The digitisation was carried out by Daniel Pitarch as part of his involvement in the *A Million Pictures* project.[1]

The software was created by CIFOG – Cicles Formatius Girona (Vocational Training Girona). CIFOG is an educational centre focused on programming for 3D animation, video games and interactive environments. CIFOG's managers were very eager to collaborate in the development of the touchscreen lantern through the involvement of students on placement. To collaborate with other organisations, companies and institutions is one priority of CIFOG, as such a collaboration provides students the possibility to gain experience with the development and implementation of an actual project by companies in the audio-visual sector.

The purpose of the touchscreen lantern was to provide a way in which the visitors of the museum can, at least virtually, engage with the fragile and well-protected historical artefacts of the collection. Its aim was to enable users/visitors to faithfully reproduce, on a touchscreen, various types of magic lantern slides with moving mechanisms that the user can manipulate as though they were a magic lantern projectionist, but in a virtual environment. It should be easy to handle and was designed for all ages.

Through the touchscreen lantern, the user can experience, through digital images, the handling of a magic lantern slide in its projection: moving tabs, turning handles, sliding plates are executed via the touchscreen. A digital projector connected to the touchscreen represented the projected image that was achieved via handling the slide.

The device, located at the end of the temporary exhibition, comprises of a touchscreen, a digital projector and a screen fixed to the wall, as well as a computer on which the software runs and the digital images are stored. The digital environment can be used in four languages: Catalan, Spanish, English and French. When not in use, the message on the screen invites the visitor to experiment and provides a summary of how it works: "Become a lanternist! Touch the screen, choose the images, discover how they work and let the show begin!"

On the touchscreen, the user can select slides from a catalogue of fifty examples, comprising slides with and without moving mechanisms. In order to facilitate their choice, the slides can be searched and selected by categories according to the iconography or the context of use. The touchscreen lantern collection consists of views of urban or rural landscapes from different countries and also from Catalonia, bringing things closer to home for a local audience; chromatropes and visual effects; *phantasmagoria* images (a demon that moves its eyes and a skeleton that dresses and undresses); comical ones (a cook who falls into the saucepan or a fisherman who falls into the water pushed by a goat); action scenes (such as a battle or the burning of a ship); educational slides (e.g. movement of the planets); and slides with written texts, such as "Descanso" (Intermission), "Good night" or "Adieu" (Goodbye). After the users have made their selection, the next step is to sort them into a timeline order depending on the story they want to tell – and then to begin the projection, manipulating the slides one after the other.

On the programming side, each slide has its own, different interaction system, and all have been reproduced with simulated 3D details: levers, cranks, tabs, sliding glasses, etc. Using just a small dose of intuition, the person taking the role of the projectionist discovers each of the mechanisms and their operation and is almost instantaneously able to get the best out of their visual and narrative ability.

While using the touchscreen, the projection image of the lantern slide can be seen on the wall-mounted screen as if it were actually projected with a magic lantern, that is, significantly enlarged and with all its effects and movements, without the frame and the mechanism: an angel that becomes a skeleton, the rotating sails of a windmill, a carriage travelling through a landscape, an acrobat spinning on a trapeze, the rotation of the planets, a landscape that changes from summer to winter, etc.

The users, just like a professional lanternist, can accompany the projection with their own explanations, sounds and effects while they manipulate the slides, while the audience visiting the exhibition can enjoy the show by looking at the

screen. Meanwhile, the original magic lanterns and slides are displayed in different areas of the exhibition.

Although our touchscreen lantern presents a (rather faithful) reproduction of the aspects, which come into play for a projectionist during a magic lantern show, we have been forced to adapt, modify or omit some aspects. For example, the slide in the analogue reality would be placed in the lantern "upside down", and moving mechanisms of the slide would appear mirror-inverted in the projected image. Also, with respect to the physical characteristics of the slides and their movement mechanism, we had to adapt some aspects: in the touchscreen lantern, panoramic slides or slipping slides can be manipulated frontally, not only from the side as would be the case if they were placed in a historical magic lantern. In some cases, if there is more than one lever and if they are located on either side of the slide, it has been necessary to put them on the same side for technical reasons. Or, finally, in the case of dissolving view effects, an illumination control option has been added to the digital display that allows the user to dissolve one image into another.

Given that the collaboration has been a very positive experience for both museum and CIFOG, and that the touchscreen lantern was very much played with by visitors, we think the result has been a great success. We have plans to continue the collaboration in order to improve the interactive display by increasing the number and type of slides and thus showing a more complete range of the iconographic and formal variety of magic lantern images.

After the temporary exhibition had been closed, the interactive display was installed in the museum's permanent exhibition, in an area dedicated to the magic lantern, where it continued to invite learning through experimentation, which is a core principle in our educational approach.

We also consider adapting the interactive display to be used as a website or even as a mobile application, which would allow *users* to become a projectionist beyond the exhibition rooms of the museum, and which could be used in classrooms, for example, or in any other field.

Thanks to modern technologies such as 3D animation, our ample collection of digitised lantern slides and the excellent work of the CIFOG professionals, it has been possible to bring the magic lantern closer to the public by means of this fun, creative and educational tool.

Note

1. For an account of the digitisation process, see the contribution by Daniel Pitarch and Àngel Quintana in this volume.

Fig. 1: KEYSTONE 600 SET slide 2 "Flashlight of Wild Moose in a Maine Forest".

Artemis Willis

The Keystone 600 Version 2.0: Archival, Pedagogical and Creative Approaches to an Educational Lantern Series

W riting a century ago, progressive educator Frank M. McMurray, inspired by the possibilities of visual education, described an image culture that is startlingly familiar to those of us involved in the pedagogy of images within our contemporary mediascape:

> Pictures furnish material for thought as does the printed page, and they even rival print in that task. How extensively, and often exclusively, do advertisers rely upon pictures for attracting customers! Cartoonists compete with the most gifted writers in newspapers and magazines; and the great picture galleries of the world quite possibly exert as much influence as the great libraries.[1]

For McMurray, a professor of elementary education at Teachers College, Columbia University, pedagogical media – particularly lantern slides and stereographs – were decidedly superior to textbook descriptions and illustrations. Nonfiction views were able to visualise situations vividly: stereographs could draw students into virtual locations, lantern slides could be assembled into narrative sequences about events, and both held great potential in shaping understandings of the world. But their virtue, their *virtual presence*, was also a liability. Too often, students and teachers, assuming images conveyed their facts instantaneously, treated them as entertainment rather than objects of study. Pedagogical images, as *interactive* media, demanded meaningful engagement – thoughtful observation, inquiry and communication – for their profit to be realised. Both their benefits and their pitfalls were anticipated in the design of the KEYSTONE 600 SET (henceforth 600 SET), a carefully curated geographic system of six hundred corresponding and cross-referring lantern slides and stereographs, which could facilitate active learning about any subject in the "viewable" world, from art and architecture, to industry and labour, to politics and science. As the 20th-century institution of cinema has been destabilised by the emergence of new media, and as hybrid forms of image practice have evolved in new sites and platforms, the study of educational media at the turn of the last century, and of the 600 SET in particular, has become increasingly relevant to understanding today's interactive nonfiction and documentary media practices.

In this essay, I will highlight some of the archival, pedagogical and creative approaches I am employing to renew the 600 SET in the digital age. Before I turn to a discussion of these approaches, however, I want to touch on some key takeaways that emerged from my case study on the 600 SET, which was published in *Displaying Knowledge: Intermedial Education*, a special issue of *Early Popular Visual Culture*, guest-edited by Oliver Gaycken.[2] One takeaway is that nonfiction "screen" and "peep" practices – Charles Musser's and Erkki Huhtamo's terms, respectively – share a longer intertwining history, in which they represented similar subjects already in the 18th century, then intersected in the Langenheim Brothers's viewable and projectable glass stereographs in the 1850s, and converged in the 600 SET at the turn of the last century.[3] Another is that the 600 SET participated in a dynamic ensemble of pedagogical media, in which lantern slides, stereographs and motion pictures played different and complimentary visual-instructional roles into the 1960s, when Keystone closed its Education Department. The 600 SET thus demonstrates a cumulative and reciprocal model of nonfiction media history, even and especially during periods of pronounced media transition, such as the introduction of 16 mm sound film. That is to say, it upends any lingering 'teleological assumptions' that the newer educational medium of motion pictures supplanted the older stereographs and lantern slides. Indeed, the Keystone View Company's canny combination of stereo and lantern views, and the respective modes of perception afforded by them, renewed the earlier media in the 20th-century classroom.

The "2.0" in my title, then, is tied to my project of renewing the 600 SET in the 21st-century media environment. This project began with an archival mission to reconstitute the series itself as a physical and digital collection, a corpus that can lend itself to a wide range of image-based research, but has been largely inaccessible or unavailable to researchers.[4] While it is relatively easy to come by a 600 SET stereograph or lantern slide in a flea market, antiquarian bookstore or on eBay, without the other 599 views, readings, and *Teachers' Guide* that accompany it, it is impossible to understand the gamut of a given 600 SET view's potential meanings and uses, let alone the thinking that underlies its composition and inclusion in the series. Nonfiction photographic views tend to be granted the status of objective "windows on the world", but no image is neutral or innocent. The views in the 600 SET were each designed to appeal to the eye, to stimulate the mind, and, as I shall soon describe, to represent multiple subjects. Most of the "facts" of these "600 gems" are not immediately apparent. "Many of the ideas that they reveal lie below the surface", McMurray stressed, and it takes a careful examination to excavate the various strata of their meaningful contents.[5]

"Flashlight of Wild Moose in a Maine Forest"

To illustrate the layers of information in a given image from the 600 SET, let us consider view number two, "Flashlight of Wild Moose in a Maine Forest" (Fig.

1). What is immediately apparent is that it is an "instantaneous" black-and-white photographic slide of a female moose, made with the silver gelatin dry plate process, a somewhat mobile camera, and flash-light apparatus. The slide is in the American standard format (4" x 3¼"), and its label indicates the publisher, the title and two numbers: "2" and "(14227)", referring to the view and negative numbers, respectively. The image acquires more meaning when combined with its reading card, showing the geographic coordinates of latitude 47 degrees north and longitude 69 degrees west, the location of Moosehead Lake in northwestern Maine (Figs. 2a, 2b). The card also contains an educational text about moose: that they are called elk in Europe, that "moose" is the Native American ("Indian") word for "cropper" or "shrub eater", and other pertinent information. Significantly, the reading card also informs us about how the image was made.

2—(14227)

FLASHLIGHT OF A MOOSE IN A MAINE FOREST

What we call a moose in this country is called an elk in Europe. To be sure, the word elk means quite a different animal in North America. The word "moose," it is said, is an Indian term that means "cropper," or shrub eater.

The moose is a queer-looking specimen of the deer family. It is the largest of the deer tribe. The Alaskan variety is the largest kind. These are said to be as much as 8 feet in height, with a spread of antlers amounting to 6 feet. They are ungainly animals on account of the length of the legs, which are out of proportion to the size of the body. Their necks are very short so that they cannot graze. For this reason they live on shrubs and young shoots of trees, such as the willow and the birch. It is because of this that the Indians called them moose.

This photograph was taken after night by flash light. The camera hunters were in a canoe

Figs. 2a, 2b: Reading card
"Flashlight of Wild Moose in a Maine Forest".

Lat. 47° N.; Long. 69° W.

in a section of Maine where moose are fairly plentiful. At night moose often come down to a lake to drink and to browse on the lily-pads. They are good swimmers and do not hesitate to swim across a good-sized lake. The hunters heard the animal splashing in the water, cut it off from the shore with their canoe, and took the picture as it was clambering in the bushes on the opposite shore.

In the winter it is the custom of these animals to live in large families. One male and several females live together in what is called a moose yard in the forest. This they keep open by tramping the snow down. When the moose calves are born they are spotted. If they are taken in time, they can be tamed. In some parts of Sweden and Canada they are used to draw sledges.

Fig. 3a, b: Stereocard 2 "Flashlight of Wild Moose in a Maine Forest".

This photograph was taken after night by flash light. The camera hunters were in a canoe in a section of Maine where moose are fairly plentiful [...] The hunters heard the animal splashing in the water, cut it off from the shore with their canoe, and took the picture as it was clambering in the bushes on the opposite shore.

With the stereocard of the view, we discover the important fact that the moose was stereographed during her evening bath (Fig. 3a, 3b). We also realise that there is a direct correspondence between the stereograph and the lantern slide, and the stereograph's verso and the slide's reading card. A colour version shows that the slide was offered in colour as well as in black and white, and that the colour was applied by hand (Fig. 4).

When we consult the *Teachers' Guide* to the 600 SET, we glean even more information about "Flashlight of Wild Moose in a Maine Forest". From 1906 to 1911, this view was not included in the 600 SET; the series began in the state of Massachusetts, so view number two was "Quincy Market and Faneuil Hall, Boston, Mass". "Flashlight of Wild Moose" first appeared in the 1917 edition,

Fig. 4: Coloured version of the slide "Flashlight of Wild Moose in a Maine Forest".

and remained in circulation in the 1918, 1919 and 1922 editions. In 1930, Keystone produced the NEW 600 SET, a complete revision of the series, which entailed replacing old subjects with modern ones, producing new negatives of conventional views, and eliminating images that did not "contribute to the interests of the intermediate and upper grades".[6] Its evidently broad appeal notwithstanding, "Flashlight of Wild Moose" did not make the cut, and was replaced by "The Rocky Coast of Maine – Cape Neddick Light, York Nubble, Me", a view with a more dynamic composition that enhances stereoscopic effects.

During its run as a 600 SET view, the *Teachers' Guide* inform us, "Flashlight of Wild Moose" was used to illustrate a number of topics, such as Leather Sources, Hunting, Community Civics, Animals, Farm Life, Nature Study, Animal Stories and Fine Arts (Drawing, Flashlight Photography, Natural History Photography). Given that the *Teachers' Guide* suggested sequences for each of these subjects, we learn that the lantern slide of the moose was joined with a number of views to create different meanings: when paired with a view of Adrien de Gerlache on skis hunting seals on South Polar pack (no. 345), it signified prey; when shown with a view of a tannery (no. 272), it represented a source of leather; and when shown with a view of a gold mine in South Africa (no. 579), it illustrated the kinds of views made possible by flash photography (Figs. 5, 6, 7).

Fig. 5: Slide 345 "Hunting Seals".

This mutability of "Flashlight of Wild Moose", in turn, underscores an important aspect of nonfiction lantern images. We typically associate the transformation of meaning in images with the medium of film – with the techniques in film editing advanced by Lev Kuleshov, or his "ingenious spiritual ancestor", Francis Doublier – but, as these juxtapositions show, the lantern medium is also able to recast its material in descriptive, narrative or argumentative sequences.[7] In fact, the 600 SET wittingly exploited this very capacity of nonfiction lantern images, as well as the immersive 3D effects of stereographs.

As this discussion of "Flashlight of Wild Moose" shows, the 600 SET offers the unique opportunity to study layers of information in its pedagogical images and reading cards, recommended sequences and overall design. The series as a whole also sheds light on the uses and objectives of educational views more broadly, and the ways in which they transformed knowledge transmission and reception in the USA. And, of course, the 600 SET itself contains multiple histories: of the visual instruction movement's rise and decline; of American imperialist and racial biases in representing the modernising world and its peoples; and of Keystone's largely female labour force, which manufactured its lantern slides and stereocards by hand, to name a few. From a media-historical perspective, the 600 SET demonstrates the exceedingly adaptable, complex and ultimately useful nature of nonfiction views, and points to the need

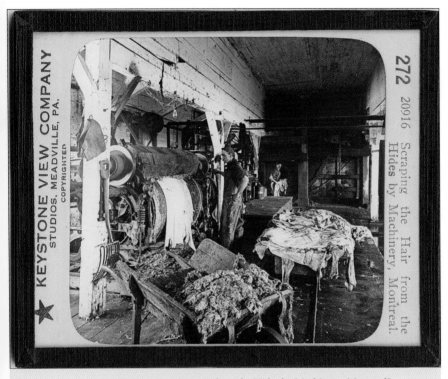

Fig. 6: Slide 272 "Scraping the Hair from the Hides by Machinery, Montreal".

for its reconstitution as a physical and digital collection in order to study the historical image repertoire.

Version 2.0

The 2.0 project began, aptly, with my acquisition of a box of slides used in the Chicago public school system. Chicago was a major centre of visual instruction and lantern slide manufacture, and the box contained slides from some local companies as well as the Keystone View Company.[8] I gradually acquired subsequent views through a combination of local sources, collectors and eBay. Given that there was no definitive 600 SET, my strategy was to represent every view number by at least one slide and reading card, regardless of edition. Reflective and transparent scans were then made of each view at a resolution of 2,400 ppi (to capture the labels and images), and the two files were "married" in Photoshop. Scanning at this resolution was time consuming (roughly 30 minutes per view), but the corpus is relatively small, and the large image files will be able to facilitate all kinds of known and unknown uses.

First and foremost, the digital collection is intended for an online resource, the first version of which, launching in 2020, will display each view with its reading card, alternate views and links to the *Teachers' Guide*, making the entire series

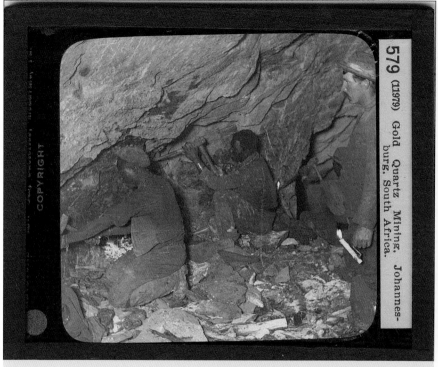

Fig. 7: Slide 579 "Gold Quartz Mining, Johannesburg, South Africa".

available online to researchers and the interested public. Eventually, the website will include more ancillary material, a digital book and some interactive elements, such as the ability to gather and display views into Keystone's recommended sequences, and an interactive map with views as they appear today. The ultimate aim of the web version of the 600 SET is to reactivate the dynamic and flexible features inherent to the original series for new pedagogical and creative uses.

Much like the original 600 SET, the pedagogical possibilities of the physical and digital collections are numerous. In my own teaching, I have used the series in several ways: I have had my students examine stereographs and stereoscopes in courses on media archaeology and visual culture, distributed lantern slides and strips of film (in gauges ranging from 8 mm to 70 mm) in an introductory film course, and projected lantern slides from the 600 SET alongside travelogues, educational films and the early documentary film NANOOK OF THE NORTH (Robert J. Flaherty, 1922) in my course "Documentary Values". I have found that showing lantern slides alongside these films is a useful way of exploring the question of how nonfiction views participated in the longer documentary tradition, and of addressing the conceptual gaps between so-called "pre-cinematic" nonfiction practices, "pre-documentary" film and the narrativised documentary film.[9] I have also uploaded digitised lantern slides and reading

cards to a Wiki site, and asked students to create Wikipedia-like entries on the views. My students attended to every aspect of the images and readings, addressing what they excluded as well as included, and in the process uncovered new layers of meaning. One student, for instance, described how the image and reading card for view number 82, "Erecting Shop, Baldwin Locomotive Works", emphasised the grand scale of Baldwin's locomotion production, while downplaying the company's enormous labour force, and omitting its manufacture of weapons and artillery during the First World War, the "darker side" of its history.

Conclusion: Re-using the Keystone 600

Keystone's interactive and participatory views, promoted by McMurray over a century ago, remain useful tools for detailed study and thoughtful teaching today. But the original series was also designed for creative uses, ranging from analysing photographic composition and techniques, to designing costumes and posters from photographs, to creating lantern performances. What is more, Keystone's "Outfits for Making Homemade Lantern Slides", distributed with the 600 SET, encouraged students to create their own images, and to mix their artwork with "official" views on the screen. By providing access to the large master files for "creative re-use" in new visual and performance works, the Keystone 600 Version 2.0 likewise aims to harness creativity. The possibilities and potentialities are limited only by the imagination of the "re-user".

Notes

1. Keystone View Company, *Visual Education: Teachers' Guide to Keystone "600 Set"* (Meadville, PA: Keystone View Company, Educational Dept., 1917), IX. The 1906–1922 version is accessible: https://upload.wikimedia.org/wikipedia/commons/d/db/Visual_education%3B_teachers%27_guide_to_Keystone_"600_Set".pdf (accessed on 5 August 2019).

2. Artemis Willis, "Between nonfiction screen practice and nonfiction peep practice: The Keystone '600 Set' and the geographical mode of representation", *Early Popular Visual Culture*, vol. 13, no. 4 (2015): 293–312.

3. See Erkki Huhtamo, "Towards a History of Peep Practice", in André Gaudreault, Nicolas Dulac and Santiago Hidalgo (ed.), *A Companion to Early Cinema* (Malden, MA: Wiley-Blackwell, 2012), 32–51; Charles Musser, "Toward a History of Screen Practice", *Quarterly Review of Film Studies*, vol. 9, no. 1 (1984): 59–69.

4. The Keystone View Company was prolific; as the last giant in the view business, Keystone not only produced its own views for many series, but also acquired most of the negative stock of its predecessors and rivals, such as Underwood and Underwood, amounting to a corpus of over 350,000 stereographic negatives. The Keystone-Mast Collection at UCR/California Museum of Photography comprises this enormous corpus. The National Museum of American History's collection of Lantern Slides and Stereographs (NMAH.AC.0945) contains what appears to be a 600 SET, though it is not identified as such. Other Keystone lantern slides or stereographs are scattered among various museums, universities and libraries, where they are not identified by series or edition, but by location or subject.

5. Keystone View Company, *Visual Education, XII*.

6. Keystone View Company, *Teachers' Guide to Keystone New 600 Set* (Meadville, PA: Keystone View Co., Educational Dept., 1930), III.

7. On Francis Doublier's program of 'Dreyfus pictures' and Lev Kuleshov's experiments, see Jay Ledya, *Kino: A History of the Russian and Soviet Film* (Princeton: Princeton University Press, 1983), 23 and 164–165.

8. The Kleine Optical Company, George W. Bond, Chicago Slide Company, Chicago Transparency Co., Genre Transparency Co., McIntosh Stereopticon Co., Stereopticon & Film Exchange and World Services Agency were all based in Chicago.

9. Charles Musser, Stephen Bottomore and others have tackled this question in various ways. See, for instance, Charles Musser, "Problems in Historiography: The Documentary Tradition before *Nanook of the North*", in Brian Winston (ed.), *The Documentary Film Book* (London: British Film Institute / Palgrave McMillan, 2013), 119–128; Stephen Bottomore, "Rediscovering Early Non-Fiction Film", *Film History*, vol. 13, no. 2 (2001): 160–173.

Performance and Re-use
beyond the Magic Lantern

Ariadna Lorenzo Sunyer

The Eameses' Slide Shows: Rethinking Lecturing in the Mass Media Culture

C harles and Ray Eames, famous American designers, are best known for their pioneering contributions to architecture and furniture, industrial and graphic design, but they are also celebrated for various visual projects, including films, exhibitions, lectures and multimedia shows. Little is known, however, about the rich photographic archive of the Eames Office, made up of some 750,000 items, and even less about the 300,000 slides among them. Most of the images of the Eameses' visual projects came, of course, from this archive, but why did they need such a huge number of images and, particularly, slides? How did they use these slides, and what for? Did these images simply illustrate the Eameses' projects and lectures at schools and universities?

A quick overview of the Eameses' works allows us to note that slides played a main role in their visual projects, such as in the film DAY OF THE DEAD, the exhibitions *Photography and the City* and *What is Design?*, the multimedia show *Glimpses of the USA*, the book *National Fisheries Center and Aquarium* or the series of illustrated lectures *Charles Eliot Norton Lectures*. Firstly, as was the case for the *Charles Eliot Norton Lectures* and *What is Design?*, a large number of these visual works were based on slides made by the Eameses and members of their Office.[1] Secondly, although the Eameses made use of different visual media, slides series were often used at the beginning of a project, before it was transformed into a film, an illustrated book or an exhibition, as was the case for DAY OF THE DEAD, *Glimpses of the USA, National Fisheries Center and Aquarium* and *Photography and the City*.[2] This proves that slides were regularly part of the creative process. These observations lead us to question why slides were so important in these projects.

This paper presents a preliminary study of Charles and Ray Eames' uses of slides in their communication and pedagogical projects between the 1950s and 1970s. It aims to outline some ideas to help us understand how these slide shows worked and, especially, how slides were used as a tool to promote innovative teaching methods and new communication theories. This paper also attempts to integrate these usages of slides into discussions about the broader histories of the use of images in pedagogy and of visual communica-

tion. It also aims to explain the noteworthy role of the Eameses' slide shows in these entangled histories.

Studying the Eameses' slide shows

Before focusing on the Eameses' slide shows, we should define what a slide show is and how it works. The basic elements needed for a slide show are slides, a projector, a screen and a darkened room – as in most of projected images shows –, and a lecturer and an audience – as is the case for lectures and theatrical events.[3] Sound has an important role in slide shows since projected images are usually accompanied by speech or narration, and music or sounds, which could be either performed live or played from recordings. These elements define a slide show as an audiovisual, ephemeral event.[4] An audiovisual show can be repeated in different circumstances and it can also be easily modified, depending on the lecturer's intention or the audience's response.

However, the articulation of these basic elements in a slide show implied that a slide is not a mere image carrier, but a tool for communication. Indeed, slide shows are communicative events, where a lecturer transmits a message to an audience, through words and projected images.[4] This means that slide shows should not only be defined as an audiovisual spectacle, but also as a communicative space for debate and exchanging of ideas.[5]

Considering the essential characteristics of slide shows and their complex articulation, we decided to study the Eameses' slide shows with the following method. Firstly, I have described and classified in detail the different slide sets.[6] Then, I have grouped them into three categories based on the use the Eameses made of them: "illustrated presentations" – gathering under this generic category all the live speeches supported by slides, from formal lectures and to informal talks –, "exhibitions", "others" and "non-identified".

The results of this analysis have shown that at least 46 out of 64 slide sets were used as "illustrated presentations". It can thus be claimed that the Eameses' main use of slides was to illustrate their presentations. Indeed, the Eameses gave several illustrated lectures and courses in various educational and cultural institutions, and they also regularly used slides to illustrate informal talks during the office's internal meetings with the staff, friends and/or clients. Actually, I discovered that, although rarely mentioned, slide shows have played an essential role in the Eames Office. As some former Office staff members recall, slide shows formed part of both internal staff meetings in the Eames Office and external meetings with clients.[8] In addition, the office had a rich photographic archive, with its own storage system and archivist, and was equipped with a light table and slide projectors.[9] Max Underwood, former staff member, describes how slides and the concerned equipment were used as it follows:

> [...] Charles, Ray and members of the staff would gather around the light table, followed by the conference room to see what illusive new perceptions they had captured. [...] Clients, invited guests or staff members would spend many a lunch

hour in an impromptu Eames essay festival, where past and present investigations would effortlessly blend in the flickering images floating within the darkened conference room.[10]

From our short glimpse into the archival sources, we can understand slides were a very important and not secondary medium used by the Eameses. Not only were the slides used to illustrate Eameses' numerous lectures and courses, but slide shows were also part of the office routine. In the following part, we will study why the Eameses used slides and not another medium.

The Eameses' uses of slides: "Intensive Looking" and "Awareness Shows"

In 1953 and 1954, Charles Eames was invited to give a series of lectures at the University of California, Berkeley to architecture students.[11] It was on these occasions that the essential concepts to understand the Eameses' reasons of using slides became evident.

In the first lecture, Eames claimed that "an important aspect of the involvement [of the design] process [was] learning to see things with new eyes, realizing the possibility of gaining new emotional experiences through intensive looking".[12] Then, he gave two examples of ways to achieve "intensive looking":

A. Capturing a scene with a camera is of value for it helps the individual learn to see. Looking at familiar objects from a different perspective [...] helps to stimulate greater awareness.

B. As an example of 'intensive looking' the lecturer presented the first of his 'Awareness Show' [...]. This is an example of a creative shuffling and working of elements [...].[13]

Interested in photography since his youth, Charles Eames would take pictures throughout his life, sharing his passion with the people around him and making photography essential to his work.[14] Photography and slide shows, in the citation referred to as "awareness shows", are presented by Charles Eames as tools for learning to see and think differently, tools for practicing the fundamental concept of "intensive looking".

So, we can understand that the Eameses worked regularly with slides because slide shows enabled them to creatively shuffle the images, drawing unexpected associations between them that stimulated audience's awareness and creativity. It was this creative potential of slides that was at the core of the Eameses' promotion of this medium as a pedagogical tool inside their office and also outside in educational institutions.

Indeed, in the fourth Berkeley lecture to students of architecture, Charles Eames recommended "awareness shows" because of their capacity of originating compelling audiovisual association experiences, experiences that according to him each student in this field of study should be aware of.[15] In the Eames Office, as several former staff recall, awareness shows were a tool to train and develop their vision and promote creativity. For example, Max Underwood pointed out: "[...] these visual notes and visual essays became essential tools

for gaining critical distance to [Eameses'] work, as well as a method for re-seeing and raising new questions."[16] In addition, the Eameses used often the triple-screen technique of projection,[17] which exponentially increased the slide shows' effects of creative shuffle and unexpected associations.

However, there is another facet to the Eameses' use of slides. Indeed, as the more complex slide shows demonstrate, this medium also emerged in their visual projects as a powerful communicative tool. By stimulating creativity and awareness, slide shows also helped to convey ideas beyond preconceptions, breaking down barriers between disciplines, preconceptions and promoting multidisciplinary. Although mainly exploited in the spectacular multimedia shows,[18] this communicative aspect of slide shows was also taken into account and developed in their illustrated presentations, which explains the common use of the triple-screen technique.

To summarize, the Eameses used slides in their presentations as both a pedagogical and communicative tool. In the last part of this article, we will study the evolution of the Eameses' illustrated presentations and integrate them into the broader histories of the use of images in pedagogy and of visual communication.

Lecturing in the mass media culture: The Eameses' exploration of illustrated lectures

Other articles in this volume show that the Eameses were far from being the first to use images to accompany a discourse. As we can see in this volume, practices of this kind had existed since the 19th century, when the tool par excellence to promote visual education were the magic lantern projections. These performances laid the foundations for the traditional format of illustrated lectures, that is, a speech accompanied with projected images, given by a specialist in an educational space.

From the 1930s, major innovations in the photography industry, such as the replacement of glass slides with celluloid slides and the emergence of colour photography, made projected images even more accessible (cheaper and easier to use). Slides became part of the daily routine at schools, enterprises and amateurs' milieus, revolutionising education and mass media culture and thus inaugurating the golden age for illustrated lectures.

The Eameses' gave their first illustrated lecture in 1945[19] and, since then, they continued using slides in their courses, lectures and talks, exploring this medium with several screens, music and sometimes with even smells.[20] The Eameses' slide shows opened a new chapter for illustrated lectures in the history of visual pedagogy and communication.

Influenced by both the visual theory of György Kepes, an artist close to the Bauhaus school, and the pedagogy of John Dewey, a psychologist, philosopher and educational reformer, their slide shows promoted innovative teaching methods and new communication theories, transforming illustrated lectures.[21]

Critical of the lecture's traditional format,[22] the Eameses proposed bringing in more experientially diverse educational methods that were supposed to stimulate audience's creativity and awareness and, so, to help to better understand abstract ideas.[23]

The Eameses' experiments with illustrated lectures took place during critical years for communication and mass media culture. Indeed, communication as a research field was being strongly developed,[24] and significant technologies appeared (such as the television or the computer) that would change communication and mass media culture forever. The Eameses contributed to these major changes through their projects, and specially their illustrated lectures, which transformed the traditional illustrated lecture into a rich audiovisual show, conferring it as a high pedagogical and communicative potential and blurring the boundaries between education and mass media communication.

In the late 1940s and the early 1950s, as Lecture I[25] exemplifies, the Eameses' slide shows were relatively simple, with one screen and 30 to 40 slides. From the late 1950s onwards, they became more and more complex – employing at least three screens, 50–250 slides and additional audiovisual formats – evolving to spectacular multimedia shows. For example, Konditorei and Picasso consisted both of a triple-screen projection of 96 slides.[26] Here, it seems logical to link the illustrated lectures and the multimedia shows since, when slides were not directly used, they were transformed into a film through the slide-to-film technique mentioned above and screened in the events.

The Eameses' main ideas in the core of the illustrated lectures' transformation can be found in A Rough Sketch for a Sample Lesson for a Hypothetical Course.[27] Created in collaboration with the designer George Nelson in 1953 as a result of developing a new educational policy for the Department of Fine Arts at the University of Georgia, it was a prototype for a course aiming to improve communication through introducing new audiovisual technology at universities. Going in depth in the concepts of "awareness shows" and "intensive looking" presented above, the main goal of this project was to create a space made of information and sensations, through several graphic materials covering the walls, alternated projections of films and triple-screen slide shows, a soundtrack made of music, sounds and texts, and also smells diffused through the air conditioning system. This space saturated with information and sensations was supposed to facilitate the transmission of knowledge and to also promote spontaneous connections between the different elements beyond the academic disciplines.

After this project, the Eameses continued exploring illustrated lecture, using the three-screen slide shows in the Office and developing at the same time complex multimedia shows, such as the already mentioned Glimpses of the USA or Think.[28] The Eameses' practicing of illustrated lectures culminated in 1970 and 1971, with the renowned Charles Eliot Norton Lectures at Harvard University, richly illustrated with slide shows and short films.[29]

In conclusion, the Eameses' experimentations with slide shows are far from being isolated practices in history. Through the form of the illustrated presentation, they fit perfectly in the history of pedagogy and visual communication, playing a noteworthy role in the updating of the traditional illustrated lecture.

Conclusions

To summarise, we can claim that, through their illustrated presentations, the Eameses emerge as crucial figures in the history of education and visual communication. This research has shown that slide shows, and especially illustrated presentations, played a significant role in the Eameses' work for different reasons. Firstly, slides were technically and conceptually at the origin of several visual projects, such as films, exhibitions, books and multimedia shows. Secondly, among the different uses of slides, illustrated presentations have appeared as the most common use of slides inside and outside the Eames Office. In the third place, through illustrated presentations, slides were part of the Eameses' working method and were also the principal motor for developing their ideas on visual communication and pedagogy. Indeed, as we have seen, the Eameses used slides as a pedagogical tool, as well as a visual communication medium, experimenting with the power of images and other audiovisual forms to stimulate the audience's creativity and awareness.

Finally, we can also claim that, with a multidisciplinary and experimental approach, the Eameses' illustrated presentations updated the traditional format of the illustrated lecture to meet the communicative and pedagogical needs of society, rendering the border between education and mass communication more and more porous and contributing to the development of the mass media culture. Through the form of the illustrated presentation, the Eameses' experimental performances with slides constitute a new chapter of the history of pedagogy and communication, being representative of a new way of understanding visual learning and communication.

Notes

1. Given by Charles Eames between 1970 and 1971 at Harvard University, the *Charles Eliot Norton Lectures* were a series of lectures illustrated with slide shows and short films about "Problems Relating to Visual Communication and the Visual Environment". *What is Design?* was a triple-screen slide show created by the Eameses in 1969 for a collective exhibition with the same title, taking place in the Musée des Arts Décoratifs in Paris. See John Neuhart, Marylin Neuhart and Ray Eames, *Eames Design: The Work of the Office of Charles and Ray Eames* (New York: Harry N. Abrams, Inc., 1989), 345, 355–362.

2. Sponsored by the Museum of International Folk Art in Santa Fe, New Mexico, the film DAY OF THE DEAD was made in 1957 by slides of pictures taken by Deborah Sussman and Charles Eames some years before. Presented during the American National Exhibition in Moscow in 1959 *Glimpses of the USA* was a multiscreen show, projecting simultaneously several short films made of more than 2,200 slides on seven screens. Accompanying the architectural project for a national fisheries center and an aquarium, the book *National Fisheries Center and Aquarium* was illustrated in 1967 by mixing different kinds of images, among them slides. The photography exhibition *Photography and the City: The Evolution of an Art and a Science* was made by the Eameses in 1968 for the Arts and Industries building of the Smithsonian Institution in Washington, DC. A very significant part of curating this exhibition was based on slides. See Neuhart and Eames, *Eames Design*, 212–213, 238–242, 315–318, 330–333.

3. See Robert S. Nelson, "The Slide Lecture, or the Work of Art 'History' in the Age of Mechanical Reproduction", *Critical Inquiry*, vol. 26, no. 3 (2000): 415.

4. Ibid.

5. For a deeper analysis of the slide show's complex articulation, see Ludwig Vogl-Bienek, *Lichtspiele im Schatten der Armut. Historische Projektionskunst und Soziale Frage* (Frankfurt am Main: Stroemfeld, 2016) and Frank Kessler's contribution in the present volume.

6. As Ludwig Vogl-Bienek and Richard Crangle (ed.), *Screen Culture and the Social Question, 1880–1914, KINtop 3* (New Barnet: John Libbey Publishing, 2014) demonstrated, the cinematograph and the magic lantern, both devices for the first slide shows, were used as "social agents" at public lectures, election campaigns and church services from the late 19th century until at least the early 20th century, rising public awareness of the destitute circumstances of certain social groups.

7. This analysis is based on the most exhaustive catalogue of the Eameses' work from 1941 to 1978: Neuhart and Eames, *Eames Design*. In this book, slide sets that "have remained in the slide-show form are presented as separate projects; slides that were later transferred to motion-picture [sic] film are designated only as films" (51). This analysis is based on a classification of the several slide sets, according to their creation date, their title, their subject, the images' origin, the kind of event and the place where the slide shows took place, the slide shows' participants and the date and place of the slide shows' repetition.

8. Max Underwood, "Inside the office of Charles and Ray Eames", *Ptah*, no. 2 (2006): 55 (http://www.eamesoffice.com/wp-content/uploads/2012/02/INSIDE-THE-OFFICE-OF-CHARLES-AND-RAY-EAMES.pdf). Jeanine Oppewall, interviewed by Demetrios Eames on 2 August 1992, and Gordon Ashby, interviewed at Inverness, CA, ca. 1995, both quoted in Demetrios Eames, "An Image Can Be an Idea", in Demetrios Eames (ed.), *An Eames Primer*, revised edition (New York, NY: Rizzoli, 2013), 232–233.

9. Marilyn Ibach, *Eames slides (draft)* (Washington: Library of Congress, 13 August 2015). *Inventories 1960–1988*, Box II: 232, "Charles Eames and Ray Eames Papers", Manuscript Division (Library of Congress, Washington, DC).
As former office staff member Gordon Ashby recalls, the slides and the concerned equipment were used widely and occupied a central part of the working method: "[...] looking at a light and a white light table and having to focus on images again and again [was] one of the most fatiguing, energy-draining activities" (Gordon Ashby, quoted in Eames, "An Image Can Be an Idea", 232).

10. Underwood, "Inside the office", 55.

11. Charles and Ray Eames, "Architecture 1 and 2, University of California, 1953–1954", in Daniel Ostroff (ed.), *An Eames Anthology: Articles, Film Scripts, Interviews, Letters, Notes, and Speeches* (New Haven, CT: Yale University Press, 2015), 120–127.

12. Ibid, 120.

13. Ibid.

14. In Eames, "An Image Can Be an Idea", 227, he describes this passion as it follows: "It was a form of investigating, celebrating, meditating, explaining, exploring, recording, communicating, teaching, sharing, playing, and much more. Even new staff members would be instructed to go and shoot a roll of film, which was then used in their evaluations. [...] Many staff members took this love of photography with them long after they had moved on. [...] Photography was critical to the Eameses' work and world." Underwood, "Inside the Office", 55, also recalls that pictures and filming played a relevant role in the Eames Office design process. In their exhaustive catalogue (Neuhart and Eames, *Eames Design*, 51) they explain the Eameses' interest for close-up pictures "as a way of looking at the world and demonstrating the richness of everyday life and the connections between apparently dissimilar phenomena".

15. Eames, "Architecture 1 and 2", 123.

16. Underwood, "Inside the Office", 55. Jeannine Oppewall also explains that the Eames Office was "[...] one place where [she] learned an enormous amount about how to see. [She thinks] you come into the world with a certain predisposition [...] to see or not to see. But, [she thinks], for [her], that predisposition [...] was manufactured, or completed, [she guesses], in the Eames Office. Because [she] spent so much time looking at the way Charles saw [...] and trying to understand why some things fit together better than others." (Oppewall, quoted in Eames, "An Image Can Be an Idea", 232–233.)

17. According to Eames, ibid., 232, "over a dozen three-screen slide shows were made at the Eames Office". Neuhart and Eames, *Eames Design*, 51, explain that the Eameses' standard approach consisted in "showing sequential images in quick progression (eventually 2 or 3 slides were projected simultaneously side by side) [accompanying it with a] project presentation, lecture or informal talk".

18. The best example is GLIMPSES OF THE USA, already mentioned in the footnote no. 2. It was commissioned by the US Information Agency to portray the American way of life in the American National Exhibition in Moscow in 1959. See Eames, "An Image Can Be an Idea", 233–236; see also Elizabeth L. Altimus, *Out of Many, One: Glimpses of the USA by Charles and Ray Eames, The Family of Man by Edward Steichen, and universal thought in Cold War propaganda* (Louisiana: Louisiana Tech University, MA-thesis 2012), 22–31; Demetrios Eames, "An Image Can Be an Idea", 233–236; Beatriz Colomina, "Enclosed by images: the Eameses' multiscreen architecture", in Christopher Eamon and Stan Douglas (ed.), *The Art of Projection* (Ostfildern: Hatje Cantz, 2009), 35–56.

19. *Lecture I* (the name was given to it later by the Eameses) was first presented at the California Institute of Technology in Pasadena. Made of a single projector and 30 to 40 slides, it addressed the "relationship between design and the structure of the natural and man-made worlds". It was also shown later to public groups, office visitors, students and clients and modified for special occasions as well as including new images. See Neuhart and Eames, *Eames Design*, 51.

20. See Altimus, *Out of Many, One*; Colomina, "Enclosed by images".

21. The Eameses' pedagogical and communicative ideas were highly influenced by the main concepts of Dewey and Kepes. On the one hand, although it seems that the Eameses did not read Dewey's books, from the 1940s to the 1960s the innovative ideas of the philosopher were widely known in the U.S.A. In this context, the "learning-by-doing" approach and the promotion of active participation of the audience to build a participatory democracy, both regularly used by the Eameses, were typical from the Deweyan educational philosophy. On the other hand, the Eameses were close to the former members and artists related to the Bauhaus school, among them Kepes, and they were particularly influenced by the painter's book *Language of Vision*. The Eameses' development of visual communication was based on Kepes' ideas of visual communication as a universal and international language. See Constance Chunlan Lai, *Charles Eames and Communication: From Education to Computers*, Master of Science in Architecture Studies at Massachusetts Institute of Technology (Cambridge, MA, 1999), 13–48 (accessed 5 August 2019, https://pdfs.semanticscholar.org/96e7/a5d8970d74780222156776fddb2885ea5857.pdf).

22. See Charles Eames, "Industry Film Producers Association Speech" (1962), quoted in Ostroff (ed.), *An Eames Anthology*, 241.

23. See Pat Kirkham, *Charles and Ray Eames: designers of the twentieth century* (Cambridge, MA: MIT Press, 4th edition, 2001), 38–39.

24. For a deeper analysis of the role of communication in the Eameses' work and Charles Eames' relation with the complex notion communication, ranging from education to computers, see Lai, *Charles Eames and Communication*.

25. See note no. 19 for a description of *Lecture I*.

26. *Konditorei* was created in 1955 after a trip in Germany and was presented to friends and staff members. *Picasso* was made in 1967 after the Eameses' visited a Picasso exhibition in the MoMA that same year in order to be shown to the staff members that could not visit the exhibition. See Neuhart and Eames, *Eames Design*, 203, 324.

27. See Neuhart and Eames, *Eames Design*, 178. For more information of this project and its role in the development of projecting images on several screens during the 1960s, see Olivier Lugon, "Exposer/projeter: la diapositive et les écrans multiples dans les années 1960", in Nathalie Boulouch et al. (ed.), *Diapositive. Histoire de la photographie projetée* (Lausanne: Noir sur blanc / Musée de l'Élysée, 2017), 188–201.

28. For *Glimpses of the USA*, see footnote no. 2. Consisting of projections of films and slide shows on 22 screens, *Think* was created in 1964 for the IBM pavilion in the World Fair in New York. See Neuhart and Eames, *Eames Design*, 284–291.

29. See footnote no. 1.

Kurt Vanhoutte

Re-enactment and the Magic Lantern Performance: Possessed by History[1]

Touched by the past

There is more to the history of the magic lantern than meets the eye. Generally spoken, the focus is on visible remains of lantern shows. This is hardly surprising. The slides, surviving lecture texts, the projection devices: these technologies are tangible, storable and available within an archive. Whether this archive belongs to a private collector, a researcher or a curator, in all these cases a collection of objects pre-eminently stands out to bear witness to the history of the lantern. These collections suggest that it is possible for the researcher or/and the *aficionado* to quite literally possess history. What narrows the distance between us and the past, then, are the objects that seem to testify to what actually happened in former centuries, when an old hand started operating the lantern in front of a spectator who held her breath. Magic lantern shows obviously were live events. They adapted the lantern and its users to suit a certain venue, occasion and audience, and produced certain experiences. The archive of objects allows us to re-imagine the dispositive of these shows. It helps us draw a more or less accurate picture of the dynamic system of relationships between space, technologies, the human operator and his audience, and how these relationships varied over time.[2]

Drawing these relationships is also always a matter of energy exchange: between past and present, and between actors and spectators. That is to say that there may be more at stake than the promises archives at first sight hold. Document- and object-based archives should more specifically stimulate us to imagine that crucial, albeit somewhat mysterious, condition of the history of the lantern that goes under the name of the performative. As a category, the performative remains stubbornly slippery, and with good reason, because the term introduces a dimension to historiography that at the same time transcends the world of objects. In principle, the performative triggers a shift in how we look at the theatrical event from what it depicted to the experiences that it produced, from representation and meaning to relationality and effect. What the notion of the performative brings into perspective is the contingent and elusive realm that an event brings about. A performance does not only represent reality, it also produces a reality. It engenders a situation that inscribes the

spectator in certain values, conventions and imaginaries. This situation is hard, if not impossible, to pin down for who was not there when the event took place.

A challenging way to learn something about the ephemerality of the lantern show is in itself performative. Contemporary re-enactments have reconstructed historical shows, entertaining their audiences and spurring the interest of collectors and researchers. They quite literally revive the past. At the same time, although it is not always consciously dealt with, these re-enactments produce their own contemporaneity. They select and preserve a particular idea of the lantern show and bring it into discourse. In turn, they shape the archive. Sabine Lenk comprehensively describes how "classical shows" up to a certain degree create a canon which is preponderant today.[3] What we see are for the most part the beautiful slides made to be projected by impressive lanterns in environments that are aesthetically pleasing. They tend to retain the romantic aura commonly associated with the practice of the magic lantern. Lenk goes on to describe the "bewilderment" she encountered when seeing slides that did not belong to this canon, precisely because they disrupted standard expectations. The didactic slides in case are not part of the performative canon, because they did not directly meet the aesthetic standards set by most lantern performances today.

The question then arises whether it is possible to transgress the boundaries of the canon and performatively reach beyond its limits and into the more obscure realms of history. This would involve an acknowledgment of what is irretrievably lost after the historical show ended. It would come down to a historiography of ephemeral cultural heritage. And why not start from the same motivations that draws audiences to classical magic lantern shows? There is a profound popular desire to touch and to be touched by history. This longing need not be automatically naive. It is my conviction that this desire is in itself complex and ambivalently contradictory, born from the promise to enter a new world and the awareness to be forever excluded from the past. This split consciousness allows the contemporary spectator to ravel in the bygone era in all its nostalgic glamour in order to repossess a certain mood of the past. (This is probably why nostalgia is the signified or manifest content of most lantern shows today: the costumes of the showmen, the asides in which they address the audience, the choice of slides, etc.) Although the past stays forever beyond our reach, the drive remains alive. This drive is part of theatre historiography in as far as performance genealogies trace what Joseph Roach so eloquently called "kinesthetic imagination": "expressive movements as mnemonic reserves, including patterned movements made and remembered by bodies, residual movements retained implicitly in images or words (or in the silences between them), and imaginary movements dreamed in minds, not prior to language but constitutive of it".[4] Re-enactment *might just* be able to tease these sensibilities.

So, let us ask the questions that are in tune with this longing. How did the first audiences experience the shows? Are there ways, techniques or methods, to actually make us feel the breath of the spectator in anticipation of the living picture to be projected by the lantern? Can we become the spectator? Can we, if even for a brief moment, be her sitting in the audience watching the projected images, listening to the projectionist, maybe holding the hand of the one sitting next to her, feeling her own and the other's fingers? These questions may sound odd, even scandalous, as they overtly hint at ephemeralities every passionate historian (or amateur) admittedly wants to grasp but that, by definition and according to common sense, are impossible to attain – or are they?

Intellectual illusions

The above questions challenge the archives to provide a new productivity for transmission of historical live events into the present. The discipline of 'theatre archaeology' has raised similar issues in its efforts to create a richer sense of the 'live' of the past in the present. All the same, as noted by Mike Pearson and Julian Thomas in their seminal essay in 1994, "[t]he term 'theatre archaeology' is a paradox: The application of archaeological techniques to an ephemeral event".[5] The endeavour involves a great deal of speculation, so best to not overstate the scientific feasibility of this quest. Let us follow the suggestion, then, by theatre scholar Baz Kershaw to "proudly confess to pleasure at tilting windmills and propose that the twenty-first century's distributed archives profusely secrete degrees of ephemerality".[6] The media vary in their possibility to resuscitate the live of past events, and such degrees do hold the promise that "variable intensities of immediacy" in those media can trigger the "possible reappearance of the past alive".

Kershaw is far from alone in his quest for an idiom that can arrest the "live" of the past. Yet, few would claim that this epiphany is not composed in difference from the thing itself.

For the influential literary theorist Hans Ulrich Gumbrecht, the "presentification of past worlds – that is, techniques that produce the impression (or, rather, the illusion) that worlds of the past can become tangible again" – even has pedagogical value.[7] For Gumbrecht, concerns about the desire for presence, and the ways in which this desire sticks to the belief that we can access what really happened, are appropriate concerns. The desire makes us "imagine how we would have related, intellectually and with our bodies, to certain objects (rather than ask what those objects 'mean') if we had encountered them in their own historical everyday worlds".[8] This "intellectual illusion" does not encourage us to actually inhabit the past. But the living body is able to, through imagination and sensibility, retrieve the spirit of past live events and make it present again.

Consider the words hitherto used to describe what is at stake: feeling, living, breathing, becoming. They indicate the affective and the processual. They

denote a sense of embodied transformation at work in every performance which directly involves the senses and minds of the spectators. In her book *The Transformative Powers of Performance* theatre scholar Erika Fischer-Lichte demonstrates that the dynamics of co-presence are indeed both the basis and boundary of performance. There is a continually operating feedback loop in any theatrical event provided by the interactions, both explicit and implicit, between performer and spectator. The peculiar mode of experience that a performance evokes blurs distinctions between artist and audience, body and mind, life and art. The feedback loop raises the barrier to the point where, as Fischer-Lichte argues, "[r]ather the performance brings forth the spectators and actors", as "it aims at the involvement of all participants, in order to create a reciprocal relationship of influence".[9] The feedback loop ties the performative event back to life itself, and as such involves a good deal of unplanned, unpredictable and ephemeral elements. It is, in our words, the shared breath between the person operating the lantern and the audience attending the show.

What does it mean to consider the living and breathing body an adequate archive? For one thing, it pushes us in experimental directions. In the following I will outline an immersive digital re-enactment that, quite literally, tried to make tangible some constitutive elements of the dispositive of a lantern show on the basis of historical research. I will show that this performance explicitly, and radically so, aimed at calling into play the dialectics between bodily engagement and cognitive reflection. This re-enactment deliberately did not aim at veraciously reconstructing the conditions of the lantern shows of the 19th century, nor was it an attempt to bring the past into the present moment in a realistic manner. Authenticity was not an issue. We will see how the performance rather formalised, and even abstracted, the principles at work in the historical lantern show.

Re-enacting celestial bodies

At first, the term needs some explication. It is commonly associated with popular practices of living history, such as the reconstruction of war battles or role playing. However, starting in the 1990s and reaching a peak in the 2000s, there has also been a remarkable proliferation of re-enactments in the domain of contemporary performance, theatre and dance. Artists have been re-staging works from the past as a procedure to re-visit the history of their discipline. Re-enactment allows them to negotiate between their own work and major concepts that have defined the history of performing arts of which they are part – concepts such as repertoire, avant-garde or embodiment. These forms of re-enactment are less concerned with meticulously reconstructing reference works in all their details. Instead of merely animating a historical artefact, they intentionally constitute new work that explicitly incorporates contemporary genres, technologies and styles. This strand of re-enactments is not so much concerned with the image of history, but rather with the theoretical assumptions that inform our understandings of history and of performance.[10] Never-

theless, while this approach gives rise to deliberately unorthodox versions of historical dance pieces, it still succeeds, through affective engagement, in restoring and conveying some of the original impact or spirit of the work. Embodiment here plays a pivotal role.

Through processes of embodiment, thinking, doing and feeling enter into a complicated interplay. Phenomenology has for long been a point of departure in research on body-mind connections. A key reference are the writings of queer theorist Judith Butler, who reclaimed Maurice Merleau-Ponty's conviction that the body is "a set of possibilities to be continually realized", because, through articulating a set of historical possibilities, one "is not simply a body, but, in some very key sense, one does one's body".[11] The message here is obviously that behaviour creates gender, as performative acts constitute identity. However, I read Butler's subsequent insistence that "the body is a historical situation, […] and is a manner of doing, dramatizing and reproducing a historical situation"[12] also to suggest that performance, embodiment and re-enactment are on par. The suggestion, again, is here that it might be possible to redo history and become a historical agent.[13]

In our specific case, the artistic re-enactment by Eric Joris and the Brussels based theatre company CREW, embodiment is achieved through immersive digital technologies. Although their work is often presented in theatre venues, CREW is quite unlike the usual theatre company. It may be better described as a multidisciplinary team of artists, researchers and technicians using live performance as medium to test, play with and reflect on the aesthetic possibilities of digital technologies. For the past fifteen years, they have attracted much attention with high-tech performances in which audience members are partially immersed in virtual worlds. Characteristic of their ways of working, is their use of various kinds of head-mounted displays that present users with panoramic video images that respond to the user's viewing direction and movements. In movement-based interaction the user controls the interface via body movement and direct manipulation of screen objects via gestures. The mobility of the participant is key, as walking and touching in these environments remarkably heightened the immersion in the scenery projected inside the goggles.[14]

Rather than being an evening show, *Celestial Bodies* is best understood as a cluster of experiments that developed over the course of two years (2014–2016), culminating in an immersive performance at the "Garden of Sciences" of the University of Strasbourg in front of an audience of academic scholars. The re-enactment was developed in the context of *PARS – Performing Astronomy Research Society*.[15] *PARS* is an informal network that brings together theatre and performance scholars with historians of science, as well as artists, visual technicians and planetarium professionals. The team was formed to trace the history, present state and future of popular astronomical spectacle. One of the aims was to investigate shows that used the magic lantern to popularise astronomical knowledge in the 19th century. The researchers looked into the

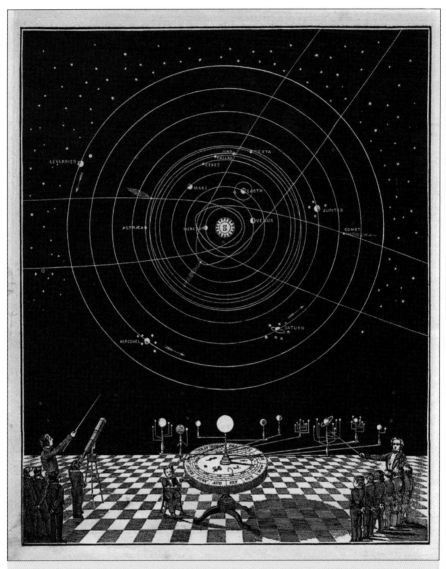

Fig. 1: Asa Smith, Solar System with students viewing an orrery. From *Smith's Illustrated Astronomy, Designed for the Use of the Public or Common Schools in the United States* (2nd edition, New York: Cady & Burgess, 1848).

history of these shows, their social and cultural contexts but also their perception and experience by different audiences. The lion's share of this endeavour was archive-based. The focus was on the changing conventions of science performance throughout modern life, the impact of mediating technologies, the value of artistic legacies for science popularization, and the intertwinement of aesthetics and didactics in both the practice of the showmen and the experience of the audience.[16] The arts-based complement, on its turn,

Fig. 2: Astronomical, Multiple Slide, "Newtonian System" and "Earth's Shadow", England, circa 1847. Photographer: Jon Augier. Copyright: Museum Victoria.

functioned as a heuristic for exploring the performativity of the images, the bodily engagement of the spectators and how embodied experiences of spectacular astronomy might stimulate belief. With this aim, artist Eric Joris and the Brussels based theatre company CREW created *Celestial Bodies*, a family of immersive and interactive virtual orreries.[17]

In its most common usage, an orrery first functioned as a clockwork mechanism with balls of various sizes attached to copper arms, used as a scale model to illustrate the relative position of the celestial bodies. It was a very popular amusement and teaching device in the 18th and 19th century, used as an aid to demonstrate the new heliocentric universe being evoked by the Scientific Revolution.

After centuries of believing the Earth was the static and privileged centre of the universe, the device shook the notion that man was in the middle of it all. Turning the handle to make the earth, and eventually other planets, orbit the Sun made the European imagination recalibrate to a greater here and a longer now. The magic lantern subsequently transformed the orrery into intermedial theatre using projection to embed the performance of the lecturer in a scientific context. These shows, mounted on stages across Europe by showmen such as Henri Robin, Adam Walkers and his son, or Sir Bartley, bear a remarkable similarity with a typical magic lantern show at the Royal Polytechnic Institution, following the sequence and slides of COMPENDIUM OF ASTRONOMY by Carpenter and Westley from 1849.[18]

All in all, the orrery as theatre had an important role to play in balancing immersive involvement and conscious meditation, cognition and affect. Looking at historical practices, the makers of the digital re-enactment decided to also use the orrery as basic pattern and design for their performance. Likewise, they focussed on the value of artistic legacies for science performance, the

Fig. 3: Guide / avator demonstrating the orbit of Venus to an immersant. Copyright: Eric Joris.

intertwinement of aesthetics and didactics, the influence of mediating technologies and, more specifically, the enduring persistence of the notion of projection in the history of the magic lantern. Even so, they had to take into account the shifting conditions of projection in the digital era. The audience today is used to mediated images that provoke highly immersive experiences. The experimental re-enactment consequently took the experience one step further, implementing virtual reality technologies, while, at the same time, adhering to the dialectics of instruction and immersion embedded in historical shows.

Celestial Bodies more specifically integrated the user's point-of-view in a universe where she could walk around between the planets, touching and rearranging the celestial bodies as she went along. Moving and touching together formed a way to navigate through space. As a consequence, the solar system unfolded from the direct encounter and interaction with the user. Moreover, what the user saw was in turn projected on the screen for the other spectators to witness, so that an interaction also occurred between embodied knowledge (the immersant inside the image) and critical contemplation (the audience in front of the screen). The immersant herself first saw the image of an avatar speaking in the voice of the person who helped to don the display. The avatar introduced herself as a guide.

Walking around with her allowed immersants to change their perspective and to explore the relationships between the sun, earth, planets and moons and their movements relative to one another and relative to themselves. The experience was overwhelming, if not entrancing. As a result of direct collaboration with astronomers the company was now able to put the immersant into an orrery that depicts an existing universe with two suns, or into the constel-

Fig. 4: Immersant in motion capture suit. Copyright: Eric Joris.

lation that contains the seven recently discovered exo-planets in orbit around a star.

The embodied enactment was meant to fully capture and engage the senses of the audience. There was a feeling of displacement, a sharpening of sensation, which produced a higher degree of sensory involvement and "liveness". At the same time, the relationship between the virtual world and the space from which it was activated was brought to conscious attention time and again, for example, when the guide invited the immersant to touch a football on a string, the movements of which, tracked by motion capture, was used to create an impression of the sun in orbit in the virtual space. In other words, a connection was staged between the avatar as encountered in the virtual universe and an actual person in the space in which the immersant found herself.

This connection highlighted how the virtual universe was generated through a digital interface. The result of such a dialectic between empathy and distance, immersion and contemplation afforded embodied knowledge.[19] It also acted as a measure that varied degrees of ephemeralities can be revitalized, experienced and eventually turned into pedagogical strategies.

Conclusion

At the close of this speculative inquiry, what can we say with certainty? Repetition as a link to verity does not need veracity. *Celestial Bodies* went beyond pure mimicking operations, constituting instead a vigorous field of activity in which the many tangled notions essential to the art of projection were actively

renegotiated by re-inventing historical sources – notions such as immersion, spectatorship and belief. Far from it being a matter of copying historical details, re-enactment happened in the embodied mind of the immersant. Re-enactment casts lines of relations to the past as well as to today. Somewhere along those lines, in the entanglement of affect and cognition (or, for that matter, immersion and distance), we might get a glimpse of how science theatre was 'really' perceived in the age of the magic lantern. It is safe to say that this glimpse differs from the act of repossessing the past through objects and written documents.

Theatre and performance scholar Rebecca Schneider, who has written ground breaking work on re-enactment, explicitly links the question of historiography to property and ownership. The proven method is to possess the past – just as the collector possesses history through his collection of objects, or the researcher through his archive. Schneider asks us:

> But why is it better to own something – to take as property – than to be owned by something – to be spoken through and taken by? Is thinking on the (preferable) master's side, and feeling on the (undesirable) slave's side? Thinking on the male side, and feeling on the female?[20]

Writing history and re-enactment, it seems for Schneider, also implies "embodied passions that can 'possess' an historian (or an actor)".[21] Another sense of the word ownership is being evoked here, more obscure but no less pressing. One can also be possessed by history, Schneider contends, as in "spirit possession, possession trance, or other practices of mediumship".[22] Actors and performers know this to be the case, as they – from shamanism to Stanislavski's realism – have heavily relied upon embodied recall as an acting technique. They felt the breath of the past and passed it on to their audiences. From this perspective, re-enactment can indeed be said to challenge the "stability" of material remains in the archive. By insisting on the primacy of performance and "liveness" in their making it defies classical classification.

It seems advisable, then, to save the last words for a performer of re-enactments. In April 2018, in Antwerp, I witnessed an enchanting re-enactment of the 1926 piece *Hexentanz* by the German expressionist choreographer Mary Wigman. It is probably no coincidence that the historical dance is about ecstasy and demonic possession. But what need is there for a dance piece to survive, when it is the ephemeral nature of the discipline that is at stake? The artist Danya Hammoud has this to say on the subject:

> I revisited a dance piece that was created by another body, by inhabiting it with my own experiences and positioning it in the context from which I come. Through the dialogue with this witches dance, I was able to question the figure of the witch, and to examine an extreme and marginal state of the body where conflicting forces are at work.[23]

Notes

1. This article was presented at the conference as part of the panel "Appropriation, Re-use and Re-enactment: Contemporary Perspectives on the Lantern" together with the contributions by

Sabine Lenk and Nele Wynants (see elsewhere in this volume). The three articles report on the work and results of the University of Antwerp team in the European project *A Million Pictures*. We examine the dispositive of the magic lantern from a contemporary point of view and concentrate on the legacy of the optical lantern and its accessories as well as the question of how to revive a collection. This is important for many museums and cultural heritage institutions as the aim is to bring a collection back to life for contemporary audiences. The contributions focus more specifically on (1) the appropriation of the historical projection device (Wynants), (2) the re-use of the projected object (Lenk) and (3) the re-enactment as performance (Vanhoutte).

2. Frank Kessler, "La cinématographie comme dispositif (du) spectaculaire", *Cinémas: Revue d'études cinématographiques / Cinémas: Journal of Film Studies*, vol. 14, no. 1 (2003): 21–34. Kessler describes the arrangements and conditions of early cinema as dispositives that are historically variable. Ludwig Vogl-Bienek adapts the theory of dispositive to current theatre and performance research in his book on magic lantern shows and social questions. See Ludwig Vogl-Bienek, *Lichtspiele im Schatten der Armut. Historische Projektionskunst und Soziale Frage* (Frankfurt am Main: Stroemfeld 2016). The author tackles notions such as liveness, performativity, embodiment and re-enactment that are equally important for my approach, and my own subsequent plea for presentification and epiphany in the present article.

3. See Sabine Lenk's contribution to this volume.

4. Joseph Roach, *Cities of the Dead. Circum-Atlantic Performance* (New York: Colombia University Press, 1996), 26.

5. Mike Pearson and Julian Thomas, "Theatre/Archaeology", *TDR*, vol. 38, no. 4 (1994): 133–161, here 134.

6. Baz Kershaw, *Theatre Ecology: Environments and Performance Events* (Cambridge: Cambridge University Press, 2007), 79.

7. Hans Ulrich Gumbrecht, *Production of Presence. What Meaning Cannot Convey* (Stanford, CA: Stanford University Press, 2003), 95.

8. Ibid., 24.

9. Erika Fischer-Lichte, *The Transformative Power of Performance – A New Aesthetics* (London and New York: Routledge, 2008), 50.

10. See Timmy De Laet, "Giving Sense to the Past: Historical D(ist)ance and the Chiasmatic Interlacing of Affect and Knowledge", in Mark Franko (ed.), *The Oxford Handbook of Dance and Reenactment* (Oxford: Oxford University Press, 2018), 33–56.

11. Judith Butler, "Performative Acts and Gender Constitution: An Essay in Phenomenology and Feminist Theory", *Theatre Journal*, vol. 4, no. 4 (1988): 519–531, here 521.

12. Ibid., 521.

13. Recently, re-enactment has grown into an established scientific methodology. One of the most interesting recent initiatives is the "RRR Network" set up at the University of Utrecht: "The network's aim is to offer a platform for sustained, interdisciplinary reflections on performative methods, variously known as reconstruction, re-enactment and replication (RRR) practices [...]." (accessed on 1 May 2018, https://rrr-network.com).

14. On the phenomenology of this experience in CREW's performances, see Kurt Vanhoutte and Nele Wynants, "Performing phenomenology: negotiating presence in intermedial theatre", *Foundations of science*, vol. 16, no. 2–3 (2011): 275–284.

15. See https://parsnetwork.org (last accessed on 1 May 2018).

16. For detailed studies on the intertwinement of performance and astronomy, see the special issue by Charlotte Bigg and Kurt Vanhoutte (ed.), "Spectacular Astronomy", *Early Popular Visual Culture*, vol. 15, no. 2 (2017): 115–272.

17. See, on the precepts of PARS, the function of performing arts as heuristics and the role of performing astronomy, in particular: Kurt Vanhoutte and Charlotte Bigg, "On the border between science, performance and the digital: the embodied orrery", *International journal of performance arts and digital media*, vol. 10, no. 2 (2014): 255–260.

18. See my chapter "Performing Astronomy: The Orrery as Model, Theatre, and Experience", in Nele Wynants (ed.), *Media Archaeology and Intermedial Performance. Deep Time of the Theatre* (London et al.: Palgrave Macmillan, 2018), 145–172. For a detailed account of the astronomical science

performances of Henri Robin, see Kurt Vanhoutte and Nele Wynants, "On the passage of a man of the theatre through a rather brief moment in time: Henri Robin, performing astronomy in 19th century Paris", *Early Popular Visual Culture*, vol. 15, no. 2 (2017): 152–174.

19. According to Maaike Bleeker, who examined CREW's *Celestial Bodies* in the context of digital media studies: "They show the universe itself as a phenomenon that cannot be disjoined from the generativity of the human–technology configurations in which the world and the universe get articulated in an ongoing, open-ended process". Maaike Bleeker, "Who knows? The universe as technospace", *Early Popular Visual Culture*, vol. 15, no. 2 (2017): 247–257, here 256.

20. Rebecca Schneider, *Theatre and History* (New York: Palgrave Macmilan, 2014), 53–54.

21. Ibid., 53.

22. Ibid.

23. Danya Hammoud in program notes to her performance *O.T.*, performance seen in the context of the *BOUGE B* Festival at De Singel in Antwerp, Belgium, on 28 April 2018.

Nele Wynants

Dissolving Visions:
From Slide Adaptation to Artistic
Appropriation in Magic Lantern Practices[1]

Introduction

To this day the magic lantern appeals to the imagination. Although old and out-dated, its poetic potential and visual appeal still inspires artists, researchers and audiences interested in the history of media and art. It should therefore not come as a surprise that the legacy of the lantern lives on in the iconography and aesthetics of contemporary media art and intermedial performance. Many artists have rediscovered this projection device, which was invented in the 17th century and used until the mid-20th century. They deliberately adapt, remediate or appropriate the magic lantern, also known as an optical lantern, to a contemporary *dispositif* and audience. This allows media artists of this kind not only to revisit often forgotten or neglected parts of media history; it also makes it possible to reflect on the role of science and technology in our contemporary context.

This archival-based work corresponds to what art critic Hal Foster has termed an "archiving impulse" in contemporary art, a tendency in which artists "seek to make historical information, often lost or displaced, physically present".[2] Archival artists or media archaeologists indeed have a common interest in historical research, albeit not to reconstruct or represent history. In most cases, archival sources are retrieved in "a gesture of alternative knowledge or counter-memory", as Foster calls it:

> [...] archival art is as much preproduction as it is postproduction: concerned less with absolute origins than with obscure traces (perhaps "anarchival impulse" is the more appropriate phrase), these artists are often drawn to unfulfilled beginnings or incomplete projects – in art and in history alike – that might offer points of departure again.[3]

This archival impulse became particularly vital the moment when, thanks to reproduction technologies, the repertoire of sources and images became profoundly extended, and especially in the 20th century, when appropriated images and serial formats became common idioms.[4]

This contribution takes a contemporary appropriation of the historical magic lantern as a starting point to reflect on the concept of appropriation as an inherent feature of magic lantern practice since its inception. I will more particularly discuss a project of the Belgian video artist Sarah Vanagt, who, in 2016, developed an exhibition as part of the European *A Million Pictures* research project for the Museum of Contemporary Art Antwerp (M KHA).[5] *Schijnvis / Showfish / Poisson brilliant*, Vanagt's exhibition in M HKA, continues a recent tradition first introduced to this museum by curator and media archaeologist Edwin Carels. As museum for contemporary art, M HKA deliberately established an active relationship with its early media collection, assembled by Robert Vrielynck (1933–2000). A notary from Bruges, he assembled objects relating to the history and technology of moving pictures such as early film cameras and projectors, film posters, optical devices, as well as a beautiful collection of magic lanterns and a number of slides.[6] Between 2011 and 2013, the collection was an essential resource for a series of exhibitions by media artists Julien Maire, Zoe Beloff and David Blair. Sarah Vanagt was the fourth to work with the collection, and she took the magic lantern as her point of departure.

Not coincidentally a central theme of Vanagt's exhibition was the act of looking, a recurring topic in her earlier works. As filmmaker and historian, she combines an interest in the (origins of the) moving image, the history of optics and studies of vision. Investigations into the historical context and the technicalities of optical media form the basis of her markedly media-archaeological work. Old or forgotten technologies are translated into a contemporary artwork: a film, a photograph or an installation. She has experimented with the *camera obscura*, old photographic procedures and more recently with microscopy. In this way Vanagt has built an *œuvre* with explicit historical references and a poetic signature that is uniquely hers. She examines the specific nature of each medium with a keen eye for the optical and material qualities of the technology and the uniqueness of the image quality they produce. With her camera she directs the attention of the viewer to what we rarely see or barely notice, to details, texture and particular colours.

For the exhibition *Schijnvis / Showfish / Poisson brilliant*, Vanagt did not simply put the historical lantern on display, nor did she choose to work exclusively with original and historical slides. Instead she opted for a contemporary appropriation of the lantern and its particular aesthetics. Before I discuss her contemporary lantern exhibition and films, I will first elaborate on the concept of appropriation to better understand this recurring practice in art and media practice. Based on earlier, historical examples of appropriation in lantern culture, I will distinguish different appropriation strategies. Then I will discuss Vanagt's contemporary lantern exhibition to differentiate several appropriation strategies as an example of a way of reviving lantern culture and reflecting on its impact as cultural heritage.

Appropriation and its historical significance

In contemporary art discourse "appropriation" refers, according to the definition from the glossary of the Museum of Modern Art New York, to "the intentional borrowing, copying, and alteration of preexisting images and objects".[7] Today, in the 21st century, and as a result of the growing digitisation of culture, appropriating, adapting, sampling and sharing images and media has become a self-evident practice for visual, media and performance artists. However, as a concept, appropriation took on a particular significance in the 20th century. In the context of postmodernism, the rise of consumerism and the proliferation of popular images via mass media outlets ranging from magazines to television and the internet, traditional notions of authorship and originality were challenged. Postmodernism was according to Fredric Jameson a "quotation culture".[8] The concept of art changed fundamentally. The notion of genuine creation was lost in favour of "pastiche" – the method by which found material and styles were recombined, and which Jameson proclaimed as one of the essential characteristics of postmodern practices.

However, appropriation's significance is not limited to our contemporary cultural and political moment, nor is it only an artistic practice. As a visual strategy appropriation has been a common practice for millennia. Renaissance artists already devoted a great deal of time to the appropriation of technical skills and artistic examples, with the intention of surpassing these examples and skills in their assimilation.[9] Classical academic art training can also be understood as the teaching of practices of appropriation. Until modernity, however, this form of appropriation remained focussed on the development of craftsmanship as a form of preparatory training for one's own unique art practice.

From a media archaeological point of view, the process of appropriation can be traced back to the late 18th and early 19th centuries, and is inextricably connected with magic lantern culture in relation to their technological production and dissemination. Recognised as the "age of mechanical reproduction", this period saw numerous technological advances and scientific developments, which revolutionised cultural production through an on-going process of adaptation, tinkering and copying. More particularly the development of several print and reproduction techniques allowed lanternists and slide production companies to copy and appropriate images from different contexts in magic lantern shows.

As long ago as the 18th century, travelling lanternists appropriated images from popular engravings. In his study on the Savoyards, Roger Gonin pointed out that copying printed source material was a cheap way of producing slides. These travelling showmen came from the poor French region of Savoy and travelled from village to village and town to town putting on magic lantern displays in public places or in the houses of the wealthy to entertain and earn money.[10] Unlike original hand-painted slides commissioned by rich families from celebrated artists, manufacturers of slides for these itinerant peddlers

were happy to reproduce images that were *en vogue*, and in particular those which already existed as low-cost engravings.[11]

The idea of copying popular engravings from established print editors on glass slides was apparently also known at the court of Louis XVI. Comte de Paroy, who wanted to use a lantern for the education of the dauphin, confirms in his *Mémoires* that he had developed a process to "transport the engraving of a print on glass":

> De cette façon, je pourrais avoir un grand nombre d'exemplaires du même sujet et les propager à un prix modique. L'exécution, en effet, serait coûteuse s'il fallait dessiner chaque sujet sur les verres, pour les peindre ensuite; mais le prix de revient baisserait beaucoup par la multiplication.[12]

Unfortunately, this pedagogical adviser to Queen Marie-Antoinette did not leave us a description of his method. Only a few years later, it was the legendary Étienne-Gaspard Robert, also known as Robertson, who added, to his patent for the fantascope, a complementary patent for a "way to print on glass the engravings found in books for science teaching" for lantern demonstrations on physics, anatomy, natural history and even botany.[13] Robertson's printing method consisted of the transfer onto glass of an *intaglio* engraving by means of an intermediate print, produced with a mixture of *noir de fumée*,[14] white lead and drying oil. When still wet the print was immediately applied to a piece of glass by means of a roller. In order to blacken the printed line with smoke, the piece of glass was held above a series of candle flames. After fifteen days of drying one could remove the carbon black with a piece of cotton while the engraving remained fixed on the glass.[15]

Due to the improvement of printing techniques and the invention of reproducible photographic procedures, appropriation became even more significant in the magic lantern practice of the first half of the 19th century, when it became possible to produce lantern slides on a large scale. In England mass production started slowly after 1830 with the development of the copperplate transfer process.[16] This procedure, however, did not as yet allow for true mass reproduction, as the transfer-printed images were still hand-coloured and thus required a lot of work by painters, people who prepared the glass, assembled the wooden frame, etc. It nonetheless did enable slide producers to standardise images by repeating each outline and image subject. Since then, instrument makers such as Philip Carpenter were able to sell a growing number of serially produced images. In its heyday, the majority of established slide-producing companies were located in, among others, London (Carpenter & Westley, York & Son), Paris (Duboscq, Molteni, Mazo), Düsseldorf (Liesegang, Carl Simon & Co.) and Nuremberg (Plank, Gebrüder Bing, Falk). They produced slides on a large scale and sold them all over Europe (and overseas), where they were adapted to different national and local contexts.

Appropriation strategies in lantern culture

Lantern performers often combined various strategies of appropriation, adaptation and creation, depending on the social and political context and the message they wanted to convey. Preliminary research conducted for the purposes of the *B-magic* research project,[17] as well as the sparse secondary sources,[18] show that the greater part of the preserved slides available in different Belgian collections were either acquired from mainly French, German and British manufacturers or were self-made. For instance, in collections of slides for educational purposes, commercially produced slides were appropriated and discursively reframed into new narratives within local frameworks.[19] Several preserved sets of slides in Belgian collections[20] likewise combine images from print media (newspapers, books, maps) with handmade drawings, handwritten texts, and sometimes (amateur) photographs as well. The appropriation of magic lantern practices can therefore be defined and understood in several ways, and of course all appropriation strategies are related to each other. For the sake of analysis, we can distinguish the following (but not exclusive) strategies:[21]

Iconographic appropriation: The most common example of appropriation is probably the *visual and narrative adaptation from other media to magic lantern slides* (and the other way around). For instance, the process of appropriation of single printed pictures from newspapers, books, postcards, etc. was a regular practice among showmen such as Robertson, travelling lanternists and the like. These images were not only taken out of their intended context, but also reframed into a successive order to support the narrative of a lecture, story or performance. In addition to the appropriation of printed media, magic lantern practices also adapted, absorbed and transformed iconographic and narrative conventions known from other media, such as theatre, literature and painting. Tales from children's books and comics in particular were popular subjects that lent themselves easily to lantern adaptation. The museum House of Alijn in Ghent, for instance, holds a beautiful collection of slides for children with detailed, often hand-painted, popular visual stories such as LITTLE RED RIDING HOOD, ROBINSON CRUSOE, TOM THUMB, PETIT JACQUES and other images related to classical literature or less well-known local narratives.

Interdisciplinary appropriation: The consequence of the growing proliferation of lantern images and series of slide sets was that *the same image could be used within various institutionalised frameworks and media dispositifs* such as schools, religious and political organisations as well as at entertainment venues. Commercial slides made for export to other countries were often adapted to locally specific activities and contexts and used in initially unintended ways. A commercially manufactured image produced for serious science teaching could also be integrated into popular entertainment shows at public venues and in domestic settings. For instance, one of the most popular subjects and probably *the* top-selling series of the 19th century is the astronomy slide series produced by Carpenter & Westley. The series can be found in many slide collections all over

Europe, and from historical sources we may deduce that it was used in scientific lectures, schools, as well as in popular theatre.[22] The series is now part of what Sabine Lenk has called the "slide canon".[23]

Appropriation of the technology: The *creation of self-made slides* from existing models with the help of handbooks can also be considered as a form of appropriation and allowed laypersons to become lanternists themselves. This practice was increasingly stimulated during the second half of the 19th century. In particular the rapid development of photography resulted in the appearance of do-it-yourself manuals and handbooks that introduced amateurs to the magic lantern, including practical and technical descriptions on how to make lantern slides from photo negatives and print images.[24] By the end of the 19th century, the painting, or at least the colouring, of slides had even become a popular pastime.[25] Colouring, however, was apparently no sinecure as the author of a little booklet from 1901 entitled *Lantern Slide Making* stresses that "it almost goes without saying that before attempting to colour a lantern slide the worker

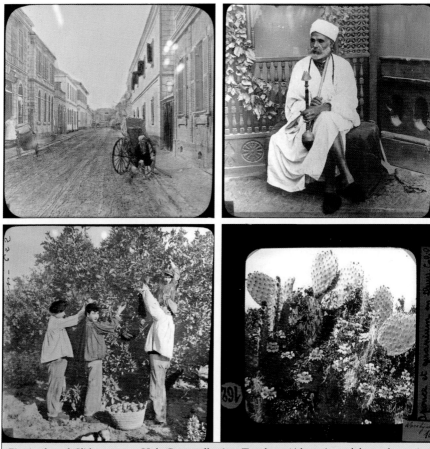

Fig. 1 a, b, c, d. Slides courtesy Holy Grave collection, Turnhout (title, series and date unknown). Images probably copied from print media, hand-coloured.

should have had some previous experience in painting".[26] The slides from the Holy Grave collection (Turnhout) demonstrate that colouring printed images indeed requires a steady and trained hand if an amateurish result is to be avoided.

Artistic appropriation: Reappropriation can also refer to all kinds of *modifications, adjustments and additions* to acquired slide sets. Laternists often took the liberty of *recombining or reorganising* a series of images into a different order than the one recommended in the instruction booklets or the text books that came with the industrially manufactured sets – as we may deduce from slide series with different sets of numbers written on their frames, suggesting alternative orders of display, dependent on the lecturer's choice. Sometimes laternists also made changes to the slides themselves by superimposing images, text and colours. In this sense, the slides acquired new meanings, supporting the narrative of the lecture, or even mocking the originally intended meaning thus adding a critical or artistic level to the performance.

To conclude this section, one might say that like 20th century appropriation art, 18th and 19th century laternists too used lantern images to criticise or parody modern society and to offer new perspectives on established knowledge. Or they used it as a propaganda tool to manipulate political and religious opinion. Many lantern series in Belgian and international collections contain stereotypes, caricatures and transgressive imagery in order to address moral issues, gender, race and power relations. In this way, the visual and narrative strategies developed, appropriated and transformed by magic lantern practitioners shared in the circulation of images and the dissemination of a local and transnational visual culture as well as its own critical responses.

Showfish: historical appropriation in a contemporary art museum

Although appropriation *art* is primarily associated with the recycling or re-use of images from popular culture or earlier artists, this is somewhat different in the case of Sarah Vanagt's exhibition *Showfish*. Vanagt did not appropriate popular or canonical lantern images. Instead, she appropriated the particular aesthetic features of the projection lantern, mainly used for scientific purposes, and translated them into a contemporary art museum's context. However, all the aforementioned appropriation strategies, which are so fundamentally inherent to magic lantern practice, are in some way resumed and can be recognised in this historically inspired exhibition: from iconographic to intermedial, technological and artistic appropriation.

She set up five historical children's lanterns in the museum's collection at the centre of M HKA's exhibition space. These colourful projection devices allowed the children of prosperous families to project brightly painted slides of animals, fairy-tale figures, stars and planets onto the walls of their bedrooms. The installation was entitled "A Scotch Gesture". In it Vanagt connected the children's magic lanterns to one another with a long strip of transparent adhesive tape (called "scotch" in France and Belgium) to which various

Fig. 2: Installation view *Schijnvis / Showfish / Poisson Brillant*, an exhibition by Sarah Vanagt at the Museum of Contemporary Art Antwerp, 2016 © M HKA.

specimens were stuck. These were collected during a walk along the banks of the Scheldt, the river hardly 150 yards from the museum's doors. All kinds of things stuck to the tape, including dust, sand, twigs, leaves, sweet wrappers and a fragment of coloured glass. This collection of dirt and grit, of all the unsightly stuff that we wipe from our hands, of everything that inevitably returns to dust, represents the archaeological "film" that she projects on the museum walls with the children's magic lanterns.

This installation can be considered as an *artistic appropriation*, not only of the magic lantern but also of the *technology* of the projection microscope – a microscope combined with an optical lantern.[27] The lantern and the microscope share the feature of enlarging something that is, initially, quite small. Similarly, the magic lantern and the microscope were both used for science and entertainment. But whereas the table-top microscope allowed only one viewer to closely examine an object, the projection microscope allowed the specimen's magnified image to be appreciated by a larger audience. Every minute detail, invisible to the naked eye, was revealed to a wide, interested audience. Numerous variations were conceived of for the enlarged projection of organic materials, insects and minerals. Through the advent of the projection microscope, microscopy became in the early 19th century a successful scientific show that was as popular as the panoramas, dioramas and other forms of early spectacle entertainment.[28]

In terms of *iconographic appropriation*, Vanagt was indeed also inspired by the historical microscopic slides developed for the projection microscope. The magnified images that were projected with children's lanterns onto the museum walls were highly reminiscent of the sort of phenomena that early developers of the microscope might have seen for the first time through their tiny lenses, such as the minuscule life in a drop of water, the graphic texture

I have been filming now since several weeks through a fish egg, and try to see what you must have seen, eons and eons ago.

Fig. 3: Film still from THE FIRST MICROSCOPIST, a short film by Sarah Vanagt (B 2016).

of a piece of cloth and the delicate structure of a cobweb. She more particularly appropriated the fauna and flora iconography from the well-known solar microscope slides produced by Carpenter and Westley with plants, insects and butterfly's mounted between two glass plates (ca. 1850s).[29]

Regarding *interdisciplinary appropriation*, Vanagt not only reframed lantern iconography from a scientific context to create a more artistic and poetic *oeuvre*, but also adapted the visuals created by lantern and microscope technology in two short films. Wearing headphones, the visitors could listen and immerse themselves in the audio-visual worlds of these historically informed artistic documentaries. The first film, A MICROSCOPIC GESTURE (B 2016, 6 min.), was based on a fragment from a letter written by Antoni van Leeuwenhoek (1632–1723), a 17th-century draper who made frequent use of lenses and magnifying glasses to examine the textiles he bought for his shop.[30] The versatile shopkeeper became famous for the microscope he built and for his pioneering work in cell biology and microbiology. In the second film, THE FIRST MICROSCOPIST (B 2016, 8 min.), Vanagt embarked on a fictional conversation with a historical character: a harpoon fisher from Crete with long eyelashes.

For these films, Vanagt experimented with a projection microscope and recorded the images on film, using a historical apparatus operated by collectors and lantern performers Karin Bienek and Ludwig Vogl-Bienek from the performers' collective Illuminago (www.illuminago.de). For this historical reenactment, the performers used original microscope slides of all sizes and types from their collection, where these consisted mainly of organic materials such as plants and insects: the petal of a poppy, the leaf of a fern, a moth's wing and the eye of a fly. In the exhibition these miniature worlds were displayed in magnified form on the walls of the museum. Reminiscent of abstract paintings, they showed the visitor an endless variety of lovely patterns and colours that we would be unable to discern with the naked eye.

Here again, resonating with the spectacular and poetic universe of the projection microscope, Vanagt appropriated the scientific microscopic slides from the Illuminago collection and adapted them to a fictional narrative. She reorganised the original series, and integrated single slides into her own artistic montage, combined them with other images from self-made slides and added a voice-over to support the narrative. Apart from self-made slides with cobwebs and translucent plants such as *Lunaria annua* (honesty, silver dollars, Chinese money), Vanagt also experimented with aquarium slides, inspired by the "tank slides" of the past, which were filled with water and plant residues. The resulting vegetal imageries are simultaneously beautiful and terrifying, reminiscent of the ghosts of early phantasmagoria shows. In this contemporary version, constellations of titanic dust bunnies appear as if in a shadow play, chased by gigantic fragments and monstrous patterns.

In conclusion

Appropriation has always played a significant role in art history. Particularly since reproduction technologies allowed artists to easily copy, paste and adapt existing images to other contexts. In that sense, it should not come as a surprise that appropriation has always been an indispensable part of magic lantern culture, its production and dissemination. Essential to our understanding of appropriation in the context of 20th century art, however, is the idea that the new work recontextualises whatever it borrows to create the new work. In most cases the original remains as accessible as the original, without change, and the new work comments on aspects of culture and society.

With her historically inspired exhibition, in which she poetically appropriates images and technologies from the past, Vanagt takes more freedom to artistically rethink and reconfigure her archival sources. She takes a step backwards to allow a certain distance. Not to look back at history as it was, but to look more closely at our present time and recognise the traces of the past. As an 'archaeologist of the present time' Vanagt presents her viewers a magnifying glass. By magnifying the small and invisible to render it visible to the eyes of the modern-day viewer, she offers a contemporary vision of the history of microscopy and lantern projections as both science and spectacle. More specifically this media archaeological approach provides another perspective on the magic lantern and enables the viewer to situate the optical lantern in the history of visual culture and mass communication.

Notes

1. This article was presented at the conference as part of the panel "Appropriation, Re-use and Re-enactment: Contemporary Perspectives on the Lantern" together with the contributions by Sabine Lenk and Kurt Vanhoutte (see elsewhere in this volume). The three articles report on the work and results of the University of Antwerp team in the European project *A Million Pictures*. We examine the *dispositif* of the magic lantern from a contemporary point of view and concentrate on the legacy of the optical lantern and its accessories as well as the question of how to revive a collection. This is important for many museums and cultural heritage institutions as the aim is to bring a collection back to life for contemporary audiences. The contributions focus more

specifically on (1) the appropriation of the historical projection device (Wynants), (2) the re-use of the projected object (Lenk) and (3) the re-enactment as performance (Vanhoutte).

2. Hal Foster, "An Archival Impulse", *October,* vol. 110 (Fall 2004): 3–22, here 4.

3. Ibid., 5.

4. Ibid., 3.

5. *Schijnvis / Showfish / Poisson brillant* was first exhibited in the Museum of Contemporary Art Antwerp (M KHA) from 27 October until 13 November 2016 on the occasion of the third *A Million Pictures* workshop on "The Magic Lantern Today: Creative Re-Use of Cultural Heritage", and later as part of the *Nuts & Bolts* exhibition, curated by Edwin Carels at the International Film Festival Rotterdam (26 January to 4 February 2017).

6. For more on Robert Vrielynck and this collection, see Edwin Carels, "Het museum met de camera's" (unpublished lecture, 2009) which may be consulted online at: http://s3.amazonaws.com/mhka_ensembles_production/assets/the_vault_original/000/019/158/original/Essay_Edwin_Carels_%2810-05%29.pdf?1381314093 (last accessed on 5 August 2019). See also Jan De Vree, "Contemporary art and remediating a collection of media-archaeological objects", in *Decolonising Museums*, a thematic publication of *L'Internationale Online* (2006), 64–70 (accessed on 5 August 2019, http://www.internationaleonline.org/media/files/decolonisingmuseums-2.pdf); Sabine Lenk, "De Robert Vrielynck collectie: Een 'imaginair museum' rond het bewegend beeld", *Tijd-Schrift. Heemkunde en lokaal-erfgoedpraktijk in Vlaanderen*, vol. 8, no. 1 (2018): 126–131.

7. A definition taken from the glossary *MoMA Learning*, Museum of Modern Art New York (accessed on 28 April 2018, https://www.moma.org/learn/moma_learning/glossary#appropriation). On appropriation in contemporary art discourse, see David Evans, *Appropriation* (London: Whitechapel 2009); Liz Linden, "Reframing Pictures: Reading the Art of Appropriation", *Art Journal*, vol. 75, no. 4 (2016): 40–57 (DOI: 10.1080/00043249.2016.1269561).

8. Fredric Jameson, "Postmodernism and Consumer Society", in Hal Foster (ed.), *The Anti Aesthetic. Essays on Postmodern Culture* (Seattle: Bay Press, 1984), 111–125, here 113.

9. See Isabelle Graw, "Dedication Replacing Appropriation: Fascination, Subversion, and Dispossession in Appropriation Art", in Philipp Kaiser (ed.), *Louise Lawler and Others* (Ostfildern-Ruit: Hatje Cantz Verlag, 2004), 45–67.

10. See Roger Gonin, *Ces Savoyards montreurs de lanterne magique* (Albertville: Société des amis du vieux Conflans, 2016), 41; Annie Renonciat, *Images lumineuses. Tableaux sur verre pour lanternes magiques et vues sur papier pour appareils de projection* (Rouen: Institut National de la Recherche Pédagogique / Musée national de l'éducation, 1995).

11. See ibid., 37.

12. Jean-Philippe-Gui Le Gentil Paroy, *Mémoires du comte de Paroy: souvenirs d'un défenseur de la famille royale pendant la révolution (1789–1797), publiés par Étienne Charavay* (Paris: E. Plon / Nourrit et Cⁱᵉ, 1895), 277 (accessed on 5 August 2019, https://gallica.bnf.fr/ark:/12148/bpt6k36413g/f335.item).

13. Brevet no. 109, 26 janvier 1799: "Pour faire servir ma lanterne aux démonstrations de physique, d'anatomie, d'histoire naturelle et même de botanique, j'ai imaginé le moyen d'imprimer sur le verre les gravures que l'on trouve dans les livres qui servent à l'explication des sciences", signé Robert, professeur de physique, rue du Provence, no. 24. Institut National de la Propriété Industrielle, Paris. See Renonciat, *Images lumineuses*, 38.

14. *Noir de fumée* (lamp black) is a carbon residue obtained by the incomplete combustion of various carbon-rich organic materials which was used as a pigment for paints, ink or polish.

15. See Renonciat, *Images lumineuses*, 38.

16. Based on a reconstruction of lantern trade, Phillip Roberts challenged the generally accepted claim that it was the British optician and instrument maker Philip Carpenter who developed this process of automatically produced lantern slides, see Phillip Roberts, "Building Media History From Fragments: A Material History of Philip Carpenter's Manufacturing Practice", *Early Popular Visual Culture*, vol. 14, no. 4 (2016): 319–339. See also Phillip Roberts, "Philip Carpenter and the convergence of science and entertainment in the early-nineteenth century instrument trade", *Sound and Vision* (Spring 2017), http://dx.doi.org/10.15180/170707.

17. The Belgian Excellence of Science programme (EOS) has granted funding for large-scale research into the history of the first visual mass medium in Belgium (2018–2022). Research teams at two Flemish (Antwerp University and KU Leuven) and two French-speaking universities (Université

libre de Bruxelles and Université Catholique de Louvain-la-Neuve), in collaboration with an art college (KASK Ghent) and a Dutch partner (Utrecht University), will spend four years researching the magic lantern in Belgium. The project (EOS number 30802346) is coordinated by spokesperson Kurt Vanhoutte (University of Antwerp). See www.B-magic.eu.

18. Sabine Lenk's and Nele Wynants' unpublished feasibility study for the purpose of the *B-magic* EOS research application (Antwerp, University of Antwerp, March 2017), and archival-research-based MA-theses written under the supervision of Sabine Lenk and Kurt Vanhoutte at the University of Antwerp: Heleen Haest, *Van Wieg tot Graf: Het gebruik van de Magische Lantaarn als didactisch instrument door de Katholieke Zuil in Vlaanderen tussen 1890 en 1914* (Antwerp: University of Antwerp, 2017) and Kristien van Damme, *De optische lantaarn als instrument in de Belgische politiek tussen 1900–1920* (Antwerp: University of Antwerp, 2017).

19. Preliminary research based on the data from the Holy Grave collection; see also Sabine Lenk's contribution to this volume "Re-use practices, the classical canon and out-of-canon slides".

20. Vrielynck collection (M HKA Antwerp), Holy Grave (Turnhout) and Kadoc (Leuven).

21. I wish to thank Natalija Majsova for her valuable suggestions on this topic.

22. See Kurt Vanhoutte and Nele Wynants, "On the Passage of a Man of the Theatre through a Rather Brief Moment in Time: Henri Robin, Performing Astronomy in Nineteenth Century Paris", *Early Popular Visual Culture*, vol. 15, no. 2 (2017): 152–174, DOI: 10.1080/17460654.2017.1318520.

23. See Lenk's contribution to the present volume.

24. See, for instance, Frederick Charles Lambert, *Lantern Slide Making* (John Albert Manton, 1901); Thomas Cradock Hepworth, *Manuel pratique des projections lumineuses (avec des indications précises et complètes pour obtenir & colorier les tableaux transparents pour la lanterne* (Paris: Société d'éditions scientifiques, 1892).

25. Gerald W.R. Ward, *The Grove Encyclopedia of Materials and Techniques in Art* (Oxford: Oxford University Press, 2008), 351.

26. Lambert, *Lantern Slide Making*, 103.

27. As early as 1665 the laterna magica was used for microscopic projection, and it was recognised as a kind of microscope. But particularly in the late 18th and early 19th century the projection microscope became a device for popular entertainment. On the projection microscope, see Simon Henry Gage, "The Annual Address of the President. The Origin and Development of the Projection Microscope", *Transactions of the American Microscopical Society*, no. 28 (1908): 5–60 (last accessed on 5 August 2019, www.jstor.org/stable/3220904).

28. See for a more elaborate analysis of this work in relation to early examples of microscopic theatre and historical examples of the theatrical use of the projection microscope my chapter "Mediated Visions of Life. An Archaeology of Microscopic Theatre", in Nele Wynants (ed.), *Media Archaeology and Intermedial Performance. Deep Time of the Theatre* (London et al.: Palgrave Macmillan 2019), 253–272. On the projection microscope, see also Richard Altick, *The Shows of London* (Cambridge: The Belknap Press of Harvard University Press, 1978); Jeremy Brooker, *The Temple of Minerva. Magic and the Magic Lantern at the Royal Polytechnic Institution, London 1837–1901* (London: The Magic Lantern Society, 2013); Barbara Maria Stafford and Frances Terpak, *Devices of Wonder: From the World in a Box to Images on a Screen* (Los Angeles: Getty Research Institute, 2001).

29. Each of these lantern slides was constructed using an approximately three-inch diameter double glass slide component, mounted in a 3 3/4 inch x 6 7/8 inch solid mahogany frame piece. These were originally produced for use with their Solar or Oxy-Hydrogen Microscopes, as well as for various other magic lantern models. The successful preparing and mounting of large or multiple insects in Canada balsam, with few, if any air inclusions or severe displacements, required a very high degree of specialist skill.

30. On Van Leeuwenhoek and changing ideas with respect to "seeing" in art and science in 17th century Europe, see Laura Snyder J., *Eye of the Beholder. Johannes Vermeer, Antoni Van Leeuwenhoek, and the Reinvention Of Seeing* (New York: W.W. Norton & Company, 2015); see also Edward G. Ruestow, *The Microscope in the Dutch Republic: The Shaping of Discovery* (Cambridge et al.: Cambridge University Press, 1996).

History of the Screen

Erkki Huhtamo

The White Behind the Picture: Toward a Media Archaeology of the Screen

"Magic lantern is a species of lucernal microscope, its object being to obtain an enlarged representation of figures, on a screen in a darkened room." (*Oxford English Dictionary*, vol. XIV, entry from 1846)

Introduction

The history of the magic lantern is intimately associated with what Charles Musser calls the history of screen practice.[1] As a silent film scholar Musser was interested in positioning early cinema in relation to preceding traditions, suggesting that screen practice "presents cinema as a continuation and transformation of magic lantern traditions in which show-men displayed images on a screen, accompanying them with voice, music, and sound effects".[2] An essential element of screen practice is of course the screen itself. It has received relatively little attention from scholars, perhaps because it seems so obvious.[3] What difference does it make what kind of surface or material is used as long as the images are seen clearly by the spectators? Much difference, as I will argue in a forthcoming book on what I call screenology or media archaeology of the screen.[4] This article offers a tasting of some of the issues that will be discussed in much greater detail in that context. Here I will concentrate on screens in magic lantern shows, and try – after performing an etymological excavation – to relate them with a broader context where the notion "screen" was used. The area is by no means homogeneous – there are gaps and contradictions. However, I believe that the different screens, and even things never explicitly associated with the word but used for similar purposes, form a dynamic "field".

Screen – an etymological excavation

Except for a short discussion in Thomas Elsaesser's and Malte Hagener's *Theory of Film: An Introduction through the Senses* (2010), media scholars have made few attempts to trace the etymology of the word screen.[5] In their "brief etymologi-cal-archaeological overview" Elsaesser and Hagener suggested that the word developed "in the early fourteenth century from the old Germanic term "scirm" [...]".[6] A more detailed excavation is needed because of the multiplicity

of meanings assigned to the word screen, the metamorphoses it has undergone, and the linguistic migrations that have affected its vicissitudes. Such an operation is precarious – etymology is a notoriously "non-exact science". Besides, as the *Oxford English Dictionary* remarks, screen is of "difficult etymology".[7] Scirm, also written "skirm", "skerm", "scerm", "scherm" or "schirm", was a token of migratory language 'processing' across the European Continent and the British Isles. Variants can be found from many languages. Beside the English *screen*, *skreen, screne, skrene*, etc., there is the French *escran* which became *écran*, the Italian *schermo*, the Polish *chronic, schronic*, the Bohemian *schrana*, etc.[8] The timing and the routes along which the word and its signification spread are not clear.[9]

Aspects of the interplay between these and other variants can be glimpsed in multi-language dictionaries that related European vernacular languages with each other (and Latin). The third edition of Nathanael Duez's *Dictionarium Gallico-Germanico-Latinum* (1664) defined *Escran* as follows: "Ein fewerschirm / oder ein brett das man zum schirm der hitz und des winds vor oder hinter sich hält / Umbella, erecta umbella, & dorsuale" ("A firescreen or board held in front or behind [a person] to protect from fire or wind").[10] The Latin *umbella* ("little shade", diminutive of *umbra*, shade or shadow), *erecta umbella* (upright little shade) and *dorsuale* (in Medieval Latin "back of a throne", "hanging behind an altar", saddle cloth, etc.) do not share the same root as *escran*, which is vernacular in its origin.[11] In 1674, an Italian-French-German dictionary listed the Italian variants matching *escran* and *Feurschirm* as *schermaglio* and *parafuoco*; the latter influenced the French *pare feu*, emphasising the link between screens and fire.[12] A corresponding pair of words, *paravento* and *paravent* ("draught screen"), had been adopted by the turn of the century.[13] Related combinations between words from other languages could be quoted. James Howell's *Lexicon Tetraglotton: An English-French-Italian-Spanish Dictionary* (1660) presented the following word quartet: "A Skrene; *Escrein*; Schermaglio; *Respalda*".[14]

The referent was a material artefact, a "contrivance for warding off the heat of fire or a draught of air".[15] Such pieces of furniture had been known for centuries. Jean Palsgrave stated in 1530: "Skrene made of wycars [wicker] to put bytwene the fyre – *escrain, s*, m: *estrane z*, m.".[16] In his dictionary of French furniture from the Carolingian era to the Renaissance, Eugène Viollet-le-Duc referred to 14th-century sources, including the account book of King Charles VI from 1382, where *écrans d'osier* ("wicker grid" screens) were listed.[17] According to Viollet-le-Duc, they were practical necessities because of the large open fireplaces needed to keep medieval habitations warm. Movable boards could temper the intense heat and direct it to the sides of the room. Such screens quite logically offered themselves as surfaces to be decorated with embroidery and paintings, as examples preserved in French museums and castles demonstrate. Some can be seen in early picture postcards from places like Musée de Cluny and Musée des Arts Décoratifs (Paris) and the Château de Pau, the residence of the Kings of Navarre, where illustrated screens from the 16th century survive. Few early firescreens are on display today – or even pictured

in museum guidebooks – testifying of their cultural decline. Compared with the ubiquity of media screens, the situation seems paradoxical.[18]

Another screen type was mentioned in a manuscript in 1548: "Two litle Skrenes of silke to hold against the fier".[19] A related object was described a century later: "[N]ominated a screene, it is a thing made round of crisped paper, and set in an handle to hold before a Ladies face, when she sits neere the fire".[20] *Dictionaire Universel* (1690), which claimed it included "all the French words, both old and new", acknowledged the existence of two types, mentioning floor-standing screens mounted on legs and handheld versions "decorated with various stories and images".[21] Handscreens have a long history, going back to ancient Egypt and probably beyond.[22] They have similarities with fans (*éventail*), but should not be confused with them. Fans were a more recent – perhaps Japanese – invention popularised in the West via China. They are made of paper stretched on an array of jointed sticks, which allows opening and closing them in a matter of seconds. Handscreens are boards of wood or papier maché attached to a dowel-like handle. Both could be used for air ventilation, but because of their thinness the usefulness of fans as firescreens was limited; they gained other uses and became prominent as pictorial surfaces embodying parts of a rich iconography. In Larousse's *Grand Dictionnaire Universel du XIX^e Siècle* (1866), the light hand-held *écran* (also known as *écran à main*) was the primary point of reference, while only a short mention was reserved for floor-standing firescreens. This reflected contemporary fashion trends.

The etymological debates around "screen" sometimes led to questionable claims. A 19th-century dictionary associated screen – probably erroneously – with the Latin *scrinium*, the German *schrein* and the French *escrain* – chest, casket or shrine, "cabinet or place to keep anything in".[23] Its purpose was to protect valuables, but it could also become an object for gazes if it contained a saint's relics and was treasured at a site of pilgrimage. In his *Evangelienbuch*, written in the Franconian dialect of Old High German, Otfrid von Weissenburg (ca. 790–800 – ca. 870) used the expression *mit gotes scirmu* ("with God's protection").[24] It can be associated with *Schirm* (shield) or *Schutz* (protection, protector).[25] The word skirmish – "to fight behind cover, hence to advance to fight under shelter" – has also been connected with the same etymological complex. Yet another link, suggested by some etymologists, is the French word for fencing, *escrimer*, "to exercise the art of defense, to fence or fight scientifically with swords or foils".[26] As intriguing as such associations are, it must be kept in mind that they are not unanimously endorsed by linguists.[27] Cultural agents choose words from existing repertoires.[28] The choices may not be etymologically valid, but it does not void their historical value.

William Shakespeare (1564–1616) wrote in *Macbeth*: "Now neere enough: your leauy Skreenes throw downe, And shew like those you are".[29] The "leafy screens" refer to the branches of trees the army of Malcolm, Macbeth's enemy, was using as camouflage as it marched toward Dunsinane Hill. Once it had reached Macbeth's castle, they were thrown away.[30] Assuming that Shake-

speare's expression was inspired by firescreens and draught screens he certainly knew may seem an exaggerated interpretation, whereas a link with the meanings associated with shields and skirmishes would feel logical. At least two centuries and probably longer had passed since the word "screen" had come to use. Whether its original denotation had been a material object or not, it had had time to mutate and migrate within discursive traditions. In his *Dictionary of the English Language* (orig. 1755), Samuel Johnson evoked the *Macbeth* reference. His entry on screen, which has been quoted or paraphrased in countless later discourses, is worth a closer look.[31] Johnson presented a three-fold definition, listing "any thing that affords shelter or concealment", "any thing used to exclude cold or light" and "a riddle to sift sand". The verb "to screen" he associated with "to shelter; to conceal; to hide" and also "to sift; to riddle", cross-referencing it with "to shadow", which he found synonymous with "to conceal under cover", "to screen from danger" and to "shade".[32]

As centuries passed, new meanings and emphases were added, demonstrating the word's growing currency. According to Larousse's *Grand Dictionnaire Universel du XIX^e Siècle* (1866), screen had by then come to be used about anything functioning *in the manner of an écran*, including the human hand held in front of a light source or a person serving as a screen for someone else, such as a young lady's older female companion, *chaperon*.[33] Larousse's dictionary further demonstrated that *écran* had gained technical and industrial meanings as a surface for protecting the worker, and was also used about anti-reflection shades utilised by artists and printmakers at work to avoid glare. Most interestingly, reflecting the rise of art criticism, screen had come to be used as a derogatory expression about poorly executed paintings, "evoking those that used to cover the screens in the past". In a curiously de-emphasised manner, we detect here a glimpse of the screen as something to be looked at. Ultimately, media screen proper makes its appearance, but only toward the end of the entry (followed only by a short concluding etymological formulation). Classified under "physics", we read that *écran* refers to a "white canvas or board (*tableau*) on which the image of an object is cast".[34]

By using the expression "any thing" – twice – Samuel Johnson implied that the polysemy of the word was increasing. Echoes of the usages he listed have been transmitted through cultural filters and semantic force fields to our time. Window screens and screen doors covered with wire mesh sheets shelter inhabitants from insects, while roller screen shades (blinds) block off sunlight or intruding gazes.[35] Automobile windscreens function as draught screens in motion.[36] Security screens at airports "sift" guns and explosives from humans and safe items. The panning screens employed by gold diggers share much the same idea, and so does the practice recommended in an online training course: "It is best to screen applicants based only on skills & qualifications necessary for performing the job." In these examples sifting has to do with making visible rather than blocking from view. However, last but not least, some meanings, which used to be commonplace, have all but disappeared. The rood screen

(alternatively choir, chancel or cathedral screen) used to be a familiar element of church interiors, a *fixed* wooden or stone barrier separating the nave from the choir. Most have been dismantled as theological currents, liturgical practices and architectural fashions have changed.[37]

The word "screen" often referred to material objects, but it also gained metaphoric and symbolic meanings. 16th- and 17th-century sources reveal rich discursive activity, which led to semantic displacements. "Screen" was transfigured into a trope for poetic and allegorical imagination. A wide variety of discursive fragments can be found, but a few examples must suffice here. It is significant that the screen, a human made artefact, came to be subsumed to the humans themselves. Francis Bacon (1561–1626) wrote in his *Ornamanta rationalia*: "Some ambitious men seem as *screens* to princes in matters of danger and envy."[38] In 1630 we read how a "screene, that stands betwixt me and the fire, is like some good friend at the Court, which keepes me from the heate of the unjust displeasure of the great".[39] William de Britaine wrote in 1693: "A Man in great Place had need of a generous Patience to bear the Calumnies and Malice of others: It will be Prudence in him to have some Ambitious Person about him which may serve as a Skreen so keep off the Indignities and Affronts which may be offered."[40]

John Dryden (1631–1700) made Adam state to Eve after their expulsion from Paradise: "Deep into some thick covert would I run, Impenetrable to the Stars, or Sun, And fenc'd from day, by night's eternal skreen; Unknown to Heav'n, and to my self unseen."[41] The "screen of night" may also have become a topos, for it resonates with an 18th-century translation of one of the Psalms: "The veil of night is no disguise, No screen from thy all-searching eyes."[42] It may not come as a surprise that screen was repeatedly associated with religious imagery. In English religious traditions, screen separating life from death became a topos. An English adaptation of the Easter mass stated: "Blessed are they, who have not seen, And yet whose faith entire hath been, Them endless life from death shall screen, Alleluia."[43] Reverend Edward Irving preached: "[T]he open gates of hell and of heaven, which lie upon the other side of death, are hidden as if by an impenetrable screen from every man who is still unenlightened, they are still hidden from his spiritual eye."[44]

Jonathan Swift, who was supremely versed in the subtleties of religious discourse, imagined in his satirical poem *Verses on the Death of Dr. Swift* (1731) how others would react to news of his death. The screen between life and death became related with age:

The Fools, my Juniors by a Year,
Are tortur'd with Suspense and Fear;
Who wisely thought my Age a Screen,
When Death approach'd, to stand between;
The Screen remov'd, their Hearts are trembling;
They mourn for me without dissembling.[45]

Screens became figments of the human mind. The dramatist Nicholas Rowe (1674–1718) wrote in *The Tragedy of Jane Shore* (1714): "This gentle Deed shall fairly be set foremost, To *screen* the wild Escapes of lawless Passion."[46] Half a century later, it was Edward Young's (1683–1765) turn: *"Where,* Men seek not the *Means* of Serving, but an *Excuse* for not serving Others; and *Words* change their Nature, and do not *reveal,* but cover the Mind; the *Passions* themselves, those Betrayers of Truth, are taught to *act a Part;* the very *Eye* can lye, and that Natural *Window* of the Soul has a Skreen before it, that you may not see through; he only who discovers his own *Interest,* gives you a Key to his Heart [...]."[47] Human life was again and again associated with screens. In 1709, a manual for the young gentleman connected them with moral education: "When Innocence left the World, Cloaths [sic] came into fashion; they were only invented as a Screne [sic] to Nakedness, and a Defense to *Decency* [...]."[48] Whatever their form, the purpose of the early screens was to shield, interrupt, protect, prevent, disguise or hide. They were in-betweens serving separation and invisibility. It can be claimed that media screens are in-betweens too, but their purpose is the opposite: to display and connect. How did screen become a surface for projected media content?

Screens in 18th-century optical experiments

Screens and magic lanterns were associated already in the 18th century. James Wood made the connection in *The Elements of Optics* (1799), a textbook for university students.[49] Although words like "cloth" or "sheet" were also in use, replacing them with "screen" became common, at least in the circles of the learned. As early as 1748, Thomas Rutherforth wrote that the magic lantern will produce a picture "upon a white wall, a sheet, or a screen of white paper".[50] Samuel Johnson's *Dictionary of the English Language* did not mention projection screens, but evoked Francis Bacon's words from his posthumous *Sylva Sylvarum*: "When there is a screen between the candle and the eye, the light passeth to the paper whereon one writeth."[51] This reference evokes the scientific background from which many screen-based applications emerged. 18th-century books on optical science demonstrate that the word screen was firmly associated with luminous projections. Authors of popular tracts borrowed from each other, which led to persistent traditions in terminology and phraseology.

It is interesting to discover that customary household screens were repurposed for media usages. In *A Compleat System of Opticks* (1738), Robert Smith explained how outdoor scenes could be projected into a darkened room by means of a "sky-optick-ball" [scioptic ball] installed in a window-shutter. The scioptric ball was a swiveling optical interface (a ball with a lens, installed into a socket) for turning a room into a camera obscura (a device we will encounter again). Smith wrote:

> The pictures of objects will be so much the larger as the focal distance of the lens is longer, and so much the brighter as its aperture is larger. The focal distance of the lens being 8 or 10 feet, it is convenient to receive the pictures upon a large skreen [sic], covered with linen or white paper, and to have it moveable upon

Fig. 1: Scioptic balls, England, Lignum vitae wood, ca. 1750–1770. Author's collection.

small wheels for the purpose of placing it readily at the due distance from the lens.[52]

The contraption Smith described is an adaptation of a common household screen. The experiment may have been performed by covering its decorations with a blank surface, so that the scene from outside could be projected onto it.

A particularly rich source that demonstrates how the word screen was adopted for the purposes of natural and experimental philosophy and thereby affected both visual education and common parlance is Benjamin Martin's *The Young Gentleman and Lady's Philosophy* (1763). Martin (1704–1782) was a celebrated scientific instrument maker, so he was thoroughly familiar with the subject. Composed as a dialogue between two characters, Euphrosyne and Cleonicus, the second volume, titled *The Philosophy of Light and Colours, and the Use of all Sorts of* Optical *INSTRUMENTS*, explains several applications with screens.[53] These include projection experiments with prisms and a kind of "astronomical dispositive" for observing the sun and celestial phenomena like the transit of Venus. This "new Solar Apparatus", which allows the participants to view "the TRANSIT OF VENUS over the SUN'S DISK, without darkening the Room", has two screens.[54] One of them is "a Screen of white Paper, of a circular Form, on which is drawn a black Circle of twelve Inches Diameter". The second is, as Martin explicitly states, "adapted" from "the Common Candle Screen [shade], made of black Silk, and which, in the usual Manner, expands itself into a circular Form".[55] Once again, we witness how common everyday screens were transformed into media screens.

The blackened paper screen makes it unnecessary to darken the room, creating a mediated experience in a fully lighted room, which in an anachronistic way brings to mind discussions about how to improve laptop computer screens by means of LED technology to make them visible even in bright daylight. "You

will by means of this Apparatus, in the most lightsome Room, have the Pleasure of viewing the Face of the Sun, and every Thing that may appear in or upon it, with as much Pleasure, and almost as perfectly as in the *Camera Obscura* itself", Martin writes.[56] Euphrosyne and Cleonicus also conduct the scioptic ball experiment Smith described on a "large moveable Paper-screen, upon a Stand". The conversation leads to an inspired description of the real world wonders projected into the interior space.[57] It is worth reproducing here in full, because it raises issues artists using photography, film and video have since been occupied with. No doubt one can detect a salesman's pitch underneath. Why pay for an inferior painting when you can buy more exciting lenses from Martin for less?

> *Cleon.* Upon this Screen you observe, there is instantly formed a beautiful Landskip [sic] of all the distant Scenes of natural Objects without.
>
> *Euphros.* Indeed, I do; and a finer Picture was surely never seen. —- What wondrous Painting is this! —— I see the distant Fields and Meadows, with the meandrous Windings of the River! —- I view every Thing in Motion, the People walking, the Cattle grazing, and the Ships sailing in the River. —- The Objects all richly variegated with their natural Tints and Colours, —- the Buildings all in Perspective, with a natural Relievo by Light and Shade! —- I do not know that I was ever so delighted with a View of Nature at large, as I am with this Picture of it in Miniature; —- and, upon the Whole, I cannot but observe how infinitely the beauteous Paintings from Nature's Pencil exceed the Imitations of those who Copy her; and when I hear of those incredible Sums of Money that have been given for such inferior Performances, and at how small a Price those Glasses are purchased which present us with the inimitable Original, I am quite at Loss to conjecture at the unaccountable Fate of Things.[58]

One of the interesting details is the expression "Nature's Pencil", which was used by William Henry Fox Talbot (1800–1877) as the title of his famous book *The Pencil of Nature* (1844), an early exposé of photography. In Talbot's case, the tracings of the nature's pencil were frozen on photographic paper. In the introduction he stated that "[…] the plates of this work have been obtained by the mere action of Light upon sensitive paper. [...] They are impressed by Nature's hand."[59] In optical science, the expression "pencil" was used about a concentrated ray of light. "When the image is real, the rays of each pencil actually come to a focus", George Adams wrote.[60] However, "Nature's Pencil" was also used in the 18th century in other metaphorical senses. "What atom-forms of insect life appear! / And who can follow nature's pencil here", the poet Anna Laetitia Barbauld versed.[61] About a Tuscan style temple in Mr. Duncomb's gardens, a commentator stated that it "commands such various scenes of the sublime and beautiful as to form a theatre worthy of the magnificent pencil of nature".[62] Fox Talbot may have given the expression a new interpretation by applying it to "photogenic drawing", but as we see he resorted to a formula that was already well-known, most likely a topos.

The camera obscura, a common optical device used by scientists, artists and amateurs, also had a "screen", as Wood pointed out in *The Elements of Optic* (1799):

If light be admitted, through a convex lens, into a darkened chamber, or into a box from which all extraneous light is excluded, and the refracted rays [will] be received upon a screen, placed at a proper distance, inverted images of external objects will be formed upon it. And if the lens be fixed in a sliding tube, the images of objects at different distances may successively be thrown upon the screen, by moving the lens backwards or forwards, as in the magic lantern.[63]

Camera obscuras existed in different formats: as darkened rooms or buildings constructed for the purpose, box-like instruments, and even as tents that were erected and dismounted where needed.[64] The box camera obscura, which gave the model for the photographic camera, as Fox Talbot's experiments demonstrate, had normally a ground glass screen (alternatively called "object glass" or simply "glass") installed horizontally on the top side of the apparatus.[65] An adjustable lens tube and an inclined mirror inside the box projected the scene from the outside on the screen from below, to be sketched by pencil on translucent paper superimposed on it.

The building camera obscura was a little hut erected by the sea shore or in other scenic locations. Sometimes the top floor of a tower was used for this purpose, as can still be witnessed on the Castlehill in Edinburgh.[66] The surrounding scenery was projected on a round "table" by a lens and mirror combination installed on the rooftop. This optical assembly was rotated by the visitors by a rod or crank, making it possible to observe the entire surrounding view drift by "panoramically". The experiences were described in words that recall Euphrosyne's and Cleonicus's wonderment about the effects of the scioptic ball. Such descriptions seem more frequent than those occasioned by devices like the magic lantern, perhaps attesting to the surprise and awe the camera obscura created. Of course, the recycling of topoi must have also played a role. In the 19th century, when camera obscura buildings became popular at tourist destinations, cartoonists commented on the effect, associating scopic pleasure with panoptic peeping. In their drawings unsuspecting amorous couples cuddling at the beach were being peeked at by groups of mischievous eyes inside a nearby camera obscura.[67] What may seem like stereotypical genre scenes from romantic paintings were, as if captured from real life and turned into optical entertainments, shown – interestingly – in a circular frame.

A drawing manual (1805) explained why the horizontal screens inside room camera obscuras were circular: "The screen, upon which the picture is received, should be placed at the focal distance of the lens, and bent into an arc of a circle, of which the lens is the centre, that when the lens is turned sideways, the picture may still be cast on the screen at the focal distance of the lens."[68] The 360-degree range of vision of the rotating lens/mirror assembly best fitted within a circle. A box camera obscura's configuration was different, because it was used by one person only and always had to be pointed toward the scene to be sketched. The shape of its screen was normally rectangular, which may have to do with design and fabrication (a quadrangular box is easier, faster and cheaper to produce), but also with the tradition of framing landscape paintings and even formats of sketching paper. A screen was not absolutely necessary for

Fig. 2: Room camera obscura at Worchestershire Beacon, England. Albumen photograph, 1860s. Author's collection.

such purposes, which is proven by the success of a competitor, the camera lucida, developed by the British scientist William Hyde Wollaston (1766–1828) in the first years of the 19th century and patented in 1806.[69] Judging by the quantity of surviving examples and models, it soon superseded the popularity of the camera obscura as a sketching device. There is no screen, unless we want to consider the sheet of paper as such.[70]

Screens and magic lantern shows

Magic lanterns were employed by showmen and savants alike since the second half of the 17th century. *Philosophical Transactions of the Royal Society of London* noted in 1698 that "[t]here are every where [sic] made of these [Magick] Lanthorns to represent and magnifie figures upon a Wall [...]".[71] The word screen was not yet evoked in this context. In the 18th century the public image of the magic lantern was affected by presentations of itinerant lanternists, often known as Savoyards, which refers to the impoverished region where many seem to have come from.[72] Against this background a 1770 dictionary defined the magic lantern as "a little optic machine, by which are represented on a wall, in an obscure place, many hideous shapes which are taken to be the effect of magic, by those that are ignorant of the device".[73] Others saw different potential. The eminent mathematical instrument maker George Adams wrote: "The magic lanthorn has been generally applied to magnify small pictures in a dark room for the amusement of children: we shall shew you that it may be applied to more important purposes, by using it to explain the general principles of optics, astronomy, botany, &c."[74] The magic lantern was on the way to become a demonstration tool in the service of visual education.

Better than from written sources, we learn about screens in the 18th-century magic lantern shows from paintings and prints. Their rich iconography has been assembled by the cinema historian and collector David Robinson.[75] Iconographic sources should not be used naively as "reflections" of the realities of their time, but their testimonies do not have to be rejected. Scenes where an itinerant lanternist is shown giving a presentation in a well-to-do house,

Fig. 3: Daniel-Nicholas Chodowiecki (1726–1801), artist, and Daniel Berger (1744–1824), engraver, *Der Savoyarde*. A magic lantern showman giving a performance. Etching, late 18th century. Author's collection.

often accompanied by a young man as an organ grinder, give us important information about the dispositive. Normally only a handful of spectators are present. The magic lantern is visible in the centre of the room, projecting a large circular image on a surface. As a relatively little-known device for many it must have been part of the attraction. Instead of a plain wall, a large white cloth is normally used as projection surface. In Jean-François Bosio's well-known print *La Lanterne Magique* (1804) the cloth seems to have been stretched across a doorway. A watercolour by Paul Sandby (1760, British Museum) shows a large sheet hung over framed paintings covering the walls of the salon with dark wallpaper. The projection surface serves as a kind of palimpsest, at the same time revealing pictures and covering others.

Bringing one's own white cloth or borrowing one from the household where the presentation was given was a necessity, because the walls were often covered with pictures, ornamental wallpaper or tapestries. Oil lamps and candles with parabolic reflectors were often the only illuminants available. The projected images must have been faint; if the lantern was brought close to the screen to increase luminosity, they became small. Even the invention of the improved Argand or Quinquet oil lamp in the 1780s did not entirely resolve these problems.[76] In illustrations, the magic lantern is normally relatively close to the projection surface. In Johann Eleazar Schenau's well-known engraving *La Lanterne Magique* (1765) it is almost at arm's length; a mother and two children are standing *in front of* the projected image, casting shadows on it. Something is not right: the magic lantern is too close to be able to cast such a large projected image. The artists and illustrators who depicted such scenes may have exaggerated the size and clarity of the projected image to make it more visible for those inspecting the painting or print. Another factor may be composition: to be able to include everything essential regarding the elements of the dispositive, including the audience, these appear as if 'squeezed' together. Pictorial tradition overrules truthful representation.

Phantasmagoria, eidouranion and rear projection

The *Oxford English Dictionary* claims that the word "screen" was first associated with projected images in 1810 in the following quote: "To make Transparent Screens for the Exhibition of the Phantasmagoria."[77] As we have seen, this information is incorrect. The magic lantern had been associated with the word "screen" much earlier. The screen became an important issue for Phantasmagoria, a new type of magic lantern show which began raising curiosity in Europe in the final decades of the 18th century. It was a horror spectacle, which often pretended to be educational. The inventor is thought to have been a mysterious showman named Paul de Philidor, who exhibited in continental Europe in the 1780s–1790s.[78] In Paris, an experimental physicist known as Étienne-Gaspard Robertson began exhibiting *Fantasmagorie* in an abandoned monastery in 1798.[79] Thanks to a lull in the wars that had isolated England from the rest of Europe for years, a person named Paul de Philipsthal, who may have been Paul de Philidor behind a newly adopted alias, introduced

Phantasmagoria to London. He began presentations at the well-known show-place called Lyceum on the Strand in October 1801. Profiting from being the first to exploit a new and lucrative idea in England, Philipsthal quickly filed an application for a patent.[80] He surely knew that Robertson had already patented his *Fantasmagorie* in Paris, with poor success to guard the secrets.[81] Elements of phantasmagoria had been known for decades, utilised by showmen and natural magicians in their presentations.[82]

The dispositive of phantasmagoria featured rear projection, hidden projectors and the deliberate "dissolution" of the screen – it was as if made to disappear by making it translucent. The main feature was rear projection by means of an improved magic lantern known as Fantascope.[83] It was a large and cumbersome projector mounted on wheels so that it could be pushed along tracks towards the screen and pulled back again. The transparent screen was made of thin fabric, said to be of "white muslin, calico, or oil-cloth".[84] The figures – monsters, skeletons, flying skulls, apparitions of dead celebrities, etc. – seemed to advance toward the audience or to retreat into the distance. There was a demand for something new: normal magic lantern shows had become too familiar. Phantasmagoria renewed screen practice by creating a guessing game about what was really happening behind the scenes – magic lanterns were never mentioned in the publicity. By using rear projection, not even the light beam of the Fantascope lantern was left visible. Still, it is unlikely that many spectators thought occult forces were involved; more likely they took part in a game of suspended disbelief. When he introduced his *fantasmagorie* spectacle in the turmoil of the French Revolution, Robertson carefully claimed that he was *only* demonstrating superstitions of the past; smart observers might have taken that as a hint that he was really doing something else.

The showmen Schirmer and Scholl, who opened their own phantasmagoria spectacle at the Lyceum in 1805, promised to "produce and fully explain" the inferior tricks of Philipsthal and the other phantasmagores. They even announced that: "Ladies and Gentlemen, having a particular curiosity, may even be admitted behind the curtain [screen], on the Stage, to see them make these experiments [...]."[85] *Ergascopia*, Schirmer's and Scholl's own production, was said to differ "as night and day from what is stiled Phantasmagoria".[86] The reporter assigned to cover Philipsthal's spectacle for the *Monthly Magazine* had already done his best to spoil the fun. Whether for self-promotion or for advancing the cause of rationalism, he was adamant to reveal the secrets for the reader:

> The people of London [...] have, during the present month, been attracted in crowds to see an exhibition of optical images in the Strand. These ghosts and spectres, as they are called, are the simple production of a common magic-lantern, the objects from which are thrown upon the farther side of a transparent screen, which is hung between the lantern and the audience. When the lantern is brought nearer the screen, the object is diminished in size, and appears to retire; when taken farther off, the object is increased [sic] in size, and appear[s] to approach the spectator.[87]

The similarities and differences between common magic lantern shows and Phantasmagoria were understood and discussed by contemporaries. The book *Systematic Education* (1817) said: "The *Phantasmagoria* produces an exhibition very similar to that of the Magic Lanthorn. In the common Magic Lanthorns, the figures are painted on glass, and the parts of the glass not occupied by the painting are transparent, of course the image on the screen is a circle of light having a figure upon it; but in the Phantasmagoria, all the glass is opaque, except the figure only, which being painted in transparent colours, the light shines through it; of course no light can come upon the screen but that which passes through the figure itself, consequently the figure only is visible on the screen, without any circle of light."[88] The author compared projection surfaces as well: "In common lanthorn the representation is made on the wall, or on a sheet, but in the Phantasmagoria it is thrown upon a silk screen placed between the lanthorn and the spectator."[89] He noted that it was the darkness of the auditorium that made the Phantasmagoria screen as if disappear: "[A]s no part of the screen can be seen, the figure appears to be formed in the air [...]."[90]

Phantasmagoria was not the only rear projection-based form of screen practice at the time. The less well known *Eidouranion, or, Large Transparent Orrery* had similar features, but a very different purpose. Until now, hardly anyone has drawn a connection between these two forms, but by comparing their dispositives the parallels become evident. The word referred to illustrated lectures and demonstrations of astronomy. *Eidouranion* was introduced in England during the final decade of the 18th century, around the same time Robertson's *Fantasmagorie* was drawing audiences to the ghastly corridors of a former Capuchin monastery in Paris. The pioneering exhibitors, who coined the term, were Adam Walker (1730 or 1731–1821) and his sons William (1766–1816) and Deane Franklin (1778–1865). They claimed they were demonstrating celestial phenomena by means of a gigantic transparent orrery. Mechanical orreries were familiar devices in popular scientific education. However, only a handful of people could fit themselves around these devices in lecture rooms or physics cabinets. Planets, attached to the ends of metal rods, swirled around on their orbits. The Walkers offered similar experiences for larger paying audiences. Some historians of science and technology still believe that an enormous version of the traditional orrery was used, making guesses about its construction without any clear evidence. Although Adam Walker may initially have used a mechanical orrery, perhaps with transparent planets, it is clear that as it was normally performed, *Eidouranion* was a series of mechanical magic lantern slides rear projected onto a large screen by a hidden magic lantern.[91] The wood-mounted slides were animated by means of a crank. These were novelties constructed by optical instrument makers, capable of producing – like Phantasmagoria – astonishment among spectators who had not witnessed such effects before.

Eidouranion could be characterised as an "astronomical Phantasmagoria". Monsters and ghosts were replaced by the celestial bodies: the solar system in

rotation, an eclipse of the moon, a comet shooting across the sky, etc. Instead of titillating horrors matching the otherworldly interests of Romanticism and the atmosphere of terror during the French Revolution, the audience was treated with rational and scientific demonstrations of the mechanism of the universe. But there were also differences. The magic lantern was likely station-ary – the celestial bodies did not shoot out from the screen toward the spectators; their movements were aligned with the surface of the screen. The exhibitors did not attempt to hide the presence of the screen, although the auditorium naturally had to be darkened. Considering Phantasmagoria and *Eidouranion* as practically the same thing or as polar opposites would be misleading; the truth lies in-between. In actual performances, Phantasmagoria was often combined with other program items, including popular scientific demonstrations.[92] *Eidouranion* and *Phantasmagoria* could be part of the *same* show, as we learn from a broadside used by a Mr. Hayes, Lecturer of Queen Elizabeth Grammar School, to advertise his "Three Lectures on Astronomy" in 1830. In addition to detailed descriptions of astronomical orrery slides, we read: "PHANTASMAGORIA. The Lectures will be diversified with novel and interesting TRANSPARENCIES, and a variety of GROTESQUE and SPLENDID DIMINISHING FIGURES, constituting a degree of grandeur, variety, and interest never before combined."[93]

Both Phantasmagoria and *Eidouranion* were at first technical secrets treasured by the showmen, but they gradually became part of the magic lanternist's standard repertory. As early as 1814, the London optical and mathematical instrument maker Charles Blunt was offering for any prospective buyers: "A COMPLETE EIDOURANION, on a small scale, for the amusement and instruction of a family circle, or the higher classes of schools."[94] It was listed under the general heading "Paintings [slides] for the Magic Lantern". Astro-nomical lantern slides became standardised and sold as boxed sets of ten or twelve slides throughout the century. England was important in turning the magic lantern show into a vehicle for popular education. In 1823 the optical instrument maker Philip Carpenter (1776–1833) introduced a compact Im-proved Phantasmagoria Lantern meant to be strapped to the projectionist's body with a belt, which allowed him to move freely behind the screen.[95] Carpenter's lantern slides, which he called "copper plate sliders", were also a novelty, because a contact printing method was used. The outlines of the figures were burned on glass and only the colouring done by hand.

An illustration, which was included in a small booklet where Carpenter described his inventions, shows a lanternist rear-projecting a picture of a zebra onto a small floor-standing screen. The audience, which is standing on the other side, consists of a family; two children are pointing at zoological wonders – animals have taken the part of Philipsthal's monsters![96] Carpenter was clearly targeting his products not only for professional exhibitors but also for educa-tors and amateurs who wanted to visualise their lectures both for entertainment and for learning purposes. In his customary clear and meticulous style,

Fig. 4: Demonstration of Philip Carpenter's Improved Phantasmagoria Lantern. From a supplement to Carpenter's *Elements of Zoology* (Liverpool: Rushton and Melling, 1823). Author's collection.

Carpenter described the screen best suited for "Exhibiting the Phantasmagoria". The description, which both summarises earlier developments and points to future forms of screen practice, is worth reproducing at length.

> For this purpose, instead of the image being exhibited on a white wall or sheet, it is thrown on a transparent screen placed between the spectators and the lantern. The screen not being seen, the image appears to be suspended in the air, and when the image is increased or diminished, it appears to the spectators to approach, or recede from them. The deception is so complete, that even those who are accustomed to the exhibition, and know where the screen is placed, are deceived by it. For the production of this very amusing and striking exhibition, no additional apparatus is necessary, except a transparent screen. This has usually been made of silk or muslin, either varnished or coated with a mixture of turpentive or bees' wax. These screens are not only expensive but they soon get injured and dirtied. A gentleman has lately communicated to me a very simple method of making an excellent one. Instead of varnishing the muslin, it is only dipped in water, and hung up quite wet. A screen of this kind costs but a trifle, can be folded up in a small compass, and when dirty is easily made clean; so far from having any disadvantage to counterbalance these advantages, it is superior in effect to any other, and has this peculiar and great convenience, that it requires no stretching, and hangs more level than any other. The muslin it is made of should be of the closest texture, and need not be very fine. The screen should be hung on a frame, and being wet will require no fastening; the frame itself may be made so as to take to pieces and tie up together in a small compass. The screen being prepared it should be so placed in the room as to leave space enough for the spectators, without their being too near it. If there is a door between two rooms, the screen may be suspended from the door frame; and for figures that do not require much breadth this is a very convenient method.[97]

Magic lantern shows and screens in the later 19th century

During the 19th century, magic lantern shows became even more ambitious, sophisticated and diversified, successfully competing with other spectacles. This happened in parallel with the formation of mass society, which led to an increasing demand among the bourgeoisie for visual education, moral entertainments and dazzling spectacles for the lower classes. The bourgeoisie wanted to calm down, enlighten and amuse the crowds, besides profiting from them financially. Charities and religious organisations adopted the magic lantern, but not without debates for and against. "Illustrated lectures" became a respectable institution addressed to the bourgeoisie. A typical genre was the travelogue based on the presentation of photographic lantern slides and explained by a 'refined' lecturer. Well known characters like the Americans John Stoddard and Burton Holmes created recognisable profiles and gave the impression they had experienced everything they talked about first-hand. Magnificent bi-unial (double) or tri-unial (triple) magic lanterns, fitted with powerful oxy-hydrogen (limelight) jets, were routinely mentioned in the advertisements.[98] The projector could normally be seen by the audience – it was an extra attraction. Renaming the magic lantern "stereopticon" (United States) or "optical lantern" (England) helped to distinguish the event from low class magic lantern shows for the masses. It raised curiosity and gave the enterprise an extra flavour of respectability.

The most common arrangement of the dispositive involved a seated audience facing the screen. The lantern operator was at the back of the hall, while the lecturer stood by the screen, indicating details with a long pointer. They communicated by a flasher or bell which were parts of the lecturer's table lamp or by a battery-operated signalling cable, which had a push button in one end and a light bulb in the other. Musicians routinely accompanied the event. Their number and placement in the hall varied depending on venue and the ambitions of the enterprise. Except for rare exceptions, such as the legendary shows of dissolving views at the Royal Polytechnic Institution in London, where the large lanterns were enclosed in a projection booth at the back of the auditorium, the majority of late 19th-century shows were shown in venues adapted for the purpose. The configurations differed somewhat depending on the circumstances. The musicians were, like the lecturer and the lantern operator, normally seen by the audience. Compared with Phantasmagoria, this supported educational values at the expense of magic and mystery. However, "rational entertainment" was supported by visual special effect slides like abstract chromatropes ("artificial fireworks") and the "magic" transformations of dissolving views. In the latter, one slide was made to 'melt' smoothly into another by lowering and raising the flames of the gas jets or by using a shutter blade to reveal and block the light beams emanating from the projector's lens tubes.

The dispositives of the more ambitious magic lantern shows adopted features from established proscenium arts, the theatre and the opera. The screen was erected where the proscenium arch separating the stage from the auditorium

Fig. 5: Magic lantern showman displaying his equipment. United States, after May 31, 1889 (Johnstown Flood is in the program). Judging by one of the broadsides, the showman's name may have been A.A. Zimmerman. He has created a dissolving view apparatus by combining magic lanterns made by two competing Philadelphia manufacturers. The one on the left is the Artopticon by William McAllister, the one on the right a Sciopticon by Lorenzo J. Marcy. Musical accompaniment was produced by a hand-cranked Tournaphone organette, manufactured by Tournaphone music Co., Worchester, Massachusetts. Both photographic and chromatrope effect slides can be seen. Cabinet card. Author's collection.

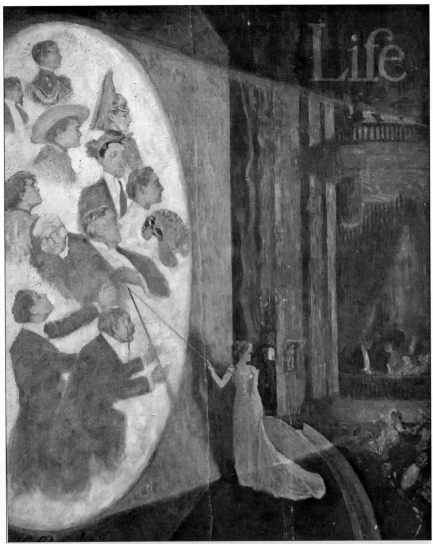

Fig. 6: "Animals I have known", cover illustration, *Life*, vol. LV, no. 1438 (19 May 1910). From an oil painting (?) by C. Clyde Sguires (1880–1970). A woman as a magic lantern lecturer commenting on experiences in the "animal world". Obviously a parody of illustrated lectures on natural history. Author's collection.

would be. It could be characterised as a virtual stage. As before, the screen got less attention in projection manuals than the other elements of the magic lantern show. Published illustrations seem to indicate that its dimensions were made as large as possible, but once again we should be sceptical: iconographic traditions also live their own lives, only partially matching actual realities. There was an application, which certainly required large screens: outdoor projections, particularly to announce the results of events like presidential elections. They were often installed at rooftops.[99] Essential for the use of large

screens was the availability of new powerful light sources, oxy-hydrogen limelight and electric carbon arc lamps.

Lantern slides are in an ontological sense separate pieces of glass. They have to be "stitched" together by the lanternist to create some continuities in the program. Late 19th-century presentations were often combined with interludes by living performers, singers, dancers and magicians. The realm of the stage became material again when they appeared, but turned into something else when the lantern slides were beamed from the projector. Features like these compromised the integrity of the screen as an *Ersatz* stage. The lecturer was a remnant of the displaced actors, but in a different role. Instead of being an impersonator, the lecturer was a mediator between the audience and the mediatic content. His role could perhaps be compared with that of a spiritistic medium, but it differed from that of the more rational stage magicians performing tricks to the audience with sleight of hand dexterity, physical props and assistants. When Georges Méliès, David Devant and others began appearing in silent films, their stage presence was subsumed into the screen. The mode of direct address was used, but the tricks became mediatised, enhanced by the possibilities of trick film techniques.

The essential features of the "vehicle" in the transition from magic lantern shows to early cinema were captured in a description of a magic lantern spectacle by the American showman Alexander Black (1859–1940), a prominent transitional figure in the 1890s:

> The other night I went into a darkened hall filled by a breathlessly attentive audience. A man on the platform was telling a story. On the sheet [sic] the story was being unfolded in pictures. All the characters of the story, photographed from life, were acting out the drama. The pictures were made, and this 'picture play' written by the man who was speaking for all the characters.[100]

Black later characterised his spectacles with expressions like "a play on a white sheet", "slow movie", "picture play" or "photo-play".[101] Instead of film, which was not yet available for such purposes, he used series of photographic lantern slides staged with living actors in the famous touring production *Miss Jerry* (1894). They were projected with a dissolving bi-unial magic lantern. The slides followed one another in rapid succession, "melting" into a quasi-seamless continuity. Black's spectacles anticipated filmic continuity editing, which gradually became the standard in narrative cinema. They enhanced the integrity of the screen as a "place" or succession of places, to which the spectators could develop a relationship, identifying with characters, settings and narrative developments.

Black's dispositive anticipated those used by early film exhibitors. Films did not replace magic lantern shows, moving panoramas, mechanical theatres and other familiar spectacles. Rather, they were added to the mix as a new highlight, at times integrated with the other elements of the show, at other times given a more independent role. *Hale's Tours*, which became popular for a while after 1904, was an effort to create a film-specific dispositive separated from adjunct

forms. The audience sat in a stationary railway or tram car watching "phantom ride" films projected on a screen at its far end. The Nickelodeon boom, which began in 1905, led to the establishment of permanent cinemas as the standard venue for watching moving pictures. For years to come they coupled films with attractions like singalong song slides ("Illustrated Songs"), accompanied with Wurlitzer "photoplayer" organs and other musical instruments. Singers, travel lecturers and others were also employed. With the triumphal march of the feature film, these other treats were gradually pushed into more peripheral roles, although they persisted. When sound film made its breakthrough in the late 1920s, the film lecturer's days were numbered. Screen (ir)reality – a token of media culture – overcame the physical human presence inherited from the theatre stage. The magic lantern survived as metamorphosed into the 35 mm slide projector used at schools and homes alike.

In the late 19th century, opaque screens were often recommended instead of transparent ones. One guidebook for "lantern manipulation" wrote:

> The screen, on which the pictures are thrown, is best opaque, the company being on the same side as the Lantern. If the apparatus be placed behind, and the pictures shown through a semi-transparent medium, the effects obtained are comparatively poor and flat, as they are seen partly by transmitted and partly by reflected light; but in many places the exhibitor might be in the way of the audience if his apparatus had to be placed a few feet from the screen; to obviate this disadvantage, focus lenses of different lengths are required: with a little range of optical power the same instrument will show the same sized pictures either crosswise or lengthwise of the room, or from a gallery.[102]

As this quotation shows, the issue of the screen really depended on all the elements of the dispositive as it was adapted to changing circumstances. Other elements, like the choice and manipulation of optics, could compensate for issues dictated by the shape and size of the auditorium.

Around 1900, when cinematograph projectors were being added to the repertories of magic lantern shows as the latest gimmick, the problematics of the screen began merging with the development of new presentation venues. The newly established trade press for the dawning film culture began discussing the screen with new vigour. With the Nickelodeon boom, it became an essential element of the movie house, and a feature which was linked with the financial success or failure of the enterprise. This lively discussion belongs to another article. It involved new varieties of screen surfaces, like the "Silver Screen", and also the desirable shape and size of the screen. The latter issue was related with the bigger conversations about the interior architecture of the buildings and auditoria meant for moving picture shows. Perhaps surprisingly for a contemporary reader, large screen as the ultimate goal was sometimes questioned and related with technical parameters, economic considerations and cultural values. It was even claimed that an educated audience could derive more pleasure from smaller screens comparable with etchings and oil paintings.[103] The habit of using decorative frames around movie theatre screens may

have had to do with such money metrics; quality and respectability had to be enhanced. That part of the story is forthcoming.

Notes

1. Charles Musser, "Toward a History of Screen Practice", *Quarterly Review of Film Studies*, vol. 9, no. 1 (1984): 59–69; Musser, *The Emergence of Cinema: The American Screen to 1907. History of the American Cinema*, vol. 1 (Berkeley, Los Angeles and London: University of California Press, 1990), chapter 1.

2. Musser, *The Emergence of Cinema*, 15.

3 Exceptions include John Belton, *Widescreen Cinema* (Cambridge, MA: Harvard University Press, 1992); Anne Friedberg, *The Virtual Window: From Alberti to Microsoft* (Cambridge, MA: The MIT Press, 2006); William Paul, *When Movies Were Theater: Architecture, Exhibition, and the Evolution of American Film* (New York: Columbia University Press, 2016); Francesco Casetti, *The Lumiere Galaxy: Seven Key Words for the Cinema to Come* (New York: Columbia University Press, 2015), chapter 5: "Hypertopia"; Dominique Chateau and José Moure (ed.), *Screens: From Materiality to Spectatorship – A Historical and Theoretical Reassessment* (Amsterdam: Amsterdam University Press, 2016).

4. I first presented the idea of screenology and outlined the area it would cover in: "Elements of Screenology: Toward an Archaeology of the Screen", *ICONICS: International Studies of the Modern Image* (Tokyo: The Japan Society of Image Arts and Sciences), vol. 7 (2004): 31–82.

5. However, inspired by my work on screenology, Giorgio Avezzù has published "The Deep Time of the Screen, its Forgotten Etymology", *Journal of Aesthetics and Culture*, vol. 11, no. 1 (2019): 1–15. The issue of screen etymology is also raised in Chateau and Moure, *Screens*, 14.

6. Thomas Elsaesser and Malte Hagener, *Theory of Film: An Introduction through the Senses* (New York: Routlegde, 2010), 38.

7. *Oxford English Dictionary*, 2nd edition, vol. XIV (Oxford: Clarendon Press, 1989), 722. *OED* from now on. This is seconded by other sources. The same concerns the origins of the French *écran*, a word which is agreed to be closely associated with the English *screen*. L'Abbé J. Espagnolle, *L'origine du Français*, Tome deuxième (Paris and Leipzig: Librairie Ch. Delagrave / Librairie H. Le Soudier, 1888), 29.

8. In Finnish, a Finno-Ugric language, entirely different words were used: *valkokangas* ("white cloth") is used to refer to the cinema screen and *kuvaruutu* ("picture square or frame") for the television screen. The word *varjostin* is used for the lampshade and was applied to other kinds of screens too, while *väliseinä* ("a wall in-between") has been used for partitions. These may have been free translations of the German word pair *Leinwand* and *Bildschirm*. Unless stated otherwise, all translations are by the author.

9. The German *Bildschirm* belongs to this tradition, whereas *Leinwand*, also used for media (projection) screens, belongs to a different trajectory (linen, piece of cloth, canvas, etc.). As a projection screen *Bildschirm* was associated with optical instruments like the solar microscope by the mid-19th century. *Leinwand* has been traced back to the Middle German *linwat* (linen) and was used for paintings on linen canvas. The latter is said to have been concocted in the 13th century from the English-French and old French *canevaz, canevas*, perhaps drawn from the vulgar Latin *cannapaceus*, adaptation from Greek (see www.lasaludfamiliar.com/wissensbasis/cnzyklopadie/leinwand.php, last accessed 26 April 2016). The etymological trajectories of *Bildschirm* and *Leinwand* require more attention.

10. The book also gives the following example: "Petit escran ou contenance d'osteres [osier], que les Dames tiennent devant le visage quand elles sont devant un grand feu. / Ein fewerschirm den die weiber vor dem angesicht halten / wann sie bey einem grossen fewer sitzen / damit die hitz ihnen nicht daran komme / Umbella faciai opposita ad ignis calorem arcendum."

11. Umbrella, derived from umbella, became characterised as "a screen used in hot countries to keep off the sun, and in others to bear off the rain". "Umbre'l, Umbre'lla", in J. Johnson, *The New Royal and Universal English Dictionary*, vol. II (London: A. Millard and R. Dorsley, 1763).

12. Antonio Udino, *Nuovo et Ampio Dittionario Di Tre Lingue*, Parte Prima (Francofurto: Giou. Pietro Zubrod., 1674), 794. An alternative expression is *écran de cheminée*.

13. *Paravento* was identified as the source of *paravent* in "Paravent", Antoine Furetière, *Dictionnaire universel, Contenant généralement tous les mots François, tant vieux que modernes*, Tome Troisième (Rotterdam: Reinier Leers, 1708). The word pair appears in Isidoro Lanfredini, *Nouvelle et facile méthode pour apprendre la langue italienne dans sa dernière perfection* (Paris: Laurent d'Houry, 1683), 219. It seems that the corresponding expression *pare feu* (from *parafuoco*) became common more gradually in France. We encounter it as a protector linked with a furnace for metal in Jacques Savary des Bruslons (ed. Philemon-Louis Savary), *Dictionnaire Universel de Commerce*, Tome Second (Génève: Chez les Héritiers Cramer & Freres Philibert, 1742), 1254.

14. James Howell, *Lexicon Tetraglotton: An English-French-Italian-Spanish Dictionary* (London: for Samuel Thomson, 1660), listed under S; original italics. A French-Flemish dictionary translated *écran contre le feu* as *Schutbert, Schutselbert. Schouberdt*, see Ian Louys Jean Louis d'Arsy, *Le Grand Dictionnaire François-Flamen, de nouveau Revû, Corrigé, & Augmenté de plusieurs mots et Sentences* (Rotterdam: Pierre de Waesbergue, 1643). Middle Dutch also knew *scherm* "screen, cover, shield", etc. (www.etymonline.com; last accessed 24 April 2016).

15. *OED*, vol. XIV, 722. *OED* further defines the screen as a "piece of furniture consisting usually of an upright board or of a frame hung with leather, canvas, cloth, tapestry, or paper, or of two or more of such boards or frames hinged together".

16. Jean Palsgrave, *L'éclaircissement de la langue Française, suivi de la grammaire de Giles du Guez*, edited by F. Génin (Paris: Imprimerie nationale, 1852), 271. The book is an English-French dictionary originally published in London. The vicissitudes of *screen* and *écran* are agreed to have been closely connected, but which influenced which has been debated. After dismissing some possibilities, Auguste Scheler decided that *écran* was a *francisation* of *screen*, but declined to discuss the latter's provenance. See his *Dictionnaire d'étymologie française d'après les résultats de la science moderne* (Bruxelles: Auguste Schnée, Paris: Firmin Didot, 1862), 404–405.

17. Eugène-Emmanuel Viollet-le-Duc, *Dictionnaire raisonné du mobilier français de l'époque Carolingienne à la Renaissance*, Tome premier (Paris: V.A. Morel & Cie, 1872), 105–106.

18. I have collected early postcards depicting firescreens from these places. In May 2017 I visited Musée de Cluny and Musée des Arts Décoratifs in Paris to find out if any of them are on display. The result was negative. I did not try to get access to the storage houses. I have not been to Château de Pau, but the numerous photographs of its interiors on the internet do not display even a single example.

19. A manuscript, quot. *OED*, vol. XIV, 722.

20. Holme, *Armoury*, 1688, III: xvi 83/1, quoted in *OED*, vol. XIV, 722.

21. Antoine Furetière, *Dictionaire Universel*, Tome premier (La Haye, Rotterdam: Arnout & Reinier Leers, 1690), 985.

22. There is little research dedicated to handscreens. They are usually mentioned as a side issue in books about the history of fans. There is no general agreement about their relationship: are they two different things or is a handscreen one type of fans (or vice versa)? For Mayor in "its earliest form the fan was probably a hand-sized screen". She defined handscreens as "pieces of a rigid material of various shapes on the end of a stick". Susan Mayor, *Collecting Fans*, Christie's International Collectors Series (New York: Mayflower Books, 1980), 6 and 9. See also Alexandre F. Tscherviakov, *Eventails du XVIIIe au début du XXe siècle: Collection du Palais d'Ostankino à Moscou*, trans. Aline Chmakotine (Bournemouth: Editions Parkstone, 1998); Pascal Payen-Appenzeller, *Fancy Fans*, trans. William Wheeler (Paris: L'Aventurine, 2000). About Asian fans, see Carol Dorrington-West (ed.), *Fans from the East* (New York: The Viking Press / Debrett's Peerage Limited, 1978).

23. "Screen. – Shrine" and "Shrine", in Hensleigh Wedgwood, *A Dictionary of English Etymology*, 2nd edition (London: Trübner & Co., 1872), 564–565. The derivation of *escrin* from *scrinium* was already suggested by the Jesuit R.P. Philippe Labbe in *Les etymologies de plusieurs mots François, Contre les abus de la Secte des Hellénistes Du Port-Royal* (Paris: Guillaume & Simon Bénard, 1661), 217–218.

24. It appears in the opening dedication, see Paul Piper (ed.), *Otfrids Evangelienbuch*, Erster Theil, Zweite Ausgabe (Freiburg i.B., Tübingen: Akademische Verlagsbuchhandlung von J.C.B. Mohr (Paul Siebeck), 1884), 4, line 20; in modern German: "durch Gottes Schutz". See also Oskar Erdmann, *Untersuchungen über die Syntax der Sprache Otfrids*, Zweiter Teil (Halle: Verlag der Buchhandlung des Waisenhauses, 1876), 254. For English translation, see Irmengard Rauch, *The*

Phonology / Paraphonology Interface and the Sounds of German Across Time (New York: Peter Lang, 2008), 73. In Johann Kelle, *Glossar der Sprache Otfrids* (Regensburg: G. Joseph Manz, 1881), 535, *Skirm* is explained to mean *Schirm, Schutz*. Other uses, with slight variants, are also recorded.

25. Rudolf Schützeichel, *Althochdeutsches Wörterbuch*, 7. Auflage (Berlin, Boston: De Gruyter, 2012), 290. Compare with: Paul Piper (ed.), *Otfrids Evangelienbuch*, Zweiter Theil: *Glossar und Abriss der Grammatik* (Freiburg und Tübingen: Akademische Verlagsbuchhandlung von J.C.B. Mohr (Paul Siebeck), 1884), 421; E.G. Graff and H.F. Massmann, *Vollständiger Alphabetischer Index zu dem althochdeutschen Sprachschatze* (Berlin: Nicolaische Buchhandlung, 1846), 196.

26. Walter W. Skeat, *The Concise Dictionary of English Etymology* (Ware, Hertfordshire: Wordsworth Editions, 1993), 440.

27. According to Wedgwood: "Skirmish is quite a different word." *A Dictionary of English Etymology*, 564; *OED* (vol. XIV, 722) admits that the Middle English *skrene* and *skreene* may have been confused with *screne*, meaning a scrine (chest, coffer).

28. Writers and poets are cultural agents working against the automatisation of everyday language by practicing estrangement (*Ostranenie*) and disruptions of customary rhythms and expressions, as Viktor Shklovsky explained in "Art as Device", included in his *Theory of Prose*, trans. Benjamin Sher (Elmwood Park, IL: Dalkey Archive Press, 1990), 1–14.

29. *Macbeth*, act 5, scene 6.

30. John Milton (1608-1674) associates screens with nature, describing how a ridge of hills "screen'd the fruits of th' earth, and feats of men, [f]rom cold Septentrion blasts". Milton, *Paradise Regain'd. A Poem In Four Books*, 5th edition (London: Jacob Tonson, 1707), 67.

31. Samuel Johnson, A.M., *A Dictionary of the English Language: in which the Words are deduced from their Originals, Explained in the Different Meanings, and Authorized by the Names of the Writers in whose Works they are found*, 5th edition (London: W. Strahan et al., 1773). Later editions retain this basic definition but include more examples. See the entry in the 8th edition, vol. II (London: J. Johnson et al., 1799).

32. A shade is a "screen causing an exclusion of light or heat; an umbrage", Johnson wrote, quoting John Arbuthnot (1667–1735). Ibid., under the entry "Shade".

33. Pierre Larousse, *Grand Dictionnaire Universel du XIXe Siècle*, Tome septième (Paris: Administration du Grand Dictionnaire Universel, [1866]).

34. Some years earlier a similar explanation was given, related to optics, in Adolphe De Chesnel's *Dictionnaire de Technologie: Étymologie et Définition*, edited by l'Abbé Migne (Petit-Montrouge: J.-P. Jacques-Paul Migne, 1857), 891.

35. Such screens are so omnipresent in areas like California that it is easy to forget that they also have a history. Window and door screens made of wire mesh stretched in a wooden frame were introduced in the 1870s (see americanhistory.si.edu/object-project/household-hits/window-screen, last accessed 28 May 2017).

36. In 1904, A.B. Wilson Young wrote in *The Complete Motorist* (VII, 176): "When a cover is used it should have a removable glass screen in front." Quoted in *OED*, vol. XIV, 723.

37. It was characterised as "skreen" by the 17th century. [Henry Keepe], *Monumenta Westmonasteriensia: Or an Historical Account of the Original, Increase, and Present State of St. Peter's, or The Abby Church of Westminster* (London: for C. Wilkinson and T. Dring, 1682), 157. John Evelyn referred to such screens in his diary, 24 December 1643 (*OED*, vol. XIV, 723). The replacement of a "wooden screen" with a "stone screen" at the Cathedral of York was described in Francis Drake, *Eboracum: or the History and Antiquities of the City of York* (London: William Bowyer for the Author, 1736), 523. Daniel Defoe repeated this information in *A Tour Thro' the Whole Island of Great Britain*, vol. III (London: for S. Birt, T. Osborne et al., 1748), 173. The architect A. Welby Pugin wrote *A Treatise on Chancel Screens and Rood Lofts, Their Antiquity, Use, and Symbolic Signification* (London: Charles Dolman, 1851). See also Jacqueline E. Jung, "Beyond the Barrier: The Unifying Role of the Choir Screen in Gothic Churches", *The Art Bulletin*, vol. 82, no. 4 (December 2000): 622–757. The corresponding German word was *Lettner*, the French *jubé*. Jung does not give etymological information about these words. The only surviving *jubé* among the churches in Paris is at Saint-Étienne-du Mont. The word screen has also been used about the fence erected in front of the house to mask its façade. The first reference to this meaning in *OED* is from 1842 (vol. XIV, 723).

38. Francis Bacon, "Ornamanta rationalia: or, Elegant Sentences", no. 12, in *The Works of Francis Bacon*, vol. II (London: M. Jones, 1815), 85. This example was mentioned by Samuel Johnson. The Parliament could also serve as a screen, "to hide [ministers] from public scrutiny"; reference from 1777 in: *The Parliamentary Register; or, History of the Proceedings of the House of the Lords [...]*, vol. IX (London: John Stockdale, J. Walker, R. Lea and J. Nunn; Wilson and Co., 1802), 84.

39. Joseph Hall, "112. On a Screene", in *Occasional Meditations*, CXII (1630), 282, quoted in *OED*, vol.XIV, 722. "Screene" has been corrected as "screen" in the 1851 edition of *Occasional Meditations. Also the Breathings of a Soul* (London: Reprinted for William Pickering, 1851), 126. Hall also wished Christ would "screen me from the deserved wrath of that great God, *who is a consuming fire*" (ibid.).

40. William de Britaine, *Humane Prudence or the Art By which a Man may Raise Himself and Fortune to Grandeur*, 6th edition (London: J. Rawlins for R. Sare, 1693), 126.

41. John Dryden, *The State of Innocence, and Fall of Man: An Opera*, Act V, Scene I (London: Printed by T. N. for Henry Herringman, 1677), 37–38. In another context Dryden wrote: "The curtains closely drawn, the light to skreen." *The New Encyclopaedia; or, Universal Dictionary of Arts and Sciences*, vol. XXI (London: Vernor, Hood and Sharpe, and Thomas Hostell, 1807), 32.

42. Psalm CXXXIX, 12, in *The Christian's Universal Companion* (Gainsbrough: J. Mozley, 1778), 67. These versions of the Psalms were first published as: N. Brady and N. Tate, *A New Version of the Psalms of David Fitted to the Tunes Used in Churches* (Tranquebar [India]: Printed in the Office of the Danish Missionaries, 1717); reference on page 227.

43. The Latin text does not refer to the screen: "Beati qui non viderunt, Et firmiter crediderunt, Vitam aeternam habebunt, Alleluia." In Rev. B. Rayment, *The Divine Office for the Use of Laity*, vol. II (Manchester: T. Haydock, 1806), 11. The book was published by "permissu V. A. D. S.", which refers to the permission of Vicarii Apostolici Districtus Septentrionalis. The original edition seems to have been published in Newcastle in 1780.

44. Edward Irving, "A Sermon Delivered by the Rev. E. Irving, M.A.", *The Preacher*, no. 50 (14 July 1831): 347. Irving continued his screen parable in the following paragraphs.

45. Jonathan Swift, *Verses on the Death of Dr. Swift. Written by Himself: Nov. 1731*, 2nd edition (London: C. Bathurst, 1739), 13.

46. Nicholas Rowe, *The Tragedy of Jane Shore. Written in Imitation of Shakespear's [sic] Style*, Act I, Scene I (London: Printed for Bernard Lintot; and sold by W. Feales, 1736), 5.

47. Edward Young, *A Vindication of Providence, A True Estimate of Human Life, in Which The Passions are considered in a New Light* (London: T. Lowndes and W. Nicoll, 1765), 63.

48. [William Darrell], *The Gentleman Instructed, In the Conduct of a Virtuous and Happy Life. In Three Parts. Written for the Instruction of a Young Nobleman*, 4th edition (London: E. Smith, 1709), 36.

49. James Wood, *The Elements of Optics: Designed for the Use of Students in the University* (Cambridge: J. Burges, 1799), 149.

50. Thomas Rutherworth, *A System of Natural Philosophy, being a Course of Lectures in Mechanics, Optics, Hydrostatics, and Astronomy*, vol. I (Cambridge: J. Bentham for W. Thurlbourn, 1748), 453. This formulation was adopted by *Encyclopaedia Britannica*, vol. III (London: John Donaldson, 1773), 427.

51. Francis Bacon, *Sylva Sylvarum; or a Natural History, in Ten Centuries* (posthumous, 1627), in *The Works of Francis Bacon. New Edition. In Ten Volumes*, vol. I (London: C. and J. Rivington et al., 1826), 337. Bacon used the spelling "skreen".

52. Robert Smith, *A Compleat System of Opticks In Four Books*, vol. II (Cambridge: Printed for the Author, 1838), 384. The variant "scioptric" was also used.

53. Benjamin Martin, *The Young Gentleman and Lady's Philosophy*, vol. II (London: W. Owen, 1763), original emphasis.

54. Ibid., 156.

55. Ibid., 157.

56. Ibid., 158.

57. Ibid., 212. The lens used in the experiment was the object lens of a telescope, which was taken out and fixed in the "Scioptric Ball and Socket".

58. Ibid., 212–213. Benjamin could not resist the temptation to blame those "who have not Curiosity enough to do this", by purchasing "the Instrument at a small Price". These people are "deservedly excluded from participating in those Pleasures which are the most exquisite that Nature affords, and place us at the greatest Distance from the Brute Creation" (footnote on page 212). It is worth remembering that Martin was a scientific instrument maker by profession.

59. William Henry Fox Talbot, *The Pencil of Nature* (London: Longman, Brown, Green and Longmans, 1844), second text page, no page numbers.

60. George Adams, *Lectures on Natural and Experimental Philosophy*, vol. II (London: Printed by R. Hindmarsh, sold by the Author, 1794), 514. The book contains numerous other examples.

61. "To Mrs. P[riestley], with some drawings of birds and insects", published in *Poems* (1773) and probably written in the Autumn 1767. Quoted in: *The Contemplative Philosopher: or Short Essays on the Various Objects of Nature Throughout the Year*, vol. I (London: M. Brown for G.G. and J. Robinson et al., 1800), 285. Published in Anna Laetitia Barbauld, *Selected Poetry and Prose*, edited by William McCarthy and Elizabeth Kraft (Peterborough, Ontario, CA: Broadview Press, 2001), 44–49.

62. *A New Display of the Beauties of England or A Description of the most Elegant or Magnificent Puplic* [sic] *Edifices, Royal Palaces, Noblemen's and Gentlemen's Seats, and other Curiosities, Natural or Artificial, in the different parts of the Kingdom*, vol. II, 3rd edition (London: Printed for R. Goadby and Sold by J. Towers, 1776), 152.

63. James Wood, *The Elements of Optics: Designed for the Use of Students in the University* (Cambridge: J. Burges, 1799). On the magic lantern and the screen, see page 149.

64. John Hammond, *The Camera Obscura. A Chronicle* (Bristol: Adam Hilger Ltd., 1981); Martine Bubb, *La Camera obscura: Philosophie d'un appareil* (Paris: L'Harmattan, 2010).

65. Fox Talbot's early cameras were adaptions of box camera obscuras.

66. It used to be part of Short's Observatory, Museum of Science and Art, opened at this location along the Royal Mile in 1853 by Maria Theresa Short, an inheritor of the scientific instrument maker Thomas Short. Today the attraction housed by the "Outlook Tower" is named *Camera Obscura and World of Illusions*.

67. *At the Beach*, lithograph by Frederick Burr Opper, lithographed by J. Jacob Ottmann, *Puck*, 30 August 1890; *The Illustrated Police News*, 14 August 1880 (cover); Georges du Maurier, "'Where Ignorance is Bliss', &c.", (cartoon), *Punch*, October 1868. Giambattista Della Porta described how a camera obscura could be used as a dark auditorium for a performance taking place outside in *Della magia naturale*, Libri XX (Naples: Antonio Bulifon, 1677), 486–487. See facsimile in Laurent Mannoni, Donata Pesenti Campagnoni and David Robinson, *Light and Movement. Incunabula of the Motion Picture 1420–1896* (Gemona: La Cineteca del Friuli / Le Giornate del Cinema Muto, 1995), 51–52. Ellen Zweig realised a performance with the camera obscura at Cliff House, San Francisco, along similar lines. Erkki Huhtamo, "Art in the Rear-View Mirror: The Media-Archaeological Tradition in Art", in Christiane Paul (ed.), *A Companion to Digital Art* (Chichester, West Sussex: John Wiley & Sons, 2016), 69–110.

68. T. Hodson and I. Dougall, *The Cabinet of the Arts; being a New and Universal Drawing Book* (London: T. Ostell, 1805). Other varieties were also discussed, including book-shaped camera obscuras, which were set up in "pyramidical form" for use. "In this form the image is reflected from the mirror through the lens to a white screen placed at the bottom of the box, where it may be easily outlined with a black lead pencil, the operator standing with his back toward the object: by these means, a print, or picture, placed before the mirror, may be copied very exactly." Ibid., 90.

69. John H. Hammond, *The Camera Lucida in Art and Science* (Bristol: Adam Hilger, 1987), 4–6. New versions of the camera lucida are still produced, including a device called Neolucida, crowd funded by Kickstarter. The project was started by the media artists Pablo Garcia and Golan Levin.

70. When it comes to both their basic apparatuses and their dispositives, the relationship between the room or tent camera obscura and the camera lucida resembles the relationship between the peepshow box and the zograscope. The room or tent camera obscuras were enclosed spaces, whereas the camera lucida and the zograscope were open. Another device that deserves to be mentioned here was the landscape mirror, often known as the Claude Glass. It was a portable device too, but could also be hung from a wall, etc. Claude Glasses were sometimes round, sometimes rectangular. Arnaud Maillet, *The Claude Glass: Use and Meaning of the Black Mirror in Western Art*, trans. Jeff Fort (New York: Zone Books, 2004).

71. *Philosophical Transactions*, no. 245 (October 1698): 364.

72. Roger Gonin, *Ces savoyards, montreurs de lanterne magique* (Albertville: Société des Amis du Vieux Conflans, 2016).

73. *A New Complete English Dictionary; Containing, A Brief and Clear Explication of Most Words in the English Language* [...], 2nd edition (Edinburgh: Printed by David Paterson for John Robertson, Robert Duncan et al., 1770), 327.

74. George Adams, *Lectures on Natural and Experimental Philosophy* [...], vol. II (London: Printed by R. Hindmarsh, sold by the Author, 1794), 206.

75. David Robinson, *The Lantern Image. Iconography of the Magic Lantern 1420–1880* (Nutley, East Sussex: The Magic Lantern Society, 1993); *The Lantern Image. Iconography of the Magic Lantern 1420–1880. Supplement No. 1* (Kirkby Malzeard Ripon, North Yorkshire: The Magic Lantern Society, 1997).

76. Patrice Guerin, *Du soleil au xenon. Les techniques d'eclairage à travers deux siècles de projection* (Paris: Prodiex, 1995), 14–16. Ami Argand's lamp, invented in Geneve, was improved by Quinquet in Paris and became the principal illuminant in phantasmagoria. The name is given as Amie Argand in Frederick Penzel, *Theatre Lighting Before Electricity* (Middletown, Connecticut: Wesleyan University Press, 1978), 24.

77. *OED*, vol. XIV, 722. The quotation is from *The New Family Receipt Book* (London: John Murray, 1810) and instructs the reader how to prepare such screens, obviously for domestic projections (257).

78. Mervyn Heard, *Phantasmagoria: The Secret Life of the Magic Lantern* (Hastings: The Projection Box, 2006). See also my critical review: Erkki Huhtamo, "Ghost Notes: Reading Mervyn Heard's *Phantasmagoria: The Secret Life of the Magic Lantern*", *The Magic Lantern Gazette*, vol. 18, no. 4 (2006): 10–20.

79. Laurent Mannoni, *Le grand art de la lumière et de l'ombre* (Paris: Nathan, 1994), 147.

80. A commentator found the application without merit in *The Monthly Magazine; or, British Register*, vol. XXIV, no. 87 (June 1, 1802): 488. It is unclear if the patent was ever issued.

81. Reproduced in facsimile with clarifications in Mannoni, Pesenti Campagnoni and Robinson, *Light and Movement*, 102–117.

82. Calling it the "nebulous magic lantern", William Hooper gave detailed instructions about how to use it "to produce the appearance of a phantom". See his *Rational Recreations, in Which the Principles of Numbers and Natural Philosophy are clearly and copiously elucidated* [...], vol. II (London: L. Davis, J. Robson, B. Law and G. Robinson, 1774), 43–47. Phantasmagoria's ancestry was discussed in a booklet by the showmen Schirmer and Scholl (first names unknown), who appeared in London in 1805, *Sketch of the Performances, at the Large Theatre, Lyceum; and a short account of the history of the origin, history, and explanation of all the late Optical and Acoustic Discoveries, called the Phantasmagoria, Ergascopia, Phantascopia, Mesoscopia, &c. Together with The Invisible Girl* (London: Warde and Betham for the Proprietors, 1805), 15–19.

83. About basic techniques of Phantasmagoria, see *Lanterne magique et fantasmagorie. Inventaire des collections* (Paris: Musée national des techniques / CNAM, 1990).

84. Schirmer and Scholl, *Sketch of the Performances*, 19. In his reminiscences Robertson characterised it as "rideau de percale que nous avons appelé *miroir*". Étienne-Gaspard Robertson, *Mémoires récréatifs scientifiques et anecdotiques*, vol. I (Paris: Chez l'Auteur et à la Librairie de Wurtz, 1831), 329. Sir David Brewster wrote: "The power of the magic lantern has been greatly extended by placing it on one side of the transparent screen of taffetas, which receives the images while the spectators are placed on the other side, and by making every part of the glass sliders opaque, excepting the part which forms the figures." David Brewster, *Letters on Natural Magic* (London: John Murray, 1833), 80.

85. Schirmer and Scholl, *Sketch of the Performances*, 22.

86. Ibid., 19.

87. *The Monthly Magazine*, no. 80 [no. 5, of vol. 12] (1 December 1801): 432.

88. W. Shepherd, J. Joyce and Lant Carpenter, *Systematic Education: or, Elementary Instruction in the Various Departments of Literature and Science; with Practical Rules for studying Each Branch of Useful Knowledge* (London: Longman, Hurst, Rees, Orme and Brown, 1817), 74.

89. Ibid.

90. Ibid. This had been appropriated from Jeremiah Joyce, *Letters on Natural and Experimental Philosophy, Chemistry, Anatomy, Physiology, and Other Branches of Science Pertaining to the Material World* (London: J. Johnson and Co., 1810), 224. Phantasmagoria could be associated with later phenomena such as holography and virtual reality which aim at presenting "free floating" visual illusions without a framed screen.

91. Erkki Huhtamo, "Watching the Borders and Peeking Beyond: Astronomical Demonstration Instruments as a Challenge for Screenology", *Écranosphère*, vol. 1, no. 1 (2014), 23 pages (accessed on 5 August 2019, http://www.ecranosphere.ca/articles/2014/pdf/E.Huhtamo_n1.pdf). On the *Eidouranion*, see also Kurt Vanhoutte's contribution to the present volume. Adam Walker's initial performances took place in Birmingham in November 1781 at a two-thousand seat theater. See Deidre Loughridge, "Celestial Mechanisms: Adam Walker's Eidouranion, Celestina, and the Advancement of Knowledge", in James Q. Davies and Ellen Lockhart (ed.), *Sound Knowledge: Music and Science in London, 1789–1851* (Chicago: Chicago University Press, 2016), 65. Loughridge notes that the title may have been influenced by Philip James de Loutherbourg's Eidophusikon introduced in London in February 1781. However, that was a mechanical theatre, not a magic lantern show.

92. Popular scientific demonstrations could include electric shocks, laughing gas and comic lantern slides.

93. The three lectures were given at London Mechanics' Institution, 29, Southampton Buildings on 28 June, 1 July and 5 July 1830. Printed by W. H. Tickle, Middex Street, Croydon. Hayes repertory included intriguing items like Transparent Vertical Tellurian, Horizontal Lunarian, Grand Horizontal Orrery, Dioastrodoxon, or Grand Transparent Orrery, in addition to 10 Grand Transparencies. Were traditional mechanical devices and astronomical slides shown together? The broadside was bought by the author in 2019, but may have been lost in transit. Digital copy in author's archive.

94. Advertisement in *The Repository of Arts, Literature, Commerce, Manufactures, Fashions, and Politics*, vol. XI, no. 63 (March 1814), unpaginated advertising section.

95. It was described and illustrated in a supplement to Philip Carpenter, *Elements of Zoology* (Liverpool: Rushton and Melling, 1823), reprinted in fascimile in Mannoni, Pesenti Campagnoni and Robinson, *Light and Movement*, 125–131. The illustration is on page 131. The lantern comprised other improvements, including the use of four lenses.

96. Carpenter wrote: "[T]he natural history subjects may [...] be given in their natural sizes with the utmost facility." (ibid., 129). The size of a zebra of course differs from that of a butterfly as can be made clear with a movable magic lantern. By tilting and shaking the lantern the animals could appear as if brought to life.

97. [Philip Carpenter], *A Short Account of the Copper-Plate Sliders, and a Description of the Improved Phantasmagoria Lantern, with the Method of Using It* (Liverpool: Rushton and Melling, ca. 1823), 9–10. Original in author's collection.

98. Earlier a matching pair of magic lanterns was normally used for dissolving views. They had Argand oil lamps and needed a mechanical shutter in front of the lens tubes (the oil lamps had to burn continuously). When one lens tube was blocked, the light shone from the other, and so on.

99. Charles Musser, *Politicking and Emergent Media: US Presidential Elections of the 1890s* (Berkeley: University of California Press, 2016), 123–126; Erkki Huhtamo, "The Sky is (not) the Limit: Envisioning the Ultimate Public Media Display", *The Journal of Visual Culture*, vol. 8, no. (December 2009): 329–348; Erkki Huhtamo, "Messages on the Wall: An Archaeology of Public Media Displays", in Scott McQuire, Meredith Martin and Sabine Niederer (ed.), *Urban Screens Reader* (Amsterdam: Institute of Network Cultures, 2009), 15–28.

100. This comment is said to have been made by Reverend Russell H. Conwell of Philadelphia to the lyceum lecturer George R. Wendling, quoted in the editorial introduction to Alexander Black, "Making the First Picture Play: The Forerunner of the Movie Drama Described by the Pioneer Screen [sic] Playwright", *McBride's Magazine* (October 1915): 64.

101. Black, "Making the First Picture Play", passim.

102. *Lantern Manipulation: Being Suggestions and Instructions in the Management of Dissolving Views, The Oxyhydrogen Light, &c.*, 2nd edition (Birmingham: A. Pumphrey, ca. 1877), 18.

103. Comment by Frank Daugherty, 1937, as mentioned by William Boddy in his guest lecture in the UCLA Department of Film, Television, and Digital Media Graduate Student Colloquium, 2 April 2019.

Author Biographies

Richard Crangle has a PhD in early film and related media and has been researching magic lantern slides for over twenty-five years, with a particular focus on British commercial slide manufacture of the late 19th and early 20th centuries. He is co-editor of *The Encyclopaedia of the Magic Lantern* (2001), *Realms of Light* (2005), and *Screen Culture and the Social Question 1880–1914* (2014), and author of numerous articles and conference papers. Most recently he was an Associate Research Fellow at the University of Exeter, working on the *A Million Pictures* European collaboration project researching the use of the projected image in educational and heritage contexts in several EU countries. Among other projects he has been largely responsible for creating and developing the Lucerna Magic Lantern Web Resource (lucerna.exeter.ac.uk).

Sarah Dellmann is a film and media historian with expertise in European visual culture of the 19th and early 20th centuries. Her interests lie in the field of magic lantern, early cinema, information science, documentation of cultural heritage, and research methodologies. She initiated and coordinated the *A Million Pictures* project (2015–2018) and is one of four directors of the Lucerna Magic Lantern Web Resource CIC. Her book *Images of Dutchness. Popular Visual Culture, Early Cinema and the Emergence of a National Cliché, 1800–1914* (Amsterdam UP 2018) was longlisted for the 2019 Kraszna-Krausz Best Moving Image Book Award.

Ine van Dooren fell in love with the Lantern at a Magic Lantern Society meeting in The Hague in 1988 and has been a committee member of this international society for many years. Since 1995 she works as Moving Image Archivist for Screen Archive South East, a public sector regional archive in England. She has represented SASE as an active associated partner in the *A Million Pictures* project. Her special lantern heritage interest is in Life Model slide productions and she contributed to publications such as *Realms of Light* (2005) and *Screen Culture and the Social Question* (2014). Close to her heart is the Lucerna Magic Lantern Web Resource of which she is a co-director.

Claire Dupré la Tour is an Affiliate Researcher at the Institute for Cultural Inquiry – ICON, Utrecht University, where she received a PhD in 2016 for her thesis on the intertitle genesis and its developments for fiction films construction, 1895–1916. She also is an Associate Researcher at the Institut de Recherche sur le Cinéma et l'Audiovisuel – IRCAV, Université de la Sorbonne

Nouvelle Paris 3. She authored many articles on the intertitle and early cinema co-directed conferences and co-edited books on cinema history and theory She is a member of The Magic Lantern Society UK, Domitor, Les Amis d Georges Méliès and other associations. She was a co-editor of the journal *Ira* from 1992 to 2004.

Jennifer Durrant is a museum professional with over 15 years specialism curating archaeology and social history collections. As Assistant Curator o Antiquities at Royal Albert Memorial Museum, Exeter, UK, she sought to bring life to under-used areas of the collection, including the magic lantern collection. In this role she was also project curator for temporary exhibition and permanent gallery displays, developed research partnerships, and encour aged public engagement with collections. She is currently a PhD researcher i Museum Studies at University of Leicester, funded by the AHRC Mid lands3Cities DTP, examining how communication affects public visibility and transparency of 'hidden' museum practices.

Francisco Javier Frutos-Esteban is Professor at the Department of Socio logy and Communication of the University of Salamanca where he teache photography, media history and social studies of science. Previous and curren research topics include communication history, photography and media psy chology. He has published more than 30 peer-reviewed papers, seven book as main author and forty book chapters. He has been principal investigator (PI of four funded projects and collaborator on nine more.

Anna Grasskamp is Assistant Professor at the Academy of Visual Arts at Hong Kong Baptist University. She was Post-Doctoral Fellow at Cluster of Excel lence "Asia and Europe in a Global Context" at Heidelberg University, visiting post-doctoral fellow at Max Planck Institute for the History of Science, and held fellowships at International Institute for Asian Studies at Leiden Univer sity and other institutions. She has published in *Res*, *The Rijksmuseum Bulletin* and *World Art*, she co-edited *EurAsian Matters: China, Europe, and the Transcultura Object, 1600–1800* and is the author of *Objects in Frames: Displaying Foreig Collectibles in Early Modern China and Europe*.

Emily Hayes is a Research Associate and Lecturer at Oxford Brookes Uni versity. She holds a first degree in archaeology and anthropology (Universit of Cambridge), an MSc in environmental science and archaeology (Paris Sorbonne) and a PhD on the lantern practices and lantern slide collections o the Royal Geographical Society (University of Exeter). Her research ha appeared in the *Journal of Historical Geography*, *Early Popular Visual Culture* and the *British Journal for the History of Science*. In her investigations of *fin de sièc* popular science, histories of education and the history and philosophy o science she employs imaginative and transdisciplinary methods.

Erkki Huhtamo is Professor of Design Media Arts, and Film, Television, and Digital Media at the University of California, Los Angeles (UCLA). Hi research concentrates on media archaeology, a field he co-founded a quarte of a century ago. He also writes about media arts and museum studies. Hi

most significant book to date is *Illusions in Motion: Media Archaeology of the Moving Panorama and Related Spectacles* (The MIT Press, 2013).

Martyn Jolly is an artist and a writer. He is an Honorary Associate Professor at the Australian National University School of Art and Design. In 2006 his book *Faces of the Living Dead: The Belief in Spirit Photography* was published by the British Library, as well as in the US and Australia. His work is in the collections of the National Gallery of Australia, the National Gallery of Victoria and the Canberra Museum and Gallery. In 2015 he received an Australian Research Council Discovery Grant to lead the international project "Heritage in the Limelight: The Magic Lantern in Australia and the World".

Joe Kember is Professor in Film at the University of Exeter. He is the co-editor of the *Film History* book series at the University of Exeter Press. He is the author of *Marketing Modernity: Victorian Popular Shows and Early Cinema* (University of Exeter Press, 2009) and co-editor of *Popular Exhibitions, Science, and Showmanship, 1840–1910* (Pickering and Chatto, 2010). He was the Principal Investigator in the UK for the *A Million Pictures* project (JPI Heritage plus) and Partner Investigator in the "Heritage in the Limelight" Project (Australian Research Council). He is currently completing a co-authored book, *Picture Going: Visual Shows 1820–1914*, with John Plunkett.

Frank Kessler is Professor of Media History at Utrecht University and currently the director of the Research Institute of Cultural Inquiry (ICON). He is a former president of Domitor, the international association for research in early cinema and a co-founder and co-editor of *KINtop. Jahrbuch zur Erforschung des frühen Films*, the *KINtop Schriften* series and the *KINtop Studies in Early Cinema* series. He is a principal investigator in the Belgian Excellence of Science project "B-magic" and the project leader of "Projecting Knowledge – The Magic Lantern as a Tool for Mediated Science Communication in the Netherlands, 1880–1940".

Machiko Kusahara is a media art and media archeology scholar based in Tokyo. Her research focuses on negotiation between art, popular media, technology and society both in contemporary and early media cultures. Since the early 1980s Kusahara has curated and researched in the fields of computer graphics, media art, and media history. She served in launching venues including Tokyo Photographic Art Museum and juried for competitions including Ars Electronica. Kusahara lectures and publishes internationally on media art, Device Art, magic lantern, panorama, among others. She is a Professor Emerita at Waseda University and holds a PhD in engineering from University of Tokyo.

Ying Ki Lee is an Assistant Professor at the Academy of Visual Arts, Hong Kong Baptist University. His research interest includes photographic practices in the East-Asian context and media archaeology.

Sabine Lenk is currently a postdoctoral researcher at the Universities of Antwerp (UA) and Brussels (ULB) in the research project "B-magic. The

Magic Lantern and its Cultural Impact as Visual Mass Medium in Belgium (1830–1940)". She has worked for film archives in Belgium, France, Germany, Luxemburg, Great Britain and the Netherlands. Together with Frank Kessler and Martin Loiperdinger she is a co-founder and co-editor of *KINtop. Jahrbuch zur Erforschung des frühen Films*, *KINtop Schriften* and *KINtop Studies in Earl Cinema*.

Carmen López-San Segundo holds a doctorate from the University of Salamanca (Doctoral Program Education in the Knowledge Society). She was a researcher in the projects "Dynamics of Educational and Scientific Renovation in Secondary School Classrooms (1900–1936): An Iberian Perspective and *A Million Pictures: Magic Lantern Slide Heritage as Artefacts in the Common European History of Learning*. She is currently part of the team of researchers on the project "Educational and Scientific Challenges of the Second Spanish Republic: Internationalization, Popularization and Innovation in Universities and Secondary Schools". Her research is focused on fields such as cultural heritage, archaeology and the history of science.

Ariadna Lorenzo Sunyer graduated in Art History and is a PhD candidate at the Université de Lausanne (Switzerland) and the Universitat de Girona (Spain). Through different case studies, her thesis aims to study the relationship between the artists' talks with slide shows and the different spaces of artistic practice from the late 1930s to the early 1970s in the USA to explain the rise and development of the communicative, educational and artistic uses of slides created and performed by artists. She has also collaborated in several exhibitions in Switzerland and Spain, and she is a member of several Spanish research projects.

Vanessa Otero is a Researcher at the Department of Conservation and Restoration FCT NOVA and LAQV-Requimte Research Unit (Portugal). She obtained her PhD in Conservation Science at FCT NOVA in 2018, with bachelor's in Chemistry and a master's in Conservation Science. Her main research interest is the study of 19th- and early 20th-century artists' materials including their production, characterisation and evolution over time. She intends to advance knowledge in this field, which is essential to place artwork in context as well as to establish the best conservation and authentication strategies.

Daniel Pitarch teaches audiovisual media and film history at Universitat de Girona and Escola Massana (Degree in Art and Design). His fields of research include audio-visual media of the 19th century, film theory of the interwar period (he is the editor of a Spanish compilation of Walter Benjamin's writing on film) and experimental animation. He is a member of Estampa, an artistic collective that works on experimental cinema and digital media. Their latest projects focus on the uses and ideologies of artificial intelligence, an interest that started with the project *The Bad Pupil. Critical Pedagogies for Artificial Intelligences* (2017–2018).

Jordi Pons i Busquet graduated in Contemporary History from the Universitat Autònoma de Barcelona. Since 1995 he works for the Fundació Museu del Cinema, first cataloguing the Tomàs Mallol Collection (1995–1997) and later planning and organising the Museu del Cinema (1997–1998). Since 1998, he is the director of this museum. Since 1999 he coordinates the "International Seminar on the History and Origins of Cinema", which is organised bi-annually by the Museu del Cinema and the Universitat de Girona. He is the author of the books *Guide to the Cinema Museum* and *Image Makers. From Shadows Theatre to Cinema*. He has curated several temporary exhibitions on cinema and precinema.

Montse Puigdevall Noguer graduated in Art History and holds a master's degree in Museology and Heritage at the Universitat de Girona. She is a Curator of Museu del Cinema (Girona), where she has been cataloguing their collections since its creation. She is also responsible for the Museum of Cinema's Study Institute for which she coordinates the International Seminar in the History and Origins of Cinema, which has arrived at its 12th edition in 2019. She has also curated several exhibitions about cinema and pre-cinema in the Museu del Cinema, the last of which were "Light! The Magic Lantern and digital imaging. Complicity between the nineteenth and twenty-first century" and "Trading cards, films and stars".

Angélique Quillay (Université de Paris, LARCA, CNRS, F-75013 Paris, France) holds a PhD in Languages and Cultures of the Anglophone World. Her 2016 dissertation, directed by François Brunet, is entitled *A Reverse Image The visual culture of the Pennsylvania Hospital for the Insane under the direction of Thomas Kirkbride (1840–1883)*. Her research was supported by the Terra Foundation for American Art.

Angel Quintana is a Professor of History and Theory of Cinema at Universitat de Girona (Spain). He has been an invited professor in different universities such as Universities Paris III and Paris IV, University of Lausanne, University of the Andes (Bogota) or Iranian National School of Cinema. He has published different books among which *Fábulas de lo visible. El cine como creador de realidades* (2003, award of the Spanish Association of historians of cinema), *Virtuel? À l'ère du numérique le cinéma est le plus réaliste des arts* (2008), *Después del cine* (2011) and *Lorca et le Cinéma* (2019). He has served as principal investigator in different projects, most recently in "Virtual Worlds in early cinema: devices, aesthetics and publics".

Nadezhda Stanulevich defended her PhD entitled *Sergey Prokudin-Gorskii and his contribution to the development of colour photography* in 2019. Most of her peer-reviewed articles focus on the history of photographic techniques or the history of museums' collections. She has been a Curator for Photography at the Russian Academy of Fine Arts Museum, then a Chief Curator at the Kozlov Museum (Institute for the History of Science and Technology, Russian Academy of Sciences) between 2012 and 2019. Since September 2019, she is a Junior

Researcher at Peter the Great Museum of Anthropology and Ethnography (the Kunstkamera) in St. Petersburg.

Jennifer Tucker is a historian of science and technology specialising in the study of art, visual culture, environmental history, gender and law in the History Department at Wesleyan University (Connecticut). The author of *Nature Exposed: Photography as Eyewitness in Victorian Science*, she has published over thirty articles and book chapters that explore topics in history and culture through visual media. She currently is finishing a book about photography and Victorian facial likeness entitled *Photography and Law Reader: Obscenity, Surveillance, Privacy, Evidence and Photographers' Rights, 1839 – Present*. She is an editor of the Photography and History monograph series for Bloomsbury Academic Press and co-chair of *Radical History Review* journal.

Kurt Vanhoutte is Professor of Theatre Studies at the University of Antwerp, where he coordinates a master's programme in Theatre and Film Studies. He is the director of the Research Centre for Visual Poetics. Vanhoutte is spokesperson-coordinator of "B-magic", a large-scale research project (EOS – Excellence of Science, 2018–2022) on the magic lantern and its impact as visual mass medium. His work has appeared in various books and journals, including *Early Popular Visual Culture*, *Contemporary Theatre Review* and *Foundations of Science*. He is currently working on a book on "Scientific Fiction", tracing the history, actuality and prospect of a genre aimed at mediating scientific revolutions through performance.

Márcia Vilarigues is Assistant Professor and President of the Department of Conservation and Restoration of NOVA University of Lisbon and Head of the Research Unit VICARTE. She works in the field of Conservation and Restoration of Cultural Heritage in the area of Technical Art History and Materials Degradation. Her research focuses on the preservation of our material cultural history and on enriching the knowledge about our shared past through the history of historical objects.

Joseph Wachelder is Associate Professor in the Department of History, Maastricht University (The Netherlands). His research focuses on interactions between science and culture, with special interest for the mediators and media in between, spanning the period from the 18th century till today. Research topics comprise: amateurs, professionals and discipline formation; the popularisation of science; spectacular phenomena; colour and sense experience in art and science; optical toys; educational toys and games; intergenerational exchanges, (higher) education; and societally engaged research and Science Shops.

Artemis Willis is a scholar of film and media, a media arts curator and a documentary filmmaker. She holds a PhD in Cinema and Media Studies from the University of Chicago. Willis's research, teaching and curatorial projects focus on the magic lantern tradition in relation to broader aesthetic and cultural practices. Her writing has appeared in *Early Popular Visual Culture* and various edited volumes. She has presented lantern performances at numerous muse-

ums, festivals and conferences in the U.S. and overseas. She is currently working on a book project, *Lanternology: The Possibilities of the Projected Image*.

Suk Mei Irene Wong was a Senior Assistant Librarian at the Special Collections & Archives, Hong Kong Baptist University Library. She holds an M.L.S. (Master of Library Services) from the Rutgers State University of New Jersey. She has published several articles on library services, Chinese Christianity collections and digitisation in journals and books. Her research interests include digitisation, Chinese Christianity, preservation and archival management.

Nele Wynants is an art and theatre scholar at the Free University of Brussels (ULB) and has published widely on the interplay of performance, media history and science. She is a member of the Young Academy Belgium (Flanders) and the Project Management Board of "B-magic", a large-scale research project on the magic lantern in Belgium (www.b-magic.eu). She currently conducts research on the role of the lantern in cultural exchanges between European cities and local fairgrounds. She is editor-in-chief of *FORUM*+ *for research and arts* (www.forum-online.be) and her edited volume *Media Archaeology and Intermedial Performance – Deep Time of the Theatre* has recently been published by Palgrave Macmillan.